THE HANDY ART HISTORY ANSWER BOOK

Madelynn Dickerson

VISIBLE
INK
PRESS

Detroit

THE HANDY ART HISTORY ANSWER BOOK

Visible Ink Press®
43311 Joy Rd., #414
Canton, MI 48187–2075

Visible Ink Press is a registered trademark of Visible Ink Press LLC.

Most Visible Ink Press books are available at special quantity discounts when purchased in bulk by corporations, organizations, or groups. Customized printings, special imprints, messages, and excerpts can be produced to meet your needs. For more information, contact Special Markets Director, Visible Ink Press, www.visibleinkpress.com, or 734–667–3211.

Managing Editor: Kevin S. Hile
Art Director: Mary Claire Krzewinski
Typesetting: Marco Di Vita
Indexing: Larry Baker
Proofreaders: Shoshana Hurwitz and Chrystal Rosza

Cover art: Shutterstock.

Library of Congress Cataloging-in-Publication Data

Dickerson, Madelynn.
 The handy art history answer book / Madelynn Dickerson. — 1 [edition].
 pages cm
 ISBN 978-1-57859-417-7 (pbk.)
 1. Art—History—Miscellanea. I. Title.
 N5303.D53 2013
 709—dc23
 2013000153

Printed in the United States of America

10 9 8 7 6 5 4 3 2 1

Contents

ART PRINCIPLES AND HISTORY...1

Art Fundamentals ... Basics of Architecture ... Form and Style ... Finding Meaning in Art ... Prehistoric Art

ART OF THE ANCIENT WORLD, 5000 B.C.E.–400 C.E. ... 27

Art of the Ancient Near East ... Art of India and Southeast Asia ... Art of Ancient Africa ... Ancient Egyptian Art ... Art of Ancient China ... Early Japan and Korea ... Art of the Ancient Americas ... Aegean Art ... Ancient Greek Art ... Etruscan Art ... Roman Art

THE MEDIEVAL WORLD, C. 400–1300...59

Early Jewish and Christian Art ... Byzantine Art ... Islamic Art ... Early Medieval Art from Northern Europe ... Carolingian and Ottonian Art ... India and Southeast Asia ... Chinese Art from the Sui to the Yuan Dynasties, c. 589–1368 ... Korean Art until c. 1400 ... Japanese Art until c. 1400 ... Art of Medieval Africa ... Pre-Columbian America ... North America ... Romanesque Europe ... Gothic Europe

THE EARLY MODERN WORLD, C. 1300–1600...99

Proto-Renaissance ... Early Renaissance in Italy ... Northern European Renaissance ... High Renaissance in Italy ... Renaissance Venice ... Sixteenth-Century European Art and Architecture ... Islamic Art and the Ottoman Empire ... African Art ... Art and Zen Buddhism ... Art in the New World

BAROQUE AND BEYOND, C. 1600–1850 ... 135

Baroque Italy and France ... Dutch and Flemish Painting ... The Golden Age of Spain ... Asian Art ... Rococo and the Eighteenth Century ... Mughal Art in India ... Neoclassical Art ... Romanticism ... Art of the Americas

Acknowledgments

I would like to offer my warmest, most sincere thanks to Roger Jänecke, Managing Director and Publisher at Visible Ink Press, for making this book possible. The guidance and patience of Kevin Hile, Managing Editor, was a great gift during the writing process and I can't thank you enough.

I owe so much to the friendship and support of my colleagues at the American Academy of Art, especially Lindsay Harmon, MLIS, for answering so many questions and providing access to such helpful resources, and Jaime O'Connor, Humanities Department Chair, for your understanding and enthusiasm.

And of course, to my family and my husband, Rachid, thank you for everything—listening, cooking, hugging, and laughing with me while writing this book.

PHOTO CREDITS

Artwork images that are copyrighted include copyright information in the text of the captions. All other artworks are in the public domain. The following credits should also be noted:

Aiwok: page 29. Captmondo: page 19. Cary Bass: page 195. David Gaya: page 114. Dennis Jarvis page from Halifax, Canada: page 90. Die Buche: page 45. Figuura: page 209. Georgezhao: 51. Gerard M: page 53. Gruban: page 22. Hussain Didi: page 55. Luisvassy: page 12. Lutralutra: page 77. Patrick A. Rodgers: page 106. Quartier-Latin1968: page 92. somedragon2000: page 41. Tizian: page 119. User:Tetraktys, 2005: page 50. VivaItalia1974: page 140.

Timeline of Major Art Historical Periods

This timeline is not inclusive of every period or movement of art history, but it should provide good general context for major periods of art history across the globe. All dates should be considered approximate.

Prehistoric Art

Paleolithic Art	c. 35000–8000 B.C.E.
Neolithic Art	c. 8000–2000 B.C.E.

Ancient Art

Ancient Near Eastern Art	c. 3000–600 B.C.E.
Ancient Egyptian Art	c. 3000–30 B.C.E.
Indus Valley Art	c. 3000–1000 B.C.E.
Ancient Aegean Art	c. 3000–700 B.C.E.
Ancient Chinese Art	c. 2000–200 B.C.E.
Art of the Pre-classic Period in Mesoamerica	c. 1500–300 B.C.E.
Ancient Greek Art	c. 1000–30 B.C.E.
Ancient Roman Art	c. 500 B.C.E.–476 C.E.
Art of the Nok Culture in Africa	c. 500–200 B.C.E.
Buddhist Art of the Maura Dynasty in India	c. 322–185 B.C.E.
Indian Art of the Gupta Period	c. 320–550 C.E.

Art of the Pre-Modern World

Art from the Mali Empire at Djenné	c. 200–1600 C.E.
Art of the Classic Period in Mesoamerica	c. 250 B.C.E.–900 C.E.
Art of the Kofun and Asuka Periods in Japan	c. 300 B.C.E.–646 C.E.
Early Byzantine Art	476 B.C.E.–1453 C.E.
Art of the Nara Period in Japan	c. 646–794 C.E.
Medieval Art in India	c. 650–1530
Art of the Islamic Empire	c. 700–1500
Medieval Art in Europe	c. 700–1400
Art of the Heian Period in Japan	c. 794–1185
Art of the Post-classic Period in Mesoamerica	c. 900–1500

Introduction

We are all naturally drawn to art—it can be beautiful, mysterious, and even shocking. Art and visual images surround us in our everyday lives and impact our understanding of history and of other cultures. Every culture on the planet devotes time and energy to creating and caring for works of art. Whether a ceramic vase, a painted portrait, or a video installation, a work of art can stimulate us, engage us, and even anger us.

This book, part of the successful "Handy Answer Book" series, explores the meaning and history of art from around the world by rethinking the history of art as a series of accessible questions. Questions range from broad to specific in order to provide insights into the fundamentals of art, cultural context, and details about specific works. Explanations of key terms and the inclusion of a glossary will help the reader to expand his or her art vocabulary and engage more deeply in art history discourse.

Each chapter is filled with helpful charts, spotlight questions, and of course, high-quality color images of the art discussed. The eight main chapters are divided into smaller sub-sections so as to place works of art and associated movements into broad context. For example, "From the Industrial Revolution to World War I, c. 1850–1914" discusses the ways in which art changed during the nineteenth century, compares and contrasts major movements such as Realism and Impressionism, explores the emerging role of photography, and explains the role of important non-Western art movements on the art of that period.

Many traditional art history books focus solely on the art of the Western world; however, when writing *The Handy Art History Answer Book,* the goal was to present art traditions from around the world. The art of every inhabited continent is covered here, presented chronologically along with the art of Europe and the United States, making this an inclusive and wide-reaching book.

Art, and the history of art, inspire the passions of both the artist and the viewer. When we visit galleries and museums, come into contact with public art, or look at the images in books, art can amaze, soothe, and also confound us. It is my sincere hope that *The Handy Art History Answer Book* not only provides useful, thorough, and engaging information on the history of art, but also stirs your passions and encourages you to continue reading, learning, and exploring the diverse and enigmatic world of art.

ART PRINCIPLES AND HISTORY

What is **art**?

Since this is a book about the history of art, one might assume a definition of art itself would be straightforward—it is not. In a way, art is whatever a society identifies as such, a status often given to finely crafted works of beauty, works of religious and historic significance, and even theoretical significance. Works of art can include paintings, drawings, sculpture, and architecture, but can also include furniture, textiles, dance, performance, video, and installation pieces, among other forms.

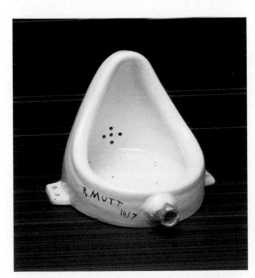

Marcel Duchamp's work is a bold statement. An upside-down urinal signed "R. Mutt 1917" that emphasizes the beauty of everyday objects. It was rejected by the Society of Independent Artists. (The Fountain. *1917 © succession Marcel Duchamp / ADAGP, Paris / Artists Rights Society (ARS), New York 2013.*)

The definition of art can change quite dramatically over time, from culture to culture, and even between individuals. A painted Greek vase, for example, was not considered valuable art by ancient Greek society. Today, however, ancient Greek pottery can fetch millions of dollars and prized examples are housed in top museums around the world. Two friends might visit a contemporary art gallery and completely disagree about the "art" contained within. The artist Marcel Duchamp shocked the art world when he submitted a porcelain urinal to an exhibition by the Society of Independent Artists in 1917. While the work, titled *Fountain,* was rejected, it is considered to be a masterpiece of the avant-garde movement and represents a monumental shift in thinking about art in the twentieth century.

1

Who is an **artist**?

At the risk of being facetious, an artist is a person who makes art; however, just as the definition of "art" has changed over time, so have our definitions and expectations of artists. Traditionally, artists were craftsmen, or artisans. Medieval European sculptors, for example, were considered to be manual laborers. It was only after the Renaissance when cultural perceptions of artists began to change. Great masters such as Leonardo da Vinci and Diego Velázquez made a point of promoting the idea that an artist was much more than a manual laborer. They wanted to be acknowledged for their genius and special talent. The idea of artist-as-genius continues to this day.

What is **art history**?

Art history is the academic study of visual art. Scholars of art history, often professors, writers, and museum or gallery professionals, are interested in the historical significance of art objects, as well as the meaning of both specific works, and the art produced by a particular culture or artist.

Art history is traditionally presented as a "survey," which is Western in focus and explains art history in a narrative form, with a beginning, middle, and end. Canonical art history texts such as E.H. Gombrich's *The Story of Art* and Janson's *History of Art* carry on this long-standing tradition. While still greatly valued, this narrative presentation of art history is coming under increasing scholarly scrutiny. Some colleges and universities no longer teach art history, and now offer programs in "Visual Studies" or "Visual Culture" with the goal of offering insights into the visual arts less constrained by the limitations of the Western-focused survey.

What is the **difference** between an **art historian** and an **art critic**?

While art historians are interested in the meaning of a work of art and its cultural and historical context, the job of the art critic is to evaluate—to decide whether or not a particular piece of art is "good" or "successful." Generally, critics view art at galleries and museums, or in private collections, and they write their personal opinions about the art they see. Like the definition of art itself, however, the definition of art criticism is murky at times, and James Elkins, a well-respected critic and scholar, raises questions about how the two are differentiated, noting that art historians, along with their art critic colleagues, are known to share their personal opinions as well.

What makes **art "good" or "bad"**?

If you've gone to see a movie with a friend and argued about whether the film you both just saw was either good or bad, you are familiar with the foundations of art criticism. Your friend might believe *The Matrix* is a ground-breaking film with profound themes and solid acting, while you might completely disagree. When the arguing has continued for hours after the closing credits, it will perhaps become apparent that nothing you can say about the awkward romance or flashy graphics will convince your friend of your opinion. In the end, you agree to disagree. The same is true when evaluating a work of art. When writing, critics think about the skill of the artist, tech-

Why is art so expensive?

This is essentially a question about the value of art as well as taste, which are not fixed. Artists and styles of art fall in and out of favor regularly, affecting a work's price and status. Paintings by Renaissance artist Sandro Botticelli were not always held in particularly high regard. From his death in the early sixteenth century until the mid-nineteenth century, Botticelli's art was for the most part ignored by collectors and forgotten. As the nineteenth century art-buying elite rediscovered his work, its value went up dramatically. Botticelli's paintings are now amongst the most prized examples of Italian Renaissance art. In another example, Dutch artist Vincent van Gogh only achieved critical success after his death at age thirty-seven. Van Gogh's highly sought-after work now sells for millions of dollars.

But why pay millions of dollars for something that arguably serves no purpose? How can a slab of stone or a stretched canvas slathered in paint cost so much? First, art is not only cultural object but also a commodity and is therefore affected by economic factors, such as supply and demand. (This might account for the fact that the price of art often rises once the artist has passed away.) Second, art is very much a luxury item and therefore a status symbol. The owner of Damien Hirst's $12 million preserved shark (officially titled *The Physical Impossibility of Death in the Mind of Someone Living*) publicly demonstrates a great deal of wealth. It is perhaps the very fact that art serves no practical purpose that drives up the price.

nique, form, and meaning of a work, but in the end, everything is debatable. Duchamp's urinal, *Fountain,* is not inherently good art or bad art. Some critics believe it is profound while others write it off as a stunt. Arguing about whether it is good or bad is not only part of the fun of art appreciation, but is an integral part of art historical scholarship.

What is **beauty**?

Humans are undoubtedly attracted to beautiful things. Beauty can be recognized in a golden sunset, a youthful face, or in any pleasing arrangement of forms and colors. However, the philosopher David Hume said, "Beauty is no quality in things themselves. It exists merely in the mind which contemplates them." Not only does this idea evoke the cliché, "beauty is in the eye of the beholder" but it also suggests that beauty doesn't necessarily serve a purpose. We humans are interested in beauty for its own sake.

Art historians and philosophers are greatly interested in aesthetics, the study of art and beauty, which covers such questions as, "Why is this work of art beautiful?" and even the previously asked, "What is a work of art?" Art scholars are interested in understanding the way beauty relates to logic, morality, and the order of the universe. A question like "what is beauty" lies at the heart of the philosophy of art.

3

What is a **patron**?

A patron is somebody (an individual or a group, or even a company or a museum) who pays an artist for a work of art, or otherwise supports an artist financially. Understanding patronage is an important part of the study of art history, as understanding the needs and desires of the patron can reveal insights into the meaning or purpose of a work of art. One of the most famous art patrons was the Medici family, a rich and powerful family that dominated the Italian city of Florence during the Renaissance. Cosimo de' Medici commissioned works by sixteenth-century artists Pontormo and Bronzino and master artist Michelangelo received key early support from the Medici family. He even lived in the Medici home as a young apprentice, and attended Lorenzo de' Medici's school of art.

Patrons continue to wield considerable influence over the art world. In the early twentieth century, American writer and art collector Gertrude Stein, along with her brother Leo Stein, supported artists such as Pablo Picasso and Henri Matisse by buying their art at a time when their modern style was unpopular in the mainstream. More recently, Charles Saatchi, a British advertising executive, helped to support the careers of the Young British Artists (YBAs), a group that includes Damien Hirst and Tracey Emin. Saatchi collected work for his aptly named Saatchi Gallery; the art he bought and displayed in his gallery directly affected art tastes and monetary values. In 2010, Saatchi donated his gallery to the British public.

What is the **difference** between an **art museum** and an **art gallery**?

The major difference between a museum and a gallery is that while each is a place that displays art, that art is usually for sale in a gallery but not in a museum. Both museums and galleries play an important civic role in the sharing of art and cultural ideas. Slightly complicating things, however, is that the term "art gallery" can also refer to a room or a series of rooms in a museum. When walking through an art museum such as the Metropolitan Museum of Art in New York, one might notice that rooms are referred to as "galleries."

ART FUNDAMENTALS

What is an artist's **medium**?

The term medium (pl. media) refers to the materials used to create a work of art. Types of media can range widely, and include different types of paint (such as oil or acrylic paint) on canvas, as well as ink, marble, concrete, wood, glass, and metal. Artists also rely on various types of technology to create prints, photographs, videos, sounds, and digital images. The term mixed media refers to works that are made with more than one type of material. Twentieth-century artist Robert Rauschenberg's "combine" pieces are a good example of mixed media work. His 1959 work, *Canyon,* is often referred to as a painting, but is made with oil paint, pencil, paper, metal, photograph, fabric, wood, canvas, buttons, mirrors, a stuffed eagle, a pillow tied with cord, and a paint tube.

What is **graphic art**?

"Graphic art" is a loose term encompassing two-dimensional art such as drawing, painting, and printmaking, especially work that emphasizes line over color. Graphic art, a broad category, is not the same thing as graphic design, which relates to printed work that incorporates text and image.

What is a **drawing**?

Drawing is a form of graphic art often done in pencil, charcoal, crayon, or ink on paper. Usually, drawings are black and white and feature images composed of lines; however, the definition of a drawing is fairly flexible and has changed a great deal over time. During the early Renaissance, drawings were associated with the fragile media they were made on and were not considered completed works of art. Drawings were used as preparatory sketches and a way for an artist to share ideas with a patron. It wasn't until the later Renaissance that drawings started to stand on their own as works of art.

What is a **sketch**?

A sketch is a quick, preliminary drawing.

What is **painting**?

Paint is a liquid mixture made of pigment (often a powder) and a binding agent such as water or oil. A painting is a two-dimensional surface, such as stretched canvas or wood panel, to which paint has been artistically applied. A wall mural, or a fresco, is also considered to be a painting, as is work on paper, such as an illuminated book manuscript or a hand scroll. Some of the most common types of paints used are oil paints, egg-yolk tempera (often used in Italy during the Renaissance), watercolors, and acrylics (a modern, water-soluble paint).

What is the **difference** between **oil paint** and **tempera paint**?

Oil paints are made by mixing pigment into oil, often linseed or another vegetable-based oil. Oil paints create beautiful rich colors that can be easily blended because oil paints dry very slowly. During the late Renaissance, oil painting techniques were developed in the Netherlands and interest in oil painting spread slowly throughout the rest of Europe. In Renaissance Italy, especially Tuscany, tempera paints were preferred over oil and had been in use long before oil paints. Tempera paint is made by mixing pigment with egg yolk. It dries much more slowly than oil paint. Like oil paints, tempera paints create lovely rich colors.

What is **watercolor**?

While oil paints are made by mixing pigment with oil, watercolors are made by mixing pigment with water, usually for use on paper. Watercolors are applied in washes, which create a light, transparent area of color. Before the nineteenth century, watercolor was mostly used for quick sketches and was not considered to be as refined as

5

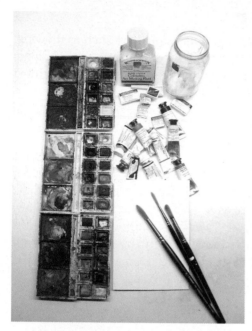

A display of watercolor supplies. Watercolors mix pigments with water, instead of with oil.

other types of painting. However, perceptions of watercolor changed after John Ruskin, a famous nineteenth-century art critic, promoted it and the artist J.M.W. Turner (who also painted in oil) used watercolor for his dramatic and monumental paintings. Watercolor is still a popular medium used by artists around the world.

What is **gouache**?

Gouache, which rhymes with squash, is a type of opaque watercolor, also known as "body color." The opacity of gouache is the result of the addition of glue and white pigment.

What is **acrylic paint**?

Acrylics are synthetic paints that have some of the features of oil paint and some features of watercolors. They are water-soluble, but some can be mixed with oil as well. Once acrylic paint dries, it can look quite similar to oil paint. Invented in the twentieth century, acrylics are amongst the most popular type of paints used by modern and contemporary artists.

What is **encaustic painting**?

Encaustic paints consist of pigment blended with hot wax, such as beeswax. Encaustic was invented in ancient Greece and popular in ancient Rome, especially when painting sculpture, because encaustics provide rich colors and a fair amount of durability. Although encaustic techniques are difficult and labor intensive, there has been a resurgence in the use of encaustics amongst some twentieth-century artists. The contemporary artist Jasper Johns is known for use his of encaustic.

What are **pastels**?

Pastels are a popular medium used for drawing. To make pastels, gum or resin is added to pigment and formed into the shape of a small stick. When pastels are applied to a surface, the colors can appear powdery, and can be smeared or blended with the tip of a finger. When completed, pastel paintings need to be fixed with a spray or the colors can smear, though these sprays can sometimes cause discoloration. Edgar Degas and Mary Cassatt are famous impressionist artists known for their use of pastels.

What is **printmaking**?

Printmaking is a mechanical process that allows an artist to make multiple copies of an image. One of the earliest types of printmaking is woodblock printing, a process

popular in Japan and China for over a thousand years. To make a woodblock print, an artist carves a relief image into a block of wood, inks the raised surface of the wood, and then presses the block against paper to make the printed image. Polychrome prints, or prints with multiple colors, can also be made by carving additional blocks, lining up the image (a process called registering), and pressing again. Contemporary artists continue to use this process; linoleum is a popular alternative to wood and prints made this way are called linocuts.

Other types of printmaking include *intaglio,* which was invented in the fifteenth century. Intaglio involves incising an image, usually into a sheet of metal such as a copper plate, and filling the grooved lines with ink before pressing the image. In intaglio printing, the printed image will be the reverse of the image on the metal plate. Common intaglio techniques include engraving, etching, drypoint, and aquatint.

What is the **difference** between **engraving** and **etching**?

Both engraving and etching are forms of intaglio printmaking. To make an engraving, an artist uses a sharp, pointed tool called a burin to cut lines into a metal plate. This is called incising. The metal plate is then inked, and the ink is forced into the grooves made by the burin. The plate can then be pressed. Drypoint is similar to engraving, though a needle is used rather than a burin.

Etching is slightly different. To make an etching, an artist covers a metal plate with an acid-resistant layer of ground. Rather than carve directly into the plate, the artist draws into the ground, revealing small areas of exposed metal underneath. The plate is then submerged into an acid bath. The acid eats away at the exposed metal, creating grooved lines in the shape of the drawn image. The longer the plate remains in the acid, the deeper the grooves will be and the more ink they will hold. Now that the metal plate bears the artist's image, it can be pressed and the image can be transferred to paper. Aquatint is a form of etching that allows the artist to create different areas of tone or value. Developed in the eighteenth century, aquatint involves heating a layer of rosin on a metal plate before placing it in the acid bath. Acid-resistant varnish is used to create areas of white on the final printed image.

What is **lithography**?

Lithography is a method of printmaking in which the artist draws an image on a smooth, polished stone with a special dense crayon. Ink applied to the surface of the stone clings to the greasy crayon, allowing the lithographer to press the image and make a print. Developed in the late eighteenth century, lithography allows the artist to draw freely, without carving.

What is **photography**?

In Greek, *phos* means "light" and *graph* means "drawing"; therefore, *photograph* literally means, "light drawing." The word itself gives insight into the process of

7

photography, which was invented in the nineteenth century, and involves capturing fixed images through the exposure of light-sensitive materials using a camera. A camera is essentially a light-proof box with photographic film inside. The photographer focuses the camera on a desired scene and then briefly exposes the film to the light from the scene by quickly opening and closing the camera's shutter. Light-sensitive chemicals covering the film react to the light. In a dark room, the film is submerged into developer to make a negative image. It is now common for contemporary photographers to complete this process digitally. Photography is arguably one of the most significant inventions in history. First thought of as a merely scientific endeavor, photography has become an important art medium. (For more information on the invention of photography, including daguerreotypes, please see the chapter on "From the Industrial Revolution to World War I, c. 1850-1914." Modern and contemporary photographers are covered in the chapter on "Contemporary Art 1960s to Present.")

What is **sculpture**?

Whereas graphic arts like drawing and painting are two-dimensional, sculpture is three-dimensional. An artist who works in sculpture is called a sculptor. Traditionally, sculptors use different processes including carving, modeling, and casting, though contemporary sculptors sometimes use construction (also known as assemblage) methods to make their works. Different materials are used depending on which technique the artist employs. Stone, such as marble, as well as wood, are often used for carving. Michelangelo's famous *David* sculpture was carved from Carrara marble, a beautiful gray-white stone from Tuscany. Modeling requires softer, more malleable materials such as clay. In the 1970s, over 7,000 terra cotta soldiers were discovered in the tomb of the ancient Chinese Emperor Qin. Terracotta, which means "baked earth," is commonly used for modeling sculpture, especially in the ancient world.

One of the more complex types of sculpting is casting, a labor-intensive process that relies on metals such as bronze and other metal alloys. In a technique known as lost-wax bronze casting, molten bronze is poured into a wax mold, which forms a negative image of the final sculpture. Once the bronze is cool, the wax mold is heated and removed, revealing a bronze form. Different versions of this process can produce both solid and hollow sculptures. Casting also allows for multiple copies of a work. For example, Auguste Rodin's nineteenth-century masterpiece, *The Thinker*, has been re-cast many times. Sculpture can range from tiny to monumental in size, and can be both representational and abstract. Sculpture made from a wide range of materials can be found all over the world.

What is the **difference** between **subtractive** and **additive sculpture**?

Carving is an example of subtractive sculpture because material is removed in order to create an image. Michelangelo believed, for example, that within each block of stone he worked on, there was a figure inside waiting to be revealed. By contrast, the additive process involves building up a form by adding material. Casting and assemblage are examples of the additive process.

What is the **difference** between **relief sculpture** and **sculpture-in-the-round**?

A relief sculpture is a type of sculpture in which a design projects from the surface of the sculpted material, like a rubber stamp, though not necessarily flat. Relief sculpture can be seen from only one vantage point, usually straight on. Sculpture-in-the-round is freestanding and finished on all sides. A viewer can move all the way around a sculpture-in-the round, and is able to look at the work from multiple vantage points.

What is **performance art**?

Performance art combines theater, music, video, and visual arts and often features artists actively participating in their own work. Though performance-based ritual art has existed for thousands of years around the world, contemporary performance art developed as part of the early twentieth-century Futurist and Surrealist movements. Notable performance artists include Joseph Beuys and Bruce Nauman. (For more information about contemporary performance art, see the chapter on "Contemporary Art 1960s to Present.")

What is **installation art**?

The term "installation art" developed in the 1970's and refers to art designed for a particular space, usually an indoor space, and is usually temporary. Installation art can incorporate sculpture, video, performance, and mixed media. In a way, installation art conceives of a museum or gallery exhibition space as a work of art in and of itself, and viewer interaction with the space is at the core of the form. Installations often have specific themes and messages and can be designed by a single artist or a group. Artists who have created notable installations include Rachel Whiteread, Ai Weiwei, and Jenny Holzer. The artist Suvan Geer even includes elements of smell in her installation work. (For more examples, see the chapter on "Contemporary Art 1960s to Present.")

What are **decorative arts**?

Traditionally, decorative arts are objects that serve a function. For example, a jewelry box may be beautifully decorated with intricate metalwork, but the box itself is used as a container for jewelry. Fine art, on the other hand, serves no practical purpose and exists for purely aesthetic reasons. Painting and sculpture, for example, are considered fine arts, whereas decorative arts include furniture, pottery, metalwork, jewelry, and some textiles. The line between decorative art (as well as craft) and fine art is increasingly blurry as contemporary artists and theorists are questioning the significance of function in art.

What are **textiles**?

Textiles are fiber-based fabrics such as cotton, wool, or silk (or synthetic fibers such as polyester). The fibers are made into cloth through various techniques including weaving, tapestry, and felting. Textiles are a major art form around the world and are gaining in popularity amongst contemporary fine artists.

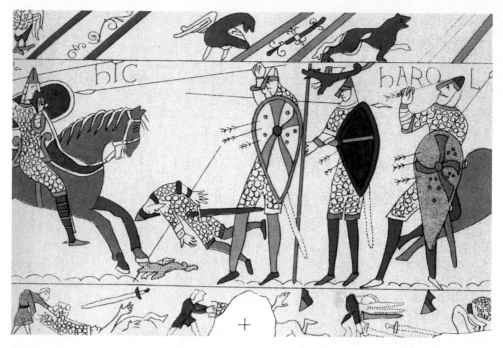

The Bayeux Tapestry (a section of which is illustrated here) is an embroidered cloth that commemorates the Norman Conquest of England in 1066. At over 200 feet long, the tapestry is a stunning example of the skill of the women who made it and has been called one of the finest examples of narrative art—making the work like an enormous, embroidered graphic novel.

What is the **difference** between **weaving** and **tapestry**?

Both terms represent a way to make cloth or fabric, though each requires a different technique. In weaving, a thread known as the warp thread is attached vertically to a loom while the weft thread is crisscrossed horizontally with the warp. Combinations of different colors and patterns create different textiles. Weaving has been around for thousands of years. The oldest woven cloth, discovered in Turkey, dates from 7000 B.C.E. Tapestry is a specific type of weaving in which the warps are hidden, and are often used for decoration and wall hanging.

What is **embroidery**?

Embroidery is a textile art found all over the world in which threads are decoratively sewn on to finished cloth such as wool or silk. Although the eleventh-century textile, *The Bayeux Tapestry,* is referred to as a tapestry, it is actually an example of embroidery. This 230-foot long masterpiece depicts the Norman Conquest of England in 1066. (For more information, see the chapter on "The Medieval World, c. 400-1300.")

What is **enamel**?

Enamel is colored glass that is fired and fused to metal for decoration. One of the earliest forms of enameling known as *cloisonné* was popular in the Byzantine period and in medieval Europe. *Cloisonné* involves firing enamel into small metal compart-

ments (called cloisons), which have been soldiered to a metal plate. Then, the entire piece is fired in a kiln to create a jewel-like effect.

BASICS OF ARCHITECTURE

What is **architecture**?

Famed modern architect Ludwig Mies van der Rohe stated, "Architecture starts when you carefully put two bricks together." Architecture is the art (or science) of designing buildings, and the study of architecture is the study of the built environment. Examples of architecture can range from the small, such as a Craftsman-style bungalow in California, to the very big, like the 108-story Willis Tower in Chicago. Architecture can also be very old. For example, Skara Brae, a Neolithic fishing village in northern Scotland, is thousands of years old, whereas the undulating metal of Frank Gehry's Disney Concert Hall was finished in 2003. There are many different architectural styles and building systems throughout history, and throughout the globe. The study of architecture is an important part of art history.

What is the **post and lintel system**?

The post and lintel system is the oldest and simplest architectural construction, in which two upright forms (called posts) support the load of a horizontal beam (known as a lintel). The posts must be strong (and close) enough to prevent the lintel from

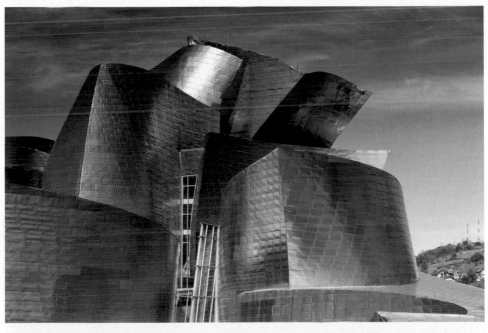

The contemporary architect Frank Gehry designed the Guggenheim Museum of Modern Art in Bilbao, Spain, which opened in 1997. The swooping planes of metal and glass breathe energy and movement into an otherwise static structure. It is a good example of postmodern architecture.

11

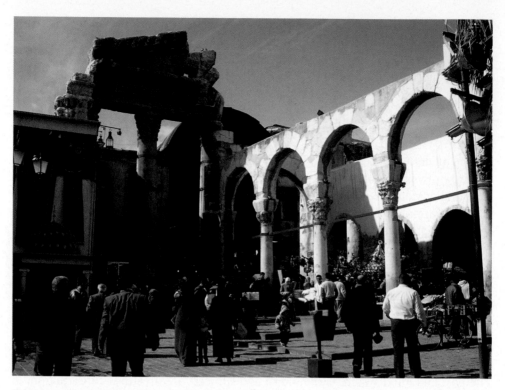

The Arche romaine de Damas in Damascus, Syria, is a well-preserved example of Roman arches.

weakening in the middle, especially if the lintel is carrying the heavy load of a wall or a roof.

What is an **arch**?

In art historical terms, an arch is a semicircular construction of blocks of material, called voussoirs, which hold each other in place due to compression, and span an open space. This type of arch is known as a "true arch." Other simple forms of arches include the corbelled arch, in which blocks of material are overlapped in order to span a similar opening. The "true arch" is stronger than a corbelled arch, especially when constructed out of stone. The pointed arch, rather than the round arch, provides superior support and was widely used in Gothic cathedrals.

What is the **difference** between a **column** and a **pier**?

A column is a cylindrical vertical support that usually tapers towards the top in the manner of a tree trunk. Columns can be freestanding or engaged, which means they are attached to a wall. Engaged columns do not provide structural support. Conventional columns that follow the traditional Greek Classical Orders feature a base, shaft, and capital (also see "Art of the Ancient World, c. 5000 B.C.E. to 400 C.E.") A pier is generally much larger than a column and is usually made of stone, brick, or concrete. Piers act as vertical supports for masonry constructions such as arcades.

What is an **arcade**?

An arcade is a series of arches, which are supported by piers or columns. Many medieval Christian churches contain interior arcades, as do many examples of Islamic architecture, including the Great Mosque at Córdoba.

What is a **vault**?

Common in medieval church architecture, vaults come in many forms. Essentially, a vault is an arched roof structure that covers an interior space. A semi-circular barrel vault, also known as a tunnel vault, is the simplest form. A groin vault is the name given to two intersecting barrel vaults.

What is a **cantilever**?

An example of a cantilever is a balcony that projects from the side of a building. Supported on one end by a vertical form, and freestanding on the other, a cantilever may seem as if it is freestanding, but is not. Architect Frank Lloyd Wright used cantilevers to dramatic effect in his design for Fallingwater, a home in Pennsylvania.

What is a **skeletal construction**?

In some forms of architecture, walls do a lot of the work of supporting the overall weight of a structure. In skeletal construction, a thin interior frame, rather than walls, supports weight, allowing for additional windows and much thinner walls. Both Gothic cathedrals and massive steel-framed skyscrapers rely on this type of construction to reach dizzying heights and incorporate large windows.

FORM AND STYLE

What is **color**?

Scientifically, color is the result of various wavelengths of light perceived by the human eye. The range of colors present in a rainbow, which transitions from red to violet, make up the visible spectrum. In art terms, the word "color" is interchangeable with the word "hue." The primary colors, or primary hues, are red, yellow, and blue. Combinations of primary colors form all other hues. Two primary colors are blended to form secondary hues such as green and orange. There are even tertiary colors, which are made up of a blend of at least three hues.

What is the **color wheel**?

The color wheel is a system of organizing identifiable hues in a way that helps artists understand the relationship between colors. The color wheel is shaped like a ring, and is made up of twelve hues. Primary, secondary, and tertiary colors are identified on the wheel. Colors placed on directly opposite sides of the wheel are considered complimentary. According to the color wheel, yellow and violet are complimentary colors. Artists

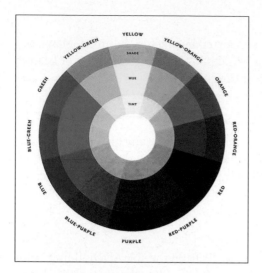

The color wheel is a tool used by many artists when selecting colors for their works.

use complimentary colors to create vivid, aesthetically powerful images.

What is the **difference** between **warm and cool colors**?

Warm colors, including hues such as red, yellow, and orange, are energetic colors associated with fire. Warm colors are sometimes referred to as "advancing" colors as they draw the eye forward. By contrast, cool colors (such as blue, green, and violet) are also known as "retreating" colors because they seem to withdraw. Artists manipulate combinations of warm and cool colors to make visually engaging images. Artists can also manipulate the warmth of a color by changing its value.

What is **value**?

Value is a property of color related to how light or dark the color appears. The higher the value, the lighter the color. For example, light blue pigment has a higher value than dark blue because more white has been mixed into it. Sharp contrasts of light and dark, known as *chiaroscuro,* can create drama as well as meaning in art; the artist Rembrandt is known for using this technique in his paintings. In *The Night Watch* (1642), Rembrandt used *chiaroscuro* to create a spotlight effect that draws the viewer's attention to the elaborately costumed Captain Frans Banning Cocq and his yellow-clad companion. The other figures seem to recede into the background as Rembrandt used drab, lower value hues for the rest of piece.

What is **line**?

Imagine holding an ink pen and pressing the pen against a piece of paper to make a black dot. Continue to hold the pen and then slowly drag the pen across the page. The original black point has now been extended horizontally to form a line. Line is one of the core elements of art. Line is used to outline shapes and to create forms. The characteristics of a line convey feeling and emotion. A shaky line is vulnerable while a bold, straight line is powerful. The term *linear,* is used to describe art that emphasizes line as opposed to light, color, or form. A linear sculpture is one that emphasizes its outline, or exterior contours.

What is **composition**?

The term "composition" refers to the arrangement of forms in a work of art. When art historians analyze the composition of a work of art, they are often interested in balance, the repetition of shapes, the use of perspective, and any sense of depth in the work.

A line drawing showing one-point perspective.

What is **perspective**?

Perspective is a system artists use to create the illusion of three-dimensional space. There are multiple different types of perspective techniques including single-point perspective and atmospheric perspective. Single-point perspective, also known as linear perspective, was invented in the fifteenth century by the Italian architect Filippo Brunelleschi. He used a system of parallel lines converging upon a central point called the vanishing point. Using this system, the space within a painting appears to be the continuation of real space.

Atmospheric perspective relies on color and form, rather than lines, to create an illusion of three-dimensional space. Using this technique, forms in the background are smaller and blurrier than objects in the foreground, forms overlap one another, and the sky is painted so that it transitions from blue to white.

What is the **picture plane**?

For more information on perspective, Brunelleschi, and the picture plane, please see "The Early Modern World, c. 400-1300."

What is **style**?

The style of a work of art is the distinctive way in which it has been formally arranged. Style can also refer to the way in which a work of art is characteristic of the work of a specific artist, and the time period (or the geographical location) in which it was created. For example, a painting by Vincent van Gogh can be instantly recognizable because of its distinctive style. Van Gogh is known for paintings that feature bold colors, thick application of paint, and noticeable brushstrokes.

15

What does it **mean** if a work of art is **representational**?

A representational work of art is one that realistically depicts objects from the real world. For example, seventeenth-century Dutch still lifes are representational as these paintings feature realistic images of everyday objects.

What is the **subject** of a **work of art**?

The subject is what a particular work of art represents. Recognizing the subject of a work of art is a good first step in understanding what meaning the piece might be communicating. Not all works of art have a subject. For example, an abstract sculpture might not be representational, but that does not mean the sculpture expresses no meaning.

What is the **difference** between **naturalism** and **realism**?

Naturalism, sometimes confused with realism, is a mode in which an artist attempts to objectively represent the natural world. Artists interested in naturalism spend a great deal of time looking and thinking about the observable qualities of the visual world. While the term realism is sometimes used interchangeably with naturalism, and also refers to art that accurately depicts the visible world, the term is slightly broader, encompassing the sometimes harsh reality of everyday life. Realism (with a capital "R") also refers to a series of different art movements including the nineteenth-century Realist movement in France, as well as Soviet-era Socialist Realism.

What is **idealization**?

Idealization is the attempt to depict physical perfection in art. For example, Classical Greek sculpture, which features immaculately carved human figures, is usually thought of as one of the first traditions of naturalism in art history. Upon closer inspection, however, many examples of Classical Greek sculpture look, overall, quite a bit better than average. Greek gods are depicted with defined muscles, broad shoulders, beautiful hair, and stoic faces. This is arguably similar to our contemporary culture's predilection for Photoshopping models in glossy magazines. Idealization occurs in art from all over the world, and different cultures emphasize different features in their attempts to achieve perfection.

What is **abstraction**?

Artists interested in abstraction are not concerned with accurately representing the visual world in their work. While some abstract artists distort the real world, other abstract artists are purely expressive and do not refer to the real world at all. Abstract art is sometimes referred to as nonrepresentational art. Piet Mondrian was a twentieth-century Dutch painter who pioneered abstraction in an art movement called *De Stijl*. Mondrian is famous for his paintings containing simple, balanced, geometric forms using a limited color palette.

FINDING MEANING IN ART

How do you **"read"** a **work of art**?

When a piece of street art catches your eye, or you find yourself walking slowly through the rooms of an art museum, you may not necessarily feel the need to "read" a work of art. Art moves us, and we respond emotionally to the beautiful, disturbing, and mysterious sights around us. A portrait of a mother and a child, such as Mary Cassatt's painting, *The Bath,* might cause you to reflect on your own familial relationships. Or, you may find yourself curiously transfixed by the sheer enormity of Claes Oldenburg and Coosje van Bruggen's 5,500-pound *Shuttlecock,* perched precariously in the garden of the Nelson-Atkins Museum of Art in Kansas City, Missouri.

Sometimes, however, we want to dig deeper and investigate the meaning of art. What is the point of constructing monstrous, purposeless badminton equipment? What were the Cubists trying to do when they fragmented visual reality in their paintings? As a starting point for thinking about the meaning of a particular piece of art, ask yourself the following questions:

- What is the content?
 For example, think about what specific images are being depicted, if any, including any familiar figures or symbols; think about the way visual forms are arranged, the shape of the piece, and the materials used to create it.

- Who is the artist?
 Think about the artist's biography and other work made by that artist. What do you think the artist intended in making the work?

- When was the work made?
 Does the work depict, or refer to, any historically significant events? Does its style match a particular historical period or art movement? When did the artist live?

- Who was the work made for?
 Think about any possible patrons or intended audiences. How does the piece affect those who view it?

- How has the art changed over time?
 Has the work been moved from its original location? Who has owned the work throughout history? Has it been stolen or damaged? Do contemporary viewers look at this piece differently than those throughout history?

- Why is this work significant?
 Somebody must have thought this piece of art was important enough to take care of it, put it in a museum or gallery, or to spend so much time and energy on it. Why?

Remember that there is no definitive answer when trying to find meaning in a work of art. A painting, building, or sculpture might mean something to one individual and something else entirely to another. Even the artist has little control over the meaning of the work he or she creates (though certainly a fair amount of influence).

17

What is a **formal analysis**?

A formal analysis is a method of understanding a work of art by studying a work's formal qualities, including shape, color, line space, and texture. A formal analysis should include as much detail as possible with the goal of understanding how a particular work of art visually communicates ideas to a viewer.

What is **iconography**?

Iconography is the study of visual subject matter. Many works of art depict the same, or similar, subject matter; for example the Virgin Mary appears frequently in Western European art. A figure such as the Virgin Mary is associated with specific objects, manner of dress, or body positions known as attributes, as well as signs and symbols. An understanding of repeated signs, symbols, and attributes, helps in understanding the meaning of art.

What is **art theory**?

Theories of art, or critical theories, help us understand the meaning of art and culture from a philosophical perspective. Many artists use art to communicate philosophic opinions and ideas about art and culture through their work, while scholars and art historians use theory to put art and artists into cultural context. Theorists are interested in looking beyond the superficial qualities of art and digging deep into questions of meaning and significance. Some (but definitely not all) important lines of theoretical questioning come from fields such as psychoanalysis, Marxism, feminism and gender studies, postcolonialism, and postmodernism.

PREHISTORIC ART

Where did **art begin**?

Most traditional art history survey textbooks and courses begin with the prehistoric art of Europe and the Near East. It is convention, as much as anything else, and fits within the mostly chronologic presentation of the history of art in this book. Do note, however, that art itself did not begin in Europe—there is no single place where art began. Examples of prehistoric art can be found around the globe.

What is **prehistory**?

Prehistory is the period of human history that preceded the invention of writing. Prehistoric art, therefore, is art made before the existence of the written word. The prehistoric art covered in this section spans from around 35,000 B.C.E. to 1,000 B.C.E.

What is **Paleolithic art**?

In Greek, *paleo* means "old' and *lithos* means "stone." Paleolithic art is therefore art created during the Old Stone Age, which lasted from about 35,000 to 8,000 B.C.E.,

during the last ice age. The Paleolithic period was characterized by the human use of stone tools; people of this period were migratory hunter-gatherers who sought shelter near rocks and caves. Art of this time is the oldest ever discovered and fascinating examples include cave paintings, rock paintings, and stone sculpture.

What is **mobiliary art**?

Paleolithic art can be broken down into two general categories: mobiliary and parietal art. As Paleolithic people were migratory, they needed to carry their belongings with them as they traveled great distances. Mobiliary is a term that describes mobile art, or art that can be carried without too much physical effort. The most common examples include small sculptures.

What is **parietal art**?

While mobiliary art is one of the major forms of Paleolithic art, parietal art includes non-portable art such as rock and cave paintings. Truly impressive Paleolithic paintings have been found all over the world, including Europe, Africa, and Australia in sites that were likely used for religious or spiritual purposes, rather than as shelter. When archeologists first discovered prehistoric cave art in Europe, they assumed the expressive, realistic images they saw must be a hoax because they didn't imagine that people from the ice age were capable of such artistic skill. Archeological evidence, such as the discovery of nearby tools made of bone and stone, convinced them otherwise. One of the most famous examples of Paleolithic cave art is the series of paintings at the Lascaux caves in France.

What is the **Venus of Willendorf**?

Also referred to as simply the "Woman of Willendorf" this prehistoric "Venus" is a small sculpture (an example of mobiliary art) discovered in Willendorf, Austria, and was made in approximately 22,000 B.C.E. Found in 1908, its given name is ironic. Venus, the goddess of love and beauty, is usually depicted as thin, graceful, and lovely. The Venus of Willendorf, by contrast, is short (less than five inches high) and obese. She has no discernible face, only what seems to be a pattern of braided hair. Her sexuality and fertility is emphasized through an exaggeration of her female features while other figurative elements have been minimized; her arms are very small and her legs taper dramatically. The work's small size and defined features suggest it was designed to be

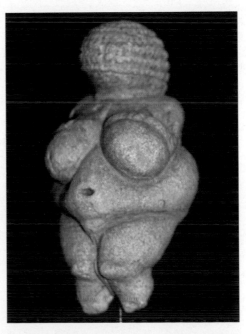

The *Venus of Willendorf* is a prehistoric sculpture carved from limestone. The artist emphasized the physicality of the female form, and the object was perhaps used as a fertility idol.

19

held and touched. Debate continues as to whether the sculpture depicts a real person, or is a symbol for fertility and health. It would seemingly be difficult to achieve such a body type during the lean years of the ice age. The Venus of Willendorf's obesity, while playfully mocked in the early twentieth century by those who discovered her, was likely highly valued as an omen of prehistoric health and survival at the time of its creation. Hundreds of similar sculptures have been found.

What is the **Lion Man of Hohlenstein Stadel**?

Most Paleolithic sculpture depicts women, not men, but an exception to this is the Lion Man, carved from mammoth ivory and dating from approximately 30,000 B.C.E. Discovered in modern-day Germany, the Lion Man sculpture depicts a blend of feline and human characteristics. Some scholars believe the Lion Man is actually a Lion Woman, and some other examples of similar female sculpture have been discovered. This sculpture is almost a foot high (much bigger than the comparatively stumpy Venus of Willendorf) and demonstrates the high quality carving skills and creativity possessed by prehistoric people. The significance of the Lion Man sculpture is not known. It is possible the piece depicts a human figure wearing a lion mask, but it is also possible that the work depicts a human-animal hybrid of spiritual significance.

What are the **Lascaux Caves**?

The Lascaux Caves in southern France are the site of an important discovery: prehistoric art on a scale never seen before and dating from approximately 15,000 B.C.E. The

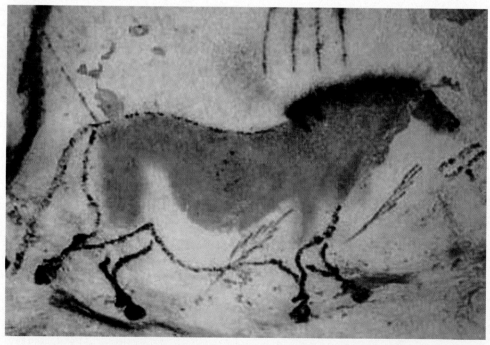

When Lascaux's prehistoric cave paintings were discovered, scholars were so impressed they at first couldn't believe the artists were prehistoric people. Cave paintings, such as those at Lascaux, have been discovered all over the world.

caves were accidentally discovered by a group of boys searching for their lost dog, and soon after, archeologists were called in to investigate. Paleolithic artists at Lascaux painted over 600 images and made more than 1,500 life-like carvings of animal, including images of horses, cows, deer, and bulls, deep within the caves. The art discovered at Lascaux was dizzyingly impressive and attracted thousands of visitors after opening to the public in the 1940s. The arrival of tourists resulted in severe damage to the art and the caves were permanently shut to visitors in 1963. Anyone wanting to see the Lascaux Caves can now visit a replica site that opened in 1983.

What **tools** did **Paleolithic artists** use?

Paleolithic artists used natural minerals to produce pigments in colors such as red, ochre, black, and brown. It is possible that these artists applied some of these pigments directly to the walls with their hands, but hollowed bones were likely used to spray paint onto the walls. Pigment-covered hollow bones have been found near some of the paintings by archeologists. Other tools include chunks of moss or animal hair that would have served as a type of paintbrush. For carving, pieces of flint were used to make engraved lines.

What is **twisted perspective**?

Many of the animals depicted in the Lascaux Caves, both predators and prey, are shown in profile, which means the viewer is looking at the side of the animal and only one half of the face can be seen. Some animals have been manipulated, however, using a fairly sophisticated technique called twisted perspective. Twisted perspective is created by showing most of the animal's body in profile, but turning a portion of the animal's head so that it seems to point directly at the viewer. This technique adds drama and energy to the image and results in a life-like depiction of an animal. In one example, an antlered deer is shown mostly in profile, but its antlers appear to swing powerfully towards the viewer.

Are those **human hands**?

Yes! Overall, there are not many depictions of humans in Paleolithic art and those images of humans that do exist are not as realistically rendered as images of animals. Floating around the top and bottom of a painting of two spotted horses from the Pech-Merle Cave in Dordogne, France, are the outlines of human hands. It is tempting to think that Paleolithic artists were merely playing around making handprints on the wall, but these images were purposefully done. Some of the hands seem to have been made by pressing a painted hand against the cave wall. Other hand prints where made by using the hand to create negative space. Paleolithic artists used their hands like a stencil and either, essentially, sponge painted or sprayed pigment with a reed or bone to create the outline.

What is **Tassili N'Ajjer**?

Tassili N'Ajjer is an approximately seven-thousand-year-old in southeastern Algeria with thousands of rock paintings and engravings—one of the earliest and most im-

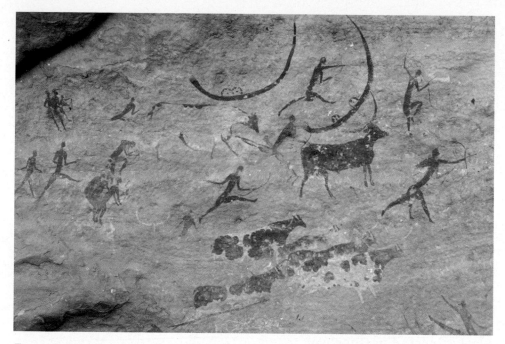
The rock paintings of Tassili N'Ajjer give us a glimpse of what life was like in prehistoric North Africa.

pressive examples of rock art in Africa. During the time when many of the images were made, this section of the Sahara desert was a grassy plain and the paintings include images of elephants, hippopotami, and giraffes. Later images depict men, women, and children gathered around small houses, cattle grazing nearby. As the Sahara dried over thousands of years, new animals appear in the rock art, such as camels and horses introduced from nearby Egypt.

What is **Neolithic art**?

The Neolithic Period is the "New Stone Age," which lasted from approximately 6,000 B.C.E. until 2000 B.C.E. Unlike their Paleolithic predecessors, Neolithic people were settled rather than migratory, domesticating plants and animals for the first time. The earliest evidence of Neolithic culture has been found in the Near East, including the modern-day countries of Jordan, Syria, and Turkey. Examples of Neolithic art include clay pottery and monumental stone monuments.

What is **Prehistoric Jericho**?

Prehistoric Jericho, also known as Tell el-Sultan, is one of the most important Neolithic sites excavated by archaeologists, and contains key examples of Neolithic art and architecture. Prehistoric people had settled at the Jericho site as early as 12,000 B.C.E. and domestication of animals began around 9,000 B.C.E. The architecture of Neolithic Jericho included mud-brick houses with plastered floors, which were painted red and white, as well as evidence of sophisticated fortifications including a twenty-eight-foot high stone tower and twenty-foot high walls surrounding the

village. By 7000 B.C.E., as many as two thousand people may have lived in Neolithic Jericho.

What are the **plastered skulls** of **Jericho**?

The people of Neolithic Jericho buried their dead under the floors of their houses in a practice interpreted as a form of ancestor worship. While complete bodies were often buried, sometimes the head was removed and carefully reconstructed using colored plaster. Red and black paint was used to mimic facial features and shells, such as cowries, were used to create white eyes. The result was

Painted pottery vase, black and red, Neolithic period, late third millennium B.C.E., from Lanzhou, Gansu province, China. (*Art courtesy The Art Archive / Genius of China Exhibition.*)

a lifelike representation of the deceased and the practice has been considered by some scholars to be one of the earliest examples of portrait making. Similar examples of plastered skulls have been found at other sites across the Near East.

What was **Çatal Huyuk**?

Çatal Huyuk was a sophisticated, urban-like Neolithic settlement that developed about one thousand years after Jericho in present-day Turkey. The densely clustered houses of Çatal Huyuk were made of timber and mud brick; the village had no streets and the houses had no doors—the villagers entered their homes through the roof. Many apparent religious shrines have been found at Çatal Huyuk, though nothing is known of specific religious beliefs practiced by the inhabitants here. Naturalistic figures made of clay and stone have been found at the site, including representations of animals such as goats, cattle, and boars that appear to have been ritualistically stabbed in a manner that suggests hunting rites. Stylized female figures have also been discovered with pointed legs and angular faces, along with larger figurines that scholars associate with a commonly revered Great Mother deity. Çatal Huyuk is also notable for its paintings, including a wall painting of the town itself, with Hasan Dag, a nearby twin-coned volcano shown hovering just beyond the village limits. This wall painting is among the earliest paintings ever done on a man-made surface.

What is the **art** of **Neolithic China**?

In China, the Neolithic period lasted from 10,000 B.C.E. to 2,000 B.C.E. Multiple different cultural groups created art during this time, each with a distinctive style. The Yangshao culture (which developed along the Yellow River) produced painted pottery, before the invention of the potter's wheel, by hand-coiling clay into a shape and then smoothing the edges and decorating the vessels with red and black paint using a brush. Most of these earthenware vessels were decorated with either animal motifs or complex abstract deigns. Another style of Neolithic pottery is associated with the

23

Hemudu, Dawnekou, Longshan, and Liangzhu cultures, which were established across many regions of China. This style is known for tripod-shaped pottery and jade carving, one of the most important forms of art in China. Common forms of Neolithic jade include the *bi* (disk) and the *cong,* a short rectangular column with a hole through the center and decorated corners. Because of the lack of written records, the meaning of both the *bi* and the *cong* forms are unknown.

What is **Skara Brae**?

Skara Brae is a seaside Neolithic settlement on the Scottish Orkney Islands, which are situated in the far north of the country. The relatively small Skara Brae was inhabited between 3100 and 2600 B.C.E., thousands of years after Near Eastern settlements such as Jericho and Çatal Huyuk, and was constructed of stone due to the lack of timber on the islands. Whereas other populations on the British Isles did not settle until nearly the Bronze Age, evidence of settled life at Skara Brae includes discoveries of cooking tools, decorated pottery, and stone-carved furniture such as beds and dressers. The fact that stone was a primary building material resulted in uniquely well-preserved examples of Neolithic art and architecture in Northern Europe.

What is a *menhir*?

In the Celtic language, *men* means "stone" and *hir* means "long." A translation of "menhir" is therefore "long stone." Menhirs were roughly shaped single stones likely of symbolic importance to the Neolithic people of northern Europe who made them. An enormous arrangement of these stones, known as menhir alignments, was discovered at Carnac, in southern France. Likely made around 3,000 B.C.E., the Neolithic people of the area placed thousands of heavy menhirs in a series of rows nearly four thousand feet long. The exact purpose of the menhir alignments at Carnac remains a mystery.

What is a **dolmen**?

In Celtic, *dol* means, "table." A dolmen is a tomb made of three enormous stones known as megaliths. Two vertical megaliths support a third megalith, which rests flat

like a tabletop, essentially mirroring the post-and-lintel system. Dolmens are usually built into a mound of earth, forming an interior burial chamber big enough to hold a single body. Dolmens were later used as passage entryways into larger structures.

What is a **cromlech**?

Translated from Celtic, the word "cromlech" means "circular place" and refers to a circle of standing stones. Cromlechs are either circular or semicircular arrangements of megaliths. There are many theories about the function of these large-scale Neolithic sites, including the idea that they served some kind of religious function; however, like the menhir alignments in France, cromlechs remain a mystery.

What is **Stonehenge**?

Stonehenge is perhaps the most famous megalithic structure from the Neolithic period, and an example of a large-scale cromlech. Its name comes from the Saxon language and means "the place of hanging stones." The site, located near Salisbury in England (about eighty miles west of London), was built over a thousand years starting from around 3,000 B.C.E. Seventeen enormous megaliths weighing up to fifty tons each remain standing in an approximate circle, though scholars think the site originally included at least thirty megaliths. All together, Stonehenge is made up of around 150 simple, non-decorated stones, some of which have fallen down and broken. At the center of the site is an altar stone, though whether this stone was used as such is unknown.

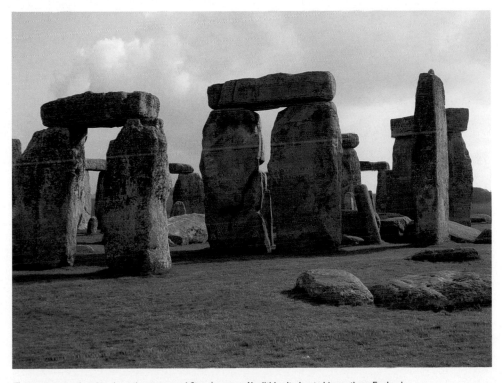

There are many theories about the purpose of Stonehenge, a Neolithic site located in southern England.

It is unclear exactly how Neolithic people constructed Stonehenge. The blocks alone are extremely difficult to move and both scholars and amateurs have attempted to recreate the engineering marvel. The post-and-lintel system is evident in the megalithic henges themselves, and it is notable that no mortar was used to hold them together—all of the joints are dry joints. It is possible that timber played a role in the construction of Stonehenge, though any timber remains have since disappeared.

What was the **purpose of Stonehenge**?

Like all other Neolithic art, lack of written records and other archeological evidence makes it extremely difficult, if not impossible, to know exactly what sites like Stonehenge were used for. The theories about Stonehenge are wide-ranging, and some are more plausible than others. Much has been made of Stonehenge's possible religious significance, including the idea that it may have been used for human and animal sacrifices, and though cremated human remains have been found, this suggestion has fallen out of favor. A complete skeleton was unearthed at Stonehenge; it was the body of a man who had been shot through the chest with arrows. While this discovery does indicate violence, it does not necessarily suggest religious sacrifice.

Some scholars, particularly a core group of astronomers, believe the purpose of Stonehenge is technological. They think the site served as a Neolithic observatory and was used to track the movements of the sun, an important function in a society reliant upon agriculture to survive. While Stonehenge is aligned to the summer solstice, this theory is also hotly debated.

ART OF THE ANCIENT WORLD, c. 5000 B.C.E.–400 C.E.

ART OF THE ANCIENT NEAR EAST

Where is the **ancient Near East**?

The ancient Near East is a term used by art historians to refer to the area near the Tigris and the Euphrates rivers, also called Mesopotamia. Mesopotamia is a Greek word that means "the land between two rivers." The ancient Near East is also thought of as the "Cradle of Civilization," as it is here that urban society developed for the first time; with it came the invention of writing and laws, the first examples of epic poetry, the construction of cities, and of course, monumental art and architecture.

What is **cuneiform**?

Cuneiform is the first system of written language; invented by the Sumerians around 3100 B.C.E., it was originally pictographic. This means, for example, that a bull's head, would represent a bull. Over time, cuneiform evolved into a more abstract system of signs consisting of wedge-shaped lines pressed into clay tablets with a pointed tool called a stylus. Cuneiform was used to keep track of business records in cities like Uruk, in modern day Iraq. Cuneiform tablets have withstood the test of time and offer scholars a wonderful window into the culture of the ancient Near East.

What is a *ziggurat*?

A *ziggurat* is a mountain-like structure formed by a series of steps and topped with a temple or a shrine. Placing shrines and temples at a higher elevation served both practical and religious purposes. Practically speaking, the higher elevation would protect the religious structure from flooding or attack. It also served to glorify the ruler and the gods worshipped at the site. *Ziggurats* represented a place where heaven and earth met.

The ruins of the White Temple at Uruk are located in what is now known as Warka, Iraq. This temple was part of a ziggurat dedicated to the Sumerian god Anu, and housed statues of gods, goddesses, and temple patrons. It was oriented along the points of the compass and had a central chamber with an altar for religious rituals.

What is the **Warka Vase**?

Also known as the Carved Vase of Uruk, the Warka Vase is a three-foot-tall alabaster vase found by archaeologists near the White Temple. The vase is decorated with stories that have been divided into registers, or bands, almost like a comic strip that tells a story of humans making offerings to the gods. The lowest register depicts the natural world of water and plants while above this are domesticated animals. The middle register features nude men holding baskets, and the top register shows a king giving an offering to the Sumerian goddess Inanna. The figures in the registers are shown with their heads and legs in profile view, but with torsos and shoulders in a three-quarter view.

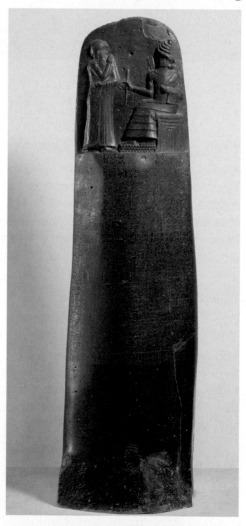

What **happened** to the **Warka Vase**?

In April of 2003, the Warka Vase was stolen from the Iraq Museum in Baghdad, during the civil unrest that followed the U.S. invasion of the country. It was a devastating loss for art history, and especially the people of Iraq, for whom the vase represents an important part of their cultural heritage. Fortunately, the vase was returned a few months later, though it was badly damaged.

What is the **Stele of Hammurabi**?

Hammurabi was a Babylonian king who ruled over the lands of Mesopotamia during the second millennium B.C.E. He is famous for his code of laws, the earliest known legal code. The code itself is carved into a seven-foot stele, a large slab of black diorite, and in it Hammurabi declares that his code will "cause justice to prevail in the land and to destroy the wicked and the evil, that the strong might not oppress the weak nor the weak the strong" (as quoted in Stokstad 38).

The Code of Hammurabi (eighteenth century B.C.E.) was written in cuneiform, the first system of written language. At the top, Hammurabi is depicted standing with the Babylonian sun-god Shamash, also the god of justice.

At the top of the stele, above the written code, is a carving that depicts Hammurabi himself standing before the sun-god Shamash. Shamash, who was also the Babylonian god of justice, is seated in his throne and is surrounded by symbols of power. He rests his feet on a mountain top, wears a long, elaborate robe, and offers a rod and rope circle in his hands. Hammurabi's arms are crossed respectfully in front of him, and he receives the laws as given to him by Shamash. The stele serves as a powerful marker of Hammurabi's high status and represents the divine inspiration of his code.

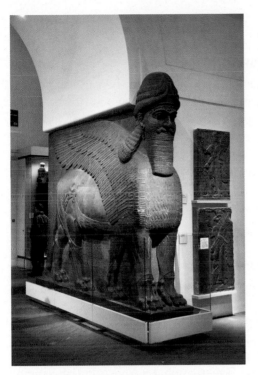

These monumental sculptures of winged bulls with human heads were used as protective palace decoration and are similar to the Sphinx that guards the entrance to the pyramids at Giza.

What is a *lamassu*?

A *lamassu* is a monumental stone sculpture famously part of Assyrian palace decoration, and serves as a protector of the palace gateway. A *lamassu* combines human and animal features and includes a lion or bull body, wings, a human head with full beard and eyebrows, and a total of five legs. When approached from the side the *lamassu* appears to be walking, and from the front, it seems to be standing firmly at attention. The *lamassu* from the Fortress of Sargon in the Assyrian city of Khorasabad was constructed around 720 B.C.E. and stands over fourteen feet tall. Part sculpture and part architectural feature, this giant creature keeps a watchful eye on any approaching palace visitor.

What is the Ishtar Gate?

The Ishtar Gate was a Neo-Babylonian, double-arched gateway with four towers, each featuring notched walls known as crenellations. The Ishtar Gate was originally over forty feet tall, and the towers rose to nearly one hundred feet. The deep blue brick structure was decorated with stylized lions and palm trees—an impressive fortification indeed. The monumental gate mirrored the wealth and extravagance of other Babylonian structures such as the Hanging Gardens, which was one of the Seven Wonders of the Ancient World. A reconstruction of the Ishtar Gate has been installed in a museum in Berlin, Germany.

ART OF INDIA AND SOUTHEAST ASIA

What was the **Indus Valley Civilization**?

The Indus Valley Civilization (c. 2600–1900 B.C.E.) was one of the earliest civilizations in South Asia and was established in present-day Pakistan and northwest India. It is sometimes referred to as the Harappa Civilization. Major urban areas of the Indus Valley include Mohenjo-Daro, Harappa, and Chanhu-Daro, which form a cohesive group due to their architectural similarities. Not much is known about Indus Valley culture or religion, but the discovery of art artifacts, including ancient seals, greatly interests art historians and other scholars who are eager to make cultural connections between the Indus Valley and contemporary art and culture in India and Southeast Asia.

What was the **Great Bath** at **Mohenjo-Daro**?

Mohenjo-Daro was an Indus Valley city constructed on a grid-plan and made of sun-baked brick, featuring extensive drainage and plumbing systems. There are records of private bathing areas, toilets, and hundreds of wells in the city—some of the earliest known in the ancient world. The Great Bath was a large, watertight pool built near a citadel and was thirty-nine feet long, twenty-three feet wide, and eight feet deep. The Great Baths likely served not only a recreational purpose, but also might have been a place for religious rituals.

What are **Indus seals**?

Indus seals are small, flat squares carved from stone; each with an impression carved onto one side, and a knob protruding from the other. Most Indus Seals depict naturalistic animals and an as-yet untranslated script. The one-horned cow is a common animal featured on Indus Seals, sometimes portrayed next to an altar. Other animals

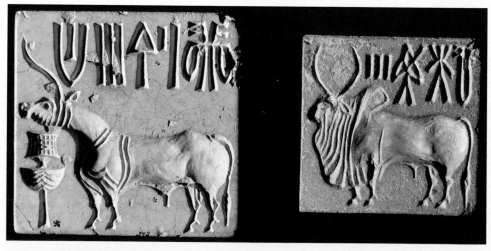

Many Indus Seals depict animals and include an untranslated form of writing. The Indus Valley Civilization flourished in present-day Pakistan and India during the Bronze Age.

include the elephant, rhinoceros, and tiger. Due to the fact that the language remains a mystery, the exact function of these seals is still unknown, though scholars think they were used to stamp clay as a method of keeping business and trade records.

What is **Hinduism**?

With its roots in the culture of the Indus Valley, Hinduism is not a monolithic religion, but a name that encompasses diverse groups who worship many different gods and goddesses with multifaceted attributes. One major unifying element of Hinduism is adherence to the Vedas, ancient works of literature that serve as the foundation of the Hindu religion.

What common **images** are found in **Hindu iconography**?

Hindu art includes a wide range of images, especially of important deities. The following table explains four important Hindu deities and their iconography.

Deity	Description	Representation in Art
Shiva	Personifies both creation and destruction; embodies all of existence; has over one thousand names; is often represented as Lord of the Dance	Often depicted as a phallus or pillar; if shown as human, can feature multiple limbs, matted hair, and a crescent moon above the head. Sometimes shown with a third eye and a trident; wears a serpent as a scarf. As Lord of the Dance, is shown surrounded by a ring of fire
Vishnu	Preserver of order and balance in the universe; takes the form of Krishna, a divine lover who battles the demon Kansa	Often depicted with blue skin; shown riding Garuda, a large bird. Wears a tall crown and jewelry; takes many different animal forms including a boar and a tortoise. Can also take the form of Krishna or Buddha.
Devi	Multiform female goddess worshipped as Parvati (wife of Shiva), Lakshmi (wife of Vishnu), and Radha, lover of Krishna. She also personifies anger as Durga.	Takes numerous forms, each with a different identity. As Durga, she rides a lion.
Ganesha	Son of Devi (as Durga); worshipped as the Remover of Obstacles.	Shown with an elephant head.

What is **Buddhism**?

Buddhism developed in India during the Mauryan Period (322–185 B.C.E.) and became the official religion of Emperor Ashoka, who ruled between 273 and 232 B.C.E. Buddhism is founded upon the teachings of Buddha, the "Enlightened One." Buddha was born Siddhartha Gautama, a wealthy prince. It was foretold that Siddhartha would become either a great military leader or a fully awakened being. After he

reached Enlightenment, the Buddha held his first teachings in which he explained the Four Noble Truths. The Noble Truths make up the foundation of Buddhist philosophy. They are as follows:

1. Life is *dukkha* (translated as suffering, stress, or dissatisfaction)
2. The cause of *dukkha* is *tanha* (translated as craving or clinging)
3. *Dukkha* can be extinguished
4. The way to extinguish *dukkha* is by following the Eightfold Path

In the Buddhist tradition, the Eightfold Path is a set of principles for achieving *nirvana,* a state in which one escapes from the recurring cycle of death and rebirth and is free from *dukkha.* The Buddha's teaching is often symbolized as a wheel, known as the Wheel of Law.

What is the **difference** between **Theravada Buddhism** and **Mahayana Buddhism**?

Theravada Buddhism is the earliest form of the religion and is called the Path of the Elders. It is most popular in India, Sri Lanka, and parts of mainland Southeast Asia.

Mahayana Buddhism is the second important school of Buddhism and is known as the Great Path. Mahayana Buddhist worship *bodhisattvas,* compassionate "Buddhas-to-be" who understand the path to enlightenment and devote themselves to teaching others who to achieve *nirvana.* Mahayana Buddhism is popular in northern India, China, Japan, Korea, and Nepal.

What **markings distinguish images** of the **Buddha**?

The Buddha is not a god, but an enlightened being who has achieved suprahuman status and has escaped the Buddhist cycle of life and death. The earliest images of the Buddha show the holy figure as a monk wearing long robes and can be identified by certain body attributes called *lakshanas.* As a boy, the Buddha was wealthy, therefore one important body attribute is elongated ears due to years of wearing heavy jewelry. Another important marking is called the *urna,* a curl of hair between the Buddha's eyebrows, often depicted as a dot. *Mudras,* or hand-gestures, allow images of the Buddha to convey specific messages. For example, if the Buddha is shown with his right hand reaching towards the ground, this represents a call to witness the Buddha's enlightenment and is a *mudra* known as *bhumisparsha* (earth touching).

What is a *stupa*?

A *stupa* is a hemispherical Buddhist monument based on Southeast Asian burial mounds, but not used as a tomb. After his death, the Buddha's cremated remains were placed in small containers known as reliquaries and buried in the earthen *stupas.* Buddhist pilgrims worship the Buddha's remains by walking clockwise around the *stupa,* which mirrors the revolutions of the earth and sun. *Stupas* do not have to be large—some of them are small enough to fit in the palm of a hand. They represent the Buddhist concept of the "world mountain" and are sacred diagrams of the universe.

What is a *yakshi*?

A *yakshi,* an erotic goddess figure worshipped throughout India, represents fertility and vegetation. These sensual figures are used to decorate the exterior of the Great Stupa in Sanchi, India. The *yakshi* from Sanchi are partially clothed and are depicted holding onto mango tree branches, encouraging them to bloom. The curving poses of the *yakshi* were later adopted by Buddhist artists in their depictions of Buddha's mother giving birth.

What were **Ashoka's pillars**?

Ashoka was considered one of the greatest emperors of the Iron Age Maura Empire, located in the eastern portion of modern day India. Ashoka converted to Buddhism, formalized a legal code according to Buddhist principles, and spread Buddha's teachings across his land by inscribing monolithic stones with his code. These stone pillars reached as high as forty feet tall and are said to symbolize the *axis mundi* or the "axis of the world." The pillars mark the coming together of heaven and earth, as well as pilgrimage sites associated with the Buddha. The tops of the pillars were elaborately carved and often depict back-to-back open-mouthed lions, which proclaim Buddha's message for all who will listen.

ART OF ANCIENT AFRICA

What are some of the **challenges** in **studying ancient African art**?

Africa is a vast continent with significant variations in geography and culture. African art can include sculpture, pottery, jewelry, rock painting, textiles, and architecture, among other forms. Much of African art was made from perishable materials, though stone and metal were also common media, and was meant to either be used in religious ceremonies, or was meant to be worn. Most African art is neither labeled nor signed by the artist. Many objects have been discovered accidentally and therefore without any context. Though there is some documentation, in general, ancient Africa lacks a written record as religious and cultural traditions were transmitted orally from one generation to the next, and this can make it difficult for scholars to contextualize, and even confidently date, the ancient art that has been found. One of the most significant problems is illegal excavation and the selling of sensitive objects on the black market—this results in the often-irretrievable loss of important information about a work of art. Similar challenges face art historians studying art from other parts of the world including, but certainly not limited to, the Pacific and the Americas.

What is **Nok sculpture**?

Some of Africa's earliest art has been found in modern day Nigeria and was created by the Neolithic Nok people of that region. Many archaeological fragments from approximately 500–200 B.C.E. have been found accidentally during tin mining work, including fragments of human and animal sculpture. The discovered sculptures can

33

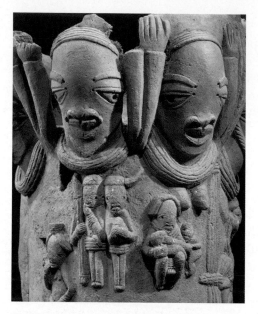

vary greatly in size—some are quite small while others are nearly life size. Made from terra-cotta, these simple yet expressive pieces often have large heads and stylized facial features. They are usually hollow and have open orifices, such as in the nose and mouth. Some figures are standing, kneeling, or seated. Their exact function is unknown, but it is thought that the artists may have been women.

The Nok people, who flourished during the Neolithic period in what is now Nigeria, are known for their figurative terra-cotta sculptures. (*Art courtesy The Art Archive / Musée du Quai Branly Paris / Gianni Dagli Orti.*)

ANCIENT EGYPTIAN ART

What is **ancient Egypt**?

Ancient Egypt was a powerful civilization in northeastern Africa, which developed along the Nile River around five thousand years ago and lasted for over three thousand years. During that long span of time, art in Egypt stayed very consistent in terms of style, form, and subject. Egypt was ruled by powerful dynasties lead by a pharaoh. These dynasties are organized by scholars into three distinct kingtoms: the Old, Middle, and New Kingdoms, as well as Intermediate Periods and a Late Period, which lasted until 332 B.C.E., when Egypt was conquered by Alexander the Great. In 30 B.C.E., Egypt became part of the Roman Empire. Polytheistic religion was an important part of daily life in Ancient Egypt, and the pharaohs were considered divine rulers. The art and culture of Ancient Egypt greatly influenced other cultures throughout history, and we continue to be fascinated by the culture's richly decorated tombs, pyramids, and other art objects.

What is the **Narmer Palette**?

The Narmer Palette (c. 2950–2775 B.C.E.) is one of the most important examples of Egyptian art. The shield-like palette was made from a material called greenschist, and depicts a king identified as Narmer, but is possibly the ruler Menes, who was celebrated for uniting the lands of Egypt under his rule. The story is told through a combination of hieroglyphic writing and imagery. On one side of the palette, Narmer is the largest figure depicted, an example of Egyptian art's use of the hieratic scale; the pharaoh's large size indicates his importance. His hand is raised above his head, about to strike an enemy with a club. The opposite side features the headless bodies of Narmer's enemies, watched over by Horus, the falcon god of the sky. In a lower register, the cat-like animals have their necks intertwined. All in all, the imagery of the palette serves to proclaim the strength of Narmer, and represents the unification of the lands of Egypt.

What is the **hieratic scale**?

The hieratic scale is a system used to visually communicate power in Egyptian, as well as the art of other cultures, including the ancient Near East and in medieval European art, for example. Significant or important individuals, such as pharaohs, were depicted as being much larger than any figures in a scene. In the Narmer Palette, the hieratic scale helps to identify Narmer in a busy scene filled with many individuals.

What are **hieroglyphs**?

Hieroglyphs were used by the ancient Egyptians as a formal writing system made up of a combination of pictures and alphabetic letters. The term comes from the Greek word *hieros,* which means "sacred" and *glyph,* which means "writing" or "drawing." The meaning of ancient Egyptian hieroglyphs was mostly unknown until the eighteenth century discovery of the Rosetta Stone, an ancient stele made of diorite upon which the same text was written in three languages: ancient Egyptian hieroglyphs, another Egyptian script called the Demotic script, as well as ancient Greek. This allowed scholars to finally understand many previously untranslatable hieroglyphic inscriptions. Ancient Egyptian hieroglyphs are found on papyrus scrolls, wall paintings, and carved into stone. They often accompany images and are used to identify scenes and figures.

Why did the **Egyptians build pyramids**?

A pyramid is an example of monumental funerary architecture with a square base and sloping, triangular sides. These massive, mountain-like buildings are the burial places of Egyptian pharaohs and serve an important religious and political function: to protect the pharaoh's soul, or *ka,* and to aid in the transition of the *ka* to the afterlife. One of the most famous of all pyramid sites is the Great Pyramids of Giza. The Great Pyramids of Giza, the tallest of which is 450 feet high, were built during the Old Kingdom, c. 2575–2150 B.C.E., and were intended for the rulers of the Fourth Dynasty: Menkaure, Khafre, and Khufu. They were built of granite and limestone and memorialize these rulers as divine beings.

What is the **Sphinx**?

The Great Sphinx at Giza (c. 2520–2494 B.C.E.) is a monumental human-headed lion sculpture carved from a natural limestone hill. This 240-foot colossus is thought to represent the Old Kingdom pharaoh Khafre. Like the Assyrian *lamassu,* Egyptians protected gateways with depictions of lions. It was thought that lions never slept and they were associated with the sun. In Egypt, as in much of the ancient world, human-animal hybrids were considered divine and this promoted Khafre's status as a divine ruler.

Why is **Egyptian portrait sculpture** so **stiff**?

Egyptian portrait sculpture, especially sculptures of the pharaohs, were designed to last for eternity and were made according to strict guidelines. Pharaohs needed to be clearly identifiable by their elaborate headdresses and false beards. Pharaonic sculptures show the ruler either standing erect, or sitting enthroned with hands resting

35

The Sphinx, a monumental human-headed lion, guards the entrance to the pyramid complex at Giza. The Sphinx is approximately 240 feet tall and likely represents the Egyptian pharaoh Khafre.

on the knees, one first clenched and one lying flat. These dignified sculptures command respect, and are also very durable.

Carved from the same piece of gray sandstone, the double-portrait of Menkaure and a Queen, from Giza, depicts the pharaoh with his wife. Each figure stands with a rigid, upright posture. Menkaure's body is youthful and strong; his hands are at his sides, fists clenched, and his left leg takes a stern step forward. The queen's arms, however, wrap delicately around the pharaoh's waist, joining the couple in a supportive embrace. This piece follows strict Egyptian conventions of portraiture, clearly indicating the ruler's power and the queen's status at his side.

What is the **Nefertiti Bust**?

Nefertiti was the queen of the Pharaoh Akhenaten who ruled during the Amarna period, c. 1349–1336 B.C.E. When the bust was discovered in 1912, by German archeologist Ludwig Borchardt, it immediately captivated both scholars and the public. The painted limestone bust emphasizes the grace and elegance of Nefertiti's face and neck. She appears to be wearing makeup, particularly around the eyes and lips. Her unique blue crown is decorated with a geometric pattern. The sculpture is a testament to the fact that Nefertiti is often considered to be one of the most beautiful women of the ancient world.

Why does art from the **Amarna period** look so **different** from other **Egyptian art**?

During the New Kingdom, a ruler named Amenophis IV broke away from the traditional religious values of Egypt and focused his worship on a single god: the sun god,

Why do Egyptian figures have two left feet?

Egyptian figures, especially depictions of pharaohs and other important individuals, tended to be done in profile, but in a twisted perspective. Egyptian artists were concerned with depicting everything they knew to exist, not necessarily what they could see at any given moment. In order to make the image as clear as possible, the artists depicted everything from its most characteristic angle. A human head, for example, is most clearly understood when seen in profile, while one eye is usually depicted frontally, as are both shoulders. Like the head, each foot was depicted in profile, which results in each foot appearing as if it were the left. This lack of naturalism is part of Egyptian artistic convention and relates to the fact that Egyptians created their art from memory rather than natural observation.

Aten. In order to honor Aten, he changed his name to Akhenaten. This pharaoh not only broke away from religious customs, but artistic customs as well. Much of the art made during his reign features the god Aten depicted as a sun disc with linear rays emanating from it. Each ray has a small hand, often pointing down towards Akhenaten, which represents divine blessing. Images showing Akhenaten, such as a limestone relief featuring the ruler and his wife, Nefertiti, are unusual in that the pharaoh is not traditionally idealized. He looks almost ugly, in fact, with a protruding chin and long, thin body. In the relief, he is shown sitting with Nefertiti, playing with their children. It is a warm, family scene that is quite different from conventional pharaonic works, from periods both before and after.

ART OF ANCIENT CHINA

What are the **major dynasties** of **ancient China** and what kind of **art** did they **produce**?

Dynasty	Dates	Types of Art Produced
Neolithic Period (Pre-Dynastic)	c. 7000–2250 B.C.E.	Large-scale architecture; painted pottery; jade carving
Xia Dynasty (debated)	c. 2205–1700 B.C.E.	Monumental architecture; tombs; earliest bronze work
Shang Dynasty	c. 1700–1045 B.C.E.	Bronze vessels made using piece-mold technique; jade and lacquer objects; carved bones
Zhou Dynasty	c. 1045–480 B.C.E.	Bronze bells made using lost-wax casting technique; monumental tombs
Period of Warring States	480–221 B.C.E.	Highly decorative bronze and jade; lacquered wood; silk textiles

Dynasty	Dates	Types of Art Produced (contd.)
Qin Dynasty	221–206 B.C.E.	Monumental tombs; naturalistic clay sculpture
Han Dynasty	206 B.C.E.–220 C.E.	Painted silk; jade carvings; metalwork; Buddhism takes root in China
Period of Disunity (also known as Six Dynasties or Northern and Southern Dynasties)	220–589 C.E.	Wall paintings; ceramics; painted screens; stone carving; Buddhist art; secular art; calligraphy

What is **Confucianism**?

Confucianism is considered to be both a philosophy and a religion, and is native to China. It is named for Confucius, a scholar born in 551 B.C.E., whose teachings form the foundation of the philosophy. Confucianism is concerned with the relationship between people in society, including relationships with ancestors and even the emperor. The virtue of human-heartedness, called *ren,* is key to being a *junzi,* or gentleman. During the Han Dynasty (206 B.C.E.–220 C.E.), Confucianism became the official religion of the state and had a major impact on Chinese art and culture.

What is **Daoism**?

Like Confucianism, Daoism (also spelled Taoism) is also considered to be both a religion and a philosophy, and is native to China. Daoist philosophy is more metaphysically focused than Confucianism, and emphasizes intuition and developing a harmonious relationship with nature. It is founded upon the teachings of two ancient philosophers named Laozi and Zhuangzi. The word *dao* means "the Ultimate Way" and is symbolically linked to water. Water is yielding and moves gently around obstacles, but it is also strong—it can turn even the largest stones into sand.

What was the purpose of **Emperor Qin's terra-cotta army**?

Accidentally discovered in 1974 in Lintong, China, the massive burial monument for Emperor Quin Shi Huang contains over seven thousand life-size terra-cotta soldiers and horses, all standing in formation. Each solider was painted and assembled from a series of molded parts, and therefore has a surprisingly realistic and individualized look. The burial chamber is as large and grand as the Emperor's palace while he was alive, and is part of an ancient Chinese tradition of burying rulers with the wealth (and the living staff) they possessed during their life, much like the ancient Egyptians. The terra-cotta army protects the emperor and his material goods in perpetuity, serving their leader even after his death.

What is a *fang ding*?

A *fang ding* is a square or rectangular vessel with four legs and is an example of ritual bronze made during the Shang dynasty, one of China's earliest dynasties (c. 1700–211 B.C.E.). Bronze vessels like the *fang ding* were associated with ancient Chinese shaman-

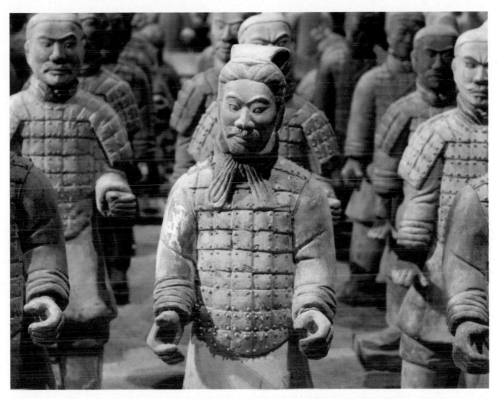

Seven thousand terra-cotta soldiers and horses protect Chinese Emperor Qin Shi Huang in a palatial tomb. Buried approximately three thousand years ago, Emperor Qin's incredibly life-like terra-cotta army was accidentally discovered in 1974 and remains only partially excavated.

ism and were used to hold food and wine offerings during religious ceremonies. Many *fang ding* have been found in royal tombs; the largest vessel discovered weighs over 240 pounds. They were often decorated with intricate animal and geometric motifs.

What is significant about the **"Standing Male Figure"** from **Sanxingdui**?

Shang artists (c. 1700–211 B.C.E.) are well-known for making bronze sculptures using the piece-mold casting process, especially bronze vessels for water, wine, and food. But, when the "Standing Male Figure" from Sanxingdui was discovered, it astonished scholars and changed the way they thought about ancient Chinese art. More than eight feet tall, this towering male sculpture is highly abstracted with a long, cylindrical body, jutting elbows, and large, circular hands. Nothing quite like this had ever been discovered, and scholars now think there may have been other significant art-producing cultures separate from the Shang dynasty during this time.

How did the **ancient Chinese caste bronze**?

The ancient Chinese used a technique known as "piece-mold bronze casting" to make their ritual vessels and other bronze work. The first step was to make a clay model of the entire piece, including all of the decorations. Another heavier clay was then packed around this model, which formed a mold. After the clay dried, the mold was cut into

39

pieces which released the interior model. The mold, now reassembled, could be filled with molten bronze. Bronze, an alloy of tin and copper, plus other metals, becomes molten at 1,800 degrees and requires an enormous amount of labor to manipulate.

What is a *bi disk*?

Although these circular pendants look like they could be worn as jewelry, they are much too bulky and heavy for such a purpose. Instead, they were likely used in ritual worship of the sky. *Bi* (pronounced "bee") disks were made of nephrite, a greenish stone similar to jade. Some were smooth, displaying only traces of the tool marks used to shape them, while others were elaborately decorated. A *bi* disk from the Zhou dynasty (1100–221 B.C.E.) was discovered in a tomb near Luoyang, China, and is intricately carved with dragons. The ancient Chinese regarded dragons as symbols of power who were thought to pass between heaven and earth and to bring rain. It would have taken many hours of difficult work to grind and polish the dragons and other abstract designs on the Zhou *bi* disk.

How are **Chinese characters** formed?

Rather than referring to sounds like the English alphabet, the letters of the Chinese alphabet refer to entire words or ideas. These are called characters, or calligraphs. Like Near Eastern cuneiform and Egyptian hieroglyphs, some Chinese characters started out as pictographs, which means the character resembles what it depicts. The Chinese language is extremely visual in that the form of the language also denotes meaning, and this made a major impact on Chinese art throughout history.

What did **ancient Chinese architecture** look like?

While no ancient Chinese buildings remain standing today, houses and palaces from the Han Dynasty (206 B.C.E.–220 C.E.) survive in ceramic models. They were made for Han tombs and give scholars an idea of what the architecture of the time would have looked like. Han buildings were made of wood and were notable for their curved roofs and jutting eaves. The weight of Han buildings were supported by a system of vertical and horizontal beams, which meant that the walls did not need to bear any of the structure's weight. Colorfully painted screens, usually red and black, were used to

separate rooms. The rest of the wood structure was either painted or lacquered, which helped to protect it from the elements.

EARLY JAPAN AND KOREA

What is **Jomon pottery**?

The Japanese Jomon culture (c. 10,000–300 B.C.E.) was a settled hunter-gatherer society with a long-standing tradition of clay pottery. Jomon pottery from the middle and later periods are very creative, and the clay was pulled and twisted into unique forms. Animalistic pieces called *dogu* are likely effigies of the people who owned them, and are highly abstracted. Some have large, heart-shaped faces, long twisting arms, and even markings similar to tattoos.

What are *haniwa*?

Haniwa are figurative funerary markers made during the Kofun period in Japan (300–710 C.E.). Developing over time from simple, cylindrical forms, these unglazed, clay works reflect a Japanese taste for simple, organic design. Never perfectly symmetrical, *haniwa* are purposefully irregular. Though their exact function is unknown, *haniwa* may serve to connect the world of the dead with the world of the living.

What is the **Ise Shrine**?

The Ise Shrine is an important Shinto complex in Japan dedicated to the goddess Amaterasu, ancestor of the Japanese emperors. Known as "the Way of the Gods," Shinto may be considered a religion or a philosophy and is indigenous to Japan. Water purification rituals and worship of animistic local deities known as *kami* are fundamental aspects of Shinto. The Ise complex features a main shrine which has a thatched roof and is raised off the ground with wooden pilings. Made of unpainted cypress wood, the shrine's style reflects natural simplicity. Historically, only members of the Japanese Imperial family were allowed worship in Ise's interior sanctuary. Every twenty years, the main shrine is completely rebuilt on the site, an important political and religious ritual.

What is the **Silla Crown**?

Though influenced by the art and culture of China, Korean art is distinct and has a

The Silla Crown is an example of ancient Korea's distinctive artistic style.

long history. Around 100 B.C.E. a kingdom known as the Silla Kingdom took control over most of the Korean peninsula. The Silla Crown is a gold and jade headpiece likely made somewhere between the fifth and sixth centuries C.E. Made from sheets of gold and adorned with jewels and spangles, the upright styling of the crown has been linked to either trees or antlers, which symbolize life and supernatural power. It is possible that this crown was either ceremonial, or never meant to be worn at all.

ART OF THE ANCIENT AMERICAS

What are the **colossal heads** of the **Olmec**?

Often considered to be the "mother culture" of Mesoamerica, the Olmecs flourished between 1200–600 B.C.E. in present-day Mexico. The Olmec society left behind no written language, but their monumental art indicates that the culture was highly stratified, with clearly defined social classes. The colossal heads found at San Lorenzo in Veracruz are one of the most recognizable monumental art forms in the Americas. Made of basalt, the colossal heads weigh between five and twenty tons each. Up to eight feet tall, the heavy-featured sculptures have broad noses and thick lips. The heads wear helmets with earflaps and straps under the chin. Scholars believe they represent rulers or historic figures important to the Olmec culture.

What is **Valdivian sculpture**?

The Valdivian culture (c. 3550–1600 B.C.E.) was based in southern Ecuador and was older than the first dynasties of Egypt. They are known for making clay figurines, which are some of the earliest representative art produced in the Americas. These figurines were usually quite small, and some pieces are hermaphroditic, displaying both male and female characteristics. Many of these sculptures have been found in domestic settings, which suggest an association with women and fertility.

What is the **Raimondi Stela**?

The Raimondi Stela depicts a human-like jaguar deity and is an example of Chavin style art from the Peruvian Andes in South America. The Chavin culture, considered a mother culture to later Peru, developed between 1500 and 300 B.C.E., and Chavin style art emphasized complex abstract patterns and featured animals such as jaguars and eagles. The jaguar creature carved on

The enigmatic Nazca lines are thousands of years old and depict symbolic shapes and animals such as the spider (pictured).

the Raimondi Stela is known as the Staff God. It is depicted wearing an elaborate headdress made from stacked, serpentine monster-heads. This interweaving image emphasizes balance and symmetry in its abstract design.

What are the **Nazca lines**?

The Nazca lines are monumental geoglyphs carved lightly into the earth in southern Peru, and were made by the Nazca culture between around 400 and 600 C.E. The lines form symbolic shapes, including animals, and natural and geometric forms, such as a hummingbird, monkey, lizard, a flower, tree, and a spiral and trapezoid. These shapes, some of which are over four hundred feet long, were made by removing a top layer of red-pebbled earth to reveal a whiter surface underneath. Scholars wonder if the Nazca geoglyphs were depictions of constellations, or in some way linked to astronomy, but no conclusive connection has been found. It is possible the Nazca lines were an important part of religious ritual, or were intended for a divine audience, as they are best seen from the air.

AEGEAN ART

What is **Aegean art**?

The term Aegean art refers to the art of three major Mediterranean cultures which predate Ancient Greece: the Cycladic culture, the Minoans, and the Mycenaeans. Together, these groups are

The Raimondi Stela depicts a Staff God of the Chavin culture, which flourished in the Andes mountains between 1500 and 300 B.C.E. The complex, repetitive patterns of the image incorporate animal and organic designs.

referred to as the Aegean Civilization and flourished during the Bronze Age, c. 3000–1200 B.C.E. The Cycladic culture established itself on a group of small islands known as the Cyclades, while the Minoans lived on the island of Crete. The later Mycenaeans were based on mainland Greece. Aegean art is quite enigmatic and is characterized by lively sculptures and wall paintings which mirror the natural world and the warmth of the Mediterranean.

What is **Cycladic sculpture**?

The Cycladic culture (c. 3000–1200 B.C.E.) is known for its ceramic figurines. Cycladic artisans made their pieces out of various materials, from poor quality clay to marble, and represented humans, animals, and other forms. Some of the most well-known Cycladic sculptures are of women. These pieces can range in size and are highly abstract and stylized. The surfaces are smooth with little carved detail—facial features and other details would have been painted. In many examples, a figurine's only facial feature is a nose, while arms are crossed over the chest, as if the figure is either asleep or dead. One side of the figure is flat and the toes are pointed, an indication that the piece was meant to lie on its back. In fact, many of these sculptures have been found near graves, raising the possibility that they served a funerary purpose, though their exact function is unknown.

What is the **Palace of Knossos**?

The mysterious Minoan culture is famous for the labyrinthine Palace of Knossos, discovered on the island of Crete in 1900 by the British archaeologist Sir Arthur Evans. Evans called his discovery the "Palace of Minos," referring to the mythological maze which imprisoned the Minotaur. The Knossos Palace complex contained hundreds of rooms of various sizes and shapes, including storerooms, workrooms, and administrative rooms. One storeroom was so large, it could hold over twenty-thousand gallons of oil in jars. While the layout of the palace appears disjointed and confusing, each space was designed to have access to fresh air and plumbing, and was elaborately decorated with wall paintings and frescoes. The palace appears to have been completely destroyed and rebuilt, and Minoan culture seems to have been severely disrupted by at least one major natural disaster, possibly a catastrophic earthquake or volcanic eruption—or both.

What is the **"Mask of Agamemnon"**?

The "Mask of Agamemnon" is a gold funerary mask discovered in a Mycenaean citadel by archaeologist Heinrich Schliemann. The mask was meant to lay over the face of a deceased man, and the almond-like eyes appear to be closed. While many details of the face are abstracted, such as the curvilinear ears and round chin, some details may be individualized. Schliemann believed the citadel where he was excavating was the home of the legendary Trojan War hero, Agamemnon, and he gave the piece its name. It has been at the center of controversy ever since, with some claiming that Schliemann committed a forgery and hammered some of the gold himself. At the very least, modern scholars no longer believe this piece belonged specifically to Agamemnon, but are still impressed by the power and craftsmanship of the mask.

ANCIENT GREEK ART

What are the major **periods** of **Greek art**?

The Greek civilization developed in the Mediterranean before 1000 B.C.E. and flourished until conquered by the Romans in the first century B.C.E. During this thou-

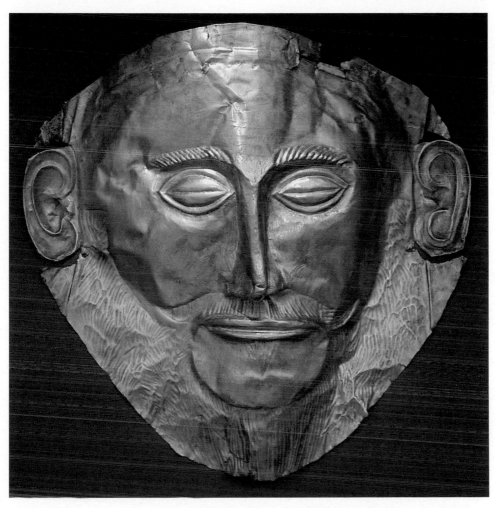

Although this gold funerary mask is known as the "Mask of Agamemnon," it probably did not belong to the mythological hero of the Trojan War. But it is an excellent example of the craftsmanship of the Mycenaean, a Mediterranean people who predate the ancient Greeks.

sand-year time span, the Greeks produced art and architecture considered to be the foundation of all Western art to come after it. Scholars divide Greek art history into a number of periods, or categories, the most significant of which include the Geometric, Archaic, Classical, and Hellenistic periods.

Period	Dates	Description	Example
Geometric	c. 900–700 B.C.E.	Painting and sculpture characterized by stylized linear motifs featuring spirals, diamonds, and cross-hatching	Funerary Vase from Dipylon Cemetery, Athens
Archaic	c. 600–480 B.C.E.	Characterized by a more naturalistic style of painting and sculpture influenced by the Near East and Egypt	Standing Youth (Kouros) from Attica

45

Period	Dates	Description	Example
Classical	c. 480–323 B.C.E.	Considered the height of Greek art and architecture, with a focus on balance, ideal human proportion, and naturalism	Warrior A from Riace
Hellenistic	c. 323–31 B.C.E.	Begins after the death of Alexander the Great; highly naturalistic painting and sculpture with an expressive and dramatic style	Laocoon and His Sons

What are the **Classical Greek Orders** of **Architecture**?

Greek architects followed fairly strict conventions when designing temples in an attempt to produce a balanced and unified look, an aesthetic valued by the Greeks. The three main "orders," or patterns of temple-building design are: Doric, Ionic, and Corinthian. Referred to as the "Classical Greek Orders of Architecture," these systems of proportion and style made a profound impact on the history of architecture and continue to be incorporated into building design to this day.

What is the **Doric order**?

The Doric Order was the earliest order to develop and did so towards the end of the seventh century B.C.E. It features a baseless *column* that supports a horizontal *entablature*. A Doric column is approximately five times as tall as it is wide, a ratio of 5:1. The shaft of the column is *fluted,* which means it is decorated in shallow, vertical grooves. A Doric *entablature* rests atop the column, and features a decorative band called a *frieze,* which is decorated with alternating *triglyphs* and *metopes*.

The Parthenon is an example of a building constructed according to the Doric Order. The Parthenon, built of marble, is dedicated to Athena, the patron goddess of the city of Athens. It sits atop the Acropolis, a prominent hill in the center of the city, which also includes other architecturally significant structures. Built under the direction of the famous statesman Pericles in the fourth century B.C.E., the Parthenon was designed to represent Athens' self-proclaimed status as an enlightened and civilized center of the world, and celebrated the democratic Greek's recent defeat of the Persian Empire. The exterior of the Parthenon was masterfully decorated with architectural sculpture on all sides, and a forty-foot, gold-covered sculpture of Athena was erected on a pedestal in the center of the temple.

What is the **Ionic order**?

The Ionic order is the second of the three Classical Greek Architectural Orders and is characterized by a longer, leaner column than the Doric order. Ionic columns were built with a ratio of approximately 9:1 and the *capital* at the top of the column is shaped like an unfurling scroll, which is called a *volute*.

The Temple of Athena Nike, located on the Acropolis in Athens and built between 427 and 424 B.C.E., is an example of an Ionic temple. This small building was only about twenty-seven by nineteen feet and it was completely demolished by invading Turks during the seventeenth century, though it was later rebuilt. The temple is famous for its two porches on each end, and for a surviving fragment of relief sculpture known as *Athena Nike Adjusting Her Sandal*. This elegant image shows the goddess wearing a long, flowing robe which clings gently to her body as she bends to adjust her shoe. Her robe slips off of one shoulder and she appears momentarily vulnerable, a delicate and erotic image of the goddess.

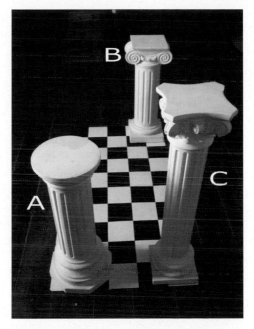

The classical orders of Greek architecture include Doric (A), Ionic (B), and Corinthian (C) columns, which are increasingly tall and complex in their design. The system of classical orders was essential to ancient Greek building design; it was heavily copied by ancient Romans and remains popular today.

What is the **Corinthian order**?

The Corinthian order was the last of the three Classical Greek Orders of Architecture to develop. The tallest and most elaborate of the three orders, a Corinthian column is built at a ratio of approximately 13:1, which means the height of the column is thirteen times taller than the width. Originally designed for interior use, the Corinthian order features a capital decorated with flowers and leaves of the acanthus plant. While the Doric and Ionic order feature a corniced entablature, the Corinthian entablature is flat. According to the Roman architect and writer Vitruvius, (and later repeated by the Renaissance writer Vasari) the artist and poet Callimachus was inspired to design the Corinthian capital after seeing a basket of overgrown acanthus leaves placed in front of a young girl's grave in the Greek city-state of Corinth.

The Temple of Olympian Zeus is a Hellenistic temple that was started using the Doric order, but finished years later using the Corinthian order. The temple's massive columns are over fifty-five feet high. Classically-inspired modern buildings continue to incorporate the Corinthian design, including the General Post Office in New York and the U.S. Capitol building.

What is a *kouros*?

Kouros (plural *kouroi*) is a term used to refer to a freestanding sculpture of a young male during the Archaic period of ancient Greek art. A female equivalent is known as a *kore* (plural *korai*). These statues were usually life-size and influenced by Egyptian sculpture. A *kouros* faces frontally and takes a small step forward, much like the sculpture of *Menkaure and a Queen*. The arms are held firmly at the sides and the

hair is formed in long rows of stylized braids. Unlike Egyptian sculptures, male *kouroi* were completely nude and emphasized youth and athleticism.

What is the **Archaic smile**?

Take a good look at an Archaic *kouros* or *kore* sculpture and you may notice a subtle, yet lighthearted smile playing on its lips. The close-lipped Archaic smile gives cold stone sculptures a sense of warmth and life. Over six feet tall, the *Berlin Kore* (570–560 B.C.E.) has remnants of red paint and depicts a poised, column-like woman. Her robes fall rigidly and the folds in the fabric look almost like the fluting of a Doric column. She also holds a pomegranate, which therefore links her to the mythological deity Persephone, who was abducted by Hades and taken to the underworld as his wife. Contrasting the otherwise stoic austerity of the work, the *Berlin Kore* features a warm Archaic smile, which brings her to life.

Who was **Exekias**?

Greek vases from the Classical period feature some of the most impressive paintings in the ancient world, and Exekias is considered to be one of the greatest vase painters of the time. Living in Athens during the sixth century B.C.E., Exekias painted in what is known as the black-figure style, which places black figures on a red background. His work is noted for its grace and sense of order. One of his most famous pieces depicts *Achilles and Ajax Playing Draughts*, from c. 530 B.C.E. The scene takes place during a break in fighting during the Trojan War when the mythological warriors paused to play a game of ancient checkers. The scene is very symmetrical and the arrangement of figures takes into account the swelling form of the vase itself. Exekias not only painted the vase, but he was also the potter; a signature on the piece reads: "Exekias painted me and made me."

What **innovations** were made by **Euphronios**?

Active in Athens between 520 and 470 B.C.E., Euphronios was a vase painter who worked in the red-figure style. The red-figure style of ancient Greek vase painting developed after the black-figure style used by artists such as Exekias. Euphronios' work demonstrates a masterful ability to use the red-figure technique to naturalistically depict the human form in multiple poses. Euphronios signed eighteen of his vases, sometimes as a painter, and sometimes as the potter. One his most famous works is a bowl-like *calyx krater* depicting the *Death of Sarpedon* (c. 515 B.C.E.). The story comes from Homer's *Iliad* and the painting shows the deities Hypnos and Thanatos (gods of sleep and death, respectively) carrying the dead body of the warrior Sarpedon. Hermes, the messenger god, holds a staff decorated with snakes called a *caduceus,* and wears a winged hat. Hermes watches over the scene and ensures the safe arrival of Sarpedon's body in the underworld. The figures in the dignified and detailed scene were rendered using foreshortening, an innovative technique in which body forms are distorted so that they appear to recede from the viewer, which creates a sense of real space in the painting.

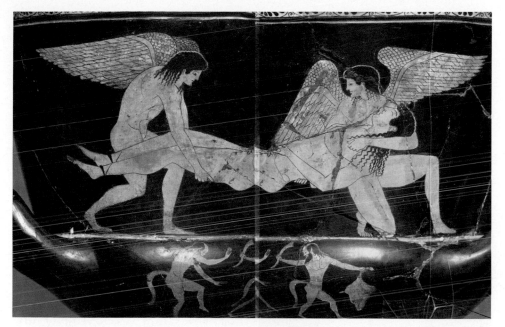

This vase depicting the death of the mythological warrior Sarpedon is an example of the classical Greek painting style. Dynamic red figures are painted against a black background. Earlier Greek artists painted the opposite—black figures on a red background.

What was so **revolutionary** about *Kritios Boy*?

Kritios Boy (about 470 B.C.E.) is damaged. His arms appear lopped off at the elbow and his legs, with no feet, end in stumps. His hair is like a stylized bowl with a rim of curls. And yet, this dusty relic represents one of the most important and exciting innovations in the history of art. *Kritios Boy* is not a mere Archaic sculpture; he does not stare straight ahead with a vacant look in his eyes. *Kritios Boy* shifts his body weight to one side, with hips tilted. One leg is slightly bent. This position is called the *contrapposto* style. *Contrapposto* literally means "counter-pose." With this small shift, *Kritios Boy* appears much more alive than his previous counterparts. There is a small curve in his spine, and his head is turned slightly to one side. This is a freestanding sculpture in the round, and the gently curving movements of *Kritios Boy* invite the viewer to make a 360-degree tour around him. Gone is the playful Archaic smile. Instead, *Kritios Boy* is solemn, and serious. A youthful athlete, *Kritios Boy* represents Greek ideals of youth, manhood, and physical and mental strength.

What is a **caryatid**?

A caryatid is a sculptural female figure utilized as columnar support in Classical architecture. The Roman architect and writer, Vitruvius, noted that caryatids were named for Spartan women from a town called Karyai who betrayed their people during the Persian Wars, and were punished by being forced to bear the weight of heavy architectural entablatures. The Erechtheion (421–405 B.C.E.) is a building on the

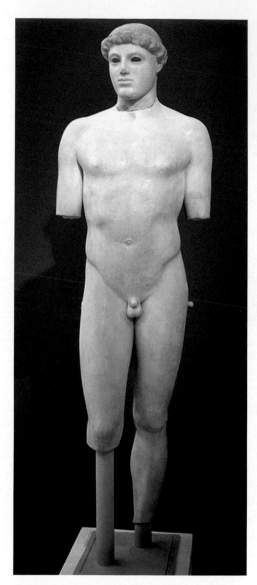

The sculpture known as *Kritios Boy* (c. 470 B.C.E.) marks a major shift in ancient Greek art; the realism of the figure, and the use of *contrapposto*, breathe life into the statue.

Acropolis in Athens famous for what is known as the Porch of the Maidens. This porch features six caryatids, which face south in the direction of the Parthenon. Like *Kritios Boy,* each caryatid is in the *contrapposto* pose, with one leg bearing the weight of the Erechtheion's Ionic entablature, and the other leg free and slightly bent. The folds in their robes mirror the vertical design of fluting found on columns and provide a sense of stability in the otherwise fluid and graceful poses of the caryatids.

Who was **Praxiteles**? or "Where did Praxiteles see me naked?"

Praxiteles was a Greek sculptor who worked in Athens during the fourth century B.C.E. and is considered to be one of the most important artists of the Classical period, along with sculptors Skopas and Lysippos. He is particularly well known for the *Aphrodite of Knidos,* made for the Greek city of Knidos around 350 B.C.E. It is thought to be the first time an artist produced a monumental female sculpture fully nude (it was common to depict the male nude, but the female form was traditionally clothed). The *Aphrodite of Knidos* demands to be admired, and from multiple viewpoints. Her flesh is soft and supple and her body is delicately off balance in the *contrapposto* pose. With this work, Praxiteles set a new standard for depiction of the female nude. The work itself was so beautiful that the real goddess Aphrodite was said to have traveled to Knidos and upon seeing the statue exclaimed, "Where did Praxiteles see me naked?" (quoted in Stokstad 205). Praxiteles' artistic style has been greatly admired, and greatly imitated, ever since.

What happened to the **Venus de Milo's arms**?

In 1820, the remains of the *Venus de Milo* were accidentally discovered by a farmer on the Greek island of Melos (from which the sculpture gets its name). Since then,

the *Venus de Milo* has become one of the most famous works of art in the world. Many other broken fragments of marble were found in the same field, and some of those pieces may have been fragments of her arms. These pieces suggest that the *Venus de Milo* might have been holding an apple in her right hand. But, there is another theory. Rather than an apple, she may have been admiring herself in the reflection of a polished shield. The second theory does the best to explain why the *Venus de Milo's* left leg is slightly bent and her body somewhat twisted. Unfortunately, the fragments found with the statue are now lost.

But, it doesn't end here; the lovely statue finds herself in yet another controversy. Is the *Venus de Milo* an example of ideal beauty and poise from the Classical period, or was she made during the

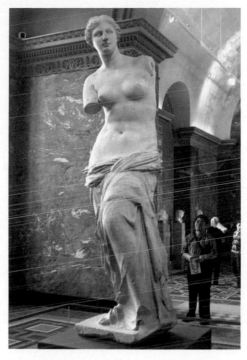

Would the *Venus de Milo* be as beautiful with all of her limbs intact?

more garish and later Hellenistic period? Many nineteenth-century scholars were convinced that she was an example of Classical sculpture due to stylistic similarities with the work of Classical master Praxiteles. Modern art historians now think she was made around 150 B.C.E., which would place her firmly in the Hellenistic period. They also cite the erotic tension caused by the way in which her robes are just about to slip off of her half-nude figure as being more in line with Hellenistic taste. It is perhaps the mystery that surrounds the *Venus de Milo* that adds to her beauty and attraction. One might wonder if she would be half as engaging with both of her arms completely intact.

What is the **Theater at Epidaurus**?

The Theater at Epidaurus (c. 350 B.C.E.) was an example of ancient Greek civic architecture meant to be enjoyed by the general public. The art of the theater was an important part of ancient Greek culture and religion, as religious ceremonies were incorporated with music and dance, and performed in public spaces. Greek drama, including tragedies and comedies, were performed in outdoor spaces like the Theater at Epidaurus. At the heart of the theater was the circular *orchestra,* the central performance area. Fifty-five rows of semicircular tiered seats were carved into a hillside, which allowed as many as fourteen thousand spectators a good view of the *orchestra*. The design of the Theater at Epidaurus is so effective that it is still in use today, and the acoustics are so perfect that no electrified sound system is needed when performances are held at the site.

What is the **Pergamese style**?

During the fourth century B.C.E., Alexander the Great marched Greek culture over nearly half the globe, and when he died suddenly in 323 B.C.E., his vast empire fell into fragmented city-states and small kingdoms. One such kingdom, Pergamon, was located in present-day Turkey and became a leading city for art during the Hellenistic period. Art from Pergamon is known for being emotionally expressive and emphasizes acts of heroism. An example of the Pergamene style is a sculpture known as *Gallic Chieftain Killing His Wife and Himself*. The sculpture depicts a military victory over the Celtic Gauls in France. It was originally in bronze, and now exists only in Roman copies. The work romanticizes the death of the leader of the Gauls who commits suicide rather than surrender to the Pergamese. His wife, who he has already stabbed to death, falls limp in his left arm as he turns away and plunges a sword into his own chest. This dramatic sculpture attempts to evoke a feeling of sympathy and admiration for the fallen chief, and is a powerful example of the expressive Pergamese style.

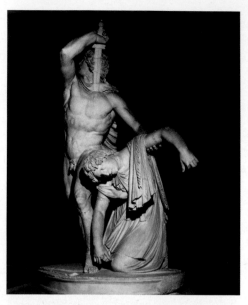

Art from the Greek Hellenistic period is known for is heightened drama and realism. This Hellenistic sculpture depicts a Gallic chief as he kills his wife and himself after a loss in battle. The work evokes a mixture of pity and respect from the viewer. (*Art courtesy The Art Archive / Museo Nazionale Terme Rome / Gianni Dagli Orti.*)

ETRUSCAN ART

Who were the **Etruscans**?

The Etruscan Civilization flourished in Italy for nearly five hundred years, until the Etruscans were conquered by the Romans in 509 B.C.E. They controlled a fertile region known as Etruria, now called Tuscany. The art and culture of the ancient Etruscans were certainly influenced by the Ancient Greeks, in fact, the Etruscans adopted a number of Greek gods into their pantheon. But, they also maintained a unique tradition of their own, and went on to influence the ancient Romans who absorbed their culture.

Why did **Romans hire Etruscan artists**?

The Etruscans were famous in the ancient world for their skill as bronze workers, and Etruscan artists were sought after to make bronze sculptures for the Romans after the Roman conquest of Etruria. Etruscan artists often made small funerary or domestic objects, and were also skilled at making portrait sculpture. One notable example

is a portrait bust of a man, likely a dignitary or an ancient hero, from around 300 B.C.E. The man's eyes, made of painted ivory, communicate a solemn nobility, and the hair and facial features are finely detailed.

What did **Etruscan temples** look like?

Etruscan temples were greatly inspired by Greek architecture, and went on to influence Roman temple architecture. Etruscan temples were nearly square and raised on a tall foundation known as a *podium*. Built of mud bricks, about half of the temple was devoted to three interior rooms, and the other half was made up of a large porch supported by a double-rows of columns. Columns were made either of wood, or volcanic rock called *tufa*. These relatively simple buildings were elaborately painted and decorated with architectural sculpture, not on the pediment (as the Greeks would have done) but on the roof. Etruscan temple sculpture was made from terra-cotta, a challenging material to work with, and they precariously placed their pieces along roof lines and ridgepoles. Overall, an Etruscan temple looks small and heavy, supporting a cast of terra-cotta gods and goddess milling around on its roof.

Why are **Etruscan tombs** built to look like houses?

Known for cremating their dead, the Etruscans seem to have thought of their tombs as being like homes for the dead in the afterlife. The tombs themselves were organized in a grid-like pattern, much like a small downtown. The Tomb of the Reliefs is a famous Etruscan tomb that features pots, tools, and even couches, all carved from

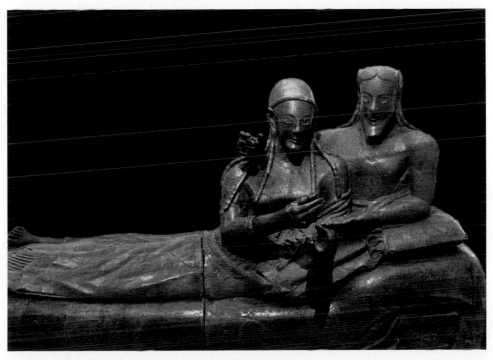

An Etruscan sarcophagus. Etruscan art is known for its energy and realism.

stone and made to look like objects from a normal Etruscan house. There is even a carving of the family dog! But, there is also a carving of Cerberus, the three-headed dog who guards the entrance to the underworld, according to Greek mythology. Much like the Egyptians, the Etruscans attempted to bring the dead the comforts of home.

ROMAN ART

Why did the **Romans copy Greek sculpture**?

Much like today, a large art collection was an indication of wealth and status in ancient Rome. Greek art was held in high regard by the ever-expanding Romans who set about conquering the Mediterranean and coming home with art and treasure from across the land. Roman artists copied many marble and bronze statues in order to meet popular demand, usually working in marble. Not all Roman sculptures were exact copies, however. Roman sculptors adapted Greek sculpture and updated it to match the tastes of the Roman art-buying public. All in all, we are lucky the Romans did so much copying; many original Greek bronzes were long ago melted down (to make things such as weapons and armor) and therefore much of our knowledge of Greek art comes from Roman copies.

How does **Roman architecture differ** from **Greek architecture**?

Greek and Roman architecture are together referred to as "Classical architecture," as they share many characteristics including an adherence to the Classical Greek Orders of Architecture and a sense of symmetry and balance. But, there are some key differences. Whereas the Greeks favored marble, the Romans invented concrete, and they relied on this key building material in much of their architecture. Romans also emphasized circular forms and made extensive use of the arch, vault, and dome in their building projects, unlike the post-and-lintel structure of Greek buildings. While Greek buildings tended to feature cramped interiors built on a more human scale, Roman buildings had dramatically high ceilings and were generally more flamboyant than their Greek counterparts.

What is the **Pantheon**?

Topped with the widest dome on earth until the nineteenth century, the Pantheon is an important example of Roman architecture, built between 125–128 c.e., during the reign of Emperor Hadrian. The name "Pantheon" refers to the fact that the temple was dedicated to all of the Olympian gods, who the Romans worshipped as the Greeks had done. The Pantheon was originally built on a podium, like an Etruscan temple, but hundreds of years of development around the site now hide this, along with the original stairs which led up the middle of the podium. The entrance portico features Corinthian columns and leads to an enormous rotunda. The walls of the rotunda are nearly seventy-five feet tall and twenty feet thick, which support the enor-

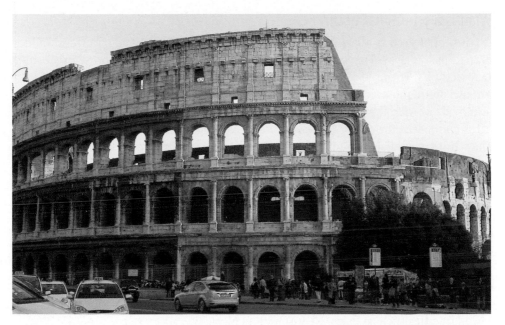

Roman civic and temple architecture celebrates both government and gods. The Arch of Titus is a formidable commemoration of military victory, while public events at the Coliseum (pictured) entertained the masses over two thousand years ago.

mous dome. At the apex of the dome is a thirty-foot oculus, which means "eye" and allows natural sunlight (and sometimes rain) to pour into the interior of the Pantheon. Besides the engineering innovations needed to build such a wide dome, spanning 143 feet, the Pantheon is impressive because of its harmonious proportions and beautiful decorations. If the dome were doubled, it would form a sphere that fits perfectly within the interior space of the rotunda. The interior of the dome ceiling is decorated with a rows of sunken, ornamental squares that create shifting shadows as the sun moves across the sky and light filters through the oculus.

What is the **Colosseum**?

The Colosseum is an ancient Roman stadium designed to seat fifty thousand spectators for events such as gladiator and animal fights. Romans even held mock sea battles here, and were able to flood the arena for such events. Built between 72 and 80 C.E., it was the largest Roman amphitheater and was originally known as the Flavian Amphitheater. The original central arena was nearly thirty-thousand square feet and the whole structure is more than six hundred feet in diameter. The façade of the building was made of three levels of eighty-arch arcades (a row of arches), plus an attic level, and supported six tiers of seats. Under the seats, barrel-vaulted corridors allowed for the passage of athletes and animals. Each of the three arcade levels is decorated according to a different architectural order, which become more complex as the building rises. The first floor utilizes the simple Tuscan order, while the second and third floor incorporate elements from the Ionic and Corinthian order, respectively. The exterior had been faced with travertine, but this relatively expensive material has since been looted.

55

What is a **triumphal arch**?

A triumphal arch is a large monumental structure in the shape of a freestanding arched passageway. They were used in ancient Rome to commemorate great military victories. The Arch of Titus (c. 81 C.E.) and the Arch of Constantine (312–315 C.E.) are two of the most famous examples of triumphal arches in Rome. Over fifty feet tall and made of marble and concrete, the Arch of Titus was constructed after Emperor Titus conquered the city of Jersualem. Relief carvings on the interior of the structure show Roman soldiers proudly carrying home the spoils of war, including a menorah taken from the Temple of Solomon. Built almost three hundred years later, the Arch of Constantine celebrates Emperor Constantine's defeat of Maxentius at the Battle of Milvan Bridge. The event is important in Christian history as Constantine was said to have had a vision of a cross and heard the words, "In this sign you shall conquer" just before battle. Constantine's mother, Helen, was Christian, and Constantine ended legal persecutions of Christians in Rome in the Edict of Milan. The Arch of Constantine was made of partly recycled material, and incorporated relief decoration from monuments dedicated to earlier rulers such as Marcus Aurelius, Trajan, and Hadrian. Triumphal arches continue to be used to mark important historic events and can be found in cities such as Paris, New York, and Moscow.

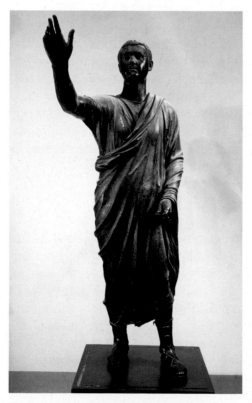

The Orator depicts politician Aulus Metellus during the time of the Roman Republic. Sculptures such as this would have been placed at the top of a column in a public space. (*Art courtesy The Art Archive / Archaeological Museum Florence / Gianni Dagli Orti.*)

What is *The Orator*?

The Orator is a life-size, bronze sculpture of Aulus Metellus, a Roman official from the time of the Roman Republic. Made in either the first or second century B.C.E., the work depicts the authoritative politician addressing a crowd with his right arm raised. Wearing traditional leather boots and a toga, the portrait sculpture is part of a tradition of Roman realism known as *verism,* popular during the time of the democratic Republic. Statues like this would have been placed on the tops of columns as a form of memorial, where it would appear as if the figure was addressing the people below.

What is **Roman illusionism**?

The ancient Romans were known for their beautiful paintings, which they used to decorate the interiors of domestic residences. These paintings often created the illusion of space, much like a theater backdrop, and featured elements such as faux architectural motifs and outdoor

Why is Emperor Commodus dressed as Hercules?

There are many stories about the unusual behavior of the Emperor Commodus, who reigned over the Roman Empire from 180–192 C.E. Called insane by historians, Commodus was known for claiming to be a reincarnation of Hercules and for dressing as a gladiator during official engagements. He even wanted to Roman months to be renamed after him. *Commodus as Hercules* is a marble sculpture depicting the eccentric ruler dressed as the mythological hero, Hercules. He wears a lion-skin headdress, complete with paws, and carries a club and apples from the garden the Hesperides, all of which are associated with the mythological labors of Hercules. Commodus likely intended this idealized portrait to show him as noble and brave; however, he ends up looking fairly ridiculous with vacant eyes and raised eyebrows. Commodus attracted some of the best artists of his time and this piece demonstrates the high level of skill of the sculptor who captures Commodus' idealized human form, and complex character, so effectively.

scenes. The Villa of P. Fannius Synistor in Italy has some of the most important surviving wall paintings from the Roman world. The villa was buried by volcanic ash when Mount Vesuvius erupted in 79 B.C.E. (nearby Pompeii was also destroyed) and was excavated in the early twentieth century. Many of the paintings here feature objects painted using the *trompe l'oeil* technique, which means "trick of the eye." For example, an image of a glass vase in the painting looks so real that it appears to exist in three-dimensional space. These illusionistic wall paintings were a status symbol for the wealthy Romans who filled their villas with them.

How did **Romans** make their **mosaics**?

Mosaics were very popular in ancient Rome and, like realistic wall paintings, were used extensively to decorate the floors of private homes and villas of the

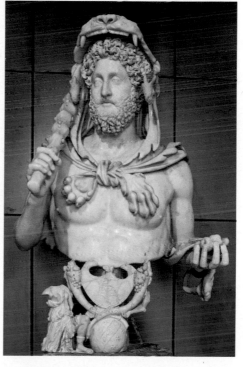

Emperor Commodus is laughable dressed as the mythological hero Hercules. Emperor Commodus was known for his strange, often unstable, behavior.

wealthy. At the heart of a Roman mosaic are *tesserae,* small pieces of glass and stone, often in a cube shape. The *tesserae* were pressed into cement, which was also used as a sort of grout in the spaces between the stones. Mosaic panels, called *emblumata,*

What is the Classical pantheon?

The ancient Greeks and Romans were polytheistic, which means that they believed in many gods, each with different attributes and personalities, and collectively referred to as the Greek and Roman pantheon. The human-like Classical gods and goddess were frequently depicted in ancient art, and temples were built in their honor.

Greek Name	Roman Name	Description
Zeus	Jupiter	Ruler of the gods; often depicted holding a lightning bolt; reigns from Mount Olympus
Hera	Juno	Wife of Zeus and goddess of marriage; often jealous as Zeus had many affairs
Aphrodite	Venus	Goddess of beauty, love, and sex; mother of Cupid; known for frequent love affairs with gods and mortals
Apollo	Apollo	Son of Zeus and twin brother to Artemis; god of the sun, music, archery, prophecy, and poetry
Athena	Minerva	Patron goddess of Athens; goddess of wisdom, weaving, and art
Demeter	Ceres	Goddess of fertility and harvest; her daughter, Persephone, was kidnapped by Hades and taken to the underworld
Hades	Pluto	God of the underworld
Ares	Mars	God of war
Hermes	Mercury	Messenger god; often depicted with a winged helmet
Artemis	Diana	Virgin goddess of the hunt and wilderness
Poseidon	Neptune	God of the sea; depicted carrying a trident
Persephone	Prosperina	Wife of Hades; goddess of spring and flowers
Eros	Cupid	God of love; son of Aphrodite
Kronos	Saturn	King of the Titans; God of Time
Dionysus	Bacchus	God of wine and festivals

were usually built off-site by the mosaic artist and then installed into a floor. Romans liked to copy famous paintings in mosaic form, which required very tiny pebbles in order to achieve the detail of a painting. A number of lost Greek paintings still exist in a Roman mosaic form.

THE MEDIEVAL WORLD, c. 400–1300

EARLY JEWISH AND CHRISTIAN ART

What does the **earliest Jewish** and **Christian art** look like?

Most of the earliest Jewish and Christian art dates from the Hellenistic period and takes its cues from Near Eastern and Classical (Greek and Roman) art. Early Jewish artists were forbidden from making any form that could be worshipped as an idol, and therefore avoided representational art. Early Christian art drew its symbols from Jewish tradition as well as Classical tradition. A common subject in early Christian art, for example, is the Good Shepherd. In the Classical tradition, the Good Shepherd represents the mythological figure, Orpheus, who is shown holding a sheep around his shoulders. Early Christian artists used this as a model for early images of Christ in both sculptural and painted form, referring to Psalm 23 which states: "The Lord is my shepherd; there is nothing I lack" (Psalm 23:1). This is an example of syncretism, an art historical term which refers to the merging of meaning and imagery between different cultures and religions.

Symbolism is an important part of Christian art tradition. The lamb is a common symbol for Christ; the Four Evangelists (Gospels) are often represented according to their symbols. Mark, Matthew, Luke, and John are depicted as men, or angel, lion, ox, and eagle, respectively.

What are important **symbols** in **Jewish iconography**?

Though idols are forbidden in the Jewish tradition, some images are frequently re-

peated, especially in the decoration of synagogues and the Jewish holy book, the Torah. Scenes from Jewish history, including the story of Moses, were common choices for synagogues, and can be seen in the decoration of Dura Europos. Important Jewish symbols include the following:

- *Menorah*—a sacred, seven-branched candelabrum
- *Shofar*—a ram's horn used like a trumpet during ceremonies
- *Etrogs*—citrus fruit used to celebrate Sukkot, a harvest festival
- *Lulav*—a palm branch also associated with Sukkot

In a sixth-century synagogue located in ancient Menois (in modern-day Israel), the floors are decorated with Roman-style mosaics which feature the traditional Jewish symbols mentioned above, along with stylized birds, plants, and animals, which are thought to represent earth's bounty and the unity of the Jewish people.

What was **Dura Europos**?

Dura Europos was an ancient trading town established in the third century B.C.E. and abandoned by 256 C.E. in modern day Syria. After being long forgotten, the settlement was rediscovered by British soldiers in the early twentieth century. The site features Greco-Roman temples dedicated to Greek gods such as Zeus and Artemis, as well as temples decorated with images of ancient Near Eastern deities such as the Persian God, Mithras, and a variation on the Sumerian moon goddess, Nana. Also found here was one of the earliest known Jewish synagogues and a Christian house church. (Both early Christians and early Jews built their churches and synagogues in private houses.) The Dura Europos synagogue was large and richly decorated with interior wall paintings emphasizing green and yellow color schemes, and featured a niche for Torah scrolls. The house church was built in 246 C.E. and contained one of the earliest known baptismal fonts. The walls were decorated with images from both the Old and New Testament, including an image of Christ walking on water. The Dura Europos site preserves evidence of a rich melting pot of ancient cultures and gives scholars insights into the visual culture of Early Jews and Christians of the ancient world.

What are some of the most **important Christian symbols** in art?

- Dove: A symbol of purity and peace. The dove can also symbolize the Holy Spirit of the Christian trinity.
- Lamb: The lamb represents sacrifice. Jesus Christ is referred to as the Lamb of God as he was sacrificed on behalf of humanity. A flock of sheep, by contrast, represents Christian worshippers who are protected by Christ, the Good Shepherd.
- Cross: This is the most prominent symbol of Christianity and it symbolizes the wooden beams used to crucify Jesus Christ. It is both a symbol of Christ's suffering, as well as Christ's triumph and resurrection.
- Four Evangelists: The Four Evangelists are also referred to as the Four Gospels as they wrote the Gospels in the New Testament of the Bible. Each of them is often represented with a particular symbol or attribute. Saint Matthew is shown as a man or angel; Saint Mark is a lion; Saint Luke is an ox; Saint John is an eagle.

What are the **Catacombs of Commodilla**?

These catacombs were used for Christian burials as early as the fourth century. Smaller *loculi,* or rectangular niches, held between two or three bodies, but larger (and more expensive) *cubicula* held the sarcophagi of wealthier families. The cubicula were plastered and painted with Christian imagery. Many of the images found in the Catabombs of Commodilla emphasize the Eucharist, the ritual consumption of bread and wine, the bread and body of Christ. Other popular images include the Good Shepherd and images of Jonah and the Whale. In this story, Jonah was thrown overboard while at sea and was consumed by a whale. Three days later, he was cast back out, unharmed. The story reflects themes of the resurrection as well as rebirth and salvation.

What is a **basilica plan** church/synagogue?

While early Jewish and Christian synagogues and churches started out in private homes, over time a need for larger spaces for worship resulted in buildings constructed for specific use. The Roman basilica structure was particularly inspirational to early Jews and Christians as they were designed to accommodate large public gatherings, albeit for civic functions. The basilica-plan churches featured a central nave flanked by two narrower aisles on each side, separate by rows of columns. At one end of the nave was a semi-circular apse, usually facing the direction of Jerusalem. Basilica-plan synagogues usually had space for the Torah in the apse. During the third century C.E., Emperor Constantine began a large-scale building program in Rome during which the original St. Peter's Basilica was constructed over the believed site of St. Peter's burial. It is now referred to as Old St. Peter's Basilica because it was destroyed to make way for New St. Peter's Basilica, a building that stands to this day. Old St. Peter's Basilica was so popular during its time that it served to popularize the basilica-plan style of church-building for centuries.

What is a **centrally planned church**?

A centrally planned church is a church with the altar at the center, and was often used for baptisteries or tombs. The Church of Santa Costanza is an example of a centrally planned church, featuring a central altar surrounded by an ambulatory. The ambulatory is made up of paired Corinthian columns. The Church of Santa Costanza was originally covered in elaborate mosaics and marble.

BYZANTINE ART

What is **Byzantine art**?

During the fourth century, Roman Emperor Constantine moved the capital of the empire from Rome to Byzantium (in modern-day Turkey) and named the new capital city, not immodestly, Constantinople. After the Western portion of the Roman empire fell in 476 C.E., Constantinople became the major art center of this eastern empire, which included areas of Turkey, Greece, Italy, and Eastern Europe, and por-

tions of North Africa. The people of this Eastern Roman Empire, or Byzantine Empire, referred to themselves as Romanians and considered themselves the second Rome. The Empire, and especially the city of Constantinople, was immensely powerful, surviving longer than any other imperial power except for Egypt.

Byzantine art was monumental in scope, richly decorated, and influenced by both eastern and western traditions. Common forms of Byzantine art include brightly colored mosaics, icon paintings, illuminated manuscripts, and monumental architecture.

Who was **Emperor Justinian**?

Emperor Justinian was one of the most powerful and important rulers of the early Byzantine Empire and was responsible for large-scale building projects centered in the city of Constantinople, and in Byzantine territories in Italy. The Church of San Vitale in Ravenna, on the eastern coast of Italy, contains large mosaics dedicated to Justinian.

Completed around 547 C.E. and placed in a central location in the church, *Emperor Justinian and His Attendants* is one of the most impressive Byzantine mosaic from the period, and features realistically-modeled figures composed against a golden background and framed within an abstract, geometric pattern of glass tile. The haloed figure of Justinian is in the center, flanked by his ecclesiastical personnel on his left, and both civil and military personnel on his right. The soldiers are grouped behind a large shield decorated with the Greek letters "XP," representing Christ. The church officials on his right hold a jeweled cross and a gospel book. Wearing long purple

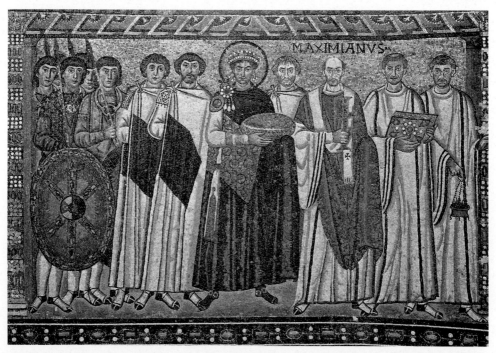

The powerful Byzantine emperor Justinian is depicted in a sixth-century mosaic, along with his stoic attendants, in the Church of San Vitale in Ravenna, Italy. The mosaic was an important form of art in the Roman, Byzantine, and Islamic empires.

robes that indicate his power (and visually align him with images of Christ), Justinian wears ornate crown jewels and carries a vessel containing bread for the Mass held in the church. Against the glittering gold background, it is as if the Emperor and his attendants hover in a detached, spiritual realm. Emperor Justinian is clearly in charge of this far flung Byzantine outpost, even if he never actually visited Ravenna during his lifetime.

What is a **Byzantine icon**?

In Greek, the word *icon* means, "image" and it is an important part of religious worship in the Orthodox Christian church. An icon is a sacred representation of a holy person usually a saint, Christ, or the Virgin Mary. Byzantine icons were usually painted on wooden panels, but also included ivory, mosaics, textiles, and more. Icons held powerful religious significance—some icons were even linked to miracles. Towards the end of the sixth century, a conservative group of iconoclasts (literally "image-smashers") worried that the icons themselves were being worshipped, and icons became targets for destruction during the Iconoclastic Controversy in the eighth century.

What was the **Iconoclastic Controversy**?

During the early history of the Christian Church, there was a debate about whether or not it was appropriate to make representational images in religious art. The term "iconoclasm" means "image-breaking" and iconoclasts believed that representational imagery should be forbidden. At the heart of the debate was the relationship between a painted image and the figure being depicted. There was fear of idolatry and a fear that beauty could distract the viewer from the religious sanctity of the figure. It is possible the rise of Islam, and the iconoclastic views of that religion, influenced the Byzantines during the Iconoclastic Controversy.

What is the **Hagia Sophia**?

The Hagia Sophia is a centrally planned church rebuilt as part of a city-wide redevelopment project headed by Emperor Justinian and his wife, Empress Theodora, in Constantinople during the sixth century. The ambitious design was created by two mathematically inclined architects, Anthemius of Tralles and Isidorus of Mileos, who applied their understanding of geometry, optics, and physics to the project, particularly to the enormous dome, which appeared to float. The result of their work was so magnificent that it was said angels from heaven had miraculously aided the construction. There were concerns, however, about the forty windows that made up the dome's base. Would they be strong enough to support such a heavy structure? In the year 558 C.E. there was an answer: the dome collapsed, not because of the windows, but due to weakness in the supporting piers. A reconfigured dome was constructed in its place, steeper and therefore even higher than the original. This new dome, along with extra supports, has survived ever since. Nearly one thousand years after its construction, the Hagia Sophia was converted to a mosque after the Ottomans took over Constantinople in 1453.

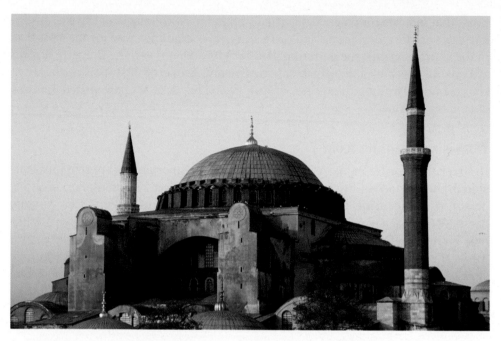

The Hagia Sophia was built in Constantinople (now called Istanbul) in the sixth century. This impressive structure is dominated by mathematically complex, light-filled domes.

Why is **Saint Mark's Basilica** in Venice considered an example of **Byzantine architecture**?

During the pre-modern era, the Italian city of Venice had many political and cultural ties to the regions east of Italy, and was therefore quite influenced by the culture and art of the Byzantine Empire. Saint Mark's Basilica is a grand architectural example of this influence, and was especially inspired by the Church of the Holy Apostles in Constantinople. The basilica, whose chapel holds the relics of Saint Mark the Apostle, is divided into five sections, each topped with a dome. The interior walls are covered in marble and over eight thousand square feet of glittering mosaics, many of which illustrate stories from the life of Saint Mark. The style is similar to that of Byzantine mosaic designs found at San Vitale in Ravenna, and other eastern European churches. The mosaics were a work in progress for hundreds of years and the basilica was consecrated as a cathedral in 1807.

ISLAMIC ART

What is **Islamic art**?

This is particularly challenging question to answer. The religion of Islam began in the Middle East during the seventh century and quickly spread east across Central Asia to parts of China and Southeast Asia, and west into large areas of North and Central Africa, and Europe. The term "Islamic art" does not necessarily indicate that the art

is religious in subject matter, but refers to art produced by cultures that practice Islam. Islamic art is therefore incredibly diverse, and influenced by both religion and secular cultural values. Some of the most common types of Islamic art include carpets and tapestries, calligraphy, book decoration, metalwork, and architecture.

How does the **religion of Islam influence art**?

Like early Byzantine art, Islamic art is influenced by iconoclastic views; this means that it is forbidden to depict idols, or images of God in human form. In Islam it is also *haram* (forbidden) to depict the Prophet Mohammad in art, and this is often extended to include the image of any human figure and animals. Much Islamic art, therefore, is characterized by mathematically complex abstraction featuring organic, geometric, and vegetal decorative patterns known as *arabesques*. There are some exceptions to this: the Islamic art of Mughal India, as well as Persian art, are both known for lively narrative paintings featuring characters from stories and legends. Still, one will not find any representation of God or Mohammad in Islamic art.

What is **considered beautiful** in **Islamic art**?

The Arabic word for "beautiful" is *jamil*. To be considered beautiful, Islamic art must be symmetrical, unified, and balanced. These aesthetic principles are also valued in Classical Greek and Roman cultures, which influenced early Islamic art. An additional quality of Islamic art is that it should also be "astonishing." The medieval philosopher Ibn-al-Haytham, known in the West as Alhazen, said visible objects are appealing due to the "composition and order of their parts among themselves" (as quoted in O'Riley 25). This attitude towards beauty helps to explain why Islamic art is often so intricate and detailed, and yet balanced and harmonious.

What is the **Qur'an**?

Like Christianity and Judaism, Islam is considered a "religion of the book" because at its heart lies the Qur'an, Islam's holy text. It contains the revelations of the Prophet Mohammad as received from God through the Angel Gabriel in seventh century Saudi Arabia. The Qur'an is made up of 114 chapters, called *suras,* and 6,000 *ayat,* or verses. The holy book explains the Five Pillars of Islam, which are five duties required by all Muslims, and serve as the foundation of the Islamic faith. Written in Arabic, the Qur'an could not be translated until recently, and Qur'ans throughout art history are known for their high-quality Arabic calligraphy and mesmerizing visual design.

What is **Arabic calligraphy**?

Beautiful calligraphy is very important in Islamic art and is a primary form of fine art and decoration. Calligraphy, or decorative handwriting, is used to decorate not only books and manuscripts, but also carpets, tapestries, and even architectural surfaces. The dome of the Great Mosque at Cordoba, for example, is covered in mosaics which feature the curvilinear Arabic script. In Islam, writing is one of the most elegant and honored forms of art, and is linked to God's revelation to the Prophet Mohammad.

What are the Five Pillars of Islam?

The Five Pillars of Islam are five essential acts that a Muslim believer must carry out during his or her lifetime, and serve as the foundation of the faith. They include:

1. *Shahada,* a declaration of belief in one God spoken by Muslim believers
2. *Salat,* five daily prayers
3. *Zakat,* almsgiving
4. *Sawm,* fasting during Ramadan, the holy month
5. *Hajj,* pilgrimage to Mecca at least once during a lifetime

What is the **Great Mosque at Córdoba**?

During the eighth century, the Umayyad Caliphate reached as far east as India and as far west as Spain and Portugal, a region known in Arabic as *al-Andalus.* The city of Córdoba was the capital of al-Andalus, and was home to one of the most impressive examples of mosque architecture in the Islamic world. The Great Mosque of Córdoba was one of the largest mosques ever built. It has no central altar or shrine, but features a prayer hall that reaches over 250,000 square feet. Besides its large size, the Great Mosque's prayer hall is notable for its use of hypostyle, creating the effect of a forest of columns that supports double rows of horseshoe-shaped arches made up of red and white bricks, called voussoirs. As a result, the Great Mosque's hypostyle hall feels immensely large. Artists and architects continued to work on the Great Mosque for over two hundred years after its initial construction, adding geometric marble carvings, grand mosaics, public fountains, and gardens. After Spain was conquered by Christians in the fifteenth century, the Great Mosque was converted into a cathedral.

What is a **mosque lamp**?

Mosque lamps are oil lamps, most closely associated with the medieval period, and characterized by a bulbous middle and flared top. Often enameled or made of glass, they are extremely fragile but well cared for because the light of a mosque lamp was associated with the light of God. Many mosque lamps were commissioned by Mamluk sultans in Egypt during the thirteenth century and were inscribed with verses from the Qur'an.

What is the **Ardabil Carpet**?

The Ardabil Carpet is, believe it or not, actually two carpets, one in the collections of the Victoria and Albert Museum in London, the other at the Los Angeles County Museum of Art. Named for the city of Ardabil in northwestern Iran, the pair of carpets were made in the sixteenth century and used to decorate the funerary mosque of Shayk Safi al-Din, a Sufi leader. The carpet design includes a sunburst medallion at its center, surrounded by sixteen leaf-like pendants. Mosque lamp motifs can be seen

above and below the sunburst. The lamp images on one of the carpets are slightly smaller is size than the other, a trick of the eye that makes the lamps look the same size when viewed from entrance of the room. The creation of these textile masterpieces was a huge undertaking—made of silk and wool, the V & A carpet is approximately 35 x 18 feet and consists of around twenty-five million knots.

EARLY MEDIEVAL ART FROM NORTHERN EUROPE

What is **"medieval"**?

The "medieval period," also referred to as the "Middle Ages," is the name given to the period of European history from the fall of the Western Roman Empire to the beginning of the Italian Renaissance in the fourteenth century. These terms are generally derogatory, and are linked to the humanist idea that the one thousand years between the Classical age and the Renaissance were somehow "dark" or barbaric. In actuality, however, European art from this period was rich and innovative, drawing inspiration from the diverse cultures thriving in Europe at the time.

What **forms of medieval European art** are there?

European art from the Middle Ages takes many forms, from metalwork to illustrated books, to architecture and sculpture. Medieval artisans designed richly decorated jewelry, book covers, and church decorations. Books, some of the most important objects of the medieval world, were meticulously written and illustrated using precious inks and animals skins. While much of the earliest medieval architecture was made of wood and no longer exists, later Romanesque and Gothic buildings are some of the most beautiful and renowned examples of architecture in all of art history.

What is the **difference** between **Hiberno-Saxon art** and **Anglo-Saxon art**?

The term "Hiberno-Saxon art" refers to non-Christian (pagan) art produced after the fall of the Roman Empire by the Irish (known as Hibernians) and the Anglo-Saxon peoples of southern England. While "Anglo-Saxon art" also refers to early medieval art of the British Isles, it is more closely associated with Christian themes and subject matter. Both of these terms are used by art historians when referring to art produced from around 600 to 1066, the date of the Norman Conquest of Britain.

What is the **Sutton Hoo ship**?

The Sutton Hoo ship is an Anglo-Saxon burial ship, discovered off the coast of England in 1939. The ship likely belonged to King Raedwald who died in 625, and was purposefully sunk as a funerary memorial to an important person. No body was ever found aboard the Sutton Hoo ship, however, so it is possible the ship served as a monument to someone who was buried in another location. The ship was over ninety

feet long and filled with early medieval treasure, such as gold coins, armor, and jewel-encrusted accessories. The objects found with the Sutton Hoo ship represent some of the most valuable examples of medieval Anglo-Saxon art.

What is the **"animal style"**?

"Animal style" is a term art historians use to describe the "zoomorphic" or animal-based design motifs popular among Anglo-Saxon artisans during the medieval period. In the animal style, abstract animal motifs merge with geometric and organic motifs, creating a lively and intricate pattern, especially in metalwork.

One of the most famous examples of the animal style is a purse cover from the Sutton Hoo burial ship. The purse cover is about eight inches long and would have been used to cover a leather pouch for carrying coins. The purse was designed with interweaving bands of gold surrounding deep blue and red plaques of enamel and garnet. A pair of highly stylized human figures with splayed legs are each flanked by a pair of wolves. Serpentine lines undulate around the curving form of the purse cover, broken into rhythmic rectangles. A study of Anglo-Saxon decorative arts, such as the Sutton Hoo purse cover, show the influence of many medieval cultures, such as Germanic tribes, Vikings, and Christians.

What is **"Viking" art**?

The term "Viking" art or "Norse" art refers to the art produced by the peoples of Scandinavia, which includes modern-day Sweden, Norway, and Denmark. Much like Anglo-Saxon and Hiberno-Saxon art, Viking art featured the animal style. Early medieval Scandinavians also practiced memorial ship-burials in which important people were buried at sea with their valuable earthly goods. The burial ship from Oseberg, Norway (c. 834) was over seventy-five feet long, and contained the interred bodies of two women, as well the skeletons of around ten horses. The front and back of the ship (the prow and stern) were formed into large spirals and the ship itself is covered in intricate animal carvings, including dragons, which were popular motifs in Viking art.

What is an **illuminated manuscript**?

An illuminated manuscript is an illustrated book, and was one of the most important forms of art in medieval Europe (and elsewhere, including the Islamic Empire). During the early Middle Ages, European illuminated manuscripts were an important part of Christian missionary activities, and Christian monasteries were at the heart of manuscript production. Specially trained monks, called scribes, wrote text on two different types of animal skin, vellum and parchment, as paper was not common until the fifteenth century. Medieval illuminators supplemented the text with colorful decoration, often designing large initials and full-color illustrations that took up an entire page. Illuminated manuscripts were very labor-intensive and expensive. The ink alone was worth as much as a semi-precious stone, and sometimes gold leaf was used in the decoration. Manuscripts were sometimes protected with expensive, jewel-encrusted covers, such as the cover of the *Lindau Gospels*.

What is the *Book of Durrow*?

The *Book of Durrow* is a seventh-century Christian Gospel book, most likely made at a monastery on the island of Iona in Scotland. The beautifully decorated *Book of Durrow* includes the text of the four Gospels of the New Testament: Matthew, Mark, Luke, and John. Each section begins with a carpet page, or a full page illustration, representing each saint's symbol. For example, the carpet page of the Gospel of Saint Matthew is decorated with the symbol of the man. In this illumination, the figure is covered in a colorful, yet flat, checkered cloak that completely obscures any sense of a three-dimensional body underneath. Rather sullen, the figure has no visible arms, and seems to float in the center of page, surrounded by an interlaced, ribbon-like design which forms a frame around the page. Not particularly life-like, the representation of the St. Matthew's symbol in the *Book of Durrow* is characteristic of much medieval art from this time period: simple, flat, and colorful.

Why is **medieval European painting** so **"bad"**?

There is no question —medieval painting is not particularly realistic. Much of it is simplistic, flat, and lacks natural proportion. What happened? Did the medieval artists forget how to draw? Is this a result of the so-called "Dark Ages"?

Looking at medieval art from a contemporary perspective occasionally raises questions about quality—but it is important to remember that medieval artists, including painters, were highly skilled craftsmen who worked meticulously on their designs. Medieval artists made specific choices about their work and were motivated not by realism, but by religion. In the sixth century, a debate arose amongst Christian church leaders as to whether or not figurative imagery was appropriate for religious art. Then, Pope Gregory the Great declared, "Painting can do for the illiterate what writing does for those who can read" (as quoted in Gombrich 135). The goal of medieval art, according to Pope Gregory, was to simply and clearly depict religious themes. The quality of the artwork was not supposed to overshadow its religious content for fear of idol worship.

What is the *Book of Kells*?

The *Book of Kells* is one of the most famous illuminated manuscripts, and is an example of medieval art that blends pagan design with Christian themes. The "Chi Rho Iota (XPI) Page" of the Hiberno-Saxon *Book of Kells* is astonishingly complex, filled with

The illuminations in the spectacular gospel book the *Books of Kells* exemplify the way Christian art traditions blended with the pagan traditions of the British Isles in the early medieval period.

twisting lines and curling spirals similar to the intricate metalwork found with the Sutton Hoo ship, yet this page proclaims, "now this is how the birth of Christ came about" as it introduces the Gospel of Matthew. In Greek, the letters "chi," "rho" and "iota" (XPI) are the initials of Christ. Looking closely at the swooping forms of the Greek letters, one can find human forms incorporated into the abstract design. The letter "P" curls into a spiral and is punctuated with a sideways, red-haired head, which also dots the "I" of the nearby "iota." This head is thought to represent Christ. Playful animals are also hidden within the design, including cats, mice, otters, and fish, all of which were likely symbolic, although the meaning has been lost over time. The beauty and richness of the *Book of Kells* demonstrates both the artistic skill and religious passion of the ninth-century monks who produced it at the monastery on Iona, Scotland.

CAROLINGIAN AND OTTONIAN ART

Why was **Charlemagne interested** in **illustrated manuscripts**?

The medieval ruler Charlemagne was crowned Holy Roman Emperor in the year 800 and controlled a territory that included Germany, France, the Netherlands, and parts of Italy. As Holy Roman Emperor, Charlemagne's goal was to unify his secular government with the Christian church and to restore the Western Roman Empire, albeit as a Christian kingdom. Charlemagne clearly saw the power of arts and education as a fundamental part of his campaign, and he turned to monasteries—the intellectual centers of the medieval world—to support his mission of conquering all of Europe. Charlemagne's court in Aachen, Germany, became a leading center for artists, including architects, sculptors, and illuminators. Charlemagne's scriptoria in Aachen produced some of the most important illuminated manuscripts of the of late eighth and ninth centuries in Europe, which resulted in the spread of Christianity, the standardization of church practices, and the solidification of the Emperor's power across Europe.

What is the **Caroline script**?

In the early medieval period, scribes were responsible for hand-copying illuminated manuscripts, and although these scribes were specially trained, penmanship was

overall quite poor, and scribes did not follow a specific set of rules when writing. During the Carolingian period (Carolingian is an adjective used to indicate the rule of Charlemagne and his descendents), a new system of writing was developed, which resulted in much greater consistency from scriptorium to scriptorium. The use of *majuscules,* or capital letters, was based on the ancient Roman alphabet. Majuscules were used in titles and headings, and on only the most formal manuscripts. Lower-case letters, or *minuscules,* were quicker and easier overall, and were used for less formal writing. Ready to take a crack at reading a tenth-century manuscript? After perfecting your reading knowledge of Latin (the primary language used in medieval manuscripts), note that the Caroline script did not include spaces between words, or punctuation marks!

What is the *Godescalc Gospel Lectionary*?

The *Godescalc Gospel Lectionary* was one of the first Carolingian illuminated manuscripts to use the new Caroline script, and was named for a scribe who signed his name in the book. Produced at the court scriptorium at Aachen, it was meant to be read aloud, and commemorated the 781 baptism of Charlemagne's son. The *Godescalc Gospel Lectionary* is notable for its artistic naturalism and incorporation of ancient Roman styles. The luxurious manuscript, with gold and silver lettering, and extensive use of the color purple (one of the most expensive pigments), served as an artistic inspiration and a model for later Gospel books.

What is **medieval expressionism**?

Medieval expressionism was a style that emphasized the communication of feeling and emotion. "The Page with St. Matthew" from the *Gospel Book of Ebbo,* illustrates a scene in which St. Matthew sits at his desk frantically writing, his face twisted with intense emotion. St. Matthew's robe, hair, and the sharply bending grasses in the background are made up of repeated linear flourishes. It seems as though Matthew, hunched over and sporting triangular eyebrows, fears divine inspiration will be lost if he does not immediately write down his evangelical text. This manuscript painting, done in gold and colored ink on vellum in the ninth century, is an example of medieval expressionism. The whole scene seems to be blowing in the wind, and the dramatic quality of the work expresses an emotional, rather than purely intellectual element of the Gospels.

The ninth century *Book of Ebbo* communicates the divine inspiration of St. Matthew through frenetic line work and is an example of medieval expressionism.

Why is the **cover** of the *Lindau Gospels* so **luxurious**?

This astonishing book cover, decorated with pearls, sapphires, emeralds, garnet, and gold, was not originally intended for the ninth-century *Lindau Gospels*, though it has been associated with this manuscript since before the sixteenth century. The book cover was made at a monastic workshop during the reign of Charles the Bald, Charlemagne's grandson, who ruled from 840 to 877, and represents Christ on the cross. Christ is surrounded by mourning figures, but stands erect with His palms forward, and stares powerfully ahead. The work was made in a style known as *répoussé*, which means the figures were hammered into low relief from the back of the metal cover. The fine gold reflects glittering light, and the jewels evoke Heavenly Jerusalem. The obvious luxury of the cover indicates the inherent value of books during the medieval period, and the richness of the materials emphasize the triumph of Christ, foreshadowing the Resurrection.

What is a **psalter**?

A psalter is a book containing the text of the Book of Psalms from the Old Testament. The most famous Carolingian psalter is the *Utrecht Psalter,* known for its lively ink drawings. The manuscript was produced at the imperial scriptorium in Reims (in modern-day France) in the first half of the ninth century. The illustrations of the *Utrecht Psalter* incorporate architectural and landscape scenes, and the text features Roman-style *majuscules*. As psalms are not narrative, they are challenging to illustrate. The artists who created the *Utrecht Psalter* illustrated them by expressively visualizing specific phrases from the text.

What is **Ottonian art**?

Ottonian art is a term that refers to the art and architecture produced under a new, powerful dynasty that established itself in the eastern portion of the Holy Roman Empire after the power of the Carolingian dynasty had faded. Three main rulers, Otto I, Otto, II, and Otto III ruled from 919 to 1002 and were based in modern-day Germany. During the Ottonian period, the arts flourished and new innovations in architecture, metalwork, and ivory carving were key elements in the so-called "Ottonian Renaissance."

What are the main **characteristics** of **Ottonian architecture**?

The Ottonian rulers emphasized their imperial strength and military prowess through the construction of monumental architecture reminiscent of ancient Rome. Churches of the period followed the basilica plan and featured wooden roofs (many of which burned down). The Church of Saint Cyriakus in Gernrode, Germany, (begun in 961) is one of the best surviving examples of Ottonian architecture. The church architects placed a newfound focus on verticality, which foreshadowed the leaping heights of much later medieval buildings. The Church of Saint Cyriakus features a second floor gallery, clerestory windows, and a westwork—a wall along the west end of the nave, one of the key features of Ottonian church architecture.

What was impressive about the **doors of Bishop Bernward**?

The splendidly designed bronze doors of Bishop Bernward were built for the abbey church of St. Michael's in Hildesheim, Germany. The doors themselves are enormous—over sixteen feet tall—and are the first example of monumental bronze sculpture made by the lost-wax process since antiquity. Each door was made as one piece—a remarkable technical feat considering the complex relief sculpture covering each door. Notable for their masterful metalwork, the doors are also impressive due to their complex narrative imagery, which outlines both Old and New Testament events. Each door is divided into eight panels, each representing a specific biblical scene, a design likely inspired from manuscript illumination.

What is the **Gero Crucifix**?

The Gero Crucifix is a life-size sculpture depicting the body of Christ on the cross. Made of gilded and painted wood and meant to be suspended above an altar, the back of Christ's head was hollowed in order to hold communion bread used in the ritual of the Eucharist. As opposed to the triumphant pose of Christ as seen on the book cover of the Lindau Gospels, this representation of Christ emphasizes suffering. Christ's head hangs heavily and His body appears limp and frail. This is the first time in history that an image of dead Christ was depicted on the cross.

INDIA AND SOUTHEAST ASIA

What does a **Hindu temple** look like?

Hindu temples are one of the primary examples of Hindu architecture in India and Southeast Asia. They are usually built of cut rock, and although there is a great deal of stylistic diversity, are generally placed within two categories: northern and southern style.

Hindu temples are raised on a podium (somewhat like an Etruscan temple), called a plinth. Temples in the northern style feature a large tower in the shape of a beehive, called *shikhara* (which means "mountain peak"). Atop the tower is a rounded form known as an *amalaka* because of the similarly shaped amala fruit. These *amalakas* are used to decorate lower portions of the *shikhara* as well. The halls of a northern-style temple have a series of halls called *mandapas,* which lead to the *garbhagriha,* an inner sanctuary used to house a sacred image. The halls are themselves decorated with smaller, tower-like roofs. An example of a northern-style Hindu temple is the Kandarya Mahadeva temple in Khajuraho, India, which was built around 1000 C.E.

Southern-style Hindu temples feature a pyramid-like tiered tower called a *vimana,* and this is topped with a round capstone. The halls of a southern-style temple also lead to an inner chamber, but have flat roofs and pillared *mandapas.* An example of a southern-style Hindu temple is the Rajarajeshvara Temple in Thanjavur, India, which was built around 1010 C.E.

Angkor Wat, a UNESCO Heritage site, is a large Hindu temple complex located in Cambodia in Southeast Asia and was built between the ninth and fourteenth centuries.

What is **Angkor Wat**?

Angkor Wat is an enormous Hindu temple complex in Cambodia featuring a series of walled courtyards leading to a group of central towers. Built over thirty years by the Khmer king Suryavarman II during the first half of the twelfth century, Angkor Wat's five lotus-shaped towers each symbolize peaks of Mount Meru, a mountain considered sacred in Hindu, Jain, and Buddhist traditions. The central tower is approximately two hundred feet tall and the entire complex is aligned with the sun, so that on the summer solstice, the sun rises up directly over the central tower when viewed from the western gate. Suryavarman II's goal was to associate himself with the god Vishnu and the entire temple complex is covered in miles of relief carvings depicting the king and the many avatars of Vishnu.

What does **Jain art** look like?

Jainism is an important religion in India, in addition to Hinudism, though only a small percentage of Indians are Jainists. Jainists believe in the cycle of death and rebirth, called *samsura,* and attempt to live pure, ascetic lives by looking inwards, avoiding material possessions, and acting kindly to others. At first glance, it may be difficult to distinguish Jain art from Buddhist and Hindu art, but one of the key types of Jain art is monumental nudes of meditating warriors, known as *jinas*. *The Ascetic Gommata* in Karnataka, India, is an example of this. At around sixty feet tall, this tenth-century, colossal sculpture represents Gommata, who was famous for meditating for years without stopping. The figure of Gommata stands at attention with poised shoulders, confident chin, and stoic face. The sculpture's nudity, along with images of tree branches and creepers that curl around his limbs, are meant to emphasize the

jina's focus on spiritual, rather than material needs. Sculpture such as the *The Ascetic Gommata* is used to aid Jainists in their own meditations.

What is the **Gupta style**?

Associated with art produced during the reign of Gupta rulers, who ruled in eastern India from c. 320 to 450 C.E., the Gupta style is characterized by naturalistic, though idealized, images of the Buddha and *bodhisattvas* in both painting and sculpture. A great example of the Gupta style is the wall painting of the bodhisattva known as the "Beautiful Padmapani." Painted in the late fifth century, Padmapani is shown as serene and relaxed, withdrawn from the material world swirling around him. Strong outlines emphasize the form of the figure, but the rest of the body is smooth and anatomically undefined. With downcast eyes, the painting exhibits the Gupta emphasis on naturalism, balance, and spiritual detachment.

What happened to the *Colossal Buddha* at Bamiyan?

While the *Colossal Buddha* at Bamiyan once rose nearly two hundred feet in a specially carved niche in the side of a mountain in the Hindu Kush region of Afghanistan, it, along with another massive (though slightly smaller) sculpture, were destroyed by the Taliban in 2001. Originally constructed between the second and fifth centuries, the style of the monumental work was influenced by the many cultures of the region, including China and India, and was once brightly painted with layers of paint and lime plaster, which resulted in a semi-transparent look influenced by the Gupta style. The *Colossal Buddha* was not the only Buddhist sculpture destroyed by the Taliban; almost all Buddhist art in the nearby region was targeted, a controversial example of iconoclastic action.

What is the significance of the **recumbent Buddha**?

The Buddha is occasionally depicted reclining on his side with an arm tucked under his ear, while the other arm stretches the length of his body. This body positions indicates the Paranirvana, or death of the Buddha, in the Southeast Asian tradition (also popular in China and Japan). In Sri Lanka, a forty-six-foot-long sculpture of the recumbent Buddha was carved from a single, massive rock at a temple site known as Gal Vihara. Made sometime between the eleventh and twelfth centuries, this monumental representation of the Buddha's Parinirvana shows the holy man surrounded by a smaller-scale mourner, likely his cousin,

The enormous sixth-century Buddha at Bamiyan (in present-day Afghanistan) was destroyed by the Taliban in 2001.

Why is Borobudur considered one of the greatest Buddhist temples in the world?

The mountain-like Borobudur is an enormous Buddhist temple built in the ninth century in Java, Indonesia, and not discovered by outsiders until the nineteenth century. Based on the *stupa* form, the temple is covered in ornate sculptures and staircases oriented to the points of the compass. The mountain form is no accident—it is in fact a key element of the temple's complex symbolism.

Ananda. A small pillow, carved from stone, supports the Buddha's head; his face is round, and his thin robes appear to cling to his body in the traditional iconographic manner.

What is a *thangka*?

The *thangka* is a painted banner, and an important form of Tibetan art. *Thankgas* often depict important people such as spiritual and political leaders in a way similar to Byzantine icons, which suggests that those individuals depicted in *thankgas* have reached a semi-divine status. The *Thankga of Green Tara* is nearly two feet long and depicts the protective Tibetan deity, Green Tara, who personifies transcendent wisdom and is often thought of as the universal mother figure to buddhas. Made with ink and color on canvas, this thirteenth-century *thangka* shows the deity surrounded by architectural forms and seventeen species of the bodhi tree. This particular *thangka* is part of the Indian and Southeast Asian art collection at the Cleveland Art Museum.

What is the **Ananda temple**?

The Ananda temple is the most famous and spiritually significant Buddhist shrine in Burma and was built in the early twelfth century by the leader Kyanzitta during the Pagan Period, which lasted from the eleventh to fourteenth centuries. The temple is notable for its cruciform shape and tall central spire, which is 165 feet high. The temple is decorated with additional small spires, spikes, and four large sculptures of the Buddha, each reaching a height of approximately thirty-five feet. The lavish ornamental architecture of the Ananda temple reflects the flourishing of Buddhism in Burma at the time of its construction.

CHINESE ART FROM THE SUI TO THE YUAN DYNASTIES, c. 589–1368

What are major **characteristics** of **Chinese painting** from the **Sui to the Yuan Dynasties**?

The range of Chinese art covered in this chapter is immense, and while it is difficult to summarize such a varied history into one answer, there are indeed important at-

tributes common to many examples of Chinese painting from this time period. Unlike medieval painters in Europe, Chinese painters did not paint on wood panels. Instead, they painted on silk or paper, usually with water-based inks and colorful pigments. The practice of painting was considered an intellectual exercise with close ties to Confucian and Buddhist philosophies. Early Chinese paintings often exhibit a balance of seemingly spontaneous movement with thoughtful calm. Artists favored landscapes and nature scenes, as well as realistic figurative paintings.

What were the **major Chinese dynasties** from the **medieval period** and what **kind of art** did they produce?

Dynasty	Dates	Types of Art Produced	Examples
Sui Dynasty	589–618	Short-lived dynasty; Buddhist art; bronze sculpture	Altar to Amitabha Buddha, c. 593. Bronze, 30.2 in. high. Museum of Fine Arts, Boston
Tang Dynasty	618–907	Colossal reliefs; timber architecture; wall paintings; painted hand-scrolls; ceramics	*Paradise of Amitabha,* Dunhuang, China, eighth century. Wall painting, 10 ft. high.
Five Dynasties	907–960	Interim period characterized by unrest	
Northern Song Dynasty	960–1127	Landscape painting; neo-Confusion themes	Fan Kuan, *Traveler's Among Mountains and Streams,* early eleventh century. Hanging Scrolls, 6 ft. 9.5 in. high. National Palace Museum, Taipei, Taiwan
Southern Song Dynasty	1127–1279	Intimate nature paintings; Guan ware ceramics	Xia Gui, *Twelve Views from a Thatched Hut,* early thirteenth century. Handscroll, ink on silk, 11 ft. long. The Nelson-Atkins Museum of Art, Kansas City
Yuan Dynasty	1279–1368	Mongolian rulers interested in carpets, metalwork, ceramics; ink painting on paper	Guan Daosheng, *Ten Thousand Bamboo Poles in Cloudy Mist,* c. 1308. Handscroll, ink on paper, 6 ft high. National Palace Museum, Taipei, Taiwan

Who is **Amitabha Buddha**?

Amitabha Buddha was a mortal king who reached an enlightened state and became a buddha in the tradition of Pure Land Buddhism, the most popular form of Bud-

dhism in China. Known as the Buddha of Infinite Life and Infinite Light as well as Buddha of the West, Amitabha Buddha promises rebirth in paradise, or Western Pure Land, for those with faith.

What is the *Paradise of Amitabha* painting?

The *Paradise of Amitabha* is an eighth-century wall painting within the Dunhuang caves, an important Buddhist site along the Silk Road in northwestern China. In the ninth century, the Tang Emperor Wuzong had ordered Buddhist temples and shrines to be destroyed, but Buddhist art in the Dunhuang caves survived such a fate. In the painting, the large figure seated in the center is Amitabha on a raised platform. Lesser deities and bodhisattvas dance around Amitabha in a lavish scene that evokes the splendor of paradise.

The Amitabha Buddha is a central figure in Pure Land Buddhism, and serves as a type of savior or role model. The *Paradise of Amitabha* wall paintings (a section is illustrated here), located in the Dunhuang Caves in Gansu Provice, China, show the Amitabha Buddha as a large, central figure.

What is **Chan Buddhism**?

Chan Buddhism (known in Japan as Zen Buddhism) is a school of Mahayana Buddhism that developed in China in the sixth century and gained importance during the Song dynasties. Chan Buddhist philosophy emphasizes the direct experience of the individual and enlightenment through meditation. While some Chan Buddhists believe enlightenment through meditation takes a lifetime to achieve, others believe enlightenment can be achieved suddenly, in a flash of understanding. Chan Buddhism had a large impact on Chinese painting. The thirteenth-century painter Liang Kai's simple, yet expressive, hanging scroll, *Sixth Chan Patriarch Chopping Bamboo*, depicts a crouching patriarch who suddenly achieves enlightenment after hearing the sound of his blade striking bamboo wood.

What are **Xie He's Six Canons**?

Xie He was a painter and scholar from the late fifth century who is known for establishing six laws or "canons" of painting. These six canons go a long way in explaining the underlying philosophy of Chinese painting. There is ongoing debate as to the exact translation of each of the canons, but according to James Cahill, author of "The Six Laws and How to Read Them," they are as follows:

1. Engender a sense of movement through spirit consonance.
2. Use the brush with the bone method.

3. Responding to things, depict their forms.

4. According to kind, describe appearances [with color].

5. Dividing and planning, positioning and arranging.

6. Transmitting and conveying earlier models through copying and transcribing. (see Kleiner 57).

While difficult to understand, Xie He's principles of painting tell art historians a great deal about what was important to early Chinese painters. The first principle suggests a strong connection between art-making and spirituality. The goal was to capture the spontaneity and intangible spirit-quality of the subject being depicted. The latter principles are slightly more straightforward, and refer to technical skills. Xie He explains how to hold the paint brush, encourages naturalism, and emphasizes skill-development through copying and practice.

What is the difference between a **handscroll,** a **hanging scroll,** and an **album leaf**?

A handscroll is a roll of paper or silk that is unfurled to reveal text and painted images. Handscrolls are kept rolled up when not being viewed. Cinematic in nature, the images are presented piece by piece as the viewer works his or her way through the handscroll. Though usually around a foot long, handscrolls can vary in length. Xia Gui's thirteenth-century handscroll titled, *Pure and Remote View of Streams and Mountains,* is nearly thirty feet long!

Unlike a handscroll, a hanging scroll can be seen all in one viewing and is displayed on a wall, though not permanently. Even though hanging scrolls can be rather large, they were not intended for large public spaces, but for smaller, private viewings.

An album is essentially a book of paintings, usually of similar subject matter. An individual painting is called a leaf.

What is a **pagoda**?

Derived from the Indian stupa, a pagoda is a tall tower notable for its repeated rooflines featuring upturned eaves. Pagodas are one of the most recognizable examples of East Asian architecture, often found at the center of Buddhist temple complexes. Early pagodas were solid structures and therefore could not be entered, and were made of stone, brick, and wood. The Foguang Si Pagoda in Yingxian, China, built in 1056 and designed to house relics, is still the tallest wooden building in the world, at nine stories.

What is **Guan ware**?

Guan ware is a type of imperial ceramic associated with the Song Dynasty. Guan ware vases were made of smooth stoneware and covered in a crackled white (and sometimes soft blue and green) glaze, with round, bulbous bottoms, graceful stretched

necks, and narrow lips. These sophisticated ceramics juxtapose meticulous crafts-manship with the unpredictability of the glazing process, in which the glaze cracks once the vessel is removed from the kiln and begins to cool.

Who were the **literati**?

The literati, or *wenren* in Chinese, were highly educated, scholar-painters often held in higher regard than the imperial court painters of the time because of their free-thinking intellectuality and because they did not rely on their art to make a living. Emerging during the Song Dynasty, the literati are known for their relatively austere black ink paintings, created using a painting technique called *shi mo*. They were also highly skilled calligraphers and poets.

What are **characteristics** of **Yuan painting**?

The Yuan Dynasty began with the rule of Khubilai Khan, the grandson of Genghis Khan, who ruled until 1294. Mongolian power remained in China until 1368 and the effect of Mongolian culture on Chinese art continues to be debated. Yuan painters preferred to work on paper rather than silk, and their style is characterized by solid, hard-edged forms.

Who was **Guan Daosheng**?

Guan Doasheng was a renowned female calligrapher, painter, and poet working dur-ing the Yuan Dynasty. She was famous for her paintings of bamboo plants. Bamboo was an important symbol in Chinese art because the plant's branches and leaves are reminiscent of calligraphy, and because bamboo is flexible under pressure—it will bend, but not break. Guan Daosheng's handscroll, *Ten Thousand Bamboo Poles in Cloudy Mist,* is the earliest surviving example of work done by a woman in China. In this painting, delicate bamboo leaves are lush and meticulously depicted, while the firm shoots are thought to represent faithfulness and fidelity.

KOREAN ART UNTIL c. 1400

What are the major **periods** of **pre-modern Korean art**?

Under the influence of the Chinese Emperor, the establishment of the Silla King-dom resulted in a unified Korea in the year 668 (around the time of the Tang Dynasty in China) and lasted until approximately the year 935. Silla rulers supported Bud-dhism, establishing it as Korea's official religion, and embraced Buddhist architec-ture, though no structures from the Silla Kingdom survive.

Overlapping slightly with the Unified Silla Kingdom was the succeeding Koryo Kingdom (sometimes spelled Goryeo), which began in the year 918 and lasted until 1392. Artists from the Koryo period were known for their refined ceramics.

What is **celadon ware**?

Celadon ware is a type of Korean ceramic from the Koryo period made with translucent, pigmented glazes. Usually gray, pale blue-green, and olive in tone, celadon ware from the eleventh century was known for its simplicity, while examples from the twelfth century were more complex, often inlaid or stamped with decorative elements, such as black and white pictorial scenes.

JAPANESE ART UNTIL c. 1400

What are the major **periods** of **Japanese art** covered in this chapter?

Period	Dates	Types of Art Produced	Examples
Asuka and Nara Periods	552–794	Tang-inspired architecture; Buddhist sculpture; painting	Tori Busshi, Shaka Triad, kondo, Horyu-ji, c. 623. Gilt bronze, 34.5 in. high.
Heian Period	794–1185	Painted scrolls; wood sculpture; Buddhist architecture	*Tale of Genji*, twelfth century. Handscroll, ink and colors on paper.
Kamakura Period	1185–1392	Painting; hanging scrolls; wooden portraits; architecture; samurai culture	Kosho, *Kuya Preaching*, c. twelfth century. Painted wood with inlaid eyes, 46.5 in. high. Rokuhara Mitsu-ji, Kyoto

How did **Buddhism influence Japanese art**?

Pure Land Buddhism (*Jodo* in Japanese) was the primary form of Buddhism in Japan, as well as China, coming to particular prominence during the Heian Period. *Jodo* remains the most popular type of Buddhism in Japan. The Amitabha Buddha, known in Japan as Amida Buddha, was an important subject in sculpture and painting, as was the concept of paradise.

Esoteric Buddhism was also important in Japan, where it was called *Mikkyo*. Highly influenced by Hinduism, Esoteric Buddhism is hierarchical and features many complex deities. An important visual element of Esoteric Buddhism are *mandaras* (*mandalas* in Sanskrit), cosmic diagrams of the universe used in ritual, meditation, and teaching. The *Womb World Mandara* from the Heian period, is one of the oldest and most well-preserved Japanese examples. The work is filled with images of gods and buddhas, and a central image of Dainichi, the universal Buddha. Some of the

gods have multiple heads and limbs, and many hold lightning bolts, which symbolize the power of the mind.

What is a *raigo* image?

A *raigo* was a type of image that warmly depicted the Amida Buddha welcoming dying souls to paradise. The *Descent of the Amida Trinity* is a *raigo* triptych from the Kamakura period in which the illuminated forms of the Amida Buddha and two bodhisattvas appear to hover against a dark background. The radiant figures were done with gold paint and gold leaf, creating a contrast with the otherwise subdued silk surface of the triptych. The image emphasizes comfort and peace in the face of death.

The "Womb World Mandala," which is from Japan's Heian period, is a cosmic diagram of the universe according to the Pure Land Buddhist tradition. (*Art courtesy the Art Archive / Sylvan Barnet and William Burto Collection.*)

Who was **Jocho**?

Jocho was one of Japan's most innovative sculptors, known for developing a process called joined-wood construction. The joined-wood method involved designing a sculpture in sections, each carved from a separate block of wood. These blocks were hollowed and then assembled. This process allowed for larger, lighter sculptures that were less likely to warp and crack. During the Heian period, Jocho created a joined-wood raigo sculpture of the Amida Buddha that evokes the rich complexity of Western Paradise and is housed at the heart of Byodo-in.

What is **Byodo-in**?

Byodo-in is a Buddhist temple originally built during the Heian period in a mountainous region near Kyoto. Considered one of the most beautiful Pure Land Buddhist temples, Byodo-in is also known as Phoenix Hall because of two bronze phoenixes on the roof, and because the building's upswept rooflines are considered bird-like. It sits in front of a reflecting pond designed in the shape of the Sanskrit letter "A," which is the sacred symbol of the Amida Buddha.

Who was **Lady Murasaki**?

Lady Murasaki was a Heian-era lady-in-waiting in the court of empress-consort Teishi. She was a celebrated poet and novelist and wrote *The Tale of Genji,* considered to be the world's first novel. While Chinese was the official language of scholarship in Korea and Japan, *The Tale of Genji* was written in Japanese. At fifty-four chapters, the work included over four hundred characters, and told the story of the love affairs of Prince Genji and life at court.

This illustration from the medieval Japanese novel *The Tale of Genji* shows Prince Genji playing the game of Go. Written by a noblewoman named Lady Murasaki, the work is a literary and visual masterpiece. (*Art courtesy The Art Archive / Private Collection Paris / Gianni Dagli Orti*.)

Twenty chapters of Lady Murasaki's *The Tale of Genji* survive as illustrated scrolls, likely completed by a team of artists, including a calligrapher. The paintings are muted and refined, with an architectural focus. Figures can be seen indoors from above using a technique of representing invisible, "blown-away" roofs. Both the novel and the images make a connection between human emotion and nature, and reflect Buddhist ideas of fleeting earthly pleasures.

What is the difference between a **shogun,** a **daimyo,** and a **samurai**?

From the twelfth century until the nineteenth century, Japan was a feudal society controlled by a powerful ruler, called a shogun. The shogun maintained power over his large territory. The *daimyo* (a Japanese word meaning "great names") were feudal landowners equivalent to medieval European lords. The *daimyo* commanded the *samurai,* a distinct class of swordsmen trained to be devoted to the *shogun*.

Did **samurai culture** influence **Japanese art**?

As samurai culture grew stronger during the Kamakura Period (1185–1392), it did indeed have an influence on the arts, including sculpture and painting. One of the most powerful handscroll paintings from the thirteenth century is *Night Attack on the Sanjo Palace,* which depicts swirling flames in deep orange hues as armored warriors on horseback attack one another in a battle between the Minamoto and Taira clans. The surprise attack was a significant historical event in Japan's military history, and though the handscroll was painted nearly one hundred years after the battle took place, it serves as a historical record of the period.

ART OF MEDIEVAL AFRICA

What is **Great Zimbabwe**?

Great Zimbabwe was an important capital city of the Bantu-speaking Shona people between the twelfth and fifteenth centuries, reaching its peak between 1250 and 1450 with an estimated population of approximately fifteen thousand people and control over a large territory. Covering an area of nearly two thousand acres, the ruined city of Great Zimbabwe is principally comprised of three structures: the Hill Complex, the Valley Ruins, and the Great Enclosure, which are surrounded by a large protective wall, nearly thirty feet tall. The Great Enclosure, which dates from the mid-fourteenth to fifteenth century, was made with a special pattern of dry stone blocks, a technique still used by contemporary builders, and is the largest stone structure in sub-Saharan Africa. Many sculpture and pottery fragments have been found at the Great Zimbabwe site, indicating a rich art culture. A popular material for sculpture was soapstone, and many examples of soapstone bird carvings have been discovered, though the exact significance of these sculptures is still unknown.

What kind of **art** was made in **Ile-Ife**?

Ile-Ife was the capital of the Yoruba people of Nigeria from the thirteenth to the fifteenth century, an era known as the Pavement Period due to the Yoruba practice of paving parts of the city with rectangular rows of stone and pottery fragments laid out in a herringbone pattern. Ile-Ife was an important center for the arts, and the Yoruba established a long tradition of portraiture, including works in stone, wood, and terra cotta, as well as later works in bronze, brass, and other metal alloys made using the lost-wax casting method. Portrait sculpture played an important role in ritualistic ancestor worship, and sculptures were often ornately decorated with veils, wigs, crowns, or neck rings, particularly during important ceremonies.

What do the **Yoruba consider beautiful**?

To make a beautiful work of art in the Yoruba tradition is a complex task with many aesthetic requirements and a long tradition of art criticism. The Yoruba are known for their multifaceted approach to beauty, in which morality of the artist affects the aesthetic value of the work they create. They value both the inner and exterior concept of self, and at the core of this value is the idea of *iwa l'ewa,* which means: character is beauty or, nature is beauty. The work of art itself, for example a figurative sculpture, must also possess specific qualities, including the following:

- Balance between realism and abstraction (for example, a sculpture should not be too real, nor too abstract)
- Clearly defined linear forms
- Smooth, delicate surfaces, and slightly rounded features
- Pleasing proportion and dignified symmetry
- Youthful liveliness balanced with calm maturity

An example of the Yoruba aesthetic can been seen in a thirteen-inch copper sculpture from the thirteenth to fourteenth centuries. This sculpture depicts a stoic, seated male figure, and though it is now damaged (the figure's forearms are missing and there is some damage in the legs), the work displays skillful naturalism, individualized detail, smooth features, and appropriate size and proportion. It is possible that the seated figure was ritualistically adorned with the clothes and ornaments of a Yoruba leader and is associated with Yoruba themes of honor and respect. Yoruba society remains one of the largest in Africa, with a population of about thirty-five million in Nigeria alone, as well as other African countries, the Caribbean, and the United States. The Yoruba aesthetic continues to be an important element in Yoruba art production, and function, to this day.

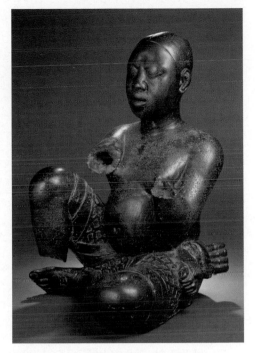

The Yoruba people of Western Africa have a complex tradition of aesthetics.

What is the **Great Mosque at Djenné**?

Also referred to as the Great Friday Mosque at Djenné, the Great Mosque is the largest mud-brick structure in the world. At least three main incarnations of the mosque have existed, including an original mosque from the thirteenth century, and two major reconstructions in the nineteenth and early twentieth centuries. The city of Djenné, located in Mali, was a sophisticated urban and religious center by the thirteenth century due to its location along Saharan trade routes, and the expansion of Islam.

The Great Mosque at Djenné is characterized by its smooth, beige walls constructed of sun-baked mud bricks (the bricks themselves were composed of clay and straw), as well as the many wooden poles that stick out from the walls. Due to the fragile nature of the mud bricks, the walls of the mosque are frequently rebuilt, and the wood supports allow workers to re-plaster the exterior during a special annual festival in which the entire community participates. The grand design of the Great Mosque at Djenné influenced Islamic architecture in other parts of Africa, including the Sudan.

What are the **rock churches** of **Lalibela**?

Lalibela was a medieval city in Ethiopia ruled by the Zagwe dynasty, which held power from 1137 until the end of the thirteenth century. The city was also an important Christian center and a popular pilgrimage route, and church-building projects were possibly conceived of as the construction of a "New Jerusalem" in the Ethiopian mountains.

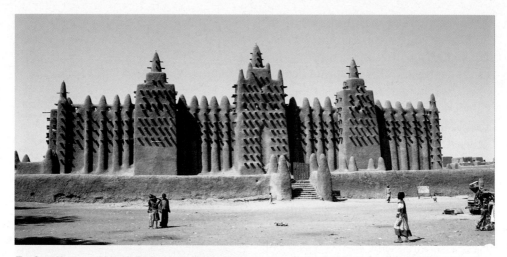

The Great Mosque at Djenné is the largest mud-brick structure in the world. Originally built as early as the thirteenth century, the mosque is regularly rebuilt by the community and is a symbol of the enduring influence of Islam in Africa.

At the behest of King Lalibela, Ethiopian Christians carved eleven churches out of red, volcanic rock, some of which are freestanding, while others are semi-detached and carved into rock walls. The churches are tall, narrow, and rectangular with a combination of arabesque and cruciform windows. These unique structures have been declared a UNESCO World Heritage Site and remain an important site for Ethiopian Christians.

PRE-COLUMBIAN AMERICA

What is **Pre-Columbian art**?

Pre-Columbian art is a broad term given to the art of Mesoamerica (which includes Mexico and Central America) and South America before the arrival of Christopher Columbus in 1492. It includes the art of large cultures such as the Maya, Aztecs, and Inca.

The following dates provide a general outline of major Pre-Columbian cultures:

Culture	Dates	Location
Olmec*	c. 1200–400 B.C.E.	South, Central Mexico
Nazca*	c. 200 b.c.e. – 600 C.E.	Pre-Inca Peru
Moche	c. 200 – 600 C.E.	Pre-Inca Peru
Teotihuacan	c. 1 c.e. – 750 C.E.	Mexico
Mayan	c. 250–1521 C.E.	Mexico and Central America
Aztec	c. 1000–1521 C.E.	Mexico and Guatemala
Inca*	c. 1400–1530 C.E.	Peru, Ecuador, and parts of Chile

*Note: The Olmec and Nazca, are covered in "Art of the Ancient World, c. 5000 B.C.E. to 400 C.E.," while the Inca are covered in "The Early Modern World, c. 400-1300."

What are the **major periods** of **Mesoamerican art**?

Mesoamerican art (art of Mexico and Central America) is divided into three main categories:

- The Pre-Classic Period: c. 1200 B.C.E.– 300 C.E.
- Classic Period: c. 300–950
- Post-Classic Period: c. 950–1521

The Post-Classic Period ended quite suddenly, when the major indigenous empires of the Americas fell to the Spanish Conquistadores led by Hernán Cortés.

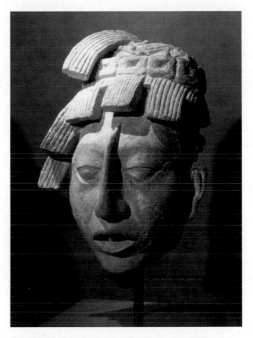

This Mayan sculpture depicts the Late Classic ruler Lord Pakal and was made in the seventh century in Palenque in southern Mexico.

What is the *Portrait of Lord Pakal*?

Lord Pakal was a powerful Mayan ruler from the ancient city of Palenque (in modern day Chiapas in Mexico) between 615 and 683 C.E. Lord Pakal and his descendants commissioned a great deal of monumental art and architecture in this Mayan capital. At his death, Lord Pakal was laid to rest in a sarcophagus; in his tomb archaeologists found a portrait of the ruler as a young man with a crown of jade and flowers. He is thought to be represented according to Mayan ideals of beauty, which emphasize a long, sloping face and skull, and full lips. Traces of red paint indicate that the piece used to be painted, as was most Mayan sculpture.

What is the **significance** of **ball playing** in **Mesoamerica**?

Ball games were popular throughout Mesoamerica, and art depicting ball games exists in many Mesoamerican cultures including the Olmec, Maya, and Aztec. Archeologists have even discovered the ruins of sunken Olmec ball courts. Not much is known about the specific rules of the game. Mayan art depicts ball players wearing protective padding, and other art shows players wearing helmets and even leather belts. It is important to note that the game wasn't just for fun—it had a serious religious significance for those who played and watched. It is possible that some ball players were forced to participate against their will and that human sacrifice played a role in the game. According to Mayan mythology, ball games were symbolic of the cycle of life, death, and regeneration.

What was **Chichén Itzá**?

Chichén Itzá was an important pre-Columbian city built by the Maya and located in the eastern portion of the Yucatan Peninsula in modern-day Mexico. Chichén Itzá is

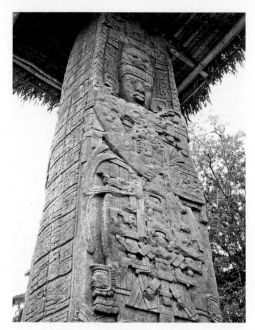

known for a large nine-level pyramid, which sits at the center of a main plaza. The pyramid is topped with a small, square temple accessible by four staircases, one on each side of the structure. The site also includes ball playing courts, palaces, and an astronomical observatory.

The city flourished between 800 and 1200 C.E., which places it mostly in the Post-Classic period of the Maya, the period just before European Conquest of the area. The buildings are decorated with bright, colorful paintings and painted relief sculpture. Popular themes include animals such as jaguars, coyotes, eagles, serpents, and mythological figures. Also found at Chichén Itzá are *chacmools,* altars in the shape of a reclining figure with hands resting at the sides. *Chacmools* are common throughout Mesoamerica.

Mayan stelae often depict figurative images and hieroglyphs in low relief.

What is the **Mayan codex style**?

Artists, held in high regard in Mayan society, wrote hieroglyphs and made illustrations in ancient folded books called codices. There is a clear link between the style of the art produced in these codices, and other types of art, such as painted ceramics. Mayan codex-style art is filled with expressive characters and bold colors. These paintings, whether in a book or on a vessel, have text which helps to explain the meaning of the images. These hieroglyphic inscriptions sometimes represent images (and are therefore pictographic) and sometimes represent sounds. A system of dots and bars was used to mark time. Scholars think it was common for the writing and the illustrations to have been completed by the same person, and refer to them as artist-scribes.

What was the **Aztec religion**?

The Aztec religion was influenced by the beliefs and mythologies of other Mesoamerican cultures such as the Olmec, Maya, Teotihuacan, and Toltec. As in other Mesoamerican religions, human sacrifice was an important part of the religion, and was linked to cycles of birth, death, and rebirth. The Aztec emphasized the importance of the sun as well as over one thousand powerful, yet occasionally fallible, deities. Huitzilopochtli was the god of war and the sun who, according to mythology, led the Aztecs to the location where they founded the city of Tenochtitlan. One of the most popular deities was the heroic Quetzalcoatl, who was often depicted in art as a feathered serpent. Religion was an extremely important part of everyday life for the Aztecs.

What is the **Pyramid of the Sun**?

The Pyramid of the Sun is an Aztec site from Pre-Classical Mexico, located in Teotihuacan, near modern day Mexico City. With a population of 200,000 people, the city of Teotihuacan reached its peak between 350 and 650 C.E. Similar in size to the Great Pyramid at Giza in Egypt, the Pyramid of the Sun was the most important architectural monument in the city. Aligned with the Avenue of the Dead, the structure was over 200 feet high and 720 feet on each side at the base. Made up of a series of steps, a stairway led to the top where a temple used to sit. The exterior of the building would have been painted, and faced a smaller temple called the Pyramid of the Moon.

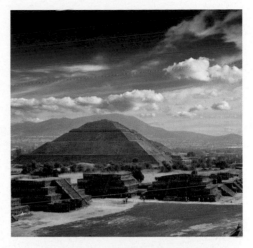

In the ancient Aztec city of Teotihuacan, the Pyramid of the Sun and the Pyramid of the Moon were connected by the Avenue of the Dead. The Pyramid of the Sun is similar in size to the Great Pyramid of Giza in Egypt.

NORTH AMERICA

How is **pre-Columbian art** in **North America organized**?

In North America, pre-Columbian art is divided into three major periods:

- *Archaic Period:* Ends in c. 1000 B.C.E.
- *Woodland Period:* c. 300 B.C.E.–1000 C.E.
- *Mississippian Period:* c. 900–1500 C.E.

What were the **major art traditions** of the **Woodland Period**?

The two dominant art traditions of the Woodland Period were the art of the Adena Culture and the Hopewell. These cultures shared a number of visual motifs and symbols, and greatly influenced the art of other native North American cultures across the continent. Both the Adena and the Hopewell were known for building large scale earthworks as well as smaller pieces of sculpture and jewelry, often made from copper, or cut from mica, a layered silicate mineral. Because of the plundering of sites and an overall lack of documentation, a great deal remains unknown about the art traditions of the Adena and Hopewell.

What is the **Great Serpent Mound**?

The Great Serpent Mound is a curvilinear burial mound in the shape of a curling snake located in the southern portion of Ohio. This monumental earthwork is nearly a quarter of a mile long and is still clearly visible. The Great Serpent Mound was at

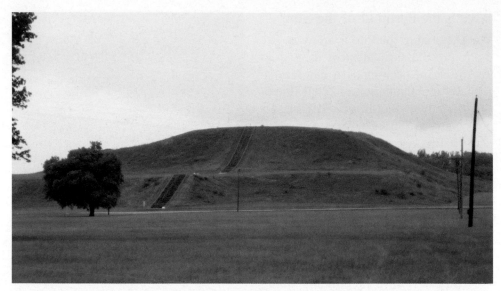

The exact purpose of monumental earthen mounds such as Monks Mound in Cahokia, Illinois, built by the Mississippian people hundreds of years before Europeans sailed to the Americas, remains unknown.

first attributed to the Adena culture, which flourished in the early Woodland Period (c. 300 B.C.E.–1000 C.E.), and was known for building monumental mounds used for burial. The site is now thought to be the work of the slightly later Mississippian culture and has been dated to around 1070 C.E. Serpentine forms appear on other types of Mississippian art, and serpents (as in many other cultures) were associated with fertility and harvest. Some scholars, however, believe that the shape of the Great Serpent Mound mirrors the path of Halley's Comet, which was visible in the year 1066 (The Bayeux Tapestry also records this event).

What was **Cahokia**?

Cahokia was the largest Pre-Columbian city in what is now the United States, and peaked in size with a population of nearly 25,000 between the years 800 and 1500—bigger than the city of London at the time. Like the Great Serpent Mound, Cahokia was built by the Mississippian people and featured numerous earthen mounds—the result of a huge labor effort. There were around 120 mounds at Cahokia; the largest, known as Monk's Mound, was one hundred feet tall, aligned to the sun, and possibly used as some kind of astronomical observatory in a manner similar to Stonehenge. Evidence of the city can be seen in Southern Illinois.

What is **Hunter's Mural**?

Hunter's Mural is a name given to petroglyphs located in Nine Mile Canyon in Utah. The petroglyphs are an example of rock art (in ancient Greek, *petros* means "rock" and *glyph* means "writing" or "drawing") attributed to the Freemont culture of the American southwest. Hunter's Mural depicts a bow hunter aiming his weapon at a flock of bighorn sheep. The Freemont used a unique method to create these rock images. The canyon walls were naturally stained a dark brown by bacteria; the

Freemont scraped this brown "varnish" away to reveal a lighter shade of rock underneath and form a picture. Petroglyphs similar to Hunter's Mural can be found across the American West and Southwest; some American rock art is thought to date from as early as 7000 B.C.E.

What is the Cliff Palace at Mesa Verde?

The Cliff Palace at Mesa Verde in Colorado was built by the Anasazi people, who lived in the Four Corners area of the American Southwest for thousands of years, and are considered ancestors of the Pueblo people. Before the fourteenth century, the area was less arid and a slightly cooler than it is now and the Anasazi lived by irrigating the land for farming. They built dwellings in natural cliff alcoves, directly underneath the land they farmed. The dwellings, which are among the most dramatic and best-preserved examples of Native American architecture, were designed for special purposes such as food storage and religious ritual. Some of the dwellings have as many as 150 rooms and are essentially cave-villages. Another structure, Pueblo Bonito, was also built by ancestral Pueblo people as early as the ninth century.

ROMANESQUE EUROPE

What is Romanesque art?

Although the term itself was not used until the nineteenth century, "Romanesque" means "Roman-like" and is used to describe eleventh through twelfth century medieval art and architecture featuring Roman characteristics. The Romanesque period saw a revival in monumental architecture, sculpture, and wall painting.

What are the main characteristics of Romanesque architecture?

Romanesque architecture is notable for its use of round arches, military-strength, and exterior architectural sculpture, the latter having fallen out of favor in Europe during earlier centuries. Romanesque buildings rely on thick walls, barrel vaults, and strong piers for structural support, allowing room for relatively small windows. As Europe was a culturally and politically fragmented landscape during the medieval period, Romanesque architectural styles vary greatly depending on the geographic region. For example, at first glance the Church of Saint-Sernin in Toulouse, France, might not look much like the Pisa Cathedral in Italy—but these eleventh century examples are both considered Romanesque due to their use of round arches, thick walls, cruciform structure, and exterior sculptural detail.

Why is the Leaning Tower of Pisa … well, leaning?

The Leaning Tower of Pisa, or *Campanile,* (Italian for bell tower) is part of a larger cathedral complex uniformly designed in white marble. The tower, built between 1171 and 1271, started to lean even before construction was completed because of the soft ground upon which it was built, and because the base was too small for the nearly

180 foot height of the tower. The builders tried to adapt to the lean during construction, and a slight bend is noticeable in the upper floors. This did not work. In the last few decades, structural engineers have excavated underneath the tower in order to stabilize it.

What is the **connection** between **Romanesque art** and **pilgrimages**?

During the eleventh and twelfth centuries, religious pilgrimages across Europe were extremely popular. On journeys that could last over a year, pilgrims walked along established pilgrimage routes, visiting important churches and religious sites. One of the most famous pilgrimage routes connected Paris with Santiago de Compostela in Spain, nearly one thousand miles away.

Pilgrimage churches, such as St. James Cathedral in Santiago de Compostela, were specifically designed to accommodate large groups of visitors. Additional aisled transepts, ambulatories, and radiating chapels were designed to aid the flow of pilgrim traffic, as well as ensure enough space for church officials to do their work. The doors of St. James were always open for visitors exhausted after a long journey.

What is a **reliquary**?

A reliquary is a vessel meant to hold a relic, or a surviving trace of a holy person. Many churches along pilgrimage routes displayed relics, which attracted traveling pilgrims. Miraculous powers were attributed to some relics, which could include preserved bodies, body parts, or the personal belongings of saints or important religious figures. Reliquaries could be as simple as a square box, or as elaborate as a fine sculpture. An example of a Romanesque reliquary is the Statue of Sainte Foy from the Abbey Church of Conques. Holding the actual skull of Sainte Foy, this thirty-three-inch figurative sculpture has a wooden core and is covered in silver gilt and jewels.

What is a **tympanum**?

A tympanum is a semi-circular space often located above a door (also known as a portal). In Romanesque churches such as the Abbey Church of Saint-Lazare in Autun, France, this space is filled with architectural relief sculpture. Common tympanum scenes include the Last Judgment, in which Christ is represented saving blessed souls and sending the damned to Hell.

What is a **historiated capital**?

An innovative element of Romanesque church decoration, a historiated capital is a space just above a column that illustrates a compressed narrative. *Flight into Egypt* is a twelfth-century historiated capital in the French Cathedral of Saint-Lazare, attributed to the sculptor Master Gislebertus. The scene depicts the Madonna and Child riding a donkey led by St. Joseph. Mary looks straight ahead while St. Joseph leans forward, his body conforming to the trapezoidal shape of the capital. More than mere decoration, this historiated capital serves to educate by representing symbolic stories from the Bible.

Who was **Master Gislebertus**?

Although most medieval artisans created their work anonymously, the name of one key sculptor is widely known—that of Master Gislebertus, who worked in the first half of the twelfth century. Gislebertus worked on a number of architectural projects throughout medieval France and Burgundy, but is most well known for his contributions to the sculptural decoration of the Cathedral of Saint-Lazare in Autun, France. Graceful, elongated figures and a unique compositional balance characterize his work, which often appeared in tympanums and historiated capitals.

What is **Mosan art**?

Mosan art is a Romanesque style of art greatly influenced by Classical sources and associated with the Meuse Valley region, which reaches from France to the Netherlands along the path of the Meuse River. The terms encompasses architecture, painting, and sculpture, though twelfth century Meuse Valley sculptors are particularly known for their mastery of metalworking. Mosan art is considered less abstract that the Romanesque art of other regions, featuring realistic anatomy and proportions (as opposed to the elongated figures of Gislebertus).

What is the **Bayeux Tapestry**?

Who knew there was such as thing as monumental embroidery! There is nothing quite like the eleventh century Bayeux Tapestry. At nearly two feet high and over 230 feet long, this work is not actually a tapestry (it is not woven), but embroidered linen. The colorful piece combines text and narrative imagery to tell the story of the Norman Conquest of England in 1066; there are over six hundred human figures, seven hundred animals, and two thousand letters in all. An astonishing work of fiber art, the Bayeux Tapestry is also an important historical artifact that documents one of the most significant military campaigns in European history.

What was **innovative** about **Durham Cathedral**?

Norman architecture, also known as the English Romanesque, is punctuated by the dramatic heights of Durham Cathedral. Norman architecture is named for the Norsemen (Vikings) who settled in France (Normandy), converted to Christianity, and attacked the British Isles in 1066, with William the Conqueror as their leader. Durham Cathedral is evidence of William the Conqueror's Christian legacy as one of the tallest cathedrals in England. But it is not simply size that makes Durham Cathedral innovative, it is the manner in which Durham's builders were able to achieve such height: ribbed vaults.

What is a **ribbed vault**?

Unlike the rounded barrel vaults so closely associated with the Romanesque style, ribbed vaults are more structurally effective than thick walls, allowing cathedrals like Durham to reach new heights, and ushering in the Gothic age. Looking much

like the human ribs, a ribbed vault is composed of a fanning framework of piped masonry that supports the weight of the ceiling and walls of a building.

GOTHIC EUROPE

What are the main **characteristics** of **Gothic architecture**?

Gothic architecture developed as a major European style in France in the middle of the twelfth century and is characterized by the use of pointed arches, ribbed vaults, and flying buttresses. These structural forms allowed medieval masons to achieve never-before-seen heights and much thinner walls than seen in Romanesque churches, as well as the addition of huge stained glass windows, such as the Rose Window at Chartres Cathedral in France. Gothic architecture was enormously popular in Europe, especially in France, until the end of the fifteenth century, and even into the sixteenth century in some countries, though it was never particularly popular in Italy, which preferred the Romanesque style.

What is a **flying buttress**?

A flying buttress is a graceful masonry support that projects from the side of a wall and adds strength to arches and piers that bear heavy loads. Notre Dame Cathedral in Paris is known for its flying buttresses, some of which can be seen on the exterior of the apse. The delicate cascade of the flying buttress belies its serious structural role. Without the flying buttress, Gothic cathedrals could not have reached the awesome heights they are known for.

What was the **first Gothic cathedral**?

The very first Gothic cathedral was the Abbey Church of St. Denis built near Paris in the 1130s under the direction of Abbot Suger, who wrote about the design and construction of the cathedral in three books. The plan was to reconstruct the old Benedictine monastery that housed the holy remains of St. Denis. Abbot Suger searched Europe for innovated sculptors and masons who experimented with rib vaults and created decorative sculpture. The result was a unified space filled with light and it served as an inspiration for new religious architecture for centuries afterward.

What is **Chartres Cathedral**?

Chartres Cathedral is perhaps the preeminent example of Gothic architecture in the world. Construction began in 1134 about fifty miles southwest of Paris. After a fire in 1194, Chartres was under construction until 1260. The cathedral features intricate relief sculptures depicting the Last Judgment over the west portal (entry doors), monumental stained glass windows, and two mismatched towers (one of which was built in the early sixteenth century). The figurative sculptures on the exterior of Chartres are so life-like, they seem to jostle and look to one another in conversation. Upon entering the building, the arcades appear weightless, the walls soaring, thin,

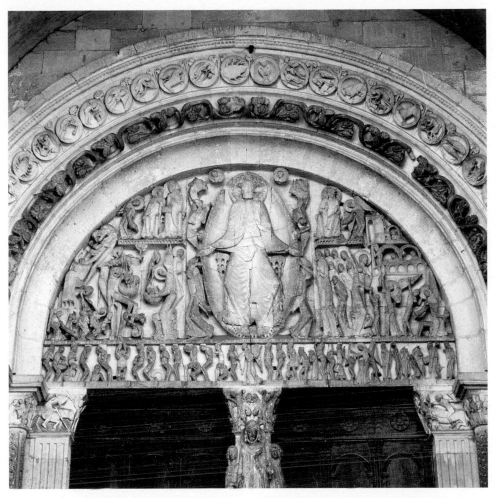

The twelfth century is known as the "Age of Cathedrals" in Europe. Cathedrals such as the magnificent Chartres Cathedral in France often had ornately decorated tympanums, or semi-circular wall areas over doorways and church entrances.

and delicate. Warm, colored light filters into the nave through the rose window where biblical narratives emanate from rich, glass panes. The aim of the Gothic architects of Chartres and other cities in Europe was to make manifest divine light from heaven, and here, it does appear as if they succeeded.

What is **stained glass**?

Stained glass is translucent colored class set in a lead framework, and usually used in windows. Stained glass was used in Early Christian and Byzantine churches as well, but was particularly favored by Gothic architects for whom it began an important form of art. The process of making stained glass hasn't changed much in nearly a thousand years. The colors in the glass come from adding metal oxides to molten glass, a labor-intensive process. Detailed images are made by using black enamel paint and fusing it to the glass through firing. The glass artist then organizes the colored glass fragments on a flat surface, like an enormous puzzle, until reaching the

97

desired image, and then joins the glass to lead strips and iron bands, which support the heavy glass.

What is a **book of hours**?

A book of hours is a private prayer book, which became popular in the thirteenth and fourteenth centuries as literacy levels among the European nobility increased. The books included specific prayers to be recited at certain times, or hours, of the day and night, and were often devoted to the Virgin Mary. A book of hours was a valuable object, and owning one was a sign of wealth. One of the most masterfully decorated books of hours from the fourteenth century is the *Hours of Jeanne d'Evreux*.

What is the *Hours of Jeanne d'Evreux*?

The *Hours of Jeanne d'Evreux* is a fourteenth-century book of hours illuminated by an artist named Jean Pucelle and was a gift from French King Charles IV to his third wife (Jeanne d'Evreux). The book may be tiny in terms of physical dimension (only a few inches, in fact), but is big in terms of artistic innovation. It is known for its *grisaille* illustrations which feature a gray, monochrome style that results in unique, sculpturesque figures. The illuminations, which often incorporate examples of Gothic architecture into the background, are innovatively rendered using spatial recession, creating a sense of depth not seen in earlier medieval painting.

THE EARLY MODERN WORLD, c. 1300–1600

PROTO-RENAISSANCE

What is the **"Renaissance"**?

The word *renaissance* is a French word meaning "rebirth." The Renaissance is generally considered to be a rebirth of Classical (Greco-Roman) culture, which resurfaced after the dark days following the fall of the Roman empire in the fourth century. This, however, is an oversimplification. Changes such as the development of cities, a growing European economy, and strong support for the arts by wealthy patrons all contributed to the birth of the Renaissance. The balanced, harmonious, and naturalistic paintings associated with the Renaissance did not burst onto the art and culture scene of Europe over night. It happened slowly over the course of the fourteenth and fifteenth centuries, beginning in Florence, Italy, and was at least partly inspired by a newfound interest in translating Classical Greek manuscripts, and the study of Roman ruins.

What is the **"Proto-Renaissance"**?

The Proto-Renaissance (essentially meaning "pre-Renaissance") is a term art historians use to describe a change in the style of art towards the end of the Gothic period in which art begins to foreshadow the characteristics of the Renaissance in terms of naturalism, realism, and humanism. Different art history books will cite different date ranges for the Proto-Renaissance, but it is generally considered to begin during the end of the twelfth century and end during the early fourteenth century in Italy. Work by artists such as the Lorenzetti brothers, Simone Martini, Duccio, Cimabue, and Giotto represent key shifts in style from Gothic to Renaissance. Famous writers and poets of the age include the poet Petrarch who wrote love sonnets that went on to influence Shakespeare. Another poet, Dante Alighieri, wrote *The Divine Comedy*, an epic tale of the author's descent into Hell.

Who were key **Proto-Renaissance painters** in **Siena**?

Thirteen and fourteenth century Siena (about forty miles southwest of Florence) was a hotbed of late Gothic, pre-Renaissance art production. The art of Siena rivaled that of any other city of the age. One of the most important artists working in Siena, Duccio di Buoninsegna (referred to simply as "Duccio"), is considered to be the father of Sienese painting. Duccio is known for the *Maestà Altarpiece* he made for the Siena Cathedral between 1308 and 1311. This piece is influenced by earlier Byzantine styles of art. The enormous altarpiece, originally made up of over fifty panels, is dominated by red and gold colors and presents the Virgin Mary enthroned as the "Queen of Heaven" in the center panel; her highly decorative throne opens up as if welcoming viewers into an embrace, a big change from the flatness of earlier Gothic and Byzantine images. Mary is surrounded by a sea of saints, each framed by the flat disc of a halo behind the head. The infant Christ, imagined as a small man, sits weightlessly in Mary's lap. Unfortunately, this beautiful example of Sienese art was dismantled in the eighteenth century and sold piece-by-piece to museums and private collections. Some remaining pieces have been reassembled and are on display in the Siena Cathedral.

Who were the **Lorenzetti brothers**?

The Lorenzetti brothers were Sienese painters who were influenced by the work of Duccio, the "father of Sienese painting." Pietro (c.1280–c.1348) and Ambrogio (d. c. 1348) are known for their simple, yet noble paintings and innovations in creating a sense of real space in their work. Ambrogio painted monumental frescoes depicting an allegory of both good and bad government in Siena's main civic building, the Palazzo Publico, in 1338. The *Allegory of Good Government in the City* visually describes the benefits of a just government on its people by depicting an idealized Siena. The complex fresco, filled with beautiful, multicolored buildings and allegorical figures, achieves a natural sense of scale between the figures and the environment. On a nearby wall in the Palazzo, the *Allegory of Bad Government in the City* shows what can happen when a city loses its way; the personified figures of Avarice, Pride, and Glory lurk above the head of a brutish ruler while the people of the city suffer.

What is a **fresco**?

A fresco is a wall-painting made using the *buon fresco* technique of applying pigment to freshly mixed, wet plaster. The process results in durable, permanent images. Another technique, known as *fresco secco,* is a method of applying pigment to plaster than has already dried. This method results in more fragile images that can flake off over time. Fresco painting is usually done in areas with warm, dry weather—ideal conditions for the *buon fresco* process. Italian cities such as Florence and Siena are well known for their frescos.

Who was **Giorgio Vasari**?

Giorgio Vasari (1511–1574) was a mediocre painter and a more successful architect, but his real legacy was the biographies he wrote about important Renaissance artists:

Lives of the Most Eminent Painters, Sculptors, and Architects (often referred to as *Lives of the Artists*). It is through Vasari that we are introduced to the early Renaissance artists Cimabue and Giotto, and hear the details of disputes between Leonardo da Vinci and Michelangelo. The book covers artists from Fra Angelico to Titian, Donatello to Salviati. Despite the book being filled with bias towards Italian artists, embellished stories, and historical inaccuracies, the impact his work had on art history and Renaissance scholarship cannot be ignored.

Who was **Cimabue**?

In *The Lives of the Artists,* Giorgio Vasari describes the thirteenth-century artist Cimabue as the man who "shed the first light on the art of painting." He is credited with innovations in naturalism; his art bridges the gap between the flat Byzantine style of painting and the more realistically proportioned style associated with the Renaissance. Comparing the work of Cimabue and his apprentice, Giotto, the difference is clear.

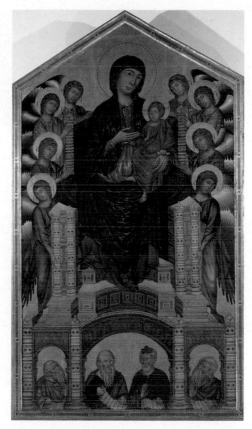

The work of Florentine artist Cimabue represents a shift from Gothic to Renaissance painting styles. (*Art courtesy The Art Archive / Galleria degli Uffizi Florence / Collection Dagli Orti.*)

Cimabue's panel painting, *Virgin and Child Enthroned* (c. 1280), depicts the Virgin Mary and Infant Christ surrounded by saints. The work is a blend of Gothic (Byzantine) style and newer Renaissance techniques: the folds of the drapery worn by the Virgin Mary are defined by gold lines. The figures of the saints are elongated and thin; Infant Christ appears to have the proportions of an adult. Despite the flatness and the stylized forms, Cimabue's scene is warm and real. The figures are naturally proportioned and their faces are thoughtful, engaging, and diverse. Giotto's painting of the same scene represents a major shift away from Gothic styles and towards more realistic images of figures and of three-dimensional space. The solid form of Mary's body can be seen through her heavy, blue robes and the Infant Christ sits firmly upon her lap. The figures in Giotto's *Virgin and Child Enthroned* are realistically modeled and Mary's throne appears to extend back into real space.

How did **Giotto** become so famous?

Giotto was a thirteenth-century celebrity. Discovered by master artist Cimabue drawing sheep while tending to his flock (as the story goes), he eventually achieved star power not seen by any artist before him. He was written about by Giorgio Vasari, dis-

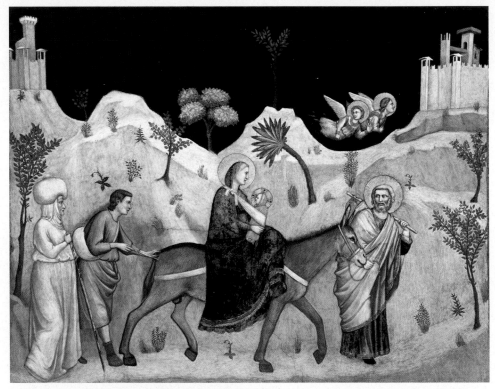

This scene, *Flight into Egypt,* from Giotto's fresco series in the Arena Chapel in Padua, Italy (completed c. 1305), is a masterpiece of visual depth and naturalism. Giotto is considered one of the most important artists of the early Renaissance.

cussed at length by the artist-writer, Cenino Cenini, and mentioned by Leonardo da Vinci as one of the most important artists who came before him. Vasari explained what made Giotto famous: he set "art upon the path that may be called the true one" (as quoted in Stokstad, *Art History,* p. 608*).* Vasari went on to explain that it was Giotto who made the biggest visual breakthroughs in depicting a realistic sense of three-dimensional space in his painting.

Giotto's masterpiece is the fresco series he painted inside the Arena Chapel in Padua, Italy. Made for the Scrovengi family and completed around 1305, the frescos cover the barrel-vaulted chapel walls in deep lapis blue, and are dotted with stars and discs featuring the portraits of saints. Giotto paints a narrative by dividing the wall up into quadrants, each telling a different part of the story of the life of Christ and the Virgin Mary. Each scene has a sense of depth and the figures are realistically modeled by using dark shades for shadow, and whiter shades for highlights. The largest fresco in the series is *The Last Judgment,* at the west wall of the chapel. In *The Last Judgment,* Christ raises His hand in blessing; the saved are grouped on Christ's right side and the damned descend to Hell on the left. The patron, Enrico Scrovengi, is shown offering his family chapel to Christ in an attempt to cleanse his sins. The Renaissance artist Lorenzo Ghiberti said the Arena Chapel was "one of the glories of the Earth" (quoted in *Art Past Art Present* 241).

EARLY RENAISSANCE IN ITALY

Why was **Florence** an **important Renaissance city**?

The Renaissance is said to have begun in Florence in the fifteenth century, a period known as the *Quattrocentro*. At this time, Florence was not just a city, but a city-state, much like the city-states of ancient Greece. Fifteenth-century Florence was also a Republic with a constitution (though it was a far cry from a democracy). Florence was an economic powerhouse with a lot of civic pride. Money was pumped into civic projects such as cathedral building, architectural decoration, and artist competitions, all in an attempt to beautify the city and enjoy the pleasures of wealth. Florentine patrons supported the careers of important artists such as Masaccio, Donatello, and Ghiberti, whose innovative work kick-started the Renaissance.

What is **humanism**?

Though the term *humanism* wasn't invented until the nineteenth century, it refers to the rejection of medieval scholastic values and the new embrace of Classical thought during the Renaissance. Humanism is also a way of thinking; an important part of humanist philosophy was education that focused on studying history, and emphasized personal ethics and civic values. Renaissance humanism resulted in a new emphasis on individuality. During the medieval period, art and literature tended to be

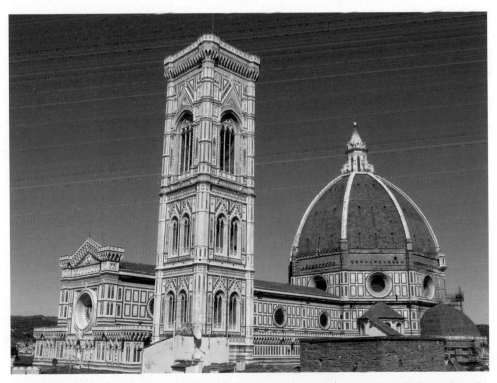

The Italian city of Florence was the epicenter of the Italian Renaissance, home to artists such as Donatello, Fra Angelico, and Botticelli. The architect Filippo Brunelleschi designed Florence Cathedral's iconic dome.

viewed through a divine lens, from the perspective of God. During the Renaissance, by contrast, artists tended to take on a more human-centered view of the world.

How was **single-point perspective** invented?

Quite literally a "Renaissance Man," Filippo Brunelleschi was a goldsmith, clockmaker, mathematician, Latin scholar, and architect. It just so happens that he also invented single-point perspective, one of the most important technical innovations of the Renaissance. Also known as linear perspective, single-point perspective is a mathematical system based on natural observation. Under the rules of single-point perspective, distant objects are depicted smaller than objects closer to the viewer, while the far edges of similarly shaped objects appear shorter near the edges (this warping of forms is known as foreshortening).

Brunelleschi invented the idea of a picture plane, in which he imagined the frame of a painting as a window through which the viewer sees an illusion of three dimensional space. The artist lays out the scene according to a grid pattern, and every object in the picture, for example architectural objects like roof lines and walls, follow invisible lines called orthogonals, which converge at a single point, known as the vanishing point, usually at eye-level to the viewer. Strangely enough, Brunelleschi was primarily interested in perspective not as a painter, but as an architect. His goal was to design an interior that drew a person's attention through a space, such as a church nave, towards the altar, which he did effectively in his design for the Santo Spirito in Florence in 1434.

How did **Brunelleschi** build the **dome** of the **Florence Cathedral**?

As civic projects boomed in the wealthy city of Florence, architects imagined building a huge dome on top of the Florence Cathedral as a way of glorifying their city.

Though he had lost the Baptistery doors design competition earlier, Filippo Brunelleschi was hired to build the dome, which needed to be 138 feet across, bigger than the Pantheon in Rome. It was not an easy task and Brunelleschi was only twenty-four years old at the time. After studying Roman ruins, including the Pantheon, Brunelleschi built an octagonal double-shell dome. The inner layer of bricks was arranged in ever-tapering circular rows, which allowed each row of bricks to support the next. The bricks of the outer shell were arranged in a strong herringbone pattern. The eight sides of the dome were further supported by ribs and metal bands.

Brunelleschi faced another significant challenge: how were the workers going to build this thing? Usually, a dome would be constructed with the aid of scaffolding, but the space to be covered was so big that no trees were long enough. Instead, Brunelleschi devised a system of smaller scaffolds and platforms for workers, along with hoisting systems, and even elevated canteens so that workers could take their lunch break without climbing back down to the ground! It is no wonder that Brunelleschi is considered to be the father of Renaissance architecture.

What is **Masaccio's *Trinità*?**

Known by his nickname, Masaccio, lengthily named Tommaso di Ser Giovanni di Mone Cassai was an early renaissance painter whose work blended the realism of Giotto with the concepts of perspective established by Brunelleschi. His monumental fresco, *Trinity with the Virgin, Saint John the Evangelist, and Donors* was painted in the Church of Santa Maria Novella around 1426. This illusionistic fresco appears to be a three-dimensional niche in the wall in which Christ, impaled on the Crucifix, hangs above an altar. Framed by painted pilasters in the Classical order, and a barrel-vaulted ceiling, the pale, emaciated Christ is frail yet powerful. God the Father, depicted in the form of a man, towers over him from behind while a white dove, symbol of the Holy Spirit, floats just above Christ's halo. Somber representations of the Virgin Mary in blue, and St. John the Evangelist in red, draw the viewer's attention to the plight of Christ, while outside the sacred arched space occupied by the saints the patrons kneel in prayer. Just below this scene is the image of an entombed skeleton with the proclamation, "What you are, I once was. What I am, you will be." The realism of the figures and the use of single-point perspective effectively trick the eye into imagining that these figures are present within the confines of Santa Maria Novella, sending a powerful message of the importance of salvation.

Who was **Fra Angelico**?

Like Masaccio, Fra Angelico, whose nickname means "The Angelic Brother" in Italian, was known for his frescos. His real name was Guido di Pietro and he was famous not only for his art, but also for his modesty and his devotion to Christianity. Starting in 1435, Fra Angelico was hired to paint the interior of the Dominican Monastery of San Marco in Florence. For nearly ten years, the artist painted in the walls of each monk's cell, as well as other walls within the monastery. The painting on the inside of Cell Three depicts the Annunciation, a scene in which the angel Gabriel visits Mary to tell her she will be the mother of Jesus Christ. Fra Angelico's figures are graceful

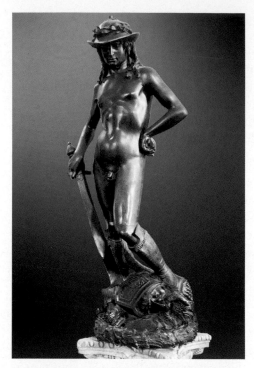

The Renaissance artist Donatello depicts the Old Testament hero David in this figurative bronze from the mid-fifteenth century. Dontello's youthful *David* marks the first time a life-size male nude was depicted in bronze since antiquity.

and elegant; Gabriel bows gently, his arms crossed over his chest and his wings brightly colored. Mary is seated to the right, framed by the architectural forms of her room. She also crosses her hands over her chest, a movement that both indicates modesty and forms a dove-like symbol of the Holy Spirit. The scene is simple, pious, and appears to glow with divine light.

What is **Donatello's *David***?

Donatello (Donato di Niccolò de Betto di Bardi, c. 1386–1466) was considered a genius of the early Renaissance. He had a long career as a sculptor and is responsible for the famous bronze *David,* the first life-size male nude sculpture made since antiquity. Donatello's David is surrounded in mystery—art historians do not who the patron was, for example, though it was placed in a courtyard at the Medici palace, home of the ruling family in Florence at the time. It is thought that the noble *David* symbolizes the recent Florentine military victory over neighboring city-state Milan, in 1428. In this piece, Donatello represents this Old Testament hero as a young, nude man in early adolescence. His hips are tilted in a confident *contrapposto* pose and he stands, with knees slightly bent, over the dismembered head of his foe, Goliath. A large feather from Goliath's helmet can be seen reaching high up the inside of David's leg. Donatello's *David* is at once a reflection of the Classical tradition of sculpture making, and an erotic depiction of youthful heroism. It is quite different from another famous *David* done by Michelangelo.

Why were **Botticelli's paintings burned**?

Sandro Botticelli (1445–1510) was a Florentine painter who was quite frequently commissioned by the powerful Medici family, often to produce secular mythological paintings such as *The Birth of Venus* (1484–86) and *Primavera* (1482). Now one of his most famous works, *The Birth of Venus* depicts the Classical goddess of love and beauty as she is being born out of sea foam. She floats to shore atop a large scallop shell, her hair blowing gently around her body, as she covers her nude body in modesty. She is propelled by the breath of the wind god, Zephyr, who holds his lover, Cloris, in his arms. Small, pink flowers float in the air. Venus is welcomed to shore by a follower who reaches out to cover her with a floral garment. This painting, like the rest of Botticelli's work, shows the artist's skill in using single-point perspective and using light to effectively model three-dimensional figures. It is also both erotic and secular.

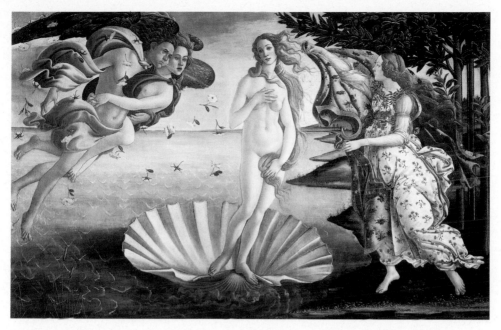

Scenes from classical mythology, such as Sandro Botticelli's *Birth of Venus* (1484–1486), were popular during the Italian Renaissance.

Things changed for Botticelli when a Dominican monk named Fra Girolamo Savonarola took power in Florence from 1494 to 1498. Savonarola gave powerful sermons in which he accused the city of Florence of being morally corrupt and materialistic. Swayed by Savonarola's conservative religious message, Botticelli burned many of his own paintings, especially his earlier more secular works. Botticelli's later work has a decidedly more religious tone.

What is an **altarpiece**?

An altarpiece is a painted wood panel, usually placed on the altar in a church. Altarpieces come in many forms. One of the most common types of altarpieces is the triptych, so named because it is made up three connected panels. Often, the panels of a triptych are hinged and the outer panels can be closed like doors, revealing additional exterior paintings. An altarpiece with only two panels is called a diptych, while an altarpiece with many panels, such as the *Ghent Altarpiece* (discussed in the following section), is known as a polyptych.

NORTHERN EUROPEAN RENAISSANCE

How is the **Italian Renaissance different** from the **Renaissance In Northern Europe**?

The Renaissance is said to have started in Italy and spread slowly north into the rest of Europe. This is not quite true, however. While the Italians were especially interested

in Classical art, (they lived amongst Roman ruins after all), artists from Northern European countries such as France, Germany, and the Netherlands had different interests.

While artists of the Italian Renaissance were interested in the idealized nude, Classical architecture, and single-point perspective, Northern European painting of the time is characterized by intense realism and attention to detail. Northern artists were interested in the material quality of objects in the visible world. Important artists of the Northern Renaissance include Jan van Eyck, Roger van der Weyden, and Claus Sluter.

What is the **International Gothic style** of painting?

International Gothic is a term used to describe a highly stylized form of painting popular in Europe between the late fourteenth century and early fifteenth century, which greatly influenced the art of the Northern Renaissance. It is most closely associated with the art of Bohemia, France, and the Holy Roman Empire. International Gothic styles were less popular in Italy, especially southern Italy. Paintings done in the International Gothic style feature graceful, elongated figures and extensive use of lines. While flat compared to art of the Italian Renaissance, International Gothic paintings do feature more realistic details, some use of perspective, and an emphasis on setting and landscape.

Who were the **Limbourg brothers**?

The three Limbourg brothers were the most famous manuscript illuminators in Flanders and worked near the end of the fourteenth century and the early fifteenth century. Paul, Herman, and Jean were originally trained as goldsmiths in Paris and went on to become the official court painters to the Duke of Berry around 1404. Arguably their most important work was the *Très Riches Heures,* a book of hours made especially for the Duke. The book included calendar pages, which listed saint's feast days, zodiac signs, and astrological information. The Limbourg brothers completed fantastically realistic, full-page paintings for each month of the year. The paintings are full of life and vivacity, for example, the deep blues and powdery whites of the February page evoke the chill of winter. The brothers used very fine brushes, and most likely magnified lenses, in order to achieve such a high level of detail. The work of the Limbourg Brothers is a good example of the International Gothic style.

What is the *Mérode Altarpiece*?

The *Mérode Altarpiece* is an example of a triptych done by Flemish artist Robert Campin, also known as the Master of Flémalle. Painted in oil, the large central feature depicts the Annunciation, a scene in which the angel Gabriel tells the Virgin Mary that she will be the mother of Christ. Gabriel's wings are brightly colored and Mary's drapery is deep red. She holds a Bible in her hands as if she has just been interrupted by the angel's arrival. As is common in Northern painting, the Virgin Mary is shown in a bourgeois setting; the room looks like it belongs in an average fifteenth-century, upper-middle class home and is filled with everyday objects. On the smaller left panel, the work's patron appears, kneeling and watching the Annunciation

through a door. On the right panel, St. Joseph is shown in a workshop making mousetraps. The *Mérode Altarpiece* blends the International Gothic style's attention to detail with a sense of three-dimensional space; each of the three panels has its own single-point perspective system. It is one of the most famous Renaissance works from the Netherlands.

What are the **symbolic meanings** of the many objects in the *Mérode Altarpiece*?

The *Mérode Altarpiece* is filled with religious symbolism related to the Annunciation. On the table next to Mary are lilies in a vase. The lilies represent Mary's purity and the fact that there are three of them suggest the Holy Trinity. Next to the lilies is a candle. The candle's flame has been recently extinguished and the wick smokes gently; this is a symbol of Christ's incarnation. A small image of Infant Christ holding a wooden cross can be seen in the upper left; He flies on a ray of light and has just entered the room through a closed, yet unbroken window, which is a reference to Mary's virginity. In the back of the room is a small, brass basin and washcloth, symbols of Christ who cleanses the sins of the world. In the right panel, St. Joseph, Mary's husband, is making mousetraps. This might sound strange, but the activity symbolizes St. Joseph's role as protector of Mary and Christ and shows him as a family man.

Who was **Jan van Eyck**?

Jan van Eyck (d. 1441) was one of the most significant painters of the fifteenth century. He worked in Burgundy and is most well known for the *Ghent Altarpiece,* a monumental work of tremendous realism and detail. Jan van Eyck came from a family of artists and was known to have worked alongside his brother, Hubert. The van Eyck brothers likely worked together on the *Ghent Altarpiece.* Philip the Good, the Duke of Burgundy, was one of their most significant patrons. Some of van Eyck's most important paintings include *Portrait of a Man in a Turban* (1433), which might be a self-portrait, and the *Arnolfini Portrait* (1434).

The enigmatic *Arnolfini Portrait* (1434) was painted by Northern Renaissance master Jan van Eyck. This marriage portrait is filled with symbolic images and emphasizes the material quality of the objects in the scene.

How did **Jan van Eyck achieve** such **incredible detail** in his work?

The work of Jan van Eyck is known for its incredible detail and realism. Like

other artists of Northern Europe, van Eyck used oil paints. Oil paints take a long time to dry, allowing artists time to work slowly and blend colors. Northern artists like van Eyck built up layers of oil paint by applying many thin glazes. Compared to the egg-based tempera paints used in Italy, oil paints can achieve much richer hues. Paintbrushes made for painting detail were important—some brushes were so thin that they were made of a single hair! Jan van Eyck is thought to be one of the first Renaissance artists to extensively use optic technology, such as convex mirrors and lenses, to help achieve a high level of detail in his work.

Why are art **historians so confused** about the *Arnolfini Portrait*?

The *Arnolfini Portrait,* completed in 1434 by Jan van Eyck, is both enchanting and enigmatic. A great deal of questions surround the work. The painting depicts a well-dressed couple surrounded by evidence of wealth, possibly a merchant named Giovanni Arnolfini and his wife, Giovanna Cenami; though new research indicates that these two individuals did not actually marry until over a decade after the portrait was painted—adding to the mystery. Perhaps the couple is instead from a different part of the extended Arnolfini family. Like the *Mérode Altarpiece,* the painting includes many symbolic objects, some religious and some secular. For example, the dog in the foreground is a symbol of love and loyalty, while the crystal prayer beads in the back of room symbolize the couple's piety. Debate rages on as to whether or not the woman in the portrait is pregnant, as her hand rests on the top of her stomach. But, perhaps the couple only desires a baby? One of the most curious parts of the painting is the mirror on the back wall. Just above this mirror is a note that reads,"Jan van Eyck was here." Within the mirror appear the backs of the couple along with the face of an additional figure. Is it van Eyck himself? Art historians aren't sure. Regardless of the mysteries surrounding this painting, it is a masterfully detailed work and serves as a window into another world.

HIGH RENAISSANCE IN ITALY

What is the **High Renaissance**?

The High Renaissance is a name given to the late fifteenth and early sixteenth centuries during which time Great Masters such as Leonardo da Vinci, Michelangelo, and Raphael were active, along with slightly later northern Italian artists such as Titian, Correggio, and Giorgione. The High Renaissance is widely considered one of the greatest periods in the history of art, and is certainly the most famous period of Italian art. The High Renaissance is not only an Italian phenomenon—Great Masters from Northern Europe include Albrecht Dürer and Hans Holbein, among others. Besides art, great scientific discoveries were also made during the High Renaissance, including the revolutionary work of Galileo and Johannes Kepler. The High Renaissance was a unique and important period of intellectual, technological, and artistic achievement in European history.

Who were the **"Great Masters"**?

The term "Great Master" can be thrown around quite loosely to indicate a highly esteemed artist, and is used to describe certain Renaissance and sixteenth century artists. Artists such as Leonardo da Vinci, Michelangelo, and Titian, among many others, are referred to both as "Great Masters" and occasionally as "Old Masters" to differentiate them from notable artists from more historically recent times. Towards the end of the Renaissance, master artists were increasingly seen as celebrities, rather than mere manual laborers.

The term itself comes from the master apprentice system that was used to train artists during the Renaissance. In this system, rather than be sent to an art school (there were none at this time), students as young as five years old would be sent to work and train as a workshop apprentice under the guidance of a master artist. The master usually promised to feed and house the apprentice in exchange for assistance cleaning and preparing materials, and eventually working on the master's art commissions. Many works by famous artists were the product of a workshop staffed by many artists, including young apprentices.

Who was **Leonardo da Vinci**?

Leonardo da Vinci (1452–1519) is one of the most famous artists of all time. He was the illegitimate son of a Tuscan notary and went on to train in the workshop of master artist Andrea del Verocchio in Florence. Leonardo da Vinci was a genius, and well known during his lifetime for his intellect and peculiarity. He was fascinated with the visible world, and spent hours drawing what he saw. It was as if for da Vinci, drawing was a method of understanding. Thousands of da Vinci's sketches have survived—drawings of human faces, swirling water, birds in flight, dissected corpses, the human skeleton, nature scenes, toy designs, and more. He wrote extensively on theories of art and science, creating categories of facial types, explaining techniques of atmospheric perspective, and analyzing the movements of the sun. Da Vinci was hired by Italian governments to design weapons and war machines, including the so-called "siege-machine." Designs for these weapons appear in sketch-form in his notebooks. Despite his prolific writing and drawing, da Vinci never published any of this work and wrote all of

Leonardo da Vinci used drawing as a means of understanding the world around him. The artist's private sketchbooks are filled with drawings of the natural world and scientific phenomena, including anatomical sketches, drawings of the womb, and the illumination of the moon.

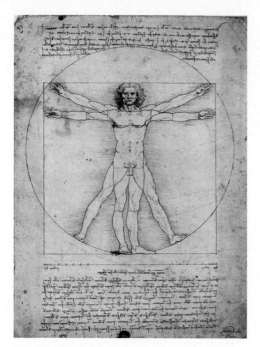

Leonardo da Vinci's representation of the classical Vitruvian Man emphasizes balance and symmetry, both important values for Renaissance artists.

his notes in reverse—rendering his notes readable only when held up to a mirror. It is possible he was paranoid of being declared a heretic by the church, or that he was simply intensely private.

It is clear that Leonardo da Vinci was not merely a painter, but a true "Renaissance Man." His paintings are among the most famous works of art in the world and include *The Last Supper* fresco in Milan and the *Mona Lisa*. Many of da Vinci's works have deteriorated significantly over time.

What is *The Vitruvian Man*?

The Vitruvian Man is a drawing by Leonardo da Vinci of a visual concept described by the Roman architect Vitruvius in the first century B.C.E. in his work *On Architecture*. As an architect, Vitruvius was interested in harmony, symmetry, and balance—all qualities that were highly valued by Classically minded artists and architects during the Renaissance, including Leonardo da Vinci. He explained his belief that supremely beautiful and unified architecture could be created using the proportions of the human body as a guide.

As Vitruvius never provided any illustrations of his own, many different artists attempted to visually depict the concept. Da Vinci's drawing is likely the most familiar version. An idealized human male is depicted standing tall within a circle and a square. The figure's outstretched arms are shown in duplicate; one set reaches the point at which the circle meets the square, while the second set runs horizontally, reaching the vertical sides of the square. The figure also has two pairs of legs, one straight, and one outstretched, mirroring the position of the arms. The drawing highlights Leonardo da Vinci's mathematical creativity and emphasizes the Renaissance preference for geometric balance.

What makes the *Mona Lisa* such a great work of art?

Her face is everywhere, from backpacks to refrigerator magnets. She occasionally sports a mustache and glasses, and her head has even been replaced by Bart Simpson's! But make no mistake, thousands of people a year crowd around the real thing hanging in the Louvre in Paris. So, what is it all about, exactly? What makes the *Mona Lisa* such an enduring image, recognizable by millions of people around the world? The *Mona Lisa* was painted by Leonardo da Vinci between 1503 and 1507. The painting itself, oil on panel, is quite small: 30 x 21 inches. It is has been stolen

and returned, appears to have had part of it cut away, and depicts a Florentine noblewoman against an enigmatic background. It is likely a portrait of a Florentine woman named Lisa Gherardini.

Spend some time looking at the painting, at Lisa's cool expression as she stares out of the frame with her arms delicately crossed. What is she thinking? Is she pleased? Sure of herself? Shy? A small smile appears to be creeping up one side of her mouth and her eyes seem to shift to the right. Is Lisa playing coy?

Leonardo da Vinci used a technique called *sfumato,* which means "smoky" in Italian, and he applied *sfumato* techniques to the corners of the Mona Lisa's eyes and her mouth, creating the famous ambiguity of personality. Because of this, Lisa's mood seems to change upon every viewing, and sometimes it feels like she's in on the joke. *Sfumato* also helps add to the realism of the portrait, making Mona Lisa appear to live and breathe.

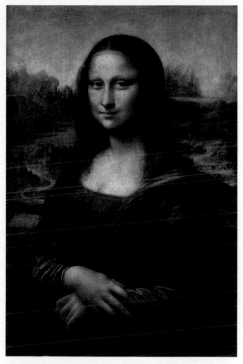

What is the Mona Lisa thinking? Leonardo da Vinci's use of the smoky *sfumato* technique makes the Mona Lisa an enduring mystery that has captured popular attention for hundreds of years.

When we look at the Mona Lisa, we are as close as we can get to the genius of Leonardo da Vinci. At some point in history, he sat in a room with this woman, mere feet apart, and painted her from life. The painting is a virtuoso work, an example of da Vinci's immense skill, and an enduring masterpiece.

What was revolutionary about *The Last Supper*?

Completed between 1495–1498 in the refectory of Santa Maria delle Grazie in Milan, *The Last Supper* is considered by some to be Leonardo da Vinci's greatest work (sorry, *Mona Lisa)*. It is a fresco, which means it was painted on a freshly plastered wall, and it depicts the biblical scene in which Jesus Christ breaks bread with his followers on the evening before his death. It was considered revolutionary for a number of reasons, including its naturalism. Da Vinci chose to depict the moment when Christ declares that one of them will betray him. The apostles gathered around the table with Jesus are shocked! St. John cannot bear it and simply faints at hearing the news. St. Peter is angered, and pulls out his knife (foreshadowing his use of the weapon when Jesus is betrayed by Judas in a later part of the biblical narrative). For the first time in art history, Judas is shown on the same side of the table as Christ, though he leans away, betraying his guilt to the viewer.

Like other works of Renaissance art, the story is clearly visually articulated. The apostles are organized into four groups of three, and are all aligned on one side of the

table. There are three windows behind the table, and three dark niches along each side, three being associated with the Holy Trinity. Despite the shock of the news, the painting is calm and the mood is thoughtful. Da Vinci's *Last Supper* was a major influence on other artists who painted the same scene, including Tintoretto, Hans Holbein, and Rubens.

Who was **Michelangelo**?

Michelangelo Buonarroti (1475–1564) was a multitalented Great Master of the High Renaissance known for his painting, sculpture, and architecture. He had an incredibly long and successful career, active for nearly seventy years. He was twenty years younger than da Vinci and well respected during his lifetime, though notorious for being moody and difficult to work with. He was one of the first artists in art history to be famous: two biographies were written about him and he was highly sought after by high-status patrons, including Lorenzo de'Medici and the pope. His most famous works include his painting on the ceiling of the Sistine Chapel and his awe-inspiring sculptures such as the *Pietà* (which he made when he was twenty-four years old) and the *David*. He also designed the dome on St. Peter's Basilica in Rome, though he died before its construction was completed.

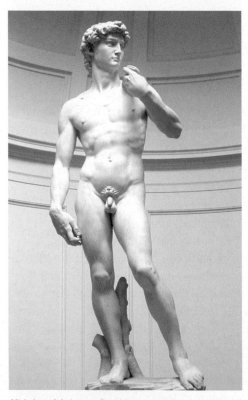

Michelangelo's famous *David* (1501–1504) is quite different than Donatello's youthful bronze: this larger-than-life marble sculpture idealizes the human form. David stands, confidently awaiting his rival—the giant Goliath—with flexed muscles and weapon in hand.

How can you **recognize** "a Michelangelo"?

The work of Michelangelo has a very particular style, in both painting and sculpture. Michelangelo's *David* is a good example of this style, which emphasizes physical idealism of the human form, especially the male form. The *David* is monumental in size at seventeen feet tall and was cut from an eighteen-foot block of white marble. David is shown at the peak of his youth; he is strong, athletic, nude, and flexing his muscles as he prepares for battle with his enemy, Goliath. His hands and feet are both oversized and highly realistic, the veins and ligaments of the hands are clearly visible even from afar. One knee is slightly bent and the hips tilt to one side—the traditional *contrapposto* pose—which adds a sense of life and realism to the sculpture. Many of Michelangelo's other works also emphasize physical perfection and include large figures with broad shoulders, flexed muscles, and serious faces.

What is the **Sistine Chapel**?

In a letter to a friend in 1508, Michelangelo admitted that he disliked painting and really didn't want to paint the ceiling of the Sistine Chapel, now one of the most famous ceilings in the world. It is located in the Vatican, the official residence of the Pope in Rome. The Sistine Chapel, named after Pope Sixtus IV, was designed to be the same size as the Temple of Solomon and was built between 1475 and 1481. The interior of the chapel is covered in frescoes depicting Christian subjects and themes. Pope Julius II personally asked for Michelangelo to paint the ceiling frescoes, and after he reluctantly accepted, rumor also has it that the artist shut himself up in the chapel for four years, refusing to let anyone else in. That part of the story is very unlikely; Michelangelo would have needed the support of his workshop apprentices to complete the project in four years.

Michelangelo did not paint the walls of the Sistine Chapel. That work was completed by other artists such as Sandro Botticelli and Domenico Ghirlandaio, Michelangelo's former master. The wall frescoes visually narrate scenes from the Bible, including the story of Moses and the life of Christ. On the ceiling, Michelangelo depicted numerous Old Testament scenes, including David and Goliath, The Creation of Adam, the Fall from Paradise, and Judith and Holofernes. With hundreds of figures in multiple poses, various different scenes, plants, nature, and illusionistic architectural elements, it's a wonder the Sistine Chapel isn't a sensory overload. But Michelangelo was able to infuse the entire 45 x 128-foot space with a sense of grace, calm, and awe.

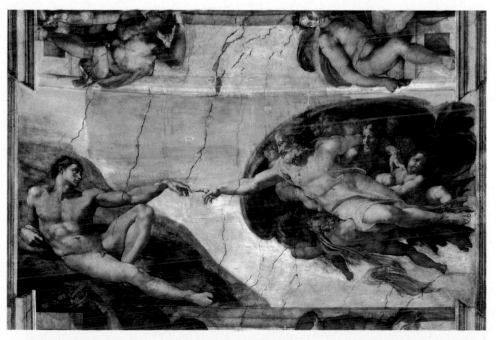

The great master Michelangelo was a sculptor, architect, and painter. His ceiling frescos in the Sistine Chapel are among the most famous paintings in the world. Michelangelo's skills in naturalism are clear in the famous panel *The Creation of Adam* in which the barely touching fingers of God and Adam heighten the drama of the scene.

What is *The Creation of Adam*?

The Creation of Adam is the most famous of Michelangelo's frescoes on the ceiling of the Sistine Chapel. Adam is seen nude, reclining on a patch of bare terrain while God the Father approaches from the air, accompanied by angels and cherubs. God is shown with long, gray hair and a flowing beard, which are blown back by the wind. A red cape swirls around the figures and God's hand reaches out toward Adam with one finger outstretched, delivering the spark of life. Adam seems to move slightly towards God, though his wrist is limp and his head lolls to one side—he is not yet fully alive. Their fingers appear mere centimeters apart, eliciting tension and drama. This is one of the most iconic images in all of art history. Michelangelo has captured the seconds immediately before God awakens Adam to life. *The Creation of Adam* is both delicate and powerful, poised and energized.

Who was **Raphael**?

Raphael (1438–1520) was thirty-one years younger than Leonardo da Vinci and eight years younger than Michelangelo. Very aware of their status and their skill, Raphael made his own place in this pantheon of High Renaissance artists. Whereas Michelangelo was moody and difficult to work with, Raphael was friendly, personable, and well organized. His paintings are characterized by a sweetness and harmony that has been frequently imitated, but rarely, if ever, equaled.

Raphael studied in Perugia and had a successful career first in Florence, and then later in Rome where he was commissioned by Pope Julius II to decorate the Vatican apartments. His most famous works include his Vatican fresco, *The School of Athens* (1510–1511) and his paintings of the Virgin and Child such as *Madonna of the Meadow* (which also includes an image of the infant St. John the Baptist). He painted one major mythological scene, *Galatea,* in 1512, as well as an influential portrait of Pope Julius II the same year. After the death of Bramante, he was called on as the architect of St. Peter's, though most of his designs were either never constructed, or were changed. Raphael died at age thirty-seven and was buried in the Pantheon in Rome.

Why was **St. Peter's basilica demolished**, and what did they replace it with?

The original St. Peter's basilica, now referred to as Old St. Peter's, was built over the site of Saint Peter's tomb in the fourth century, during the reign of Roman Emperor Constantine. Old St. Peter's was a basilica-plan church with a long nave, parallel aisles, a narthex, and an apse. Over a thousand years later, in 1506, Pope Julius II boldly decided to completely tear down the deteriorating building, shocking Rome. Imagine deciding to tear down the White House!

Donato Bramante was hired to design the New St. Peter's. Famous for his design of the Tempietto, Bramante envisioned something similar for St. Peter's: a central-plan church based on the equidistant forms of a circle and a square. Bramante's plan was never built, however, as both he and Pope Julius II died. Other great artists, including Raphael, altered Bramante's plans, and in 1546 Michelangelo became the main architect. He again reworked Bramante's design, and added a dome. The church was

built, though the dome wasn't completed until after Michelangelo's death. In the early seventeenth century, the church was redesigned yet again. As it stands now, the plan for New St. Peter's Basilica looks quite a bit like the original before it was demolished, though the exterior and famous piazza are in the style of the early baroque period.

Why is the **tiny Tempietto** an important example of **High Renaissance architecture**?

The Tempietto is a small, circular church, officially called the Church of San Pietro in Montorio, Rome. It was designed around 1502 by Donato Bramante, a famed architect from Urbino who was later hired to design St. Peter's Cathedral. Tempietto means "little temple" and its style is reminiscent of an ancient pagan temple. It was built over what is believed to be the site of St. Peter's crucifixion and housed relics associated with the apostle. Bramante's design was very much in tune with Classical aesthetics popular during the Renaissance, especially in Italy. The architectural elements are mathematically proportioned and the overall style is unified, making the building almost like a work of sculpture. The simplicity of the exterior, along with the use of Classical columns, a dome, and hemispherical entablature, inspired many other building projects in Rome. Though small, the Tempietto is one of the most significant examples of High Renaissance architecture in Italy.

RENAISSANCE VENICE

What are the **hallmarks** of the **Venetian Renaissance**?

During the Renaissance, the Republic of Venice was one of the most powerful city-states in Italy. Geographically and culturally removed from cities such as Rome and Florence, which were much further south, art in Venice was greatly inspired by Northern Europe and the East, including Islamic and Persian styles from the Ottoman Empire, formerly the Byzantine Empire. The climate in Venice was also different from other Italian cities. As the city itself was mostly water (Venice is essentially a series of islands connected by canals), it was too humid for fresco painting. Venetian painters preferred to work in oil paint, using bold colors such as deep reds, blues, and golds inspired by the east. Venetian artists also continued to make intricate mosaics in the Byzantine style, and the city's architecture featured arches and domes more reminiscent of the east than the rest of Italy.

Who were the **Bellini brothers**?

Gentile and Giovanni Bellini, members of a highly regarded family of artists, were among the most influential Venetian artists during the Renaissance. Andrea Mantegna, another famous Venetian painter, was their brother-in-law. Gentile Bellini (c. 1430–1507) received many high status commissions from the city of Venice, including decorative work on the Doge's Palace, though most of his art has been lost. One painting that has survived is his portrait of Sultan Mehmet II, which he painted as a court painter in Constantinople. His work there highlights the ties between the two cities.

Giovanni Bellini (c. 1430–1517) is slightly more famous than his brother, and is regarded by some scholars the one of the most important artists of the Venetian Renaissance. He is known for his abilities to manipulate color, space, and form and completed important Christian-themed works on a monumental scale. In 1478 he painted *Virgin and Child Enthroned with Saints Francis, John the Baptist, Job, Dominic, Sebastian, and Louis of Toulouse* for the Chapel of the Hospital of San Giobbe. In this work, Giovanni Bellini masterfully creates the illusion of three-dimensional space as the Madonna and Child sit enthroned within a vaulted apse decorated with Byzantine-inspired paintings and mosaics. Bellini is clearly a master of perpsectival techniques, such as foreshortening, and creates a realistic architectural space with rich colors, and attention to detail on par with Northern European masters. The golds, reds, and blues, along with the ornate decoration and use of light, reflect the aesthetic values of the Venetian Renaissance.

Who was **Giorgione**?

Very little is known about the Venetian painter Giorgione. He was born in 1478 in the northern Italian town, Castelfranco, was a student under Giovanni Bellini, and died of the plague in 1510. He was an innovative painter credited with ushering in the High Renaissance in Venice. He emphasized landscape in his work, which was popular in Venice at the time, and rendered both landscapes and portraits meaningful through the extensive use of symbolism. According to the writer Vasari, Giorgione was inspired by the *sfumato* technique used by Leonardo da Vinci, and preferred to draw directly on the canvas, rather than do preparatory drawings on paper. Attributing specific paintings to Giorgione is extremely difficult and scholars have only confirmed five paintings as being from his hand. His most famous surviving painting, *The Tempest,* is of a forested landscape with a lightning storm in the background. A breastfeeding woman sits partially covered by some vegetation, while a red-jacketed solider watches her from afar. The mysterious painting enthralls scholars and other viewers, who continue to wonder at its meaning.

Who is **Titian**?

Titian is the nickname of Tiziano Veccellio, who started his career as Giorgione's assistant and went on to become the official painter to the Republic of Venice. Titian essentially picked up where Giorgione left off after his early death, and worked on a number of paintings attributed by some to Giorgione. Titian was a highly regarded painter during his long life and was even praised by Charles V, the Holy Roman Emperor, who wanted only Titian to paint his portrait. Titian worked in oil, and was known to finely grind his pigments and apply many layers of glaze to the surface of his canvas. As a result, Titian's paintings are nearly unparalleled in their vibrancy and color.

What is the *Venus of Urbino*?

Titian painted the *Venus of Urbino* for Guidobaldo della Rovere, the Duke of Urbino, in 1538. The painting is unabashedly erotic, depicting a nude woman reclining on a disheveled white sheet covering deep red cushions. Her long, red hair sweeps around

THE EARLY MODERN WORLD

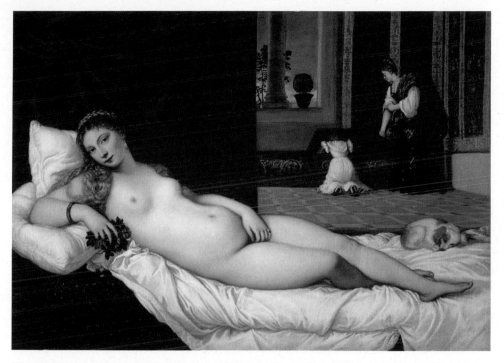

The artist Titian was a master painter from the northern Italian city of Venice. His work *The Venus of Urbino* (1538), carries on the tradition of depicting the reclining female nude and incorporates Titian's characteristic preference for deep-red color.

her neck and her hand rests gently along her hips, only partially covering her sex. She stares teasingly from within the frame, a tiny dog curled near her feet. In the background of the painting, two women appear to be rifling through a chest, collecting clothing. There is no question, Titian has created a goddess. The provocative painting, part of a long tradition of female nudes in the history of art, influenced artists even hundreds of years later. Manet's similarly bold, *Olympia* (1863), would not exist without the *Venus of Urbino*.

Why did **Veronese** get into so much **trouble**?

Veronese (1528–1588) was the nickname of Paolo Caliari, a painter from Verona who made his career in Venice during the second half of the sixteenth century. Many of his paintings celebrate the ornate architecture of the city and the well-heeled lives of its nobility. His seemingly harmless painting, *Feast in the House of Levi,* however, got him into trouble with the Catholic Inquisition. The painting was originally called *The Last Supper,* with Christ depicted in the center of a large, ornate hall, dining with a rather rambunctious crowd. The enormous painting, which is eighteen feet tall and forty-two feet long, included images of drunkards, a man with a bloody nose, cats, dogs, parrots, dwarves, and Germans—all of which the Inquisition found unacceptable in a painting of such a holy scene. In 1573, Veronese was called before the Inquisition and was asked, "Does it seem fitting at the Last Supper of the Lord to paint buffoons, drunkards, Germans, dwarfs, and similar vulgarities?" (as quoted in Stokstad 700). Veronese, who had made a few snarky responses to previous ques-

tions, merely replied, "no, milords." The Inquisition demanded that he "fix" the painting in three months or face further consequences. Instead, Veronese changed nothing about the painting except its name. No longer titled *The Last Supper,* the Inquisitors appeared to drop the matter.

SIXTEENTH–CENTURY EUROPEAN ART AND ARCHITECTURE

ITALY

What is **Mannerism**?

While many of the most successful artists of the early sixteenth century followed the Classical aesthetic so popular during the Renaissance, not everyone did. Overall, Renaissance artists valued naturalistic representations of the ideal human, both physically and mentally, and art with balanced, symmetrical, and proportionate forms. It can come as a shock, therefore, to see work such as Bronzino's *Allgeory with Venus and Cupid,* an erotic and slightly disturbing painting of Venus kissing her son, Cupid. The painting is filled with twisted, elongated figures. They appear weightless, limbs seem attached at odd angles, and the colors are off. Behind Cupid's contorted body, a woman screams, grabbing her hair. To the right, a cherub hurls flowers like a weapon. At his feet, theatrical masks depict ugly faces.

A strange and enigmatic art movement called Mannerism was popular amongst courtly artists who wished to differentiate themselves from the stoic masters of the High Renaissance. The Mannerist artist Bronzino painted *An Allegory with Venus and Cupid* in approximately 1545. The painting features a constricted, awkward sense of space, unusually twisting figures, and mysterious faces looming in the background.

Although *Allegory with Venus and Cupid* may be a sensational example, it is certainly not the only early sixteenth-century painting to exhibit such anomalies of naturalism. Other artists, including Pontormo, Parmigianino, and Benvenuto Cellini, favored what is known as the "mannerist" style in Italy. The definition of mannerism is controversial, but it is generally thought of as an intellectual and rebellious alternative to the refined styles of High Renaissance. It is characterized by elongated figures in unstable poses, the use of pastel colors, and sometimes, sexual overtones. Mannerist art was popular amongst courtly, rather than religious, patrons. While the style developed in Italy, it was also popular in Northern Europe.

Who was **Bronzino**?

"Bronzino" was the nickname of Florentine artist Agnolo di Cosimo (1503–1572), who studied under Pontormo, a fellow Mannerist painter. Bronzino's most significant patron was the Medici family, for whom he completed many projects, including altarpieces and frescoes. Today, his portraits are among his most well-known paintings, particularly his *Portrait of a Young Man,* painted in the 1530s, and now in the Metropolitan Museum of Art in New York. The identity of the young portrait sitter is unknown, but he is likely a friend of Bronzino's who ran in the same literary circles (Bronzino also wrote poetry). The sitter holds his finger gingerly between the pages of a book, eliciting curiosity about its contents. The well-dressed young man is poised, with good posture and an air of confidence that is only belied by his slightly crossed eyes. He seems to be fully aware of his own superficial airs; he is as much of a mask as the faces carved into the side of the ornate table. This is Bronzino's skill—the artist has an ability to purposefully pose his sitter for the viewer, to make us aware that we can only see the cover, and not the contents of the book.

Who was **Sofonisba Anguissola**?

It is true that most professional artists in Europe at this time were men; it was not easy for women to be accepted by patrons and male-dominated guilds. There were women artists, however, and the women who painted professionally were usually part of artist families, such as Caterina van Hemessen and the baroque painter Artemisia Gentileschi. The Cremonese painter, Sofonisba Anguissola (c. 1532–1625) was different. She was the oldest of seven children in a noble family whose father was a Classical enthusiast interested in giving a humanist education to all of his children. He recognized Sofonisba's natural talent and sent her to train under a respected local painter, Bernardino Campi. She gained esteem for her portraits, including a number of engaging self-portraits, as well as paintings of the Virgin Mary. She was asked by King Philip II of Spain to serve as a Lady in Waiting to his third wife, Isabel de Valois, an extremely high honor written about by Giorgio Vasari. There, she painted portraits of the Queen and experimented with mirrors in her self-portraits. In 1552 she painted a miniature portrait, a popular way of depicting friends and loved ones, in which she depicted herself holding a large medallion. Her name encircles the edge of the medallion while an interlaced monogram made up of her sister's names is in the center. The miniature is now at the Museum of Fine Arts, Boston.

Who was **Giambologna**?

Giambologna (1529–1608) was an extremely successful, late Mannerist sculptor who was known by many names, including Jean de Boulogne and Giovanni da Bologna. Though he was born in Flanders in Northern Europe, he worked in Florence, where he received support from the Medici family and other Flemish patrons living in the Italian city. Much of his work was done in marble and bronze; his work often features energetic figures engaged in dramatic physical activity, as well as graceful, elon-

gated female figures. He was a master at creating complex poses with multiple figures, including the *Rape of the Sabine* and the *Fountain of Neptune*. His most famous sculpture is probably *Mercury* (c. 1565), which represents the Roman messenger god (Hermes, in Greek) balancing delicately on a small puff of wind, blown by the god, Zephyr. Winged Mercury reaches one hand to the sky with a long finger pointing vertically, with one leg bent back, almost like a dancer. The sculpture was a gift from Cosimo de'Medici to Holy Roman Emperor Maximilian II.

What is the **Villa Rotunda**?

The Villa Rotunda was a residence designed by the architect Palladio in the 1560s. Palladio, who wrote *Four Books on Architecture,* was greatly inspired by the Roman temple form. He was interested in architectural theory, ideal proportions, and the Classical orders. Similar in form to the Pantheon in Rome, the Villa Rotunda is completely symmetrical, with a projecting portico on each square side and is topped with a hemispherical dome. Palladio's work went on to inspire architects for centuries, especially in Britain and the United States.

How did the **Reformation affect art** during and after the sixteenth century?

The Protestant Reformation had an enormous impact on all of Europe, forever changing the political power of the Catholic Church and shifting allegiances among European countries according to religion. The Reformation began in 1517 when Martin Luther published his *Ninety-Five Theses,* a declaration of protest against the Catholic Church, specifically with regards to the church's selling of indulgences, and questioned the authority of the pope. Luther even mentions the Pope's extravagant spending on the new St. Peter's Basilica project as a point of contention. Martin Luther was excommunicated by the Pope, but those who shared his feelings vowed to break away from the Church, resulting in violence that lasted decades. Those Christians who broke away from the Catholic church were called "Protestants."

During the sixteenth century, Europe was divided among countries that supported Catholicism, and those that supported the Protestants. The Catholic countries included: Italy, Spain France, Flanders, and Belgium. The Protestant countries were: England, Switzerland, Germany, and the northern Netherlands.

Protestant artists and patrons approached art differently than their Catholic counterparts. In Protestant countries, religious subjects were less in demand and most patrons were wealthy individuals who favored portraits, scenes depicting moral proverbs, still lifes, and eventually landscapes. In response to the Reformation, the Catholic church launched the Counter-Reformation in an effort to revive Catholic faith. Catholic patrons commissioned Christian art that emphasized reverence of the Trinity and of the Virgin Mary, as well as demonstrated restraint in the use of nudity and pagan subject matter.

Who was **Hans Holbein**?

Hans Holbein the Younger (c. 1497–1543) was a leading German painter who went on to become the court painter to English king Henry VIII. Holbein was a skilled realist with great ability to capture texture and fine detail. His work included religious paintings, prints, and even designs for stained glass windows, but he was particularly well known for his portraits, especially his portrait of Henry VIII in 1540. The painting depicts the formidably sized king dressed in his finest clothes against a dark background. The king wears an ornately embroidered coat with yellow, puffed sleeves, fine jewelry, and a feathered hat in celebration of his marriage to Anne of Cleves, his fourth wife. The oil paint captures the rich textures of the fabric and Holbein emphasizes the girth and power of the king's frame. The king's decision to invite a German painter, rather than an Italian artist, to his court highlights the strain between England and Italy after the Reformation.

Who was **Hieronymous Bosch**?

Hieronymous Bosch (1450–1516) was a successful painter from the Netherlands who painted large, complex, usually Christian-themed works of art that continue to puz-

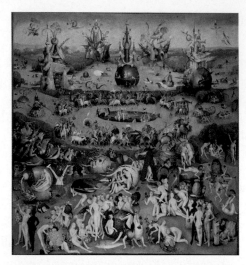

The Garden of Earthly Delights (c. 1500–1505) is a triptych by Netherlandish painter Hieronymous Bosch, whose three panels are devoted to scenes of Paradise, Earth, and Hell. For the modern viewer, Bosch's strange worlds evoke a sense of twentieth-century surrealism.

zle viewers and scholars to this day. An example of his imaginative and highly skilled work is the triptych, *The Garden of Earthly Delights,* which depicts The Garden of Eden on the left, earthly life in the center, and Hell on the right. On the exterior of the triptych, Bosch painted what scholars believe is the creation of the Earth. *The Garden of Earthly Delights* is filled with surreal imagery, such as a bulbous pink fountain, a sharp knife with a pair of human ears, figures cavorting inside transparent spheres, and monsters feeding on souls in Hell. While some scholars believe certain images are metaphors for alchemy (a tradition of science and philosophy focused on turning various metals into gold), the work is generally considered to be a critique of human behavior, suggesting that sin will be punished in Hell. Pieter Brueghel the Elder's *Netherlandish Proverbs* (1559), also known as *The Topsy Turvy World,* is similarly focused on human folly.

What is the *Isenheim Altarpiece*?

The *Isenheim Altarpiece* (c. 1510–1515) is a highly realistic altarpiece painting done by the German painter Matthias Grünewald, who was a painter at the court of the archbishop of Mainz. The work is complex, incorporating exterior paintings on the wings of the altarpiece with interior paintings that are revealed upon opening. The exterior subject is the Crucifixion of Christ, painted in gruesome detail and emphasizing Christ's suffering against a dark background. His fingers are bent and broken and his emaciated body hangs heavily from the cross. The interior paintings are completed on multiple panels and include *The Annunciation, The Virgin and Child with Angels,* and *The Resurrection.* These interior works are brightly colored and emphasize hope and joy over suffering. The physical act of opening the door is symbolic of the salvation that comes from Christ's sacrifice. The *Isenheim Altarpiece* is emotionally expressive and a powerful example of the role of art in the Christian tradition.

When did **printmaking begin**?

By the sixteenth century, printing technology, such as the woodcut, had been around for hundreds of years, first developing in China in the fifth century. Printmaking was first used to apply patterns to textiles, and then later was used on paper. Intaglio processes, such as engraving and etching, developed in Germany in the middle of the fifteenth century, evolved from techniques used by goldsmiths and jewelers. Printmaking allowed artists to make multiple copies of a text or an image, and mass production of prints began in the sixteenth century, forever changing the consumption of art images and texts.

Who was **Albrecht Dürer**?

Albrecht Dürer (1471–1528) was a Great Master from Germany known for his immaculately detailed drawings, paintings, and prints. He wrote a book of advice for artists called, *Four Books of Human Proportion,* and was known to be self-confident and scientifically minded. Like Leonardo da Vinci, Dürer was interested in the observable world. He trained as a goldsmith; this is likely where he gained the skills and experience needed to become a successful printmaker, a form that allowed him to demonstrate his great skill in working with line.

Dürer's skill was clear from a young age. At thirteen, he completed a self-portrait upon which he wrote, "Here I portrayed myself in the year 1484 in a mirror when I was still a child" (as quoted in Woods, p. 54). Later self-portraits emphasized the luxurious texture of his long, flowing hair, and one of his most impressive drawings is *A Hare* (1502) in which Dürer masterfully depicts the sheen of a hare's fur in watercolor.

Dürer's woodcuts, engravings, and etchings did a great deal to raise the status of printmaking to a fine art. Two of his most well known prints are *The Four Horsemen of the Apocalypse* (1497–1498) and *Melancholia I* (1514).

SPAIN

What is **El Escorial**?

El Escorial is an enormous monastery-palace built by Spanish king Philip II in Madrid between 1563 and 1584. Philip II took over control of Spain after his father, the Holy Roman Emperor Charles V, abdicated. Philip was therefore one of the most powerful rulers in Europe, controlling territories in Spain, the Netherlands, Milan, Burgundy, Naples, and even

The German painter and draftsman Albrecht Dürer is known for his immaculate realism and interest in drawing and printmaking. *Melancholia I* (1514) is an engraving that explores themes of creativity, inspiration, and depression.

The sixteenth century artist El Greco worked primarily in Toledo, Spain. *The Burial of the Count of Orgaz* (1586), which depicts the laying to rest of a generous, pious man in the presence of heavenly figures, is one of El Greco's most famous works.

the Americas. Philip II was a devout Catholic and El Escorial combined a seminary, convent, and basilica with a royal palace. The main architect was Juan Bautista de Toledo until his death, when Juan de Herrera took over, eventually completing the project. The building design is reminiscent of Italian Classicism, but it is formidable and severe, reflecting the power of the Spanish crown.

How can **El Greco's paintings** appear so **modern**?

To some, the paintings of El Greco appear more closely related to nineteenth-century impressionism or twentieth-century expressionism than the sixteenth-century Spanish styles of nearly five hundred years earlier. His work is characterized by loose brushstrokes, often ghostly, elongated figures, and a use of colors in line with the Mannerists. El Greco's real name was Domenikos Theotokopoulos and "El Greco" means "the Greek" in Spanish. Born in Crete in 1541, he worked in Italy before arriving in Toledo, Spain, with the unfulfilled goal of becoming an artist in the court of Philip II. Although the king didn't favor El Greco, he did find many other patrons. His 1586 painting *The Burial of Count Orgaz,* depicts the soul of the dead count as it rises to heaven, accompanied by an angel, and surrounded by an audience of saints, holy figures, and well-known individuals from Toledo. The figures are pale, ghostly, and white, which contrasts with the bright yellows worn by the clergy and the red fabrics worn by the Virgin Mary in heaven. The painting is arguably similar in style to Italian mannerists such as Pontormo, and El Greco is considered by some to be a Mannerist painter.

ISLAMIC ART AND THE OTTOMAN EMPIRE

What was the **Ottoman Empire**?

The Ottoman Empire was a Turkish state founded in the thirteenth century by Osman I, who then expanded his territories, eventually dislodging Byzantine rulers and taking over Constantinople in 1453. Constantinople, now called Istanbul, became the capital of the Ottoman Empire, which by the fifteenth century controlled large portions of North Africa, the Middle East, and the Mediterranean. The Ottoman Empire

was one of the longest lasting powers in history, only falling in 1922 when Turkey became a republic.

How was the **Hagia Sophia** converted to a **mosque**?

When the Ottoman Turks took control over the former Byzantine Empire, the Hagia Sophia, which had been built as a cathedral by Emperor Justinian in the sixth century, was converted into a mosque. The conversion of the Hagia Sophia was an important symbol of power for the conquering ruler, Sultan Mehmet II. Many of the Byzantine mosaics were covered in plaster and certain elements, such as the altar, were removed. Elements of Islamic architecture were incorporated into the building, such as the mihrab (a niche that indicates the direction of Mecca for prayer), as well as the large minarets outside. In the twentieth century, the Hagia Sophia became a public museum, and many of the Byzantine mosaics were restored.

Who was **Suleiman the Magnificent**?

Suleiman I, known as Suleiman the Magnificent (1494–1566), ruled the Ottoman Empire from 1520 until his death. He was trained as a goldsmith and was a great patron of the arts. Under his rule, ceramics, calligraphy, manuscript illumination, metalworking, textiles, and architecture flourished. Suleiman supported a royal painting society, the Naqashkhane, whose styles greatly influenced other artists throughout

The Gur-e-Amir, or "Tomb of the King" in English, is the mausoleum for the Aslan ruler Tamerlane, in Samarkand, Uzbekistan, and an example of fifteenth-century Persian architecture.

the Ottoman Empire. A good example of the Naqashkhane style is in their design for the Sultan's imperial signature, known as a *tughra*. It features bold, sweeping lines and ornate organic decoration done in ink and watercolor on paper. It incorporates both abstract design and calligraphy, and includes the name of the Sultan as well as the phrase "the eternally victorious."

Who was **Sinan the Great**?

Sinan the Great (c. 1489–1588), whose full name was Koça Mimar Sinan Aga, was arguably the most famous architect in Islamic history, designing over three hundred buildings, including the Mosque of Selim II, which is considered his masterpiece. Also known as the Selimiye Mosque, the Mosque of Selim II was built between 1569 and 1575 in Edirne, Turkey. Sinan designed it when he was almost eighty years old, and his goal was to surpass the great architecture of the previous Byzantine Empire. He created a larger dome than that of the Hagia Sophia from base to crown. The building's interior is a masterwork of mathematical proportion and geometry, fusing an octagon with a dome-covered square, with four half-domes in each corner.

What is **Islamic tilework**?

Islamic art has a long tradition of decorative tilework, which was used to decorate the walls and other surfaces, both interior and exterior, of important buildings such as mosques and palaces. The sixteenth and seventeenth centuries were considered to be a "Golden Age" of Islamic tilework. Tile mosaics, in which glass or ceramic are organized into decorative patterns and then plastered, was one very popular technique. Another was known as dry cord tilework, also known as *cuerda seca,* first popularized in Spain during Umayyad rule. This process relies on large pieces of multicolored tiles, rather than smaller, individually colored fragments. Buildings such as the Imam Mosque to Isfahan, Iran, are covered in intricately patterned tiles in astonishing geometric and abstract forms.

What is a **miniature painting**?

Particularly popular in Persian, Ottoman, and Mughal traditions, miniature paintings are small works on paper, whether book illustrations or separate paintings kept in albums (known as a *muraqqa*.) Miniature paintings were not framed and not displayed on walls, but were meant to be held in one's hands. Miniature painting required years of training and apprenticeship to create. One of the most important centers of miniature painting was the royal Herat School in Afghanistan, where students were instructed on painting and calligraphy. During the early sixteenth century, the school was moved to Tabriz, Iran. Miniature painters sat on the ground with one knee bent to support the painting board. Multiple layers of colors derived from pigments were applied, including gold, and then the painting was burnished.

Who was **Bihzad**?

Kamal al-Din Bihzad, referred to simply as Bihzad, was one of the most famous Persian manuscript painters during the fifteenth century. He was born around 1450 in

the city of Herat, in modern-day Afghanistan. He worked for royal courts under both Timurid and Safavid rule. (The Timurid rulers descended from Genghis Khan, and were succeeded by the Safavids as rulers of Iran.) Bihzad's paintings are characterized by vivid color, dynamic detail, and warping perspective. His work notably includes representations of figures, something more common in Persian and Indian painting than other Islamic art.

One of Bihzad's most famous miniature paintings is *Seduction of Yusuf* (c. 1488), a story included in both the Bible and the Qur'an. In the story, Yusuf (Joseph) is seduced by Zulaykha, the wife of Potiphar. According to the Persian version of the tale, Zulaykha led Yusuf through seven rooms of her palace, locking the door of each room behind her. In the final room, she propositioned Yusuf, but he was able to escape when the doors were miraculously unlocked. In the

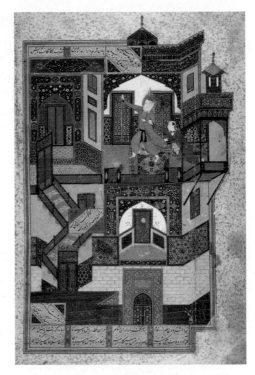

Islamic art maintains a long tradition of miniature painting. This highly detailed illustration, *Seduction of Yusuf*, was painted by the fifteenth-century Persian master Bihzad.

painting, zigzagging beige panels contain the actual Arabic text of the story at the top, bottom, and in the middle of the manuscript page. Zulaykha's palace is made up of intricately decorated, multicolored panels connected by angled, polygonal staircases. This geometric, two-dimensional painting gives the illusion of three-dimensional space and is a masterpiece of Persian manuscript painting.

AFRICAN ART

What is the **art of Benin**?

Benin, also known as the Edo Empire, was an important African state that lasted from 1440 to 1897. The heart of the empire, Benin City, was located about 150 miles away from Ile Ife in Nigeria. Similar to Ile Ife, Benin had a long tradition of memorial sculpture and shrines were built in honor of deceased *obas,* or kings. Popular materials for sculpture included ivory and bronze, and it is partly because of the use of these durable materials that more art from Benin has survived than from other African cultures from this time period. The power of the Edo Empire peaked in the sixteenth century and succumbed to the British Empire towards the end of the nineteenth century. Many of Benin's art treasures are now part of the British Museum and other Western institutions.

What is the **Queen Mother pendant mask**?

The Queen Mother pendant mask likely represents Idia, the mother of Oba Esigie, who ruled Benin between 1504 and 1550. Nearly ten inches tall, it is made of carved ivory and was meant to be worn at the hip. The face of Idia is skillfully carved in a highly naturalistic style, with powerful eyes and stylized hair. Along the top and bottom of the mask are carved images of Portuguese soldiers, with whom Benin had an amicable trade relationship. The solider images alternate with images of the mudfish, which was symbolic of wealth, creativity, and the sea. A second, nearly identical, pendant mask was also carved from the same piece of ivory. One is in the British Museum while the other is at the Metropolitan Museum of Art in New York.

What are the **Sapi saltcellars**?

Sapi saltcellars, made of ivory, were a result of Portuguese trade relationships with artists along the coast of West Africa. The Portuguese commissioned luxury goods such as spoons, forks, decorative boxes, and saltcellars. At the time, salt was itself a luxury good that only the rich could afford, and an exotic, carved saltcellar was a symbol of wealth. Art historians have identified what they think are three individual Sapi carvers who produced much of the work. The styles of the saltcellars are a blend of African and Portuguese influence, mixing Christian imagery and European hunting scenes with royal iconography familiar within the Benin art historical tradition. In a way, the Sapi saltcellars are the first example of tourist art in Africa, as these were objects created with the intention of exporting them.

ART AND ZEN BUDDHISM

What is a **zen garden**?

Zen is a Japanese form of Buddhism that emphasizes meditation as a method of breaking free of everyday distractions to reach enlightenment. (In China, this is known as Chan Buddhism.) Zen gardens are an important part of the Buddhist tradition, as they are thought to aid in meditation and facilitate a sense of calm. The Sai-

What is *feng shui*?

In Chinese, *feng shui* literally means, "wind-water." At the heart of *feng shui,* which is a Daoist belief system, is the concept that invisible energy flows known as "dragon lines" or *qi* can have an effect on human lives. Architects concerned with feng shui would take this energy into consideration when planning or designing a building. Humans also have the power to affect *qi* by landscaping and building canals, for example. *Feng shui* consultants continue to advise architects on ideal designs for buildings, especially in China.

hoji temple in Kyoto, Japan, is sometimes called the Moss Temple because of its meticulously manicured moss gardens. The temple was founded in the eighth century, and its gardens were redesigned according to Zen philosophies during the Muromachi period in the fourteenth century. Monks meditate in the mossy lower gardens, while rocks dominate the upper gardens, suggesting the drama of mountains. Some Zen gardens focus completely on rock arrangements, such as the rock garden at the Ryoanji Temple in Japan.

What was the **Orchard Factory**?

The Orchard Factory was a Chinese imperial palace workshop during the Ming Dynasty (1368–1644). The Orchard Factory primarily produced lacquered wood furniture and decorative objects of astonishing quality. Lacquer is a clear wood finish derived from tree sap that acts as a preserver. Lacquer can be colored with

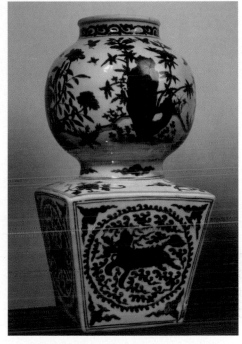

Blue-and-white painted porcelain from the Ming period is among the most expensive and most highly sought after ceramics in the world. (*Art courtesy The Art Archive / Musée Guimet Paris / Gianni Dagli Orti.*)

pigments. Multiple layers of lacquer can be carved, and it can also be inlaid with precious stones and metals. A fine example of the lacquer work likely produced by the Orchard Factory is a Ming-era folding chair dating from the mid-sixteenth century, now at the Victoria and Albert Museum in London. The folding chair, used by Chinese emperors while traveling, is ornately decorated with stylized dragon and lotus flower motifs.

What is **porcelain**?

Porcelain is a type of fine ceramic that supposedly got its name from Marco Polo, who first visited China from Europe in the thirteenth century. There are two types of porcelain: hard-paste (known as true porcelain) and soft-paste (known as artificial porcelain). Hard-paste porcelain was first developed in China in the seventh or eighth century, and wasn't seen in Europe until the early eighteenth century. Porcelain is made of fine white clay and requires a very high temperature in the kiln when fired. Blue-and-white painted porcelain from the Ming period is among the most expensive and most highly sought after ceramics in the world. Ming painters used cobalt glazes from Persia and designed heavily outlined images; dragons and nature themes were very popular.

ART IN THE NEW WORLD

What is **Machu Picchu**?

Machu Picchu was a fifteenth-century royal estate constructed by the Inca king Pachakuti, high in the Andes mountains near Cuzco, Peru. A great deal of mystery and wonder surrounds this long-forgotten and well-preserved site, which caught public attention (and public imagination) after American archeologist Hiram Bingham studied it in 1911.

Machu Picchu sits at an elevation of nine thousand feet; the site consists of stone buildings, terraced farm plots, open plazas, and religious shrines. The architecture at Machu Picchu matches other Inca sites and was built out of granite using Inca masonry techniques, a style of stone construction that consisted of joining "pillow-shaped" blocks without mortar. Similar construction can be seen throughout the city of Cuzco, as well as on a large scale in the fortress-palace, Sacsahuaman, in the hills outside of the city.

What are **Mixtec mosaics**?

The indigenous Mixtec people of Mexico and Central America were well known for their skills in pottery, metalworking, and mosaics. They used the mosaic technique to make brightly colored masks and used materials such as turquoise and pearl oyster shells to create colorful, luminescent pieces. *The Skull of the Smoking Mirror* is a sixteenth-century Mixtec mosaic mask that depicts the powerful god Tezcatlipoca. The mask itself is supported by a real human skull with the back removed and deer-skin straps attached, enabling the mask to be worn. The eyes of the mask are made with reflective iron pyrite and white shells, while the face is decorated in white, black, and turquoise stripes. As the materials needed to create this mask, such as turquoise, and black lignite, were difficult to source, it is clear that this was a highly valued object requiring time and effort to create. It also important to note that this mask was meant to be worn and had an important ritual function. The mask is now part of the collection at the British Museum.

What is the **Codex Zouche-Nuttall**?

The Codex Zouche-Nutall (c. 1350–1400) is a folded pictographic manuscript from the Post-Classic Mixtec culture in Mexico, one of the few to survive. The ten-inch high manuscript, made of deerskin, contains about forty-six folded pages and when stretched out reachers over thirty-six feet. Each side of the folded codex contains a different story, one telling the history of the Mixtec region, and the other explaining the genealogy and political successes of Eight Deer Jaguar-Claw, a powerful eleventh-century Mixtec ruler. The Codex Zouche-Nuttall is the oldest Mixtec history known by scholars.

What is the **significance** of the **Aztec eagle-man**?

The "eagle-man" (c. 1440–1469) is a sixty-seven-inch high, fired clay sculpture depicting a youthful man wearing an eagle-shaped helmet and long, winged sleeves. The

Also called the Sun Stone, the Aztec Calendar Stone weighs twenty-five tons. The circular stone is carved with symbols that represent Aztec concepts of time and cosmology.

upper portion of the sculpture is well rendered, but overall, the body is simplistic, and it was possibly dressed in military garments. The sculpture perhaps depicts an Aztec warrior. Aztec warriors were known for their fearlessness and ferocity.

What is the **Aztec Calendar Stone**?

Like the Mayans, the Aztec were deeply interested in calendars, which were linked to concepts of creation. The Aztec Calendar Stone (c. 1502–1520) is large—over eleven feet in diameter and over twenty-five tons. Also called the Sun Stone, the carved stone emphasizes the Aztec concept of cyclical time and reflects the Aztec's cosmology and mythology. At the center of the stone is an image of the creature Ollin, its tongue in the shape of a knife. Also depicted on the stone are the first four suns, and the bodies of two fire gods, according to Aztec tradition.

The monumental carving is not exactly a marker of time, though there are markings that indicate the twenty-day Aztec calendar, and the date of the birth of the current (fifth) sun. The stone was excavated in the center of Mexico City, which now lies at the heart of the former Aztec empire: the city of Teotihuacán. Teotihuacán was considered the birthplace of the fifth and current sun, and was the political center of the empire. Although the meaning of the Aztec Calendar Stone remains mysterious, its image continues to influence modern Mexican art and culture.

What is **Moctezuma's crown**?

Moctezuma was the Aztec leader at the time of the Spanish conquest of the Aztec empire, led by Hernán Cortés. His crown was made of colorful feathers (from birds such

133

as macaw parrots and the quetzal bird), which were gathered into bunches and then sewn into a reed frame studded with precious stones. The long feathers of Moctezuma's crown are dark green and the reed frame is painted in bright reds and light blues. The provenance of the crown has come under much scholarly debate but there is evidence that the crown was given to Cortés by Moctezuma himself. The crown was sent back to Europe on one of Cortés' ships and given to Charles V, the Holy Roman Emperor and king of Spain. The headdress is currently in Austria, and negotiations are underway for the Austrian government to loan the crown back to Mexico for the first time in over five hundred years.

BAROQUE AND BEYOND, c. 1600–1850

BAROQUE ITALY AND FRANCE

Is **"baroque"** a **bad word**?

The word *baroque* comes from the Portuguese word, *barocco,* which means "imperfect pearl." The suggestion is that while baroque art is as lovely as a pearl, it lacks the perfection and balance characterized by the Renaissance art that preceded it. Baroque art initially was used to describe a style of art that was more dramatic and intense than art from the Renaissance, but the term is sometimes used to refer generally to the seventeenth century in Europe. The term baroque can also refer to architecture, music, dance, and literature. Some of the most famous baroque artists include Caravaggio, Bernini, Rubens, Poussin, Rembrandt, and Velázquez. As with many art historical categories, the definition of "baroque" can be relatively flexible.

How did the **world change** during the **baroque period**?

Between the mid-sixteenth century and the mid-eighteenth century, Europe and the rest of the world went through significant changes. During this time, Europeans were engaged in the "Age of Exploration"—they sent out fleets of ships into the world's oceans with various goals, including competition between one another for political domination, economic expansion, and religious conversion of the people in the so-called "New World." In Europe, the Thirty Years War raged on from 1618 to 1648, forever shifting power on the continent, and weakening the Holy Roman Empire. Many significant scientific discoveries also took place during the baroque period, including Isaac Newton's discovery of gravity. Philosophy was impacted by Descartes' revolutionary statement, "I think, therefore I am," making him the "Father of Modern Philosophy."

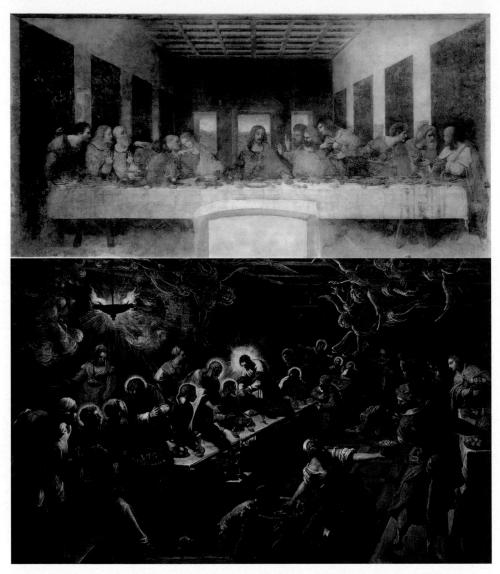

Italian artists Leonardo da Vinci and Tintoretto both painted the Last Supper, but their styles represent two distinct movements. The balanced and symmetrical scene by da Vinci (above) reflects the values of the Italian Renaissance, while the strong diagonals and sharp contrasts between dark and light tones painted by Tintoretto, in 1594, are hallmarks of the baroque.

What is the **difference** between the **Baroque** and the **Renaissance**?

One of the main giveaways that you are looking at a baroque painting rather than a work done in the Renaissance is the overall dramatic effect. Whereas paintings from the Renaissance are evenly lit, balanced, and symmetrical, baroque paintings usually feature strong diagonals, intense contrasts between dark and light tones (chiaroscuro), and ornate decoration.

Swiss art critic Heinrich Wölfflin created a list of "polarities," or points of contrast between renaissance and baroque art in his influential text, *Principles of Art History*. These polarities can be applied to architecture, painting, and sculpture. The

final two (indicated with an *) are the most complex, and are controversial amongst art critics and historians. When reading through these contrasting characteristics, think about Leonardo da Vinci's *The Last Supper* (c. 1495–1498) as a good example of a Renaissance painting, while Tintoretto's *Last Supper* (1594) is more characteristic of the baroque style.

Wölfflin's Polarities

Renaissance Art	Baroque Art
Linear (the piece can be easily outlined)	Painterly (there are so many details that line alone is not enough to define the piece)
Plane (the work appears flat)	Recession (the work has depth)
Closed (it is impossible to imagine anything outside of the picture plane)	Open (there is a sense that the world of the painting extends beyond its frame)
Multiplicity* (each part of the piece stands out as an independent unit; similar to linear)	Unity* (the artwork is so complex that it must be viewed as a whole, rather than as a collection of independent units)
Absolutely Clear* (there is less room for interpretation as to meaning, light often shines equally on all images in the piece)	Relatively Clear* (the work is less clear; there is more room for interpretation)

What is the **Church of Il Gesù**?

Built in the late sixteenth century by Giacomo della Porta, the Church of Il Gesù has what is considered to be the first baroque façade in architecture. The church was built in Rome for the Order of the Jesuits. Its plan was similar to the traditional cruciform basilica-plan, with a long nave and aisles. It was topped with a cupola, a small dome. More shocking at the time was the church's exterior. The façade is divided into two stories and blends Roman, Greek, and Renaissance architectural motifs such as doubled pilasters, engaged columns, arched pediments, triangular pediments, niches, windows, Corinthian capitals, and large, scrolling volutes. Despite the many disparate elements, the church façade is not overwhelming or chaotic. Patterns emerge to create a rich, unified space. The ornamental façade of the Church of Il Gesù greatly inspired the elaborate architecture of the baroque period.

Who was **Bernini**?

The art of Gianlorenzo Bernini (1598–1680) defines baroque style. Bernini was primarily a sculptor, but he also worked as an architect, painter, and poet. His sculpture is exceptionally naturalistic; it lives, breathes, and occasionally screams with life. Bernini was a charismatic player in the upper echelons of Rome's high society who was famous by age twenty. He was patronized by popes and aristocrats and was known for his cool confidence. Some of his highest profile commissions include the design for the *Baldacchino,* a bronze canopy in St. Peter's Basilica, and *The Ecstasy of St. Teresa,* a marble sculpture in Santa Maria della Vittoria in Rome. Bernini experienced a hiccup in his success when his part of the redesign for the façade of St. Peter's

137

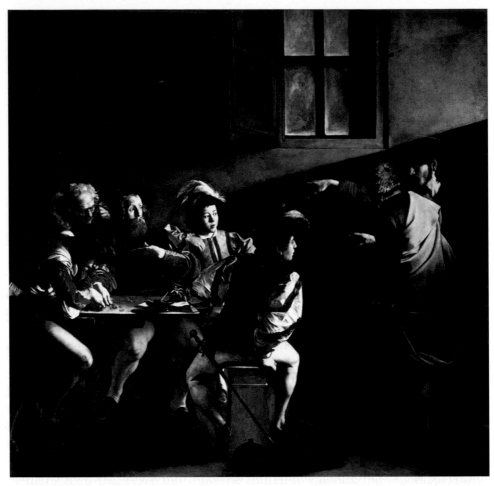

The baroque artist Caravaggio used the elements of everyday life in Rome to give his religious scenes potency during the Counter-Reformation. In *The Calling of St. Matthew* (1599–1602), Christ enters a dimly lit space with his hand outstretched in a manner similar to Adam in Michelangelo's *Creation of Adam* fresco from the Sistine Chapel.

figures. (One does not usually see Christ walk into a bar, for example.) The painting is a good example of Caravaggio's use of tenebrism, an exaggerated form of chiaroscuro with sharp contrasts of dark and light. Caravaggio's style of tenebrism was hugely popular during the baroque period, and was used by artists from Rembrandt to Zurbarán. *The Calling of Saint Matthew* focuses on a familiar theme for Caravaggio, that of the redemption of even the most sinful souls.

Who was **Artemisia Gentileschi**?

Like other *caravaggisti,* or followers of Caravaggio, the work of female painter Artemisia Gentileschi (1593–c. 1652) is characterized by dramatic diagonals, naturalism, chiaroscuro (contrasts of dark and light), and powerful subject matter. She was arguably the most successful female artist of her day. She worked for the Duke of Tuscany and was the first female member of the Florentine Academy of Design. She is known for her paintings of the Old Testament story of Judith beheading Holofernes,

a popular scene in the sixteenth and seventeenth centuries, and often analyzed in relation to a rape she suffered at the hands of her tutor when she was seventeen years old. Male or female, Artemisia Gentileschi was one of the most skilled naturalist painters of the baroque period.

What is **baroque classicism**?

Baroque classicism is a specific style of baroque art that draws heavily on classical influences and is characterized by refined idealism, realism, and an interest in antiquity. The dramatic use of chiaroscuro is not quite as evident in baroque classicism. It was most popular in France, and preferred by the painters such as Nicolas Poussin, Claude Lorrain, Charles Le Brun, and the architect Louis Le Vau. Some art historians consider the Italian Annibale Carracci, whose work greatly influenced Poussin, a classicist as well.

Who was **Nicolas Poussin**?

Nicolas Poussin (1594–1665) was a French painter who spent a great deal of time studying and working in Rome, where he was greatly inspired by the Roman ruins he saw there. Poussin was an intellectual artist who was favored by similarly minded patrons. He is known for his sophisticated subjects inspired by philosophy, ancient

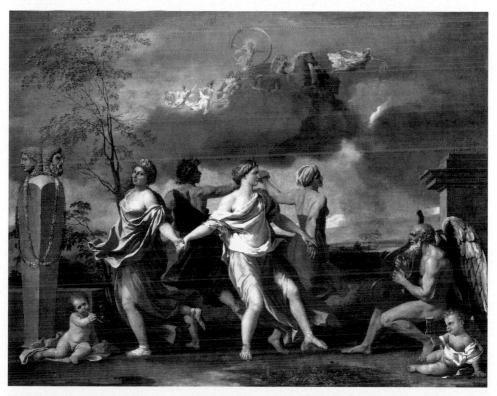

Nicolas Poussin's complex painting *A Dance to the Music of Time* (c. 1638–1640) draws its inspiration from classical mythology and is an example of the classical baroque style.

history, and the Old Testament. His fascinating painting, *Dance to the Music of Time* (c. 1638–1640) is full of complex symbolism. In the center of the painting, four maidens (or possibly three maidens and one male) wearing Roman clothing hold hands and dance in a circle to the beat of the lyre, played by a winged and bearded personification of Time. Tiny cherubs play around their feet. One blows bubbles while the other holds an hourglass, symbols of the fragile and fleeting nature of life. Next to the dancers is a tall sculpture depicting the two-headed Roman god, Janus, whose faces can see both into the future and into the past. In the sky above, Aurora, the dawn, leads Apollo, whose chariot arcs across the sky, bringing with it the sun. The painting draws heavily on classical figures and has a stoic, serious tone closely associated with Classical art. The dancers are thought to be personifications of both the four seasons, as well as representations of human progress—specifically poverty, labor, wealth and luxury. Although the painting has been interpreted in many ways, it is perhaps a representation not just of the fragility of life, but the impermanence of all civilization.

Who was **Annibale Carracci**?

The paintings of Annibale Carracci (1560–1609) were innovative for their naturalism, broken brushstrokes, and use of light. Carracci came from an artistic family; his older brother Agostino, and his cousin, Ludovico, were also highly esteemed painters. Carracci was particularly inspired by northern Italian Renaissance masters such as Titian, Correggio, and Tintoretto, and he wanted to carry on a tradition of Classically inspired painting. He studied in Rome, where he was impressed with the work of Michelangelo and Raphael. Like them, he went on to create masterfully illusionistic frescoes and ceiling paintings. In 1595 he was commissioned by Cardinal Odoardo Farnese to decorate the Farnese Palace in Rome. His work there is a baroque masterpiece known as *The Loves of the Gods,* a cycle of ceiling frescoes. It took nearly ten years to complete the paintings, which cover the barrel-vaulted ceiling of the palazzo and feature monumental scenes depicting mythological gods and heroes. Carracci's work went on to inspire other great fresco artists, such as Pietro da Cortona, as well as other painters, including Poussin and Rubens.

Why did **Louis XIV build** the palace of **Versailles**?

From 1638 to 1715, King Louis XIV—the Sun King—reigned over France with absolute power. During his rule, France was the most powerful country in Europe. In the 1660s, Louis XIV made a radical decision to renovate Louix XIII's country hunting lodge and transform it into France's new royal palace: Versailles. This change meant that the aristocrats, diplomats, and all servants would leave the Louvre in Paris and move to the relatively isolated country location. Architects Louis Le Vau and Charles Le Brun oversaw the redesign of Versailles and the finished building was a massive, nearly city-sized structure with enough space for over twenty thousand people, including fourteen thousand servants. The scale was unprecedented. The Palace of Versailles is an enormous, formidable structure with a severe, classical exterior, manicured gardens, and opulent interiors.

The magnificent palace at Versailles solidified King Louis XIV's position as the absolute ruler of France. Calling himself, the "Sun King," the king's architects incorporated many sun symbols into the palace design.

Besides any political motivations Louis XIV may have had for relocating the palace, Versailles also served to glorify this powerful king. As the Sun King, Louis XIV emphasized his divine right to rule and his unquestionable power. The king's bedroom was at the center of the palace. He performed elaborate morning and evening rituals that represented the rising and the setting of the sun. The great Hall of Mirrors, also in the center of the palace, is 240 feet long with 47-foot-high ceilings. The hall gets its name from the hundreds of mirrors and glass panels that inundate the room with sunlight. The vaulted ceiling in the Hall of Mirrors, inspired by Carracci's work at the Farnese Palace, were painted by Charles Le Brun and feature images of classical gods and the military successes of the king. The gardens surrounding the palace were designed by Louis Le Vau and André Le Nôtre. The gardens are made up of pools, monumental sculpture, and thoughtfully planned paths. The formal gardens at Versailles are carefully manicured, further emphasizing the wealth and power of the king.

DUTCH AND FLEMISH PAINTING

Who was **Peter Paul Rubens**?

Peter Paul Rubens (1577–1640) was a Flemish painter whose work is characterized by a rich, painterly style and a lively, expressive tone. His paintings are often monumental in size, include deep red colors (a favorite of Rubens), and were sought after by both aristocratic and Catholic patrons. He painted mythological, genre, and Christian subjects. Rubens worked for patrons such as King Charles I of England, the

143

Who was **Zurbarán**?

Like Velázquez, Francisco de Zurbarán (1598–1664) was influenced by Caravaggio and is known for his powerful paintings of saints and martyrs, as well as his highly realistic still lifes. One of Zurbarán's most powerful paintings is *Saint Serapion* (1628), which depicts the deceased saint after he sacrifed himself in exchange for captives held by the Moors. Against an inky black background, the saint's body is illuminated, leaning forward against his restraints. Powerful light reflects off of his long white robes, which look incredibly real. A similar contrast of light and dark is evident in another painting *Agnus Dei* (c. 1635–1640), in which a white lamb dominates the picture plane, its feet tied in a suggestion of sacrifice. The simplicity of Zurbarán's images belies moving spiritual connotations and profound visual impact.

What is Murillo's *Immaculate Conception*?

Bartolomé Esteban Murillo (1617–1682) was an important Spanish painter based in Seville whose art emphasized images of the Virgin Mary and the saints, and was painted according to rules set out by the leaders of the Catholic Counter-Reformation, which specified the manner in which the Virgin Mary could be depicted. Murillo painted multiple different paintings of the Immaculate Conception including *The Immaculate Conception of the Escorial* (c. 1678), which conforms to these rules. The Immaculate Conception is a Catholic Doctrine, not fully accepted as dogma until the nineteenth century, stating that the Virgin Mary was born without Original Sin. In Murillo's painting, Mary is clothed in blue and white and she appears suspended in

a glowing, heavenly space surrounded by cherubic angels. Her face looks upward, her hands are held in prayer, and her feet gingerly rest upon a delicate crescent moon, an image derived from Revelation 12:1, "And there appeared a great wonder in Heaven: a woman clothed with the sun and the moon under her feet" (as quoted in Janson 696). The delicate sweetness of Murillo's paintings influenced Spanish painters in the New World for nearly two hundred years.

Murillo's light-filled paintings of the Immaculate Conception inspired Catholic artists for hundreds of years in both Spain and Latin America.

ASIAN ART

Did **Chinese painting change** during the **Qing Dynasty**?

The Qing Dynasty was a Manchurian imperial power that ousted the previous Ming rulers and controlled China from 1644–1911. For many Chinese, espe-

cially Ming loyalists, this political shift was traumatic and frightening. However, although the Manchurians were a foreign power, they adopted many Chinese art traditions favored by the Ming. Multiple schools of painting developed during the Qing era, including the Orthodox School, which drew inspiration from the earlier Literati painters, and the Individualist School. Individualist painters focused on expressing their personal feelings during the tumultuous time of the Qing takeover. Leading painters of the era included Shitao (1642–1707), an Individualist painter who traced his ancestry to the first Ming emperor. When the Qing took over Beijing, he fled and went into hiding, and then became a Chan Buddhist monk. He wrote extensively on art theory, including his most well known tract, *Sayings on Painting from Monk Bitter Gourd,* which espoused the significance of the single brushstroke. His work balances expressive energy with soft tones, and is notable for it's tendency toward abstraction and use of negative space to create a sense of depth. Shitao was one of the most famous Individualist painters because of his innovative manipulations of traditional forms of Chinese painting.

What is a **tea ceremony**?

The traditional tea ceremony began in China, but became extremely popular in Japan, especially during the Momoyama period (1573–1615). The tea ceremony was known as *chanoyu,* which literally translates to "hot water for tea." These ceremonies were held in the tea houses, or *chashitsu,* of castles and palaces made of simple materials such as unfinished bamboo. The Japanese tea ceremony is very quiet and can last as long as four hours. Rules dictating movement and speech are linked to the purposeful actions of Buddhist meditation. In a way, the tea ceremony is like theater, or performed poetry, in which social etiquette is elevated to religious ritual and participants are immersed in thoughts of social harmony, humility, peace with nature, and a distance from the artificiality of the material world.

What is a **painted screen**?

In Japan, painted folding screens, called *byobu,* were popular in the imperial houses of the elite military rulers of the Momoyama period. While many of these castles and houses no longer exist, seventeenth-century screens made by the Kano family remain. Compared to Western standards, seventeenth-century Japanese houses were very empty, with no furniture or decorative trinkets filling interior spaces. Instead, moveable screens were painted in bold colors, often depicting nature, landscapes, and genre scenes. Painted screens by the Kano family include *Cypress Tree,* an eight-fold work attributed to Kano Eitoku (1543–1590), which was originally used as a sliding door. The artist emphasized the texture of the bark of the tree while simplifying the background, which serves to monumentalize the tree and evoke the vastness of nature.

How did **Korean art change** during the **Choson period**?

The Choson Dynasty lasted in Korea from 1392 until 1910, when Japan annexed the country. During this very long period, Korean art was heavily influenced by Chinese art styles and ideas, but a specifically Korean, often secular, style of art slowly devel-

BAROQUE AND BEYOND

149

Painted screens by the Kano family include *Cypress Tree,* an eight-fold work attributed to Kano Eitoku (1543–1590), which was originally used as a sliding door. The artist emphasized the texture of the bark of the tree while simplifying the background, which serves to monumentalize the tree and evoke the vastness of nature. (*Art courtesy Tokyo National Museum, Japan / The Bridgeman Art Library.*)

oped. For example, the artist, Kim Hong-do (1745–c. 1814), was known for his lively genre paintings that captured a sense of daily life in eighteenth and early nineteenth-century Korea. His paintings often depicted people engaging in normal activities such as studying at school, or sports activities like wrestling. He is known for a painting called *Schoolroom* (c. 1814), which shows a young student bursting into tears when he doesn't understand his lesson. The schoolmaster, wearing a rectangular hat and a beard, looks distracted and unsure of how to proceed with the lesson.

What was the **Silhak Movement**?

The Silhak Movement was a Korean style of painting that developed during the eighteenth century and was inspired by a newfound focus on Korean identity and Confucianism. Chong Son (1676–1759) was a celebrated Korean painter and was a leading member of the Silhak Movement. He was active during the middle of the Choson dynasty, which lasted from 1392 until 1910 and had its capital at Seoul, now the capital of South Korea. Chong Son was inspired by Chinese literati painting and is known for his ink paintings of mountain scenes, especially paintings of the Diamond Mountains, which he made with dark, textured brushstrokes. Like the literati painters, Chong Son was interested in capturing a "true view," or realistic depiction, of the natural world.

ROCOCO AND THE EIGHTEENTH CENTURY

What is **rococo**?

Rococo is a distinctive style of art, architecture, literature, music and more, popular during the eighteenth century in Europe. The name comes from French, and is a blend of the words "stones" and "shells," both popular items in eighteenth-century gardens. Like many other terms such as "gothic" and "baroque," the term was created much later and used to disparagingly describe what nineteenth-century critics considered the gaudy, bad taste of the eighteenth century. Rococo architecture is highly ornate, and characterized by curving, rather than rigid forms, pastel colors, and an element of fantasy or whimsy. Painting also features pastel colors and witty, frivolous scenes of aristocratic lovers and mythological figures, though there are occasionally cynical undertones in some rococo paintings (for example in the prints and paintings of William Hogarth). Rococo first developed as a cohesive style in Paris, and is specifically associated with the French king Louis XV and the rise of the bourgeois, or upper middle class. As with other categories of art, regional differences lead to variation of rococo style. Important rococo painters include Jean-Antoine Watteau, Jean-Honoré Fragonard, and Johann Balthasar Neumann, among others.

What is the **difference between baroque** and **rococo**?

The difference between baroque and rococo art can be fairly confusing and even art historians aren't exactly sure where to draw the line; some even consider rococo to be an ornate subcategory of baroque. In general, baroque is thought of as more rigid than rococo. For example, compare the architectural style of Versailles with the Würzburg Residenz in southern Germany, which features gold-painted capitals and pastel-colored ceiling paintings. Rococo art is, overall, less religious than baroque paintings, with a tendency towards images of parties, idealized landscapes, and romantic engagements, whereas baroque artists favored religious symbolism, biblical scenes, and monumental mythological paintings. Color choice is another way to tell the difference; baroque paintings, in the manner of Caravaggio, emphasize chiaroscuro and bold, rich colors, while rococo paintings are brightly illuminated and feature powdery pinks, light greens, and other pastels.

What is the **Würzburg Residenz**?

The Würzburg Residenz is an important example of rococo architecture in Germany designed by Johann Balthasar Neumann (1687–1744) for the prince-bishop of Würzburg, a member of the Schönborn family. The Kaisersaal, or Imperial Hall, of the Residenz has a gold, white, and pastel color scheme and emphasizes curves and elaborate ornamentation, including marble columns and undulating moldings. A grand staircase expands to over six hundred square feet, its balustrades and banisters decorated with statues and Greek vases. Above the sprawling stairs, the Italian rococo artist Giovanni Tiepolo, painted what is believed to be the largest ceiling fresco in the

the thrashing of the boatmen knocked into it by the charging elephant. According to the story, Akbar was able to calm and capture the elephant and the image stands as a metaphor for Akbar's ability to rule a large and often difficult empire.

What are **rajput paintings**?

Rajasthan, in Northern India, was not part of the Mughal Empire's vast territory. Instead, it was controlled by Hindu Rajput rulers. Painting traditions in Rajasthan were influenced by Persian and Mughal miniature painting traditions and popular subject matter included images of Hindu gods, such as Krishna, and were often romantic and erotic. In *Krishna and Radha in a Pavilion* (c. 1760) the Hindu god Krishna, commonly represented with blue skin, is caressing his lover, Radha, while a yellow bolt of lightning overhead symbolizes their sexual attraction.

Who was **Bichitr**?

Bichitr was an important court painter active during the rein of Akbar the Great's son, Jahangir (who ruled from 1605 to 1627), as well as Shah Jahan, who built the Taj Mahal. Bichitr was a skilled miniature painter who was possibly raised by the court, which is where he got his early education. He was interested in European painting and some of his work blends Indian landscapes with European perspective techniques. In his miniature painting, *Jahangir Preferring a Sufi to Kings* (c. 1625), Bichitr included

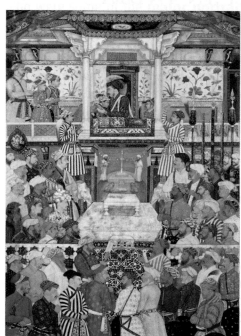

In this illustration for the *Padshahnama*, a narrative history of the Mughal Emperor Shah-Jahan, the emperor receives his three eldest sons and Asaf Khan during his accession ceremonies (c. 1630). (*Art courtesy The Royal Collection © 2011 Her Majesty Queen Elizabeth II / The Bridgeman Art Library.*)

a small self-portrait among a group of other portraits of important figures such as Ottoman rulers and even King James I of England, which Bichitr likely copied from another portrait. The self-portrait shows the artist holding a small painting of himself, resulting in a painting within a painting. Bichitr bows respectfully to Jahangir, the Mughal ruler.

What is the **Taj Mahal**?

The Taj Mahal, in Agra, India, is one of the most recognizable structures around the world, with its white onion-shaped domes, arched windows, and long reflective pool. The Taj Mahal is made of marble, inlaid with colorful stones in a floral pattern, and also decorated with calligraphy inscriptions from the Qu'ran. It is not a palace, but a mausoleum built by the seventeenth-century Mughal emperor Shah Jahan, grandson of Akbar the Great, for his third wife, Mumtaz Mahal. Monumental tombs were part of an Is-

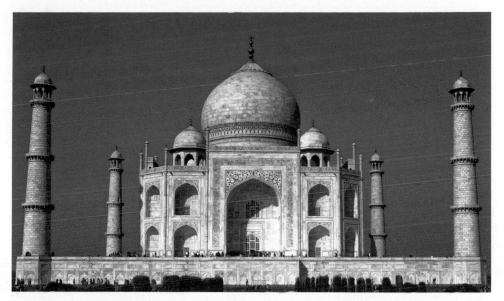

The Taj Mahal, a white marble mausoleum, was built between 1631 and 1648 at the behest of Mughal Emperor Shah Jahan in memory of his late wife. The Taj Mahal is a masterpiece of Islamic art in India.

lamic tradition and the design of the Taj Mahal mirrors the design of garden pavilions in Iran. It evokes a sense of calm and serenity through its symmetrical and balanced forms, and expansive pools and tall minarets. The building is symbolically linked to descriptions of gardens in Paradise from the Qur'an and is considered a masterpiece of Indo-Islamic architecture.

NEOCLASSICAL ART

What is **neoclassical art**?

Sometimes it feels like Classical influence never goes away, but in the eighteenth century, a fully formed "classical revival" evolved on the heels of the baroque period. During the eighteenth century, artists and aristocrats flocked to Rome to see the formidable Roman ruins and the art of the Renaissance. Also at this time, new archeological discoveries were being made in Greece, revealing more about ancient Greek society and art, and fueling increased interest in Classical ideas and aesthetics. The neoclassical style contrasted quite sharply with the flamboyant styles of Rococo and instead emphasized grand simplicity and stability as well as the noble, heroic ideal. Renewed interested in classical thought inspired more than art and architecture—it also fueled political shifts and philosophical ideas that resulted in dramatic societal changes, such as the French and American Revolutions and the rise of Napoleon.

What was **Joshua Reynolds' "Grand Manner"**?

Joshua Reynolds (1723–1792) was determined to elevate the status of British painting to that of the great masters of the Renaissance, and one of the ways in which he

157

did this was to infuse his portraits with the grandeur and heroic idealism of the highest form of painting at the time, history painting. In his series of lectures, *Fifteen Discourses on Art,* Reynolds promoted the idea that contemporary British painters should paint in the "great style" of the old masters. His enormous, full-length portraits, such as *Portrait of Jane Fleming, Countess of Harrington* (1778) and *Lady Sarah Bunbury Sacrificing to the Graces* (1765), incorporate classical elements such as sculpture, vases, and architectural elements into the background to give his paintings an element of antiquity. In the latter portrait, Lady Bunbury is depicted as a Roman priestess with her long Roman dress banded at the waist and pinned to the shoulder. As Lady Bunbury makes an offering to the Three Graces, her friend Lady Susan Fox-Strangways kneels beside her. Reynolds has elevated this aristocratic portrait to a symbolic, meaningful painting that inspires reflection on female friendship and beauty.

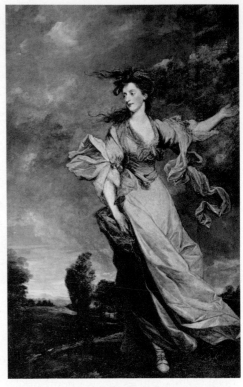

The British painter Joshua Reynolds infused this portrait of Lady Jane Halliday with aristocratic poise (1779). Reynolds was interested in elevating the status of British art through his portraits.

What is **neoclassical architecture**?

Neoclassical architecture of the eighteenth century was a powerful reaction against the highly decorative styles of rococo architecture, and emphasized logic, symmetry, and geometry in its design. Neoclassical architecture was particularly popular in the design of public buildings, and at least in Britain, private country homes.

What are some significant **examples** of **eighteenth-century neoclassical architecture**?

- Chiswick House—Designed and built between 1724 and 1729 by Robert Boyle, the Third Earl of Burlington in West London, England. Greatly inspired by the architect Palladio and his Villa Rotunda, Chiswick House features an octagonal dome and a large but simple portico with an empty pediment. The overall style is restrained, flat, and symmetrical.
- Pulteney Bridge—Designed by celebrated Scottish architect, Robert Adam (1728–1792), who also designed great buildings such as the Edinburgh City Chambers and Culzean Castle in Ayrshire, Scotland. The unique, Palladian style

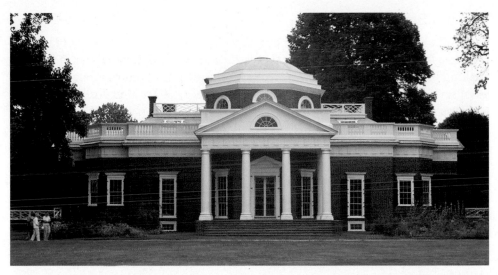

American forefather Thomas Jefferson believed in the power of architecture to help establish a unified sense of American identity and democratic idealism. As an architect, he was inspired by classical architecture and infused classical elements into his projects, including his personal home, Monticello.

Pulteney Bridge (completed in 1773) crosses the River Avon in Bath, England, and is lined with shops.

- Théâtre de l'Odéon—Originally called the Théâtre Français, this austere neoclassical building was designed by Marie-Joseph Peyre between 1767 to 1770. Almost completely void of decoration, the portico features columns of the simplest Tuscan Order and has no pediment. The building emphasizes its horizontality and geometric symmetry.

- Monticello—Designed by Virginia statements and author of the Declaration of Independence, Thomas Jefferson, as his private residence in Charlottesville between 1769 and 1782, with later redesigns between 1796 and 1908. Jefferson was interested in developing a uniquely American style of architecture that would promote patriotism and help to form the new country's national identity.

Who was **Angelica Kauffmann**?

Angelica Kauffmann (1741–1807) was an important neoclassical artist in Britain who studied in Rome, became friends with Joshua Reynolds, and co-founded the Royal Academy of Arts in 1768, though she was forbidden to study the male nude, a fundamental part of academic training to this day. Despite this, Kauffmann painted history paintings, which where held in higher regard than any other form of painting, and was the only eighteenth-century woman artist to do so. Kauffman produced rococoesque, neoclassical history paintings, including *Ariadne Abandoned by Theseus* (1774), *A Sleeping Nymph Watched by a Shepherd* (1780), and *Cornelia Presenting Her Children as Her Treasures* (c. 1785), which tells a story in the life of one of the most powerful women in ancient Rome. Many of her paintings were reproduced as prints, and she had great success as a portraitist for aristocratic patrons.

159

Who was **Benjamin West**?

Benjamin West (1738–1820) was an American-born painter who studied in Philadelphia and Rome before establishing a successful career as a history painter in London, making him the first American artist with such a successful international career; he even served as president of the British Royal Academy of Art after Joshua Reynolds, and was financially support by a powerful patron, King George III. West's historical paintings strongly adhered to neoclassical conventions; however, in a surprising change from tradition, West's *The Death of General Wolfe* (1770) depicted contemporary, rather than historical events, and included images of the king's army wearing their contemporary uniforms, not ancient dress. Although the king (and Joshua Reynolds) aggressively disliked this change, it proved extremely popular amongst the public. The king changed his tune, and named West the royal history painter.

What is **jasperware**?

Developed by the English potter Josiah Wedgwood, jasperware is a type of porcelain best known for its popular white-on-blue, unglazed finish (though various other colors were also used) and neoclassical design. Wedgwood hired sculpture John Flaxman to recreate highly popular molded relief images that closely mimicked ancient Greek vase designs, which had been recently discovered. Jasperware was effectively marketed and manufactured on a large scale, making Wedgwood's neoclassical designs available to a wider public than decorative objects made before the Industrial Revolution. Jasperware, and Wedgwood pottery as a whole, remain very popular to this day.

Who was **Jacques-Louis David**?

Jacques-Louis David (1748–1825) was arguably the most important French painter working in the neoclassical style, whose art first exemplified the values of the French Revolution, and then the imperial style of Emperor Napoleon. In his history paintings, such as *The Oath of the Horatii* (1784), David depicted patriotic Roman scenes, which emphasized themes of sacrifice and heroism, and captured the spirit of the revolution. His 1793 painting, *The Death of Marat,* which was commissioned during the bloody Reign of Terror, commemorates the bloody death of Jean-Pierre Marat, a Jacobin journalist and politician murdered while in the bathtub, by a woman aligned with the Girondins, an opposing political faction. Marat was known to have a debilitating skin disease, and

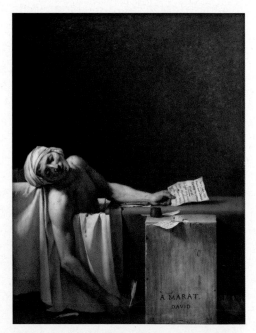

The Death of Marat (1793), an oil painting by French artist Jacques-Louis David, depicts a revolutionary politician who had been murdered in his bath during the French Revolution.

What was the French Revolution?

The French Revolution, which lasted from 1787 to 1799, was over a decade of bloody political upheaval that saw the overthrow (and beheading) of the longstanding French monarchy, the end of feudalism in France, and the establishment of the First Republic, forever changing French society. Inspired by the American Revolution and Enlightenment philosophies, the new National Assembly adopted the *Declaration of Rights of Man and the Citizen,* which gave power to the people of France rather than the monarchy, establishing social programs such as public education and welfare. There were two main political parties in the French government, the Girondins and the Jacobins, led by the revolutionary politician Maximilien de Robespierre, under whose leadership King Louis XVI and his queen, Marie Antoinette, were convicted of treason and condemned to death by beheading. Robespierre oversaw the Reign of Terror, so-called because seventeen thousand people were officially convicted and condemned to death for treason, as the revolutionary government sought to weed out any perceived threats to the new order. Robespierre himself fell victim to "La Terreur," and was executed in 1794. In 1799, Napoleon Bonaparte staged a military coup and established himself as dictator of France, temporarily ending the hard-fought republicanism of the Revolution.

often worked while soaking in the bathtub. The painting idealizes Marat, whose body slumps over the edge of the tub, which is presented in a minimalist fashion against a simple bathroom, quite unlike Marat's real bathroom, which was rather more opulent. In his left hand, Marat still holds a handwritten note, while in his right hand, a quill. Nearby is the bloody knife that the assassin, Charlotte Corday had used to stab him through the chest. David belonged to the same political party as Marat, and this painting clearly serves as political propaganda. Once the Revolution was over, David's political fortunes rose and fell, (he served a short time in prison, and then as the president!) But, he eventually aligned himself with a new power: Napoleon Bonaparte, who ruled over France from 1804 to 1815, and became an important patron for David.

ROMANTICISM

What is **"Romanticism"**?

Romanticism was an intellectual, cultural, and artistic movement that went against the rationalism of the Enlightenment and instead emphasized emotion and subjectivity. Romanticism developed in the mid-eighteenth century and remained popular until well into the mid-nineteenth century. It coincided with Neoclassicism, and some neoclassical art is even considered romantic because of its frequent idealism and nostalgia for the past. During the Romantic period, there was a new interest in

161

In William Turner's 1842 oil painting, *Snowstorm: Steamer Off a Harbour's Mouth*, the artist shows the power of nature through rough brushstrokes and swirling lines. Paintings of nature, whether wild or tamed, were popular during the Romantic period.

scape: Noon) (1821), is over six feet long, for example. His paintings are clear, detailed, and infused with emotion, which is expressed in heavy clouds, reflective ponds, and glistening foliage. Usually calm and pristine, Constable's landscapes offer a subjective image of the manicured English countryside.

By comparison, Turner's landscapes are a whirlwind of drama and dissolved images, and present nature as an overwhelming power capable of consuming man and his impermanent structures. Turner is known for his enormous oil paintings, as well as innovations in watercolor, particularly the borderline abstraction of his sweeping brushstrokes. Turner's paintings were shocking at the time. His 1842 painting *Snowstorm: Steamer off a Harbour's Mouth*, for example, depicts a ferocious ocean storm within with the actual steamer is barely visible, and it is nearly impossible to differentiate between the swirl of dark clouds and the thrusts of the thrashing waves. Unlike Constable's careful, controlled nature, Turner's is a monster.

Who was **Francisco Goya**?

Francisco Goya y Lucientes (1746–1828) was a Spanish Romantic painter who lived to see Napoleon Bonaparte absorb Spain into his Empire, a violent massacre of the people by the new government, the restoration of the Spanish monarchy, and the reinstitution of the Spanish Inquisition. Goya, who at one time was the court painter for Spanish king Charles IV (and painted a perhaps too realistic, arguably unflattering portrait of the royal family in 1800), was inspired by the Enlightenment ideas of

the French Revolution and deeply disappointed by the failure of those ideas to instill fundamental change in Spain. Charles IV cracked down hard on social change, even banning the entry of books into the country. Goya's series of eighty etchings, *Los Caprichos (The Caprices),* completed between 1796 and 1798, respond to what Goya perceived of as the folly of the Spanish people at the time.

Spanish artist Francisco Goya y Lucientes created a series of eighty etchings focused on the theme of human folly. *The Sleep of Reason Produces Monsters* (c. 1799) is an aquatint etching from that series.

The Sleep of Reason Produces Monsters, an aquatint etching from this series, depicts Reason personified as a slouched, sleeping figure. While Reason is preoccupied by slumber, ominous creatures emerge from the darkness, including owls, bats, and a cat with wide, glowing eyes. Goya's work suggests the genius of Velázquez, the satire of Hogarth, and the refinement of Reynolds, while illustrating a highly individual and complex imagination steeped in Spanish mysticism and superstition. Other important paintings by Goya include *Third of May, 1808* (1814–1815), which commemorates the massacre of Spanish prisoners by the French, dark paintings such as *Saturn Devouring one of his Children* (1820–1823), and many portraits.

What is *The Raft of the Medusa*?

Like Goya's *Third of May, 1808,* another early nineteenth-century painting, *The Raft of the Medusa* (1819) by French Romantic painter Théodore Géricault (1791 1824) emphasizes the pain and suffering of victims amidst seemingly insurmountable odds. *The Raft of the Medusa* is a great contemporary history painting that depicts a horrible accident at sea when a ship filled with French colonists ran aground. There were not enough lifeboats for all aboard, and so a barely floating lifeboat was built for the 152 seamen, which was eventually cut from the main lifeboat by the captain and the officers and left floating at sea. Thirteen days later, only fifteen suffering passengers remained on the raft after withstanding disease, starvation, and cannibalism. The story caused a sensation in France, as it was discovered that the captain of the ship was an inexperienced aristocrat who was made captain through corruption. Géricualt depicts the raft as the passengers spot a passing ship, their first hope at rescue. Twisted yet idealized bodies, some dead, are sprawled over the surface of the tiny wood raft while the dark, foreboding ocean looms along the horizon. The viewer's eye is brought upwards, as the raft is raised on the swell of a wave, to the outstretched arm of a frantic passenger waving a tattered red cloth, trying to get attention. *The*

165

Raft of the Medusa incorporates Romantic perceptions of nature with a sense of heroism, adventure, and injustice.

Who was **Eugène Delacroix**?

Eugène Delacroix (1798–1863) was not interested in the defined forms and Classical stoicism promoted by the Academy. This French Romantic painter is known for his use of thick brushstrokes, and sweeping, dramatic scenes inspired by mythology, current events, and his trips to North Africa. Delacroix's *Massacre at Chios* (1822–1824), was based on the Greek's struggle for independence from the Ottoman Empire, an event that influenced many Romantic writers and artists. The painting communicates sympathy for the exhausted Greeks by focusing on the details of individual faces. A menacing Turk dominates the scene as his dark horses rears up over the group of victims. Similarly, Delacroix's *Liberty Leading the People: July 28, 1830* (1830) makes heroes of unlikely revolutionaries who passionately take up arms as their brethren have fallen, ready to overthrow the monarchy. Red, white, and blue—the colors of the French flag—draw attention to the female personification of Liberty, whose bare breast recalls Classic sculpture, as she emerges from the dust and smoke. She holds up the French flag in one hand and a bayonet in the other, leading the revolutionaries into battle. This Romantic painting emphasizes idealism and heroism in its depiction of an important historical event.

Who was **Jean-Auguste-Dominique Ingres**?

The art of French painter Jean-Auguste-Dominique Ingres (1780–1867) exhibits a curious combination of Neoclassical and Romantic values, though he was determined to hold on to traditional Neoclassical values and was considered a nemesis of the much looser Delacroix. He was inspired by the Renaissance painting of Raphael, as well as the Revolutionary artist, Jacques-Louis David. While interested in history painting, Ingres is better known for his sensual portraits of female nudes, especially paintings such as *La Grand Odalisque* (1814), which depicts a sultan's concubine reclined languidly on luxurious, colorful fabrics. *La Grande Odalisque* is an example of Orientalism, or a Romantic interest in the exotic east. In the painting, the elongated form of the concubine, along with objects of eastern luxury, such as a fan made of peacock feathers and ornate jewelry, were decidedly Romantic, despite Ingres' preference for Neoclassicism and apparent distaste for portraiture.

ART OF THE AMERICAS

How did the **art of Spain influence art** in the **New World**?

Starting in the sixteenth century, Spanish culture began to dominate Central and South America as Spanish conquerors destroyed native temples and missionaries worked to convert native populations to Catholicism, sometimes forcefully. By the eighteenth century, Catholicism in Latin America had become infused with native be-

liefs, which directly inspired new styles of art and architecture. An example of this fusion can be seen in the nearly twelve-foot tall atrial cross from the Basilica of Guadalupe in Mexico City, which was made sometime before the 1560's. This large, stone crucifix was hung in the church's atrium, and was decorated by native artists commissioned by Christian missionaries. The cross decoration blends images associated with Christ, such as the Crown of Thorns and the Holy Shroud, with Central American symbols of the Tree of Life. The atrial cross was a common decoration in parts of the church where new native converts were introduced to Catholicism, and the decoration of the cross at Guadalupe underscores its function as a visual marriage of cultures and beliefs.

What were the **dominant styles of architecture** in the **Spanish New World**?

In Spanish Latin American, baroque styles of architecture remained popular long after it had fallen out of fashion in Europe. Throughout the eighteenth century, magnificent examples of baroque architecture continued to be built in countries such as Mexico, Peru, Ecuador, and even further afield in the Philippines. The Church of Saints Sebastian and Santa Prisco, in Taxco de Alarcon, Mexico, is a good example of an eighteenth-century baroque church heavily decorated in stucco sculpture in a popular style known as the "Churrigueresque." Near Tucson, Arizona, the Mission San Xavier del Bac was also built in the eighteenth century and reflected Spanish baroque styles. The nearly one-hundred-foot long church was built using brick and mortar, rather than adobe, which was commonly used by the native people of Arizona.

Why was **Thomas Jefferson** so interested in **architecture**?

Thomas Jefferson absolutely despised Colonial Georgian architecture, which was common in his home state of Virginia. In his *Notes on the State of Virginia* (c. 1781) he wrote, "It is impossible to devise things more ugly, uncomfortable, and happily, more perishable." Jefferson, a skilled amateur architect who studied Palladio's *Four Books on Architecture,* had a vision for an architecture that would define the spirit of the new United States and serve to bring the disparate populations of the former colonies together. Some of his most famous building designs include his own home, Monticello, which he built over forty years in Virginia, as well as the Virginia State Capitol, and the University of Virginia Rotunda, a building particularly inspired by the Villa Rotunda, in Rome. The University of Virginia was the first state-funded university in the United States, and in designing its main campus, Jefferson wanted to promote education and endow the new university with a sense of permanence and grandeur. Jefferson believed that architecture had the power to change people. His designs reflect his similar political goals—to create an enduring and powerful government, one that values individualism, democracy, and freedom.

Why was **Horatio Greenough's sculpture** of **George Washington** so **controversial**?

Horatio Greenough (1805–1852) was a neoclassical sculptor and artist, and is considered to be the first professional American sculptor. His grand marble sculpture of

FROM THE
INDUSTRIAL
REVOLUTION
TO
WORLD WAR I,
c. 1850–1914

LATE NINETEENTH–CENTURY PAINTING

What is the **difference** between **Romanticism** and **Realism**?

Although seemingly at odds, nineteenth-century realism overlapped quite a bit with the Romantic Movement of the same period. While the Romantics reacted against the Enlightenment and were often idealistic in their representation of historical and current events, the nineteenth-century realists were interested in accurately depicting the human condition, with an element of social awareness. Both realists and Romantics valued direct observation of nature, though realists further emphasized social observation and, occasionally, political and social satire.

What is **"art for art's sake"**?

During the nineteenth century, there was, and continues to be, a debate about the role and function of art in society. The term "art for art's sake" was first coined by Victor Cousins, a French philosopher, and reflects the tenets of Aestheticism, which is centered on the idea that there is no purpose for art other than beauty. There were some critics of this idea. Karl Marx, for example, thought that art is a reflection of social class and has the power to make political change. The foremost English art critic, John Ruskin, believed that art had both political and social significance and therefore had a purpose more far-reaching than beauty alone.

What was the **Barbizon School**?

The Barbizon School was a group of French painters who favored *plein air* landscape painting that broke with neoclassical conventions of idealization. The name of the group came from the small village of Barbizon where many of the founding artists lived. Artists of the Barbizon school, such as Charles-François Daubigny, Jean-

During the nineteenth century, the world experienced massive social up-heavals due to the Industrial Revolution. The German philosophers Friedrich Engels (1820–1895) and Karl Marx (1818–1883), authors of the *Communist Manifesto* (1848), believed that the working class (the proletariat) would soon revolt against the bourgeois. Marx in particular was interested in the artist as a member of the proletariat, whose work—art—was consumed and exploited by the upper classes. Because of the new availability of manufactured goods, handmade items and traditional crafts took on new value. Other important thinkers also affected nineteenth-century perceptions of art, such as Sigmund Freud (1856–1923), an Austrian neurologist who is credited with founding psychoanalysis, which inspired many artists and writers.

The nineteenth century also saw the rise of the newspaper, and along with it, the rise in the importance of the art critic, whose voice became ever more important in judging and valuing art. Unlike in previous centuries, museums and galleries became important public and business institutions, a change from the previous system of royal or church patronage that characterized art production during the Renaissance. Towards the middle of the nineteenth century, Romanticism faded and realism became more popular in European art. By the end of the century, the public was shocked by Impressionism and Post-Impressionism, which evolved from realism and, in some cases, a new interest in psychology.

François Millet, and Jean-Baptiste-Camille Corot, leaned towards realism and valued close observation of nature. Like artists before and after, they searched for "truth," in the rural countryside of France. Although occasionally criticized, the artists of the Barbizon School, whose work is characterized by softness of forms and loose brushstrokes, went on to influence nineteenth-century French Realism and Impressionism.

What is *The Gleaners*?

The Gleaners (1857) is a painting by Jean-François Millet (1814–1875), a member of the Barbizon School, which depicts French laborers on a monumental scale and exemplifies the transition between Romanticism and Realism. *The Gleaners* is a large oil painting with soft, diffused brushstrokes and a sense of nostalgia for the countryside during the time of the Industrial Revolution. The term "gleaner" refers to rural people who gathered any produced discarded by the farm workers after the harvest—extremely physically demanding work that usually resulted in very little of value. The faces of the peasant women are obscured, rendering the peasants as symbols rather than individuals. The painting elicits sympathy for the rural poor through the soft light and the monumentality of the figures. It also juxtaposes the poor with the wealthy—as more prosperous farm workers with expensive equipment can be seen efficiently harvesting in the background. After seeing the work, some critics believed

Millet harbored sympathies for the recent revolutions of 1848, eliciting controversy despite Millet's denials.

Who was **Gustave Courbet**?

Unlike Millet, Gustave Courbet (1819–1877) was open about being inspired by the 1848 revolutions in France. He was known for his socially radical beliefs and his loyalty to his hometown of Ornans, near the border with Switzerland. He believed that artists could only authentically represent their own experiences and rejected traditional academic views on painting. He disliked history painting and believed that art could not be taught. His painting, *The Stone Breakers* (1849), predates Millet's depiction of rural poverty, and similarly shows two laborers breaking large stones along the side of a road—back-breaking work. There are certain Romantic elements to the painting, such as the sense of nostalgia for the simplicity of rural life, and like *The Gleaners,* the faces of the workers are hidden. Some critics considered this painting a satire that juxtaposes demanding physical labor with the mechanical processes of the Industrial Revolution. The canvas is quite large for such a subject at nearly nine feet long and five feet high. Even bigger was Courbet's *A Burial at Ornans* (1849), which depicted a countryside funeral and is over twenty-one feet long. It was heavily criticized for depicting something as mundane as a poor man's funeral on such a large scale, but that was exactly Courbet's point. The monumentality of the image brings dignity to the ordinary working class and to the rural countryside.

Why was **Honoré Daumier arrested**?

Honoré Daumier (1808–1879) was a painter and famous lithographer whose cartoons were regular features in Parisian newspapers; his realist works tended to focus

The Stone Breakers (1849–1850), an oil painting by realist painter Gustave Courbet, depicts hard-working peasants from the French countryside on a monumental scale. The painting is approximately 9 X 5 feet.

on the plight of the urban poor and frequently criticized the French government, including Louis-Philippe, which got him into trouble. His 1831 lithograph, *Gargantua,* published in the comic journal *La Caricature,* depicted the king as "Gargantua," a grotesque character from the books of French Renaissance writer Rabelais. The king is large and bloated, with thin legs and a pointed head. He sits, "enthroned," while poverty-stricken French subjects carry heavy loads of offerings in baskets up a ramp, directly to the king's open mouth. Aristocratic scavengers huddle underneath the ramp, hoping to catch any dropping coins, while in the far right corner, a poor, malnourished woman attempts to feed her baby. Such a negative depiction of the king resulted in a fine of 500 francs and a six-month jail term for Daumier on the charge of inciting contempt for the government and personally insulting the king. This punishment did not stop the artist as in a later lithograph, called *Freedom of the Press* (1834), Daumier aggressively criticized government censorship. The work of Honoré Daumier demonstrates the role of art as social commentary as well as the power of both image and text.

What was the **Russian Realist** movement?

As in France, nineteenth-century Russian artists were increasingly critical of the traditional approach to art promoted by the Academy of Arts. In a powerful show of protest, a large group of students, thirteen in total, withdrew from the Academy and formed a group later known as the *Peredvizhniki,* or "The Wanderers." The Wanderers preferred art that was socially aware and promoted the values of the Russian working class and peasantry. Common themes in Russian Realist art were peasant scenes, landscapes, and images of the Russian clergy. The group took their art on the road, and traveled to towns and cities that would not normally attend the salons and galleries of St. Petersburg, creating uniquely accessible art. Artist members of "The Wanderers" included Ilya Repin (1844–1930), Vasily Perov (1834–1882), Nikolai Ge (1831–1894), and Ivan Kramskoi (1837–1887), among others.

Who were the **Pre-Raphelites**?

Also known as the Pre-Raphaelite Brotherhood, this group, lead by Dante Gabriel Rossetti, started out in 1848 as a secret society of students at the Royal Academy School in England who rejected the perceived materialism of the Victorian period as well as the teachings of the Academy. The Pre-Raphaelite Brotherhood, which also included William Holman Hunt and John Everett Millais, found the work of the nineteenth-century academy to be artificial and decadent, and instead preferred the simplicity and apparent sincerity of Renaissance masters such as Fra Angelico and Jan van Eyck. The Pre-Raphaelite's also valued the moralistic themes of these artists and favored religious themes. Significant Pre-Raphaelite paintings include Hunt's *The Awakening Conscience* (1853–1854), Millais' *Christ in the Carpenter Shop (Christ in the House of His Parents)* (1849–1850), and Rossetti's *The Girlhood of Mary Virgin* (1849). The Pre-Raphaelites were greatly supported by the English art critic, John Ruskin, were sometimes characterized as Romantic, and went on to influence the Aesthetic movement, the symbolists, and Art Nouveau.

What is *The Gross Clinic*?

The Gross Clinic is an 1875 realist painting by the American painter, Thomas Eakins, and depicts Dr. Samuel David Gross performing leg surgery in front of medical students. The choice of subject matter was shocking to the traditional art critics and the painting was rejected by the Philadelphia Centennial exhibition in 1876. The painting is notable for its use of chiaroscuro, a sharp contrast of dark and light that is reminiscent of baroque painting. Powerful beams of light highlight both Dr. Gross's forehead and bloody, scalpel-wielding hand, emphasizing his intelligence and dexterity. The patient's leg has been cut open, revealing the muscle underneath the skin, causing the patient's mother, also among the audience, to recoil and hide her face. *The Gross Clinic* highlights Eakins's dedication to Realism and is an important example of nineteenth-century American painting.

The Gross Clinic (1875) by American painter Thomas Eakins highlights the artist's dedication to realism and is an important example of nineteenth-century American painting.

Who was **Winslow Homer**?

Winslow Homer (1836–1910) was an American painter who worked as a magazine illustrator and war correspondent during the Civil War. He is known for his depictions of leisure activities and outdoor scenes, and like Thomas Eakin's was a proponent of Realism, though is work is characterized by its nostalgia for the simplicity of the pre-Industrial era. His painting, *Snap the Whip* (1872) monumentalizes a traditional children's game and includes a depiction of a one-room schoolhouse and boys dressed in simple, country clothes with no shoes on. The scene is in stark contrast to the pain of the Civil War, and the changes brought on during its aftermath and during the Industrial Revolution.

Who was **Henry Ossawa Tanner**?

Henry Ossawa Tanner (1859–1937) was the first internationally renowned, African American artist and was the most successful African American artist of the nineteenth century. He studied under Thomas Eakins at the Pennsylvania Academy of Fine Art and later moved to Paris, where he spent the majority of his career. Tanner is often considered a Realist painter. For example, while *The Annunciation* (1898) is a common biblical subject, Tanner includes realistic details he drew from his travels in the Middle East, such as clothing styles and interior decoration that visually grounds the Virgin's Mary's divine encounter with the angel Gabriel. Tanner's most

famous painting, *The Banjo Lesson* (1893), is a quiet depiction of an elderly black man teaching a young boy to play the banjo. The painting emphasized the dignity of the scene during a time when similar scenes would have been rendered as comical or stereotypical. Like the paintings of French Realists such as Millet and Courbet, Tanner's work exhibits social awareness and a sense of monumentality. Tanner's later work was predominantly religious, as the artist preferred to paint biblical subjects that reflected the struggles of nineteenth-century African Americans.

Who was **Manet**?

Eduoard Manet (1832–1883) is considered by many to be the first modern painter. He not only bridged the gap between Realism and Impressionism, but his work foreshadows early twentieth-century painting styles and approaches. He was highly knowledgeable about art history, and fiercely rebellious, preferring art he deemed "sincere," rather than perfect. Along with thousands of paintings by other premier artists of his day, Manet's work was rejected by the Salon, the official art exhibition of the Palace of Fine Arts. But, Manet had the opportunity to shock critics and viewers at a specially organized *Salon des Refusés,* or, "Salon of the Rejected," with his painting *Le Déjeuner sur l'Herbe (The Luncheon on the Grass)* (1863) and again in 1865 with another masterpiece, *Olympia.* Though Manet's work drew inspiration from the Great Masters, he focused on scenes of modern life, including café and

Because of its nudity and painting style, Eduoard Manet's *Le Déjeuner sur l'herbe* (*The Luncheon on the Grass*) shocked the viewing public in Paris when it was exhibited at the Salon des Refusés in 1863.

leisure scenes around Paris, war paintings, and lithographs inspired by contemporary literature. His work is among the most critically acclaimed and valuable in all of art history; however, Manet never achieved this kind of universal recognition during his lifetime. Now, he is considered one of the founding fathers of modern art.

What was so **shocking** about **Manet's paintings**?

Manet's *Le Déjeuner sur l'Herbe (The Luncheon on the Grass)* (1863) was couched in art historical tradition, and draws clear connections to a sixteenth-century painting from the Venetian Renaissance called *The Pastoral Concert,* which also depicts a small gathering of minstrels and partially nude women relaxing in a country setting. The nudity alone was not enough to shock nineteenth-century viewers, but it was apparently the contrast between the well-dressed men and the complete nudity of the central female figure, who stares confidently out form the picture plane, that pushed it over the top. She, and a semi-naked bather in the background, were interpreted as prostitutes. *Le Déjeuner sur l'Herbe* was not a neoclassical work, nor a modest depiction of female beauty as was common from the Renaissance, but a bold portrayal of contemporary figures engaging in what was perceived of as immoral behavior.

Manet's equally shocking *Olympia* (1863) also drew on Renaissance predecessors, specifically Titian's *Venus of Urbino,* but instead of a demure reclining nude, Manet presented a boldly staring women who confronts the viewer with her nudity. While in Titian's painting, a small dog (a symbol of loyalty) is curled asleep at the foot of the bed, Manet's painting includes a black cat with yellow eyes and an arched back. Though both of these paintings were shocking to the public, they were hailed by some, including Emile Zola, as masterpieces for their ability to communicate truth through realism, and for confronting traditional approaches to painting.

Why did **Whistler** go to **court**?

James Abbott McNeill Whistler (1834–1903) is now most famous for a portrait of his mother in a rocking chair, but his work during the second half of the nineteenth century is notable for its increasing abstraction. Whistler was American, but spent the majority of his career in London and never returned to the United States after moving to that English city. His early paintings were influenced by Aestheticism and he painted many successful portraits, but he was interested in the idea of art as a visual music. He even named an 1862 portrait of a girl in a white dress, *Symphony in White No. 1,*

English art critic John Ruskin was so shocked by Whistler's 1875 painting *Nocturn in Black and Gold (the Falling Rocket)* that he accused the artist of "flinging a pot of paint in the public's face." In return, Whistler sued the critic for libel.

to emphasize the musicality of his work. In his 1893 autobiography, *The Gentle Art of Making Enemies,* he wrote, "As music is the poetry of sound, so is painting the poetry of sight and the subject matter has nothing to do with harmony of sound or of color" (as quoted in Stokstad 885).

In 1875, Whistler shocked the world with his almost completely abstract painting, *Nocturne in Black and Gold,* also known as *The Falling Rocket.* Whistler was accused of having no clear subject for his work, and those who viewed it described it as looking unfinished. The painting personally enraged John Ruskin, Britain's premier art critic, who accused the artist of throwing paint in the public's face with such an abstract work. Whistler sued Ruskin for libel and soon Whistler found himself on the witness stand answering questions about his artistic intentions. When asked about the subject of the painting, Whistler explained that he was attempting an "artistic arrangement" and a "representation of fireworks over the town of Cremorne," not a realistic visualization of the town. He further explained his support for the Aesthetic concept of "art for art's sake." Whistler won the trial, but received only a single farthing in damages, a reflection of the generally negative attitude about his work at the time. The episode also highlights the vigor with which artists and critics were debating the value of increased abstraction.

EARLY PHOTOGRAPHY

Who **invented photography**?

The process of photography, in which an image is fixed by recording light through chemical (and now digital) means, was not invented by a single individual. The concept had been around for thousands of years in the form of the camera obscura, a small, dark box with a tiny hole on one side that allows light to enter. The light reveals an image from outside the box, which is either reflected onto a surface with a small mirror, or passes through onto a wall. A large-scale camera obscura can even be made in a darkened room. Artists used the camera obscura to view small details in a scene. Scholars hypothesize that Johannes Vermeer and other eighteenth-century artists may have used such a device to achieve such heightened detail in their work. The problem for artists, however, was to take the image produced by the camera obscura and make it permanent. The first person to do this was Louis-Jacques-Mandé Daguerre, a painter.

What is a **daguerreotype**?

A daguerreotype is the earliest form of photograph, invented by the French painter, Louis-Jacques-Mandé Daguerre (1787–1851). In the 1830s, J.N. Niepce had experimented with iodine fumes, and others experimented with additional photosensitive chemicals in an attempt to make a high quality image. Daguerre later used a silver iodide covered copper plate and mercury fumes to make a single fixed image. The invention was considered a huge boon for France and it revolutionized the way history could be recorded. Daguerreotypes became very popular for portraits, but by the latter half of the nineteenth century, photography techniques that allowed for multiple

prints instead of a single image, replaced the daguerreotype.

Who was **Nadar**?

"Nadar" was the common nickname of French photographer Gaspard-Félix Tournachon (1820–1910) who was interested in photography for both its artistic value and its commercial potential. He was particularly enthused by photography's potential for Realism, and he wanted to capture accurate details of the city of Paris. He even built a mobile darkroom in the basket of a hot-air balloon, and could be seen soaring overhead, capturing aerial views of the city. The French lithographer, Honoré Daumier published a lithograph, *Nadar Elevating Photography to the Height of Art* (1862), depict-

Julia Margaret Cameron was an early photographer who was interested in elevating the status of photography as an art form. Her portrait photography was often infused with dreamy light, as in *I Wait.*

ing Nadar working in his balloon, his face pressed up against the lens of a camera while his top hat blows away in the wind. The lithograph emphasizes Nadar's high hopes for the role of photography in the fine arts. In addition to his photographs of the city, Nadar took many portraits of notable figures in French society, including the poet Charles Baudelaire, the writer Alexandre Dumas, and Sarah Bernhardt, one of the most famous actresses of the day.

Who were some of the **leading early photographers**?

- Nadar (1820–1910): "Nadar," or Gaspard-Félix Tournachon, was an ambitious French photographer known for portraits and aerial photographs of Paris, and is credited with championing photography as a form of fine art.

- Julia Margaret Cameron (1815–1879): Cameron didn't start taking photographs until she was nearly fifty years old. Her portraits featured a soft, diffused light that captured the essence of her subjects. Her goal was to "ennoble Photography and to secure for it the character and uses of High Art by combining the real and Ideal and sacrificing nothing of the Truth by all possible devotion to Poetry and beauty" (as quoted in "Julia Margaret Cameron [Getty Museum]").

- Oscar Rejlander (1813–1875): Rejlander was a Swedish artist who first used photography to aid in his painting. He innovated techniques in photomontage and combination printing, and was interested in both portraiture and allegorical scenes.

- Mathew Brady (1823–1896): He was the leading American portrait photographer and journalist whose many famous images include portraits of President Abraham Lincoln and Confederate General Robert E. Lee. Brady organized a corps of photographers, including Timothy O'Sullivan, who documented the horrors of the Civil War.

Why wasn't photography considered art in the nineteenth century?

Throughout art history, painters and other artists have been interested in the concept of capturing images through light, or using light-images to inspire their work. When photography developed in the mid-nineteenth century, it also became popular with journalists and scientists interested in documenting the world around them for reasons not necessarily related to beauty or aesthetics. A debate about whether or not photography was considered art ensued, with traditional artists arguing that since photographers do not use their hands to make their images, photography should be considered an automatic process rather than an artistic process. During the 1855 Exposition Universelle (International Exhibition), photography was accepted and on view to the public—but not in the Palais des Beaux-Arts (Palace of Fine Arts.) Instead, photography was displayed in a separate building along with science and industry exhibits. Early photographers such as Gaspard-Félix Tournachon (Nadar), Julia Margaret Cameron, and Oscar Rejlander helped to elevate photography to the status of fine art, though to some extent, the argument over the (supposed) objectivity of photography and its ability to present "truth" continues to this day.

- Jacob A. Riis (1849–1914): Riis was a Danish American activist and photographer who documented the plight of the poor in New York City in photographs such as *Home of the Italian Rag Picker, Jersey Street* (c. 1888–1889). He is known as an innovator with his use of the magnesium flash.

- Eadweard Muybridge (1830–1904): Muybridge was an English-born photographer who worked primarily in America and developed an advanced shutter mechanism for the camera that allowed for high-speed photography that could create moving pictures, likely inspiring Thomas Edison in his development of the cine camera. His *Galloping Horse* (1878) captured twelve shots of a running race horse that changed the way artists depicted such an action.

JAPANESE ART

What is **ukiyo-e painting**?

In Japanese, *ukiyo-e* literally means, "pictures of the floating world." This Buddhist phrase is used to describe a style of Japanese woodblock prints and paintings that developed during the Edo Period (1603–1868) and continued on through the twentieth century. Woodblock prints from the Edo Period were a major influence on Impressionist painters in France, and were notable for their use of color, the importance of landscape, and the focus on bourgeois life through images of dancing, theaters, geishas, and urban street scenes. Ukiyo-e woodblock prints are delicately colored with natural dyes and feature thinly outlined forms. They were affordable and ex-

tremely popular during the eighteenth and nineteenth centuries, and were sold by shopkeepers and street vendors in big cities such as Tokyo (known as Edo during the eighteenth century). Three separate artists usually made woodblock prints: a painter, a carver, and a printer. The painter would first paint the original image. Then, a block of wood, often made of cherry, was carved with the outline of the image to be printed, covered in black ink, and then pressed to fine paper. A separate block was carved for each additional color used. This meant that multiple blocks were required for a single print, sometimes as many as twenty separate blocks! Ukiyo-e woodblock prints depicted the secular, material world, though artists subtly emphasized the Buddhist concept of the transient nature of physical existence.

Who was **Suzuki Harunobu**?

Suzuki Harunobu (1724–1770) was an innovative Edo printmaker who was the first to produce multicolored prints. He became famous for his *nishiki-e* (brocade) prints of beautiful courtesans, including *Geisha as a Daruma Crossing the Sea* (mid-eighteenth century), which depicts an elegant woman wrapped in a red cloak, staring into the wind as nearby reeds seem to rustle behind her. The print is an example of Harunobu's mastery of color, and of the popularity of not only courtesan scenes, but also of theater in ukiyo-e painting, as the woman takes on the persona of the mythological Daruma. During the Edo period, stylized *kabuki* theater was extremely popular, and pictures like this often depicted popular actors and characters from the stage. Suzuki Harunobu was one of the most commercially successful artists working in Edo (Tokyo) and his multicolored prints helped to popularize the ukiyo-e style.

What is the **difference** between the work of **Hokusai** and **Hiroshige**?

Katsushika Hokusai (1760–1849) and Utagawa Hiroshige (1797–1858) were two of the most successful landscape painters in nineteenth-century Japan, and their prints are among the most recognizable examples of graphic art in the world. Both artists explored the transience of the material world in their ukiyo-e paintings. Hokusai was especially well known for his series, *Thirty-Six Views of Mount Fuji*. His print, *The Great Wave off Kanagawa* represents a monumental wave cresting with stylized foam, about to crash near a group of men in long, graceful boats shaped to mirror the curves of the ocean swells. Appearing unexpectedly in the background is the distant image of snow-capped Mount Fuji, which lies low along the horizon line. The white peak of Mount Fuji looks similar to a white-capped swell in the foreground, making the formidable mountain appear as temporary as an ocean wave. *The Great Wave* is an example of Hokusai's use of the European color, Prussian blue, and demonstrates the simplicity and dynamism of Japanese art during the Edo period.

Like Hokusai, Hiroshige was a master of the Edo period who specialized in landscapes. Some of his prints also include images of Mount Fuji, including *View of Mount Fuji from Satta Point in the Suruga Bay* (1589), a woodcut that depicts a curling wave similar to the one painted by Hokusai. Hiroshige was almost forty years younger than Hokusai, and was greatly inspired by the older artist's work. Among his most famous works were his prints for the series, *One Hundred Views of Edo* (1856–1859),

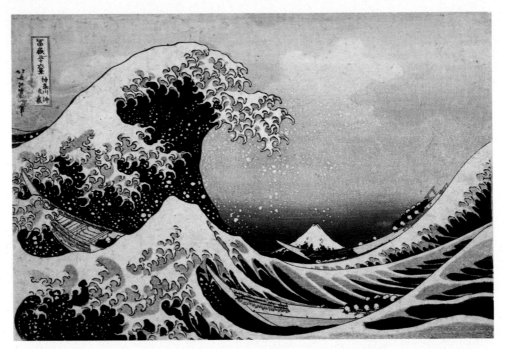

Katsushika Hokusai was an important *ukiyo-e* artist of the nineteenth century. His now iconic image, *The Great Wave off Kanagawa*, commonly known as "The Wave," is a woodblock print and part of a series of prints he called *Thirty-six Views of Mount Fuji*. The mountain can be seen in the background, seemingly smaller than the mighty wave in the foreground.

which were completed by his student, Hiroshige II. His prints often rely on an under-standing of perspective to create depth and his style had a major impact on Dutch artist Vincent van Gogh, who created an oil painting based on *Ohashi Bridge in the Rain* in 1887. Hiroshige's street scenes in prints such as *Night View of Saruwaka-machi* (1856) also inspired Impressionist artists such as Auguste Renoir and Camille Pissarro. Hiroshige was working in Japan at a time when the country was opening its doors to the outside world after centuries of isolation, and his work captures the changes occurring in the nineteenth century through a lens of the ukiyo-e tradition.

How did **Japanese art change** during the **Meiji Period**?

The Meiji Period lasted from 1868 to 1912, and during this time oil painting became popular in Japan after Japanese artists were exposed to Western styles of art. Subjects popular during the Edo Period, such as courtesans, were still popular during the Meiji Period. For example, in 1872, Takahashi Yuichi painted *Oiran (Grand Courtesan)*, a Western-style portrait painted in oil, but that incorporates patterns and colors used in ukiyo-e paintings. In this painting, Takahashi Yuichi (1828–1894) depicts the elegant sitter's brightly colored garments as disparate, abstract sections of color and texture, a technique derived from traditional Japanese painting. Western styles were so popu-lar during the Meiji Period that some artists were concerned that Japan would lose its own distinctive style. Traditional artists such as Yokoyama Taikan (1853–1908) wanted to breathe life into Japanese styles of painting by infusing them with some Western techniques, but to emphasize their Japanese character in a style known as *nihonga*.

IMPRESSIONISM

What is **Impressionism**?

Impressionism is an artistic style that developed first in France in the latter half of the nineteenth century and is known for a somewhat unfinished quality, as well as a focus on leisure and café scenes, landscapes, cityscapes, and genre scenes. Like the Realists, the Impressionists were interested in capturing visual reality, but they were particularly interested in the properties of light, both natural and artificial. Artists such as Claude Monet studied changes in the colors of the atmosphere as the sun moved through the sky. Recent rainfall intrigued artists like Gustave Caillebotte and Camille Pissarro, who both painted natural light and light from gas lamps that reflected off the rain-soaked streets of Paris. Most Impressionists came from middle or upper class French families, but because their work was initially unpopular, they often lived in poor neighborhoods in Paris, frequently gathering at the Café Guerbois in the Montmartre district. The popularity of leisure and café scenes is a tribute to the lifestyle of the Impressionists.

The Impressionists had a difficult time being accepted by both art critics and the art-viewing public, and were regularly rejected from exhibitions at the Palais de Beaux Arts (Palace of Fine Arts). Instead, they held their own shows between 1874 and 1886, and ended up having an enormous influence on modern art. Today, impressionism continues to be one of the most popular styles of painting and sculpture and impressionist shows attract thousands of visitors to museums and galleries around the world.

Who were some **influential Impressionists**?

The core group of Impressionist painters was a close-knit group living in France. Some were even related. For example, the artist Berthe Morisot was married to Manet's brother (though Manet is not officially considered an Impressionist, despite his major influence on them). The following list includes a selection of artists who are considered the major impressionist innovators.

- Claude Monet (1840–1926)—Monet favored *plein air* (outdoor) painting and is known for his landscapes, especially his water lily and haystack paintings. He painted the smoky interiors of train stations, and the façade of Rouen Cathedral more than thirty times. The term "impressionism" comes from a description of his painting, *Impression, Sunrise* (1873) by art critic Louis Leroy.

- Edgar Degas (1834–1917)—Degas was a painter, a printmaker, and a sculptor, and unlike other impressionists, was not a fan of *plein air* painting. Instead, he preferred to explore the effects of artificial lighting and usually worked in his studio. He is particularly well known for his paintings of ballet dancers and his other famous works include *L'Absinthe* (1876) and a sculpture called *Little Dancer of Fourteen Years,* now on display at the Metropolitan Museum of Art in New York.

- Berthe Morisot (1841–1895)—Morisot's work focused on landscapes and domestic scenes that highlighted the female experience. She regularly showed her work at the Salon and continued to paint professionally even after marriage to

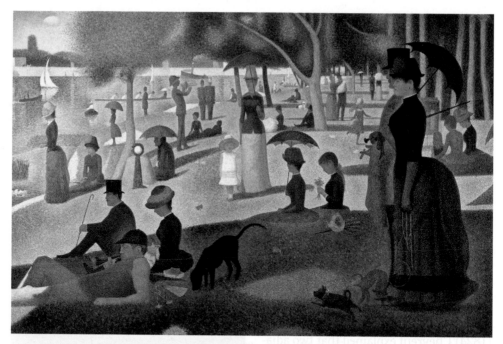

Sunday Afternoon on the Island of La Grande Jatte (1884–1886) by Georges Seurat was painted using a technique called pointillism, which was invented by Seurat himself. Pointillism involves placing differently colored dots side-by-side to create a vibrant image.

flatly colored paintings often hold significant symbolic meaning. In 1891, he expressed a desire to shed the corrupting influence of modern civilization and fled to Tahiti where he spent the majority of the rest of his life living in poverty and working on paintings infused with symbolism, mythology, and Tahitian subject matter, in what is considered a precursor of primitivism. Even before leaving for French Polynesia, Gauguin's work shows evidence of inspiration from folk art. His painting *The Yellow Christ* (1889) depicts the Crucifixion in Brittany, in Northern France. Local women encircle Christ, kneeling in prayer. The bold, flat colors of the painting are reminiscent of medieval Christian painting and emphasize the power and intangibility of prayer. Later works include *Te aa no areois (The Seed of the Areoi)* (1892), *Two Tahitian Women* (1899), and *Nevermore* (1897), a painting that mixes the influence of Edgar Allan Poe, the traditional female nude, and Tahitian imagery.

What is **nineteenth-century symbolism**?

The nineteenth-century Symbolist Movement began as a literary movement in France. Symbolist artists and writers made works that were inspired by dreams, myths, folklore, and the new psychological concept of the unconscious, as described by Sigmund Freud and Carl Jung. French poets, including Stéphane Mallarmé, Charles Baudelaire, and Paul Verlaine strived to elevate their work with symbols in an attempt to avoid the limitations of material reality. Gustave Moreau (1826–1898) and Odilon Redon (1840–1916) were French artists who embraced Symbolism, while the Norwegian artist Edvard Munch (1863–1944) is perhaps the most well known

Symbolist painter outside of France. Munch's *The Scream*, is a swirling depiction of intense emotion. Munch wrote about it in a journal, saying, "I sensed a shriek passing through nature… I painted this picture, painted the clouds as actual blood" (as quoted in Stokstad 1050). Other notable Symbolists include Belgian artist James Ensor, and the American Albert Pinkham Ryder. Many Symbolist paintings are characterized by a dark moods and macabre subject matter.

Who was **Henri Rousseau**?

Henri Rousseau (1844–1910) was nicknamed *Le Douanier*, meaning "the customs officer" because that was his profession. He was an amateur painter who began painting during middle age. Since he was not academically trained, his style was called *naïve*. He showed his work at the Paris *Salon des Indépendents*, and caught the eye of influential artists who helped him to develop his artistic career. By 1858, he was able to devote himself to art full time. His imaginative, detailed paintings were inspired by nineteenth-century symbolism and psychology and often feature exotic settings and primal themes. One of his greatest works is *The Dream* (1910), which depicts a nude woman reclining on a sofa—a traditional art historical subject—who has been strangely transported into a jungle. Wild fruit hangs from trees and exotic animals lurk in the brush while a dark figure plays a flute-like instrument. Due to the complex symbolism of the painting, Rousseau wrote an accompanying poem in an attempt to at least partially explain the work. The most common interpretation of *The Dream* is that it represents a woman sleeping on her couch in Paris, and as she dreams, her mind is transported to the jungle. Therefore, the dreamer has been merged with the dream, and the unexpected combination of elements, rendered with detailed realism, foreshadows surrealism.

Who was **Vincent van Gogh**?

During his lifetime, Dutch artist Vincent van Gogh (1853–1890) was not well understood, and he died young, at the age of thirty-seven, of a gunshot wound. Although no gun was ever found, his death has always been considered a suicide. He suffered intense bouts of depression, spent time in an asylum in southern France, and is, of course, famous for cutting off his own ear (though this story has its critics), a violent event that was documented in van Gogh's *Self Portrait with Bandaged Ear* (1889).

Although van Gogh's troubled life receives a great deal of attention, it is his incredible artistic talent that endures.

Like Rembrandt, the post-impressionist artist Vincent van Gogh painted many self-portraits, offering viewers a small glimpse of his mysterious and troubled life. Like most of his paintings, van Gogh's self-portraits rely on bold brushstrokes and bright areas of color.

191

large hat. The woman's nose is composed of the same green color that is splashed across the background and her neck is deep orange. The Fauves were free from the restrictions of a realist color palette, and with this freedom they went on to experiment with other styles and helped to usher in twentieth-century modernism.

What is **Expressionism**?

The term "expressionism" is commonly used in the arts, but with a capital "E," it refers to an art movement that developed in Germany at the start of the twentieth century. German Expressionism, like Fauvism, was concerned with communicating powerful feelings through color and visual style and Expressionist works often incorporate meaningful symbols. There were two important groups of painters who were part of the Expressionist movement in Germany. The first was called *Die Brücke* (The Bridge) and the second was known as *Der Blaue Reiter* (The Blue Riders).

Henri Matisse was one of the most innovative and influential artists of the nineteenth and twentieth centuries. His *Femme au Canapé*, also known as *Le Divan* (1921), is filled with bright, flat colors. Matisse emphasizes the importance of the light-filled window, which dominates the scene. (*Artwork: © 2013 Succession H. Matisse / Artists Rights Society [ARS], New York. Photo: RMN-Grand Palais / Art Resource, NY*)

What is the **difference** between **The Bridge** and the **Blue Riders**?

"The Bridge" and the "Blue Riders" were both groups of German Expressionist artists who shared artistic values, promoted the symbolic power of color, and believed that art could communicate powerful positive or spiritual messages to the viewer. The Bridge, known is German as *Die Brücke*, was founded in Dresden in 1905 by four architecture students: Fritz Bleyl (1880–1966), Erich Heckel (1883–1970), Ernst Ludwig Kirchner (1880–1938), and Karl Schmidt-Rottluff (1884–1976). Their name came from the philosophical writing of Friedrich Nietzsch, and they shared the philosopher's idea that the present-day can positively influence the future, acting as a "bridge" to the future. The artistic style of the "Bridge" artists was inspired by so-called "primitive" non-Western art, such as African masks, which they believed was somehow more authentic than Western art. They were also inspired by nature and Russian literature. Key works produced by members of the "The Bridge" include Schmidt-Rotluff's *Three Nudes – Dune Picture from Nidden* (1913) and Kirchner's *Street, Berlin* (1913), which depicts two prostitutes, one wearing a purple coat, against a bright pink urban background.

Der Blaue Reiter *(The Blue Riders)* was another Expressionist group founded in Germany, in Munich rather than Dresden. Members included the Russian painter

Wassily Kandinsky (1866–1944), and German artist Franz Marc (1880–1916), who was killed during World War I. Marc was interested in the symbolism of the color blue, and he believed that blue was the most spiritual color. One of Marc's most recognizable paintings is *The Large Blue Horses* (1911), which depicts the backs and bowed necks of a group of deeply blue horses as if they are distant mountains against a burnt, orange sky. Kandinsky was inspired by Russian folk art and was deeply interested in art history and philosophy. Kandinsky associated realism with the negative aspects of materialism, and as his career developed, his art became less and less figurative. He explained that he wanted his art to inspire spiritual awareness in his viewers. Kandinsky was also inspired by the nineteenth-century artist Whistler to give his paintings musical titles such as *Composition IV* (1911), *Improvisation 28* (1912), and even *Contrasting Sounds* (1924). His work is also thought to be inspired by his synesthesia, a neurological condition in which one can "see" numbers, letters, or even sound as color. Kandinsky's theories and paintings on the spiritual quality of visual art were extremely influential for modern art. Expressionist paintings from both "The Bridge" and the "Blue Riders" made a major impact on twentieth-century art due to their philosophical goals and interest in expressive abstraction.

How did **African art influence** art of the **early twentieth century**?

At the beginning of the early twentieth century, Western artists such as Pablo Picasso (1881-1973) and Emile Nolde (1867–1956) became interested in the so-called "primitive" art of non-Western cultures, including the arts of Africa and the Pacific. In France, artists were able to see non-Western art at the *Musée d'Ethnographie* in Paris. Although they were inspired by the visual expressivity and relative abstraction of much non-Western art, most European artists made little to no attempt to understand the historical and cultural context of the pieces they viewed (and often purchased). Picasso's art was significantly inspired by African style, allowing the artist freedom to explore with color and style. For example, one his most important paintings, *Desmoiselles d'Avignon* (1907), is characterized by elongated figures and abstract faces commonly found in African masks and sculpture. Another painting, *Mother and Child* (1907) uses bold colors and ovoid forms to reinvent traditional Christian subject matter. Despite the clear influence, Picasso occasionally downplayed the importance of African art his own work, preferring not to talk about it.

Who was **Pablo Picasso**?

Pablo Picasso (1881–1973), is perhaps one of the most famous modern artists of all time. Born in Spain, he produced thousands of works of art during his lifetime, and is known for his artistic genius and avant-garde innovations. Picasso was a painter and a sculptor and experimented with collage, mixed media, and sculptural assemblages. He is credited with developing Cubism (along with fellow Cubist and fierce competitor Georges Braque), he helped to popularize non-Western art, and he experimented with symbolism, expressionism, classicism, surrealism, and more.

Like many of the great artists described by Giorgio Vasari in *The Lives of the Artists,* Picasso's talent was discovered at a young age by his father, also an artist. He

This image shows an interior (1919), and a study of a ceiling (1925) by De Stijl founder Theo van Doesburg, originally published in the Autumn 1924 issue of the Paris journal, *L'Architecture Vivante*. (*Art courtesy The Art Archive.*)

tion. *De Stijl* is considered to be "reductive" because visual complexity has been distilled or reduced to only the most pure, meaningful elements. For example, *De Stijl* artists preferred primary colors: red, yellow, and blue or neutral colors such as black, white, and gray. The term *De Stijl* can be used to describe painting, furniture design, and architecture. Works include Gerrit Rietveld's *Red-Blue Chair* (1923), the Schroeder House in the Netherlands, and the paintings of Piet Mondrian.

Who was **Mondrian**?

Piet Mondrian (1872–1944) was a Dutch painter who made significant contributions to twentieth-century abstraction, especially geometric abstraction. He was an important part of the *De Stijl* movement and he is most well known for paintings that depict flat, geometric grids in neutral and primary colors. During his early career, Mondrian's art was not totally abstract. Paintings such as *Still Life with Gingerpot* (1911) and *Grey Tree* (1912) show the artist's early flirtation with Cubism and even earlier works such as *Mill at Evening* (1905) are linked to the Dutch landscape tradition.

Mondrian's style changed throughout his career. He was influenced by Cubism, but believed that the goal of painting should be complete abstraction as a vehicle for

communicating reality. He supported the idea that color and form could impose pure reality on the viewer in what he called "plastic expression." According to Mondrian, a work of art needed to balance movement, form, and color in order to achieve this reality, an aesthetic philosophy called "neoplasticism." Mondrian's paintings, such as *Composition with Large Red Plane, Yellow, Black, Grey and Blue* (1921), are meticulously painted to achieve the utmost in formal balance, and produce dynamic energy, a sense of depth, and a balance between simplicity and complexity.

The modern artist Piet Mondrian experimented with complete abstraction according to the principles of the de Stijl movement. *Composition with yellow, blue, and red* (1937–1942) is supremely balanced and produces a shifting sense of both flatness and depth. (*Art © HCR International. Courtesy Tate Gallery, London / The Art Archive / Eileen Tweedy.*)

ARCHITECTURE AND DESIGN

What is **Art Deco**?

"Art Deco" is a term that describes a style of decorative arts popular during the 1920's and 1930's, though the term was coined later. Art Deco—originally called *style moderne*—began in France and gained prominence after the *Exposition Internationale des Arts Decoratifs et Industriels Moderne,* an art and design expo held in Paris in 1925. Art Deco is characterized by the merging of fine arts with decorative arts and emphasized new support for the craftsman over the factory. Art Deco objects, illustrations, and buildings are often highly ornamental, something that was criticized by other modernist designers and writers, such as Le Corbusier (who favored a more industrial aesthetic). There are often exotic elements in Art Deco design, inspired by the discovery of King Tut's tomb in Egypt in 1922. Abstract movements such as Cubism and futurism also inspired geometric motifs associated with Art Deco.

What is the **difference** between **Art Nouveau** and **Art Deco**?

Art Nouveau and Art Deco were both design movements that flourished in the early twentieth century. Art Nouveau was established before Art Deco, and even influenced it. Art Nouveau designs tend to be busier and more ornate, with curving, organic lines. Art Nouveau artists include Alphonse Mucha and Théophile Alexandre Steinlen (the designer of the still-popular *Tournée du Chat Noir* posters). Art Deco is also ornamental; however, it tends to be more geometric due to the influence of Cubism and Futurism. Art Deco was popular during the Great Depression; the Empire State Building, completed in 1931, is an example of Art Deco architecture as are many of the jewelry designs of Georges Fouquet and many poster designs of the era.

207

With *Composition IV* (1911), Russian painter Wassily Kandinsky, who taught at the Bauhaus, experimented with abstraction. This work has been described as both an abstract and a landscape painting. (*Art courtesy The Art Archive / Kunstsammlung Norshein West / Harper Collins Publishers.*)

Klee, (1879–1940), Johannes Itten (1888–1967), and Wassily Kandinsky (1866-1944), who lived together onsite in the specially-designed school. The first director of the Bauhaus was Walter Gropius (1889–1983), a renowned modern architect known for his interest in function. The courses covered both practice-based art training (on topics such as painting, furniture-making, ceramics, bookbinding, metalworking, and eventually architecture) as well as more theoretical concepts including art historical analysis, color theory, and even meditation. Unlike many art schools, the Bauhaus included the applied arts in its curriculum and actively sought out design commissions. With the goal of creating art objects that blended art and craft, students infused everyday objects with elements of high-design. For example, Peter Keler's 1922 design for a cradle reflects both geometric simplicity and functional efficiency. The politically left-leaning Bauhaus began to lose funding as more conservative policies took hold in Germany during the 1920s. The school first moved to Dessau, and then to Berlin, but was eventually closed in the 1930s as the Nazis gained power. Many of the key Bauhaus leaders and faculty members—Walter Gropius, László Mo holy-Nagy, Ludwig Mies van der Rohe, Josef Albers—emigrated to the United States. The Bauhaus' embrace of industrialism and its goal of creating functional design made an enormous impact on the art and architecture of the twentieth century.

How did the **Bauhaus influence America**?

Many important German artists, architects, and designers fled the country during the rise of the Nazis and emigrated to America, where they achieved great success. Walter Gropius, the founder of the Bauhaus school, left Nazi Germany in 1934 and joined the faculty at Harvard University where he founded the Architect's Collaborative, a

modernist group that emphasized collaboration and created the design for the Clark Art Institute building in Williamstown, Massachusetts. In Chicago, László Moholy-Nagy directed the New Bauhaus (which lasted until 1938) and later went on to open the School of Design, which was then incorporated into the Illinois Institute of Technology (IIT). Ludwig Mies van der Rohe was head of IIT's architecture department and designed Crown Hall, a masterpiece of modern architecture.

Why was **Josef Albers** interested in the **square**?

Josef Albers (1888–1976) was a progressive German artist who taught at the Bauhaus, and went on to become one of the most influential art teachers in the United States. He held posts at the influential Black Mountain College in North Carolina, and at Yale University, where he taught color theory and abstraction, and experimented with visual perception and illusion. Albers is known for his series of prints and paintings titled *Homage to the Square,* in which he placed a square within a square using various colors, creating a dynamic and often ambiguous sense of depth, geometry, and color contrast. For such apparently simple paintings, Albers was able to use the square to experiment with color theory and depth perception in a profound way.

Who was **Le Corbusier**?

Le Corbusier (1887–1965) was an architect and designer whose real name was Charles-Édouard Jeanneret. He was also a painter and writer, publishing *Towards a New Architecture* in 1923. Le Corbusier's approach to architecture can be explained in his statement that a house is a "machine for living" (quoted in Arnason 561). He is

Le Corbusier designed the Chapel of Notre-Dame-du-Haut in 1955. The religious structure was built using one of Le Corbusier's preferred materials: concrete.

known for early home designs and later urban renewal projects. One of his earliest and most famous home designs is the Villa Savoye, built between 1928 and 1930 in Poissy, France. The rectangular plan of the house allows for long, expansive windows that help to bring the outside in. Raised on pillars, the Villa Savoye is an early attempt to design a domestic space around the use of an automobile, which could be driven and parked under the house. For his urban projects, Le Corbusier believed that architecture could serve as a solution to poverty. He envisioned a total city, in which uniform architectural design would create an ideal living environment. Between 1947 and 1952, he designed the Unité d'Habitation in Marseilles, France, with concrete as a primary building material. The project included duplex apartments along with shops, restaurants, and roof-top park space—a complete community. Le Corbusier's work on the *Unité d'Habitation* inspired an architectural style named Brutalism.

What is **Brutalism**?

The term "Brutalism" was coined in 1954 and refers to a style of modern architecture developed by Le Corbusier, who promoted the use of rough concrete and favored heavy forms. Reinforced concrete can take on sculptural qualities, as in Le Corbusier's design for Notre-Dame-du-Haut (1950–1954), with its flowing roof line and round, asymmetrical tower. Brutalism was most popular during the 1960s and 1970s and coincided with the concept of *art brut* developed by artist Jean Dubuffet.

DADA AND SURREALISM

What is **Dada**?

Dada was an anti-rational, anti-establishment movement that began in Europe. Dada was concerned with upending tradition and embracing chance, anarchism, and new forms of art-making. The word "dada" itself is essentially meaningless and was supposedly chosen from the dictionary at random by a group of artists and writers in Zurich, Switzerland, in 1916. The sound "dada" is childish, and reminiscent of a baby's first words. Dada was a reaction against the horrors of World War I, though earlier movements such as Cubism, and the writing of Kandinsky, certainly inspired it as well. Dada's influence spread and notable Dada groups were established in Germany, Paris, Barcelona, and New York. Artists associated with Dada include André Breton (1896–1966), Jean (Hans) Arp (1886–1966), Marcel Duchamp (1887–1968), and Man Ray (1890–1976).

Who was **Marcel Duchamp**?

Marcel Duchamp (1887–1968) was one of the most fascinating and thought-provoking artists of the twentieth century. He experimented with Cubism, Futurism, and championed Dada during an ever-changing and provocative career. Duchamp continually questioned artistic convention at the most fundamental levels—even the definition of a work of art. During his early career, he created the iconic *Nude Descending the Staircase, No. 2* (1912), which shocked viewers and critics at the Armory Show

in New York in 1913, though it garnered him a great deal of fame. The work blended Cubist and Futurist styles in its abstract depiction of the moving human form.

Duchamp is most closely associated with Dada and Surrealism. One of his most complicated works was 1915's *The Bride Stripped Bare by Her Bachelors, Even,* more commonly referred to as *The Large Glass.* The piece is large, and made of two panels of glass suspended with wire. It is divided into two halves; the top half is the "bride's domain" while aggressive bachelors dominate below. Highly enigmatic, despite many notes left by Duchamp as to its meaning, some critics believe the work is a commentary on art criticism itself. Duchamp's ground-breaking and complex approach to art continues to impact the art world into the twenty-first century.

What is a **"ready-made"**?

A "ready-made" is an artistic concept that describes an existing functional object that no longer serves its intended purpose and that is instead considered for only its aesthetic value. The best example of a ready-made is Marcel Duchamp's *Fountain* (1917), a porcelain urinal Duchamp signed as "R. Mutt" and submitted as a work of art for an exhibition of the Society of Independent Artists in New York. When Duchamp changed (or augmented) a pre-existing object, he called the work "ready-made aided." The act of signing the urinal can be considered such a change, but a more complex example can be seen in Duchamp's *L.H.O.O.Q.* (1919). For this work, Duchamp took a found object (or, a pre-existing object), in this case, a postcard of the *Mona Lisa,* upon which he drew a mustache. This act of aesthetic vandalism serves to question the authority of art history and the preeminence of so-called fine art. Duchamp's interest in ready-mades reflects Dada provacatism, humor, and irreverence. The concept influenced later artists such as Jasper Johns, Robert Rauschenberg, and Andy Warhol, all artists who manipulated pre-existing images in their work to communicate new meanings.

What is **Surrealism**?

Like Dada, Surrealism was an early twentieth-century movement that made a major impact on art and literature between the First and Second World Wars. In 1924, French poet André Breton (1896–1966) wrote the first Surrealist Manifesto in which he called on writers to free themselves from the restrictions of rationality and explore creativity through subconscious means, including free association, dream analysis, and automatic writing and drawing. The word "surreal" suggests the merging of dreams with reality to reveal a superior, more inclusive reality. Breton credited Sigmund Freud with developing the foundations of Surrealism in his studies in psychoanalysis.

Key Surrealist artists include Giorgio de Chirico (1888–1978), Max Ernst (1891–1976), André Masson (1896–1987), Joan Miró (1893–1983), Man Ray (1890–1976), René Magritte (1898–1967), and Salvador Dali (1904–1989), among others. The work of the Surrealists is characterized by shocking, often erotic imagery, such as René Magritte's fusion of the nude female form with a face in his oil painting, *Le viol* (1934), and the juxtaposition of surprising, seemingly unconnected elements. For example,

213

Meret Oppenheim covered a cup, saucer, and spoon with fur in her *Objet (le déjeuner en fourrure)* in 1936. Like many other examples of Surrealist art, these disorienting works were inspired by Freudian symbolism and dream analysis.

What is **surrealist automatism**?

Surrealist artists and writers attempted to free themselves from the restrictions of rationality by tapping directly into their creative subconscious through automatic drawing and writing. André Breton described this process, which he called "pure psychic automatism" in the *Surrealist Manifesto,* and Surrealist artists such as André Masson, Joan Miró, and Max Ernst are known for their spontaneous, free-form work. Many of Masson's automatic drawings were done with pen and ink, while Ernst developed

Les Soupir des Amants (Lover's Sigh) (1953) by Joan Miró was inspired by the artist's use of automatic drawing and other surrealist techniques. *(Art courtesy The Art Archive / Galleria d'Arte Moderna Rome / Gianni Dagli Orti / © Successió Miró / ADAGP, Paris, 2013.)*

what he called *frottage*. In this technique, Ernst made rubbings of textured surfaces, such as wood floor, which were then incorporated into larger collage works.

Who was **Salvador Dali**?

Salvador Dali (1904–1989) was a Spanish surrealist painter, writer, and filmmaker who gained celebrity status for eclectic art and eccentric behavior (and a curling black mustache). Dali was trained in art at the San Fernando Academy of Fine Arts in Madrid, and his early work exhibits traditional and later Cubist influence. He was a highly skilled realist, though his work was inspired by delirium and he produced jarring fantastical dreamscapes, often inspired by his Catalonian homeland. Dali called his approach the "paranoiac-critical method." His goal was to use paranoia to communicate an irrational understanding of reality, an approach quite in line with the overall goals of Surrealism, according to the Surrealist Manifesto. Dali's most famous work is *The Persistence of Memory* (1931); other notable paintings include *Birth of Liquid Desires* (1931–1932), and *Soft Construction with Boiled Beans: Premonitions of Civil War* (1936). Dali also created sculptural objects such as *Lobster Telephone* (1936) and his long-legged *Space Elephant,* which appears in both sculptures and paintings.

What is the meaning of ***The Persistence of Memory***?

The Persistence of Memory (1931) is Salvador Dali's most famous painting. In this work, Dali depicts languid, melting clocks draped over an arid, desert landscape. Unlike many of the other large, abstract works being produced at the time, *The Persistence of Memory* is quite small, not much bigger than an ordinary piece of paper. It is

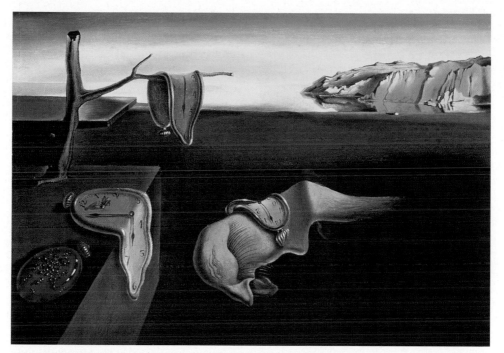

The Persistence of Memory (1931) by surrealist artist Salvador Dali, is one of his most famous paintings, and one of the most recognizable paintings of the twentieth century. The work explores themes of time and change. (*Art courtesy The Bridgeman Art Library, © Salvador Dalí, Fundació Gala Salvador Dalí, Artists Rights Society [ARS], New York, 2013.*)

highly detailed and uncomfortably realistic for such a strange picture. Against a smooth and seemingly infinite horizon, are four liquid clocks. At the center, one of these clocks (really more of a pocket watch), curls over what appears to be a boneless, fish-like face. Another clock oozes off the side of a table-like surface, while another rests upside down, black ants aggressively gathered atop it. Dali himself compared the objects in the painting to melting Camembert cheese, and the entire scene is fixed in an impossible state of timeless transformation. Although there can be no definitive definition of this painting, the work is a meditation on the unfixed nature of time and space.

Why is this **not a pipe**?

René Magritte's *The Treachery (or Perfidy) of Images* (1928–1929), is a highly realistic oil painting of a tobacco pipe with the words *Ceci n'est pas une pipe* ("This is not a pipe.") painted below. The message raises the obvious question: why not? Why is this pipe, especially one so meticulously rendered, not a pipe? The answer is that Magritte did not make a pipe, he made a painting, and with this work Magritte draws the viewer's attention to a tendency to casually equate pictures of things with what they represent. The work reinforces the idea that even a realistic painting is an illusion, a concept that would have a profound impact on later modern and postmodern art.

Who was **Man Ray**?

Born Emmanuel Radnitsky (1890–1976) in Philadelphia, Man Ray was a major contributor to both Dada and Surrealism. Though he is most well known for his exper-

215

imental photography, Man Ray was a painter, filmmaker, and writer. Like many other Dada artists, Ray was inspired by industrialism and the aesthetic qualities of machines, creating startling Dada objects such as *Gift* (1921), an iron with a row of sharp nails glued to the flat surface. He used tools more often associated with commercial art in his fine art projects, and was the first painter to use an airbrush, a process that fascinated him as it allowed him to create a painting without touching the canvas itself.

Man Ray is notable for his experiments with a camera-less photographic process known as the photogram, but which he called the "Rayograph." With the Rayograph, Man Ray could place an object next to light-sensitive paper to create automatic images. He also developed photomontages and mixed media photographs such as *Le Violon d'Ingres* (1924), perhaps his most well-known work. The title refers to the nineteenth-century French artist who often portrayed exotic women in his portraits. Man Ray's piece is a photograph of one of his favorite models, Kiki de Montparnasse (born Alice Prin), upon which he painted the f-holes of a violin, making her curving nude body reminiscent of a musical instrument. The image is oddly disturbing, as Kiki's arms are noticeably missing from view and she is transformed from a subject into an object.

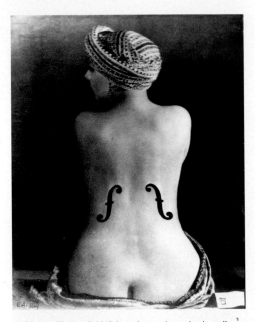

Le Violon d'Ingres (1924) is an innovative, mixed-media photograph by the American artist Man Ray. With only subtle manipulations, Man Ray creates a multi-faceted image that also becomes a play on words. In French, "le violon d'Ingres" is an idiom that means "hobby." (*Art courtesy The Bridgeman Art Library, © 2013 Man Ray Trust / Artists Rights Society [ARS], NY / ADAGP, Paris.*)

PHOTOGRAPHY

Who was **Alfred Stieglitz**?

Alfred Stieglitz (1864–1946) was an influential photographer and gallery-owner, who aimed to raise the status of photography to that of painting. Born to a German immigrant family, he was raised in New York City, and he formed a group of New York City photographers called "Photographic Secession." With a hand-held camera, he photographed the city, capturing sensitive images of a gritty, urban landscape. Stieglitz also photographed cloudscapes, and said that the ever-changing clouds reflected his emotions. Besides his photographic work, Alfred Stieglitz made a significant contribution to modern art through his "291" gallery (located at 291 Fifth Avenue), which promoted European modernism and supported the careers of many important twentieth-century artists, including Picasso, Matisse, and Georgia O'Keeffe, who he married in 1924.

Who was **James van der Zee**?

James van der Zee (1886–1983) was an African American photographer who documented the emerging black middle class in New York City during the Harlem Renaissance. He was primarily a portrait photographer and worked in his studio, though he experimented with double exposures and retouching. Van der Zee painted studio backdrops for indoor photo shoots, and even provided props and costumes for his sitters, often commemorating important life events such as weddings or family gatherings. Van der Zee's work captures the hopes and dreams of black Americans arriving in the city from the rural south and remains one of the most significant records of the Harlem Renaissance. His collected works are now held at the Museum of Modern Art in New York.

What does the **Farm Security Administration** have to do with art?

In 1935, the Farm Security Administration (FSA) was established in order to document and communicate the devastating impact of the Great Depression, especially on farm workers and the rural poor. American economist Roy Stryker hired a team of photographers that included Walker Evans and Dorothea Lange, among others. Walker Evans (1903–1975) had studied literature in Paris and was direct in his approach to photography. His work powerfully documents struggling families, notably in West Virginia, during the period between World Wars I and II. Dorothea Lange (1895–1965) had a photography studio in San Francisco, but when hired by Roy Stryker, she traveled to see first-hand what migrant farm workers had to endure. Her photographs, including *Migrant Mother* (1936), *Migratory Cotton Picker* (1940), and *Wife of a Migratory Farmer in Her Makeshift Tent Home,* are eloquent and forceful. Upon seeing her work, a London critic exclaimed, "What poet has said so much? What painter has shown so much?" (quoted in Fleming and Honour 817). The influential Farm Security Administration's photography program lasted until 1944 and made a major impact on American awareness of poverty, as well as on the role of documentary photography.

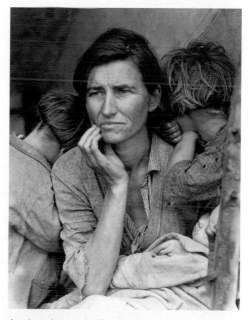

American photographer Dorothea Lange took the picture *Migrant Mother* in 1936 as part of the Farm Security Administration's project to document poverty during the Great Depression.

Who was **Henri Cartier-Bresson**?

While the FSA photographers focused their attention on rural America, French photographer Henri Cartier-Bresson (1908–2004), documented the Spanish Civil War (1936–1939) and much of twentieth-century Europe. Cartier-Bresson is considered one of the foremost early photojournalists, which means he

217

communicated the news through pictures, but he was also deeply inspired by Surrealism and took seemingly spontaneous snapshots while walking through the streets of Paris. Henri Cartier-Bresson is known for his uncanny ability to remain neutral as a photographer, to maintain a fly-on-the-wall perspective. He also subtly incorporates psychological interest into his work, making his seemingly simple photographs emotionally and intellectually complex.

MODERN ART UNTIL c. 1960

Who were **"The Eight"**?

"The Eight" was a group of American realist artists with diverse styles—Robert Henri (1865–1929), Arthur B. Davies (1863–1928), William Glackens (1870–1938), Ernest Lawson (1873–1939), George Luks (1867–1933), Maurice Prendergast (1858–1924), Everett Shinn (1876–1953), and John Sloan (1871–1951)—all of whom were rejected by the National Academy for a spring exhibition in 1907. In response, they had their own show at the Macbeth Gallery in New York City in 1908. Many of these artists went on to be known as members of the Ashcan School, a group who made gritty, realistic paintings of urban life. Their one and only show as "The Eight" received mixed reviews, with some critics feeling that the underbelly urban life was not appropriate subject matter for art, but it went on to make a major impact on American realism in the twentieth century. Though some use the terms "The Eight" and "Aschan School" interchangeably, they are not exactly the same.

What was the **Ashcan School**?

The Ashcan School was a loosely affiliated group of American realist artists made up of some members of "The Eight," including Robert Henri, William Glackens, George Luks, Everett Shinn, and John Sloan. The painter George Bellows (1882–1925) is also associated with the Ashcan School. Like the Impressionists, the artists of the Aschan School were interested in scenes of everyday American life, though they tended towards darker themes. Paintings such as John Sloan's *Election Night* (1907) and George Bellows' *Cliff Dwellers* (1913) feature bold colors and seemingly spontaneous energy as large groups of people fill the frame. The Ashcan School is considered the first modern American art movement.

What is **American Regionalism**?

While some American artists and critics were enamored with European modernism, others—like Edward Hopper (1882–1967), Grant Wood (1892–1942), and Thomas Hart Benton (1889–1975)—turned inward and examined American life during the 1930s and 1940s. The quiet, lonely paintings of Hopper, such as his famous *Nighthawks* (1942), a painting that depicts a brightly lit, if empty, restaurant interior on a dark night, evoke a sense of isolation. Iowa-born artist Grant Wood studied in Paris where he was exposed to the realism of the Northern Renaissance, a realism that he infused into his now iconic

painting, *American Gothic* (1930), which depicts a farmer couple (actually modeled by the artist's sister and a local dentist) who stand in from of their clapboard home, exaggerated to have the look of a Gothic cathedral with long, pointed windows. Wood's painting glorifies the hardworking, American farmer. Thomas Hart Benton also memorialized the American worker in his series of murals for the New School of Social Research in New York City, called *America Today*. American Regionalism provided a comfortable depiction of America's heartland after the challenges of the Great Depression and World War II. Essentially a realist style, though also occasionally political, it fell out of favor as European-inspired modernism dominated the American art scene during the 1940s.

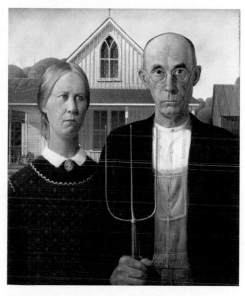

American Gothic (1930), by Grant Wood, serves as a nostalgic snapshot of the American Midwest and was part of a movement known as American Regionalism. (*Art © Figge Art Museum, successors to the Estate of Nan Wood Graham /Licensed by VAGA, New York, NY.*)

Who was **Grandma Moses**?

Anna May Moses, better known as Grandma Moses (1860–1961), didn't begin painting until she was in her seventies, when her arthritis was so bad that she could no longer sew. She is an example of a so-called "naïve artist," or a self-taught artist who has not been academically trained. Grandma Moses lived in rural New York, and first had her art displayed in a local drugstore, where she was discovered by an art collector. Her first solo-show, held in 1940, was called "What a Farm Wife Painted." Her work, primarily nostalgic landscapes of familiar places such as upstate New York, Vermont, and Virginia, became immensely popular, and has been copied in multiple formats—from greeting cards to wallpaper to postage stamps. Among her collection of over one thousand paintings are *The Old Checkered House, Eighteenth April 1949* and *Down on the Farm in Winter, 1945,* which are filled with small, lively figures and provide a nostalgic view of rural America.

What was the **Harlem Renaissance**?

The Harlem Renaissance was a cultural movement that grew from the nineteenth-century New Negro movement. Intellectuals such as Alain Locke (1886–1954) called on black artists, writers, musicians, and thinkers to draw inspiration from their African roots rather than white European traditions. Blues and jazz, played by musicians such as Bessie Smith and Duke Ellington, and poetry by writers such as Langston Hughes, were part of a cultural explosion that centered on the New York city urban experience. Visual artists, including the photographer James van der Zee, and painters Palmer Hayden (1890–1964) and Aaron Douglas, whose painting *Aspects of Negro*

Life: From Slavery Through Reconstruction (1934) is an example of the influence of African art styles on black artists during the Harlem Renaissance. The painting represents the history of black Americans, and is populated with figurative silhouettes reminiscent of ancient Egyptian paintings. With a limited color palette, Douglas' painting is filled with energy, movement, and sound in its depiction of the Emancipation Proclamation, Civil War Reconstruction, and voting rights. At the far left of the scene, the Ku Klux Klan threaten on horseback, but repeating circles draw attention to a triumphant figure at the center, who holds a ballot in his hand.

AMERICAN ART AND THE INFLUENCE OF EUROPE

What was the **Armory Show**?

In 1913, the Armory Show introduced America to European modernism. The Armory Show was actually called the "International Exhibition of Modern Art," which was held at the 69th Regiment Armory in New York City. It was organized by the Association of American Painters and Sculptors and displayed a range of styles, from American realism to Impressionism to European modernism. Although European modernism made up a small portion of the art in the exhibition, it made shock waves among American viewers and critics. The fauve works by Matisse, and the Cubism of Picasso and Braque were highly criticized. Marcel Duchamp's *Nude Descending the Staircase* was deemed to look like a pile of twigs. Despite this sensational backlash, which attracted thousands of visitors to both the New York and the additional Chicago location, the Armory Show made an unprecedented impact on American avant-garde artists and collectors, marking the beginning of modernism's dominance of the American art scene throughout much of the twentieth century.

What is **Precisionism**?

Precisionism, a term coined by American modernist artist Charles Sheeler (1883–1965), is sometimes also called "Cubist Realism." The movement began in the 1920s and was an early American modernist movement characterized by geometric simplification and broad areas of flat, hard-edged color. Precisionist paintings often depict abstract architectural or industrial scenes. The precisionist work of Charles Sheeler, such as *Church Street El* (1920) are clearly influenced by the artists' experience as a photographer, and emphasize the man-made world. Other artists associated with Precisionism are Charles Demuth (1883–1935) and Georgia O'Keeffe (1887–1986), whose works *Radiator Building – Night* (1927) and *City Night* (1926) are good examples of the style.

Who was **Georgia O'Keeffe**?

Although Georgia O'Keeffe (1887–1986) is quite popular for her large, highly detailed paintings of flowers, throughout her career she painted a range of subjects—

Georgia O'Keeffe's large paintings of flowers, including *Two Calla Lilies on Pink* (1928), are praised for their fluid oscillation between precise detail and abstraction. (*Art courtesy The Bridgeman Library, © 2013 Georgia O'Keeffe Museum / Artists Rights Society [ARS], New York.*)

from New York city skyscrapers to desert scenes, cow skulls, and adobe architecture. O'Keeffe was a modernist painter whose work was highly distilled and so precise it could border on the abstract. Georgia O'Keeffe's first solo show was in 1917 at the 921 Gallery, run by photographer and collector Alfred Stieglitz, who she later married. After his death in 1946, O'Keeffe permanently relocated to New Mexico, where she was interested in the sun's effect on the visual quality of objects and lived an isolated life. Her work oscillates between realism and abstraction, and her powerful images have brought her celebrity status as an artist.

Why did **Alexander Calder** make **mobiles**?

American artist Alexander Calder (1898–1976) was interested in sculpture that moved, also known as kinetic sculpture. Trained as an engineer and an artist, Calder was intrigued by Piet Mondrian's experimentations of color and form, and himself created "moving Mondrians"—free hanging, mobile sculptures engaged in constant physical change. Not only do Calder's works of art move, but the viewer may move around the art, allowing for ever-changing dynamic viewpoints. Calder's mobile *One of Those* (1972) is composed of abstract biomorphic forms that suggest organic, lively objects. Calder made more than mobiles; other sculptural works include the fifty-ton arched-steel *Flamingo* in Chicago (1973) and the curving, fin-studded *Whale II* (constructed of wood and steel in 1964 after the 1937 original), housed at the Museum of Modern Art in New York.

One of Those (1972) is an example of the mobile-like, kinetic sculpture of Alexander Calder, who was interested in creating dynamic work that moved through space. (*Art courtesy The Bridgeman Library, © 2013 Calder Foundation, New York / Artists Rights Society [ARS], New York.*)

Who was **Joseph Cornell**?

Joseph Cornell (1903–1972) was a self-taught American artist and filmmaker from New York, who experimented with Surrealist collage and assemblage, and is most celebrated for his shadow boxes filled with meticulously curated *objéts trouvés* (found objects), which exhibit the artists' eclectic and intellectual interests—from astronomy to arcades, from ballet to film. Cornell exhibited his work at the Surrealist Julien Levy Gallery, bringing distinction to the art of assemblage. Cornell's boxes have been interpreted as constructivist, and have also been likened to visual poems, filled with surprising, often playful objects. For example, *Homage to the Romantic Ballet* (1942) holds six frosted glass cubes on a reflective plate above a blue, velvet surface. On the inside of the lid is an inscription—a lyrical telling of a carriage ride on a moonlit night. Another piece, *Untitled (Hotel Eden)* (1945) features a cutout of a tropical bird, white-washed wood, and paint-splattered newsprint, which creates a nostalgic image of paradise. Many of Cornell's assemblages are on display at the Art Institute of Chicago.

What is **Abstract Expressionism**?

Abstract Expressionism, which lasted from the 1940s to the 1960s, was an American movement influenced by European modernism, Surrealism, and non-Western art traditions. Surrealist principles of psychic automatism were particularly influential, as was the influence of psychology and mythology. Abstract Expressionist paintings

tend to be very large and intense, and feature dynamic, bold colors. For many abstract expressionist artists, the creative process itself was as important as the work. Abstraction expressionist paintings do not represent a specific visible subject, but they do communicate emotions and other less tangible subjects. Artists labeled as abstract expressionists were diverse in their approach and styles. The movement can be divided into multiple categories and sub-styles, the most prominent being action painting and color-field painting.

What is the difference between **action painting** and **color-field painting**?

Action painting is a type of abstract expressionism with close ties to surrealist automatism. It is sometimes also called "gestural painting" or "gestural abstraction." Action painting is improvisational and emphasizes uncontrolled creativity and the process of painting itself. The three main artists associated with action painting are Willem de Kooning, Franz Kline, and Jackson Pollock, whose works emphasize the physical nature of their creation through large, often frenetic brushstrokes, visible paint drips, and aggressive style. For example, Jackson Pollock painted *Eyes in Heat* (1946) by squeezing liquid paint directly onto the canvas from the tube and then smearing it. The result is a highly textured canvas filled with swirling painted forms.

Color-field painting is somewhat less aggressive than action painting, though no less emotionally impactful. Color-field painting is characterized by large, abstract areas of solid color, as seen in the work of Mark Rothko, Barnett Newman, Robert Motherwell, Clyfford Still, and Helen Frankenthaler. Helen Frankethaler even stained her canvases with color. Both action painters and color-field painters believed that their works were in no way devoid of subject matter, but that color and action were essential to creative expression.

Who were (some of) the **Abstract Expressionists**?

• Willem de Kooning (1904–1997): De Kooning was a Dutch immigrant to America who greatly inspired the American artists he encountered in New York city. Considered part of the "New York School" of abstract expressionists, his work is characterized by aggressive brushstrokes and partial abstraction. One of his most famous works is *Woman I* (1950–1952), which he repeated a number of times. The painting depicts a large-eyed, aggressive woman with a wide, toothy smile and a wild, abstract form. The energy of de

Jackson Pollock painted *Eyes in Heat* (1946) by squeezing liquid paint directly onto the canvas from the tube and then smearing it. (*Art courtesy The Bridgeman Art Library,* © 2013 The Pollock-Krasner Foundation / Artists Rights Society (ARS), New York.)

Kooning's work aligned the artist with action painters and his work made a major impact on twentieth-century American modernism.

- Arshile Gorky (1905–1948): Gorky was an Armenian American painter whose early Cubist-Surrealist style influenced the abstract expressionists. His painting *Garden in Sochi* (c. 1943) shares similarities with the biomorphic abstraction of Henry Moore.

- Hans Hofmann (1880–1966): Born in Germany, Hofmann was an art teacher who introduced a new American generation to European modernism. His work, as exemplified in *The Gate* (1959–1960) is bold and colorful, and emphasizes visual structure and color relationships.

- Franz Kline (1910–1962): Kline's work was large and he is particularly well known for his white canvases slashed with aggressive, black brushstrokes. These works evoke Chinese calligraphy, and draw attention to the dynamic power and structural qualities of the brushstroke.

Franz Kline, whose work *Horizontal Rust* (1960) is pictured, was an important American abstract expressionist painter. (*Art courtesy The Bridgeman Art Library, © 2013 The Franz Kline Estate / Artists Rights Society [ARS], New York.*)

- Robert Motherwell (1915–1991): Motherwell was a member of the New York School and was inspired by Surrealist automatism and European modernism. He was a writer and a teacher, and had an intellectual approach to abstraction. He painted the series, *Elegies to the Spanish Republic,* throughout his long career. These works served as philosophical mediations on the nature of loss, death, and visual form.

- Lee Krasner (1911–1984): Lee Krasner was an important abstract expressionist painter and the wife of Jackson Pollock. She was highly critical of her own work, even occasionally destroying finished pieces. She produced large, gestural paintings such as *The Seasons* (1957).

- Barnett Newman (1905–1970): Newman was an important color-field painter whose work often features a "zip" or long, thin, vertical line of color painted against a boldly colored background. Newman's "zip" has been likened to an obelisk. Newman searched for the sublime through overwhelming fields of pure color.

- Jackson Pollock (1912–1956): Pollock is one of the most enduringly popular abstract expressionists, known for his aggressive painting style and technique of splattering paint directly on to the canvas. He laid his paintings flat on the

ground, and walked over them with back bent, applying paint directly. While it seems like his paintings would be chaotic, their overall effect is often rhythmic and contemplative.

- Ad Reinhardt (1913–1967): Reinhardt was known for making "art-as-art," and emphasizing the separation between art and life. He distilled his paintings to a single color and his later paintings are completely black, with no trace of a brushstroke. This was done in an attempt to completely separate the work from the act of its creation.

- Mark Rothko (1903–1970): Rothko was interested in emotional and spiritual communication in his large color-field paintings. The monumental canvases of Mark Rothko feature soft-edge areas of rich color where different hues never quite touch one another, cre-

Abstract expressionist painter Helen Frankenthaler used a staining technique to create her fluid abstractions, such as *April* (1963). (*Art courtesy The Bridgeman Art Library*, © 2013 Estate of Helen Frankenthaler / Artists Rights Society [ARS], New York.)

ating a tension Rothko linked to tension within human relations. Rothko's paintings are infused with spirituality and psychological ambiguity.

- Clyfford Still (1904–1980): Still was also a color-field painter, though his works are more aggressive than Rothko's due to jagged areas of color, varied textures, and juxtaposed hues. His massive paintings have been equated with landscapes.

- Helen Frankenthaler (1928–2011): Though she used oil and acrylic paint, Frankenthaler's large paintings have the look of watercolor, with stained canvas and large areas of fluid color. Staining produces an almost textureless, open space within the canvas that garnered her the support of modernist critic, Clement Greenberg.

MODERN ART IN LATIN AMERICA

Who was **Xul Solar**?

"Xul Solar" was the pseudonym of Argentinean avant-garde artist Oscar Augustin Alejandro Schultz Solari (1887–1963). In Latin, the word for "light" is *lux*, the reverse of which became his name. Much of Xul Solar's work is either unknown or unseen by the public as he worked on small watercolor paintings that were rarely exhibited during his lifetime. His work is indebted to European modernism, and Solar was par-

ticularly influenced by Paul Klee, but it is also infused with the artist's personal interest in mysticism and indigenous culture. Paintings such as *Jefa (Patroness)* (1923) are brightly colored and incorporate figurative imagery with abstract form and symbols, such as numbers and the Jewish Star of David. Xul Solar's work, which also included sculpture and writing, is an example of the ways in which Latin American artists took European modernism and made it their own.

Who was **Amelia Peláez**?

Amelia Peláez (1896–1968) was an important Cuban artist whose modernist paintings visually explore Cuban identity. Peláez studied art in both Cuba and Paris, where she was inspired by Cubism and Constructivism, especially the work of Russian artist Alexandra Exter. Her paintings are flat and boldly colored, with black outlines, and are reminiscent of the tropical climate of Cuba. During her later career, Peláez worked on ceramics and murals. Examples of her work include *Marpacifico (Hibiscus)* (1943), *Niña con Paloma (Girl with a Dove)* (1947), and numerous untitled works and sculptures.

What is *Muralismo*?

Muralismo, or Mexican Muralism, is an art movement that developed in the 1920s. *Muralismo* was characterized by socially aware, nationalistic murals that glorified Mexican history and cultural traditions after a period of political upheaval following the overthrow of the Mexican dictator, General Porfirio Díaz. Three key figures of the movement were Diego Rivera (1886–1957), José Clement Orozco (1883–1949), and David Alfaro Siqueiros (1896–1974). Murals were commissioned by the new government for public spaces such as schools, churches, and government buildings as a celebration of Mexican nationalism and with the idea that art should be accessible to all.

Who was **Diego Rivera**?

Diego Rivera (1886–1957) was an internationally renowned Mexican artist known for creating monumental public murals. Like Picasso, who he met while studying in Europe, Rivera was a child prodigy. During his early career, he went through a Synthetic Cubist phase; however, his mature style is characterized by large, figurative murals. Diego Rivera, along with other important Mexican artists such as José Clement Orozco and David Alfaro Siqueiros, aimed to create a new national art for Mexico. He studied frescoes in Italy and applied the technique to his murals, such as his series of Mexican history paintings at the *Palacio Nacional* (National Palace) in Mexico City, which blends European with Mayan and Aztec styles and features rich, bold colors and simplified forms. Rivera also completed murals in the United States, including his *Depiction of Detroit Industry* (1932–1933) at the Detroit Institute of Art. A vocal communist, Rivera's politics sometimes caused criticism in America. While working on a commission from the Rockefeller family in New York, for example, Rivera planned to add a portrait of Russian leader Vladimir Lenin. The Rockefellers refused, paid Rivera's fee, and destroyed his unfinished mural. Rivera ended up completing a different version of the mural, called *Man, Controller of the Universe*

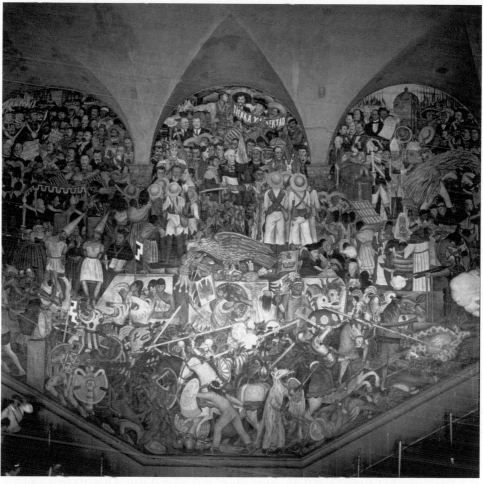

Diego Rivera was an important modern artist who was part of the Mexican Muralist movement. Many of his works explore political themes and glorify Mexican heritage and history. *Tribunal of the Inquisition* is part of a fresco Rivera painted at the Palacio Nacional in Mexico City. (*Art courtesy The Bridgeman Art Library, © 2013 Banco de México Diego Rivera Frida Kahlo Museums Trust, Mexico, D.F. / Artists Rights Society [ARS], New York.*)

(1934) at the Museo del Palacio de Bellas Artes (Museum of Fine Art), which is one of Rivera's most celebrated works.

Who was **Frida Kahlo**?

Frida Kahlo (1907–1954) may have been married to Diego Rivera, but her style of painting was highly individual and eschewed the monumentality of many of her male counterparts who were part of the Mexican muralist movement. Kahlo's autobiographical self-portraits had more in common with miniature paintings and she was highly influenced by Mexican folk painting. Although not officially considered a Surrealist, many of her paintings focus on themes of emotion and psychology through slightly disturbing, dream-like imagery. Her painting, *The Two Fridas* (1939), depicts two seated self-portraits, one dressed in a European-style dress and the other in traditional Mexico clothing, representing her dual heritage (her father was German and her

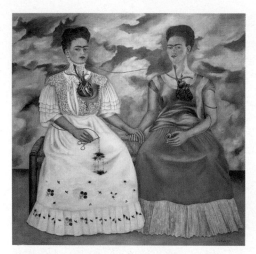

Frida Kahlo, who was married to Diego Rivera, was a Mexican artist who explored surrealist and personal themes in paintings such as *The Two Fridas* (1939). (*Art courtesy The Bridgeman Art Library*, © 2013 Banco de México Diego Rivera Frida Kahlo Museums Trust, Mexico, D.F. / Artists Rights Society [ARS], New York.)

mother was Mexican). The anatomically detailed hearts of both Fridas can be seen through their chests, each connected with a long, thin blood vessel that wraps around them. The Frida on the left holds a pair of scissors and she cuts the vessel, blood spilling from the tip. This is thought to represent both Aztec sacrifice and the life-long pain she suffered after a traumatic bus accident in 1925. Other famous works by Kahlo include *Self-Portrait with Thorn Necklace* (1940) and *Self-Portrait on the Border Between Mexico and the United States* (1932).

EUROPEAN ART AFTER WORLD WAR II

What is **Existentialist** art?

After World War II, European artists, writers, and thinkers struggled to come to terms with not only the physical destruction wrought by war, but with its psychological toll. Existentialism was a philosophical response popularized by French thinkers such as Jean-Paul Sartre (1905–1980), whose treatise *Being and Nothingness* (1943) described the anxiety and meaningless of existence, as well as the pursuit of authenticity in life. Existentialism was a powerful influence on post-war art in Europe and its themes were explored by artists such as Francis Bacon, Alberto Giacometti, and Jean Dubuffet.

Who was **Francis Bacon**?

Francis Bacon (1909–1992) was a British painter whose expressive, figurative works often depict scenes of psychological horror. Bacon is often categorized as an Existentialist artist. His paintings of Pope Innocent X were modeled after a portrait done by Velázquez in the sixteenth century; however, Bacon's pope sits within the confines of a cage-like throne, his face smeared with aggressive streaks of paint against a menacingly black background. Bacon's paintings depict intense scenes of anguish. The artist himself said, "I hope to make the best human cry in painting… to remake the violence of reality itself" (as quoted in Stokstad 1128).

What is **Magic Realism**?

First coined in 1925 by the German art critic Franz Roh, "magic realism" flourished from the 1920s to the 1950s. Magic realism can be described as a realistic approach to fantastical subject matter. Artists most associated with the style include American

artists Ivan Albright (1897–1983) and Peter Blume (1906–1992), as well as French artists Paul Delvaux (1897–1994) and René Magritte (1898–1967), who was probably the most famous magic realist painter, but is usually categorized as a Surrealist. The works of these artists are characterized by a sense of mystery juxtaposed with the normalcy of everyday objects.

Who was **Alberto Giacometti**?

Alberto Giacometti (1901–1966) was a sculptor and painter born in the Italian-speaking portion of Switzerland. During his early career, he gained critical acclaim for his Surrealist sculpture, and he was a formal member of the surrealists until he left in the 1930s. Giacometti was inspired by the philosophy of Existentialism and was friends with the philosopher Jean-Paul Sartre, who even wrote a catalogue preface for one of Giacometti's

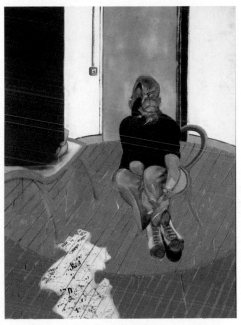

The work of artist Francis Bacon has been described as both magical realist and existentialist. His paintings often communicate themes of psychological horror, as in 1973's *Self Portrait with a Watch (Art courtesy The Art Archive, © 2013 The Estate of Francis Bacon. All rights reserved. / ARS, New York / DACS, London.)*

Paris shows. His now iconic sculptures of bronze, skeletal human figures have been interpreted in relation to the state of society after the devastation of World War II. Interested in the experience of perception, Giacometti's lurching sculptures have also been described as "shadows" of the human form. In recent art auctions, his work has fetched tens of millions of dollars.

What was **CoBra**?

CoBra was an international group of artists whose name was derived from the home cities of its founding members: Copenhagen, Brussels, and Amsterdam. The group was founded by Danish painter Asger Jorn (1914–1973) and poet Christian Dotremont (1922–1979) in a Paris café in 1948. (The group lasted until 1951.) They rejected Surrealism, and like other artistic movements after World War II, were interested in starting fresh, and developing a new art for the post-war age. For CoBra, this meant emphasizing spontaneous creativity and artistic experimentation. Many of the works by group members, which also included Karel Appel (1921–2006), George Constant (1920–2005), and "Corneille" (1922–2010), were bold, expressive, and steeped in fantasy. In Jorn's painting *In the Beginning Was the Image* (1965–1966), primary colors dominate and appear smeared across the canvas while Constant's *Fantastic Animals* (1947) evokes primal instincts through child-like depictions of wild beasts. CoBra members also valued the art of all people, regardless of background, social class, or academic training, and were particularly inspired by children's drawings.

What is *art brut*?

Art brut, meaning "raw art," is a term coined by French painter Jean Dubuffet (1901–1985) in 1945 to describe outsider art, or, art made by individuals without academic training, including the art of children, criminals, and the mentally ill. Along with Surrealist André Breton and art critic Michel Tapié, Dubuffet founded the *Compagnie de l'Art Brut,* which collected *art brut* created by mental Swiss mental patients. This collection grew to over two thousand works and was later donated by Dubuffet to the Swiss city of Lausanne, in 1971. Dubuffet, whose own art was greatly inspired by outsider art, was interested in spontaneity, originality, and freedom from the social constraints of art production.

What is *Art Informel*?

Art Informel, also known as both "Tachisme" and "lyrical abstraction," was essentially the European equivalent of American abstract expressionism, with an emphasis on non-geometric abstraction, spontaneity, and expressive brushwork. In French, the word *tache* (of "Tachisme") means "splotch," referring to the manner in which paint has been blotted onto the canvas. Artists associated with *Art Informel* include Jean Fautrier (1898–1964), Hans Hartung (1904–1989), and Alfred Otto Wolfgang Schulze, better known as "Wols" (1913–1951). The work of Jean Dubuffet, which is associated with *art brut,* is also sometimes categorized as *Art Informel.*

Who was **Henry Moore**?

Henry Moore (1898–1986) was one of the most significant modernist sculptors, and arguably the most important British sculptor, of the twentieth century. His work was influenced by non-Western art, especially Mayan art. His abstractions of the human form, such as *Reclining Figure* (1929), were directly inspired by *chacmool* figures (which also recline) from Chichén Itzá in Mexico. Representations of reclining forms, family groups, and mother-and-child pairs were an enduring subject for the artist. Moore's style is described as "biomorphic," meaning that his figural abstractions are often soft, undulating, and organic. He also produced large sculptures that were hollow and "pierced," emphasizing the mystery of negative space. Moore was incredibly prolific in his later years, requiring teams of assistants to produce monumental works of public sculpture, which can be seen around the globe.

Who was **Brancusi**?

Constantin Brancusi (1876–1957), a Romanian sculptor, was one of the most innovative and original modern sculptors of the twentieth century. During his early career he studied under Impressionist sculptor Auguste Rodin, but he soon broke away to being experimenting with extreme simplification and abstraction, and he was inspired by the art of non-Western cultures and traditional craftsmanship. He worked in various media, including bronze, stone, and wood. *The Kiss* (1913) is a representational sculpture of two figures embracing, but it has been so reduced, it appears block-like, though still full of life. The ovoid form of his *Mlle Pogany* (1913) is highly polished,

resulting in a smooth reflective surface. Brancusi is also known for his series of sensitive sculptures of birds, especially his series *Bird in Space* (1923), in which the form of a bird has been reduced to a solid, delicate curve. Brancusi's work achieves a seemingly impossible balance between softness, durability, dynamism, and serenity.

What is *Nouveau Réalisme* (New Realism)?

Founded in 1960 by French art critic Pierre Restany, *Nouveau Réalisme* is an art movement that developed as a reaction against twentieth-century abstraction and *Art Informel*. Many of the *Nouveaux Réalistes,* or New Realists, were not painters, but artists who experimented with art forms such as décollage, a process of ripping or tearing an image, usually posters of advertisements, to create something new. The best examples of *Nouveau Réalist* décollage is the work of François Dufrêne and Mimmo Rotella (1918–2006). The artist Jean Tinguely (1925–1991) extended this technique to include scrap metal, old bottles, motors, and other industrial objects in his work, *Homage to New York* (1960), which he designed to spectacu-

Constantin Brancusi's *Bird in Space* sculpture series reduces the organic form of a bird to a smooth curve that still evokes the swift weightlessness of a bird in flight. (*Art courtesy The Bridgeman Art Library, © 2013 Artists Rights Society [ARS], New York / ADAGP, Paris.*)

larly self-destruct at the Museum of Modern Art in New York. By contrast, Yves Klein (1928–1962) was a painter who explored the power of pure color, even developing his own blue, called International Klein Blue (IKB). The New Realists used the objects of the real world, often junk, as their palette, and by doing so commented on modern life in a manner unique from other artists of the period.

NATIVE AMERICAN ART

What is a **Navajo sand painting**?

Sand painting is an essential part of traditional healing ceremonies for the Native American Navajo people of the American southwest. Using natural materials such as colorful powdered stones, pigments, and even corn pollen, Navajo medicine men rit-

The sand painting techniques used by Navajo Indians emphasize the importance of the process of creation. Paintings are created according to ceremonial tradition and finished works are not publicly shared. (*Art courtesy Arizona, USA / Peter Newark American Pictures / The Bridgeman Art Library.*)

ualistically recreate the mythological journeys of gods and heroes to form complex images with healing powers. Najavo sand paintings, also called dry paintings, are often composed of highly stylized, repetitive geometric forms such as curved and angled lines. Completed paintings are never publicly shared and they are destroyed once the ceremony is over, though some sand painting imagery has been published and photographs are owned by the Library of Congress and other institutions. Strict adherence to ritual tradition is necessarily in order for the healing ceremony to be successful. The American abstract Expressionist artist, Jackson Pollock, was inspired by the process of creating the sand painting, which is laid flat on the ground while the artist stands over it—a process Pollock used when making his own art.

Who was **Maria Montoya Martinez**?

Maria Montoya Martinez (1887–1980) was a Native American artist from San Ildefonso Pueblo in New Mexico who, along with her husband Juan Martinez, is famous for highly polished, black-on-black ceramics, which are highly valuable on the art market. The Martinez's pots were often traditional in form, but decorated with geometric, curvilinear designs influenced by the Art Deco styles popular during the early twentieth century. Maria Martinez was the only Pueblo artist to consistently sign her work, which she occasionally did using her native Tewa name, *Po've'ka* (Pond Lily). The community-focused Martinez also signed pots with both her and her husband's name, as well as the names of her Pueblo neighbors.

What is a Hopi **katsina** figure?

The Hopi people, whose name means "Peaceful Ones," are Native Americans from the American southwest. In the Hopi religion, *katsinas* (or, *kachinas)* are important benevolent spirits that personify natural elements in the real world. Representations of *katsina* spirits are an important part of ritual dance, when *katsina* dancers ceremonially impersonate the spirits. Carved figures representing *katsinas* are also an important part of the Hopi religious and artistic tradition. Carved *katsina* figures can be given to children as presents and as educational tools. *Katsina* spirits are often associated with rain-bringing deities, or deities related to fertility or hunting. Hopi *katsina* figures are often made of carved cottonwood roots and decorated with feathers. They

are painted with diverse patterns and symbols, for example geometric patterns that symbolize water, and lightning bolts that symbolize rain and storms.

What were **Haida totem poles**?

The Haida people lived along the Pacific coast in an area that stretched from California to Alaska. The Haida had rich traditions of weaving, carving, and sculpting and their totem poles, which served as important representations of social status, are examples of monumental sculptures usually carved from cedar trees. A significant art form for at least three hundred years, totem poles depict images of animals or other natural object that serve as a spiritual emblem. Haida totems depict details of family lineage and social status, and were valuable enough to occasionally lead to warfare as clans disputed rightful ownership of totemic images. Haida totem poles could

Haida totems depict details of family lineage and social status, and were valuable enough to occasionally lead to warfare as clans disputed rightful ownership of totemic images.

be placed either inside or outside, and could be as much as sixty feet tall. Outside, totem poles could be freestanding and painted, and were used to guide canoes to shore. Totem poles were also used as structural support inside houses, while shorter poles were used for burials.

PACIFIC ART

What is **Pacific art**?

"Pacific art" covers the art of cultures in Oceania, Polynesia, Melanesia, and Micronesia. This includes countries such as Australia, New Zealand, and Papua New Guinea, and territories such as Easter Island, Samoa, Fiji, Tonga, and the U.S. state of Hawaii. The art of these regions is sometimes referred to as "Oceanic art." Pacific art forms and subject matter can vary greatly from culture to culture and can include paintings, ritual masks, wood and stone carvings, domestic and monumental architecture, textiles, and body art.

What is *mana?*

Mana is an important concept in much Pacific art that is essential for understanding the power of art in many Pacific cultures. *Mana* is a sacred, spiritual power possessed by individuals and art objects alike; it is invisible but formidable, and the

233

amount of *mana* one has is related to one's proximity to the gods. For example, a tribal chief and related nobles have *mana* because of their divine lineage. *Mana* can be gained or lost based on one's actions or behaviors, such as through acts of strength or acts of cowardice, for example. The *mana* of a work of art is related to the status and skill of the artist who created the piece, as well as the materials use to make it, the age of the object, and the rituals for which it is used.

What are *bisj* poles?

The *bisj* pole is an important ritual wood carving made by the Asmat people of the western portion of New Guinea. The *bisj* pole is a tall, narrow ancestor pole depicting ancestor spirits standing upon one another, and can be approximately twenty feet high. The *bisj* pole plays an important role in the Asmat tradition of headhunting and is used in ceremonies related to the cycle of life, death, and warfare. The Asmat make the *bisj* pole from sago palm because, according to legends, Asmat ancestors were first created from sago palms by a divine hero named Fumeripitsj, the first being on earth. This fact emphasizes the Asmat correlation between the human body and the tree. By extension, the human head is symbolically represented as fruit. On the pole itself, carved images of birds eating fruit represent the headhunter who eats the brain of a warrior he has captured. Large, protruding fins at the top of the *bisj* pole are phallic symbols of power and virility.

What is a *ngatu*?

A *ngatu* is a royal Tongan bark cloth made by women. The Kingdom of Tonga is a group of over one hundred islands located southeast of Fiji and southwest of Samoa (Fiji and Samoa also have bark-cloth design traditions). Textiles such as the *ngatu* are highly prized items and are given as gifts during ceremonies and special occasions. *Ngatu* are hand-painted, rubbed with dye, stenciled, and perfumed. Usually deep brown, black, and beige in color, they can feature highly abstract designs, or depict naturalistic images such as fish, or other sea life.

What is the significance of the **meeting house** in Pacific cultures?

Meeting or ceremonial houses are a significant part of Pacific architecture, and many Pacific cultures use these larger halls or houses for religious or right-of-passage ceremonies. For example, the Abelam people of the East Sepik Province in New Guinea display art and ritual objects in ceremonial houses in order to attract spirits during rituals. Abelam ceremonial houses are traditionally decorated with art objects made in a variety of materials, including fruit, leaves, stones, and shells. On the island of New Ireland, ceremonial houses are essential for *malagan* ceremonies and wood sculptures are carved and displayed at the front of the house. In the mid-nineteenth century, master carver Raharuhi Rukupo supervised the construction of *Te-Hau-Ki-Turanga,* a Maori meeting house in Gisborne, New Zealand. The house, a type known as a *wharenui,* is covered in detailed, high-relief wood carvings that have been rubbed with shark liver oil and red clay to produce rich color and luminescence. Along the A-frame ceiling, is a repeating pattern of painted wood rafters and lattice panels,

which were made by women artisans. Though the nature of the carvings is traditional, they were done with European-style metal tools during a time in the colonial nineteenth century as Maori architecture was changing under the influence of Christianity. Meeting houses across the Pacific serve as important locations for community meetings, rituals, and other ceremonial uses. Their construction is inextricably related to the creation of art objects and to both the political and spiritual function they serve within a culture.

What is the **Kearny Cloak**?

The Kearny Cloak is a Hawaiian feathered cape that was given as a gift to King George III of England by Hawaiian King Kamechameha around 1843. The red and yellow cape was made of coconut fiber to which feathers were attached. Worn like a cloak, the garment is known as a 'Ahu 'ula (red cloak) due to its color. In Hawaii, red is symbolic of royalty, and feathers were used to decorate luxury, high-status items such as clothing, blankets, and *leis,* traditional Hawaiian garlands. The status of the Kearny Cloak is tied to the status of the Hawaiian king, and is therefore an appropriate and significant gift for another ruler.

What is the significance of **tattoos** for Pacific cultures?

Tattooing was, and continues to be, an important part of cultural and religious tradition throughout the Pacific, especially in Polynesia and New Zealand. The English word for tattoo even comes from the Polynesian word *tatau*. Body art, including clothing and jewelry, as well as tattoos, indicates status, with specific patterns associated with particular ranks within a society. Tattoo designs were usually geometric. The Maori of New Zealand, whose word for tattoo is *moko,* have separate tattoo styles for men and women, and tattoos of different meanings were placed on different parts of the body. For example, tattoos on the right side of the face represented social status and lineage handed down from the father's side of the family, while tattoos on the left side on the face communicated maternal lineage. Bodies of the most prominent members of society could be completely covered in tattoos. After a period of decline, tattoos are once again being used to communicate status and cultural identity among the Maori of New Zealand.

Tattooing has been an important part of Maori culture for hundreds of years. Specific tattoo patterns on certain parts of the body serve as marks of rank and achievement within Maori society. (*Art courtesy Private Collection / Prismatic Pictures / The Bridgeman Art Library.*)

What is **aboriginal art**?

Aboriginal art is the art of the indigenous people of Australia, whose artistic traditions continue to thrive to this day. Aboriginal art includes rock art, body art, bark paintings, fiber arts, and portable sculptures (Aboriginal people are traditionally nomadic). Aboriginal peoples have lived in Australia for the last forty thousand years and their art is closely connected to their religious beliefs and complex mythology. The Aboriginal spiritual world is called *Jukurrpa,* which is usually translated into English as "The Dreaming" or "The Dreamtime," and emphasizes the connection between spiritual powers and place. It is important to note that Aboriginal artists are not creating anything new or original, but are re-interpreting designs and artistic elements that have been passed down by spirit ancestors. Many contemporary Aboriginal artists now use acrylic paint to create traditional dot paintings or bark paintings. The work of twentieth-century Aboriginal artist Clifford Possum Tjapaltjarri (1932–2002) helped bring Aboriginal art to the attention of the international art world and it is now part of major museum and gallery collections around the globe.

Aboriginal bark paintings from Australia serve an important religious function; painting traditions have been passed down through the generations. (*Art courtesy Musée des Arts d'Afrique et d'Oceanie, Paris, France / Giraudon / The Bridgeman Art Library.*)

CONTEMPORARY ART, 1960s–PRESENT

POP ART

What is **pop art**?

Pop art began in the 1950s in Britain (the term itself was invented by English art critic Lawrence Alloway) and became one of the most influential art movements of the mid-twentieth century, particularly in Britain and the United States. Pop artists challenged the status of fine art by relying on mass media images, such as those from advertisements and popular culture, to create artworks. Key pop artists include Allen Jones (1937–), Eduardo Paolozzi (1924–2005), Peter Blake (1930–), and Richard Hamilton (1922–2011), all of whom worked primarily in the UK. American pop artists include Roy Lichtenstein (1923–2007), Robert Rauschenberg (1925–2008), Jasper Johns (1930–), and most notably, Andy Warhol (1928–1987).

Early pop art shows were held in London and New York City, including the "This is Tomorrow" show at the Whitechapel Art Gallery and a number of shows at New York's Sidney Janis Gallery. Critics were mixed in their reviews, with many critics shocked at the use of "low art" to create works of "fine art." For example, Robert Rauschenberg, who studied painting under Bauhaus artist Josef Albers, created a series of works incorporating the "Coca-Cola" logo and Roy Lichtenstein's large paintings mimicked the look and style of comic book art. Pop art questioned the difference between good and bad taste, and broadened the scope of possible fine art subject matter to include everyday objects and culture.

Who was **Andy Warhol**?

Andy Warhol (1928–1987) was an iconic artist-celebrity whose pop art images of Campbell's soup cans and film celebrities continue to be highly recognizable and immensely valuable. Popularly known for his bleach-blond hair, dark sunglasses, and

Early Colored Liz (1964) is a color lithograph of the famous actress Elizabeth Taylor overlaid with areas of flat color. (*Art courtesy The Bridgeman Art Library, © 2013 The Andy Warhol Foundation for the Visual Arts, Inc. / Artists Rights Society [ARS], New York.*)

turtle-neck sweaters, Andy Warhol was interested in stripping mass media images of their symbolic value, thus rendering them anew. Born in Pittsburg, Pennsylvania, Warhol studied at the Carnegie Institute and moved New York City in 1949, where he began a career in commercial art. He also worked in painting, printmaking, sculpture, and film.

Warhol's New York studio, dubbed, "The Factory," was where Warhol and his team of assistants used silk screen machines to mass produce images. His goal was to mechanically produce familiar images until they no longer held any meaning, like saying the same word over and over until it sounds like nonsense. This explains paintings such as *Fragile–Handle with Care,* which depicts the word "fragile" repeatedly, until the words become nearly abstract. Similarly, Warhol made an eight-hour-long film of the Empire State Building, created using a single, drawn-out shot. Warhol's work dominated the 1960's art and fashion scene, and he continued to push boundaries into the 1980s, with celebrity portraits and continued exploitation of celebrity.

Why did **Jasper Johns** paint the **American flag**?

Jasper Johns (1930–) is an American contemporary artist known for his painting, printing, and sculpture. His paintings frequently feature familiar objects and symbols such as targets, numbers, and the American flag. In line with the themes and goals of pop art, Johns was interested in using familiar objects in a new way. Rather than create new images, he wanted to depict "things the mind already knows" (as quoted in the Met Museum Timeline of Art History). He said that his decision to paint flags was inspired by a dream, and his realistic works serve to highlight the artificiality of the symbols he represents.

Who was **Robert Rauschenberg**?

Robert Rauschenberg (1925–2008), along with Jasper Johns, his close friend, occasional lover, and business partner, was one of the most influential artists in pop art, and he is credited with leading art away from abstract expressionism. He is particularly famous for erasing a De Kooning drawing and then framing the empty page in a work he called *Erased De Kooning Drawing* (1953). This bold and challenging act brings attention to the looming question for many mid-twentieth-century artists— what kind of art could possibly follow abstract expressionism?

Starting in the 1950s, Rauschenberg began what are known as "combines," paintings that incorporated found objects and images such as newsprint and photographs—

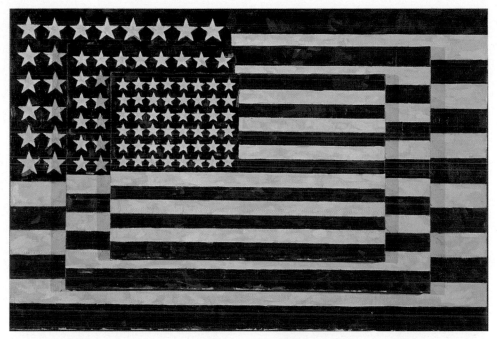

Jasper Johns said that his series of flag paintings, including *Three Flags* (1958), was inspired by a dream and an attempt to use a familiar image in a new and surprising way. (*Art courtesy The Bridgeman Art Library,* © *Jasper Johns/Licensed by VAGA, New York, NY.*)

even trash from the streets of New York, including stuffed animals, electronics, and architectural forms. One of his most famous paintings (and earliest combines) is *Bed,* a mixed media work from 1955 that frames a paint-splattered quilt, sheet, and a used pillow (upon which Rauschenberg drew in pencil). The work is considered by some to be autobiographical and comments on the connection between art and everyday life. Rauschenberg's *Persimmon* (1965) uses not trash, but an image of Peter Paul Rubens's seventeenth-century painting *Venus at Her Toilet,* in which the ancient goddess of love looks out at the viewer by way of a mirror, creating a visual riddle found in painting throughout art history. With this work, Rauschenberg is able to grapple with the history of art through his contemporary combines.

Who is **David Hockney**?

David Hockney (1937–) is considered an important early pop artist, though he dislikes that association and his work demonstrates a range of styles. A prominent contemporary artist whose career kick-started while he was still a student at the Royal College of Art in London, Hockney's early work frequently incorporated poetic fragments and personal themes. Paintings such as *We Two Boys Together Clinging* (1961) are reminiscent of the *art brut* of Jean Dubuffet with scrawled handwriting and child-like forms. Hockney's mid-career paintings are notably smooth and painted with acrylic, reflecting the artist's skill as a graphic artist as well as a painter. His most famous pop art work is arguably, *The Big Splash* (1967), a brightly painted scene of a California swimming pool in which a jarring and geometric diving board juts into the center of the scene. A swirled splash breaks the smooth monotony of the pool's blue water, cre-

Just what is it that makes today's homes so different, so appealing?

Just what is it makes today's homes so different, so appealing? is a 1956 pop art photomontage by British artist Richard Hamilton (1922–2011). The work was part of the important "This Is Tomorrow" pop art show at the Whitechapel Gallery in London. Images of the work were used in the catalogue, and in posters for the show. The picture is of a middle-class living room. A black-and-white image of a flexing body builder holds a "Tootsie Pop" candy while another cut-out of a nearly nude woman reclines dramatically on an average-looking couch. Above the room, a photograph of the earth from space looms large. The work is made up of multiple images cut out of American magazines, and is an example of pop art's use of mass media images. The work has been interpreted as a critique on suburban culture and consumerism.

Just what is it makes today's homes so different, so appealing? is a pop art collage made primarily from magazine cuttings by British artist Richard Hamilton in 1956. (Art courtesy The Bridgeman Art Library, © R. Hamilton. All Rights Reserved, DACS 2013.)

ating a photo-like image. In the 1970s and 80s, he experimented with collage by incorporating Polaroid fragments into highly ordered paintings. His work with photography led to a prestigious award from the Royal Photographic Society in 2003. Hockney continues to paint and receive recognition for his work, including monumental landscapes such as *A Bigger Grand Canyon* (1998), which is composed of over sixty individual paintings.

Why did **Roy Lichtenstein** paint **comic book** images?

Roy Lichtenstein (1923–1997), whose early work reflected interest in Cubism and abstract expressionism, began to make his comic-book paintings in the 1960s. With paintings such as *Whaam!* (1963) and *Eddie Diptych* (1962), Lichtenstein transformed comic images into monumental works of fine art by enlarging them and rendering them with the so-called "Ben Day" dots used to print newspaper images. His approach has been described by some critics as a parody, but one in line with the goals of pop art. While Lichtenstein was able to transform the "low" art of comic books into fine art paintings, he also did the opposite. His *Yellow Brushstroke* (1965) depicts a single smear of yellow paint with so much detail it becomes nearly laughable, and completely banal. He also converted famous masterpieces, such as Vincent van Gogh's *Bedroom in Arles* (1888), into his iconic comic style. One of Lichtenstein's goals in creating these comic-like images was to encourage the viewer to question the way supposedly realistic paintings accurately depict reality.

Roy Lichtenstein is perhaps most well known for his comic style paintings, such as his *Eddie Diptych* from 1962. Lichtenstein's work is an example of pop art, as it incorporates bold colors and styles drawn from popular culture and advertising. (*Art courtesy The Art Archive / Gianni Dagli Orti, © the Roy Lichtenstein Estate.*)

CONCEPTUAL ART AND OTHER MODERN ART MOVEMENTS

ABSTRACTION

What is **op art**?

The "op" in "op art" refers to optical illusion and op art paintings, such as Bridget Riley's *Metamorphosis* (1964), are composed of precise, geometric abstractions. Op art paintings pulse with an energy created by a strategic alignment of color and form, creating a blurring after-image, similar to the experience of looking at a bright light for too long, or looking into a funhouse mirror. Hungarian artist Victor Vasarely (1908–1997) was a pioneer of op art. His commercial paintings of zebras (and their repetitious black-and-white stripes) served as early optic experimentations while works such as the black-and-white *Supernovae* (1959–1961) are dynamic and restless. Vasarely linked these works to free-moving kinetic art by artists such as Alexander Calder. The viewer is an essential part of the op art experience because without the viewer—specifically the viewer's perception, there can be no optical illusion. Op

241

Op artist Bridget Riley experimented with visual illusion in her work. *Firebird* (1971), a screenprint on paper, is made up of vibrating bands of vertical color. (*Art courtesy The Bridgeman Art Library, © Bridget Riley 2012. All rights reserved, courtesy Karsten Schubert, London.*)

art serves as an inquiry into the very nature of optical perception—the experience of seeing things.

Who was **Eva Hesse**?

Eva Hesse (1936–1970) was a German American painter and sculptor whose Jewish family dramatically escaped Nazi Germany. Her highly experimental art is usually categorized as minimalist; however, unlike many minimalists, narrative and personal history are an important part of her work. Her installation sculpture *Rope Piece* (1969–1970), a tangled, slightly frightening web of rope, string, and wire, has a different form each time it is moved to a new location. The piece has been described as a "drawing in space." Her work *Accession II* (1968–1969), now at the Detroit Institute of Art, is a cube made of vinyl and steel. The cube is open at the top, revealing a lush layer of fiber-like tubes—a reaction against the severity of much minimalist art.

What is **post-painterly abstraction**?

The term "post-painterly abstraction" was coined by influential American art critic Clement Greenberg (1909–1994) to describe abstract art inspired by—but separate from—American abstract expressionism. His term encapsulated multiple categories of abstraction, including (but not limited to) hard-edge painting and stain painting.

Hard-edge painting, as exemplified by the work of artists Frank Stella (1936–) and Ellsworth Kelly (1923–), is characterized by large geometric areas of color with absolutely no blending. Colors transition abruptly from one to the next, such as in Stella's *Gran Cairo* (1962), a painting composed of a colorful series of ever-smaller square outlines. The artist Helen Frankenthaler is known for championing the technique of staining the canvas with pure color, also considered to be a form of post-painterly abstraction. Post-painterly abstraction emphasizes the formal qualities of painting, such as shape and color. Artists experimented with shaped canvas, transforming the painting into an object, or sculpture. Post-painterly abstraction lasted until the 1970s when postmodern artists began to challenge the supremacy of modernist critic Clement Greenberg.

Grant (1963), by modern artist Anne Truitt, is an example of minimalist art. (*Art courtesy The Bridgeman Art Library, © Figge Art Museum, successors to the Estate of Nan Wood Graham / Licensed by VAGA, New York, NY.*)

What is **minimalism**?

Minimalism is a term that describes simple, geometric art that is often impersonal and made with a new set of materials, including aluminum, Plexiglas, plywood, and steel. Minimalist artists attempted to distill their work into a pure form, editing any reference to personality, feelings, symbolism, or story. The style became popular during the mid-1960s, though many art critics at the time accused minimalism of being too cold, and questioned whether art could, or should, be produced by industrial means. The term "minimalism" has been used to describe the art of many artists, from Ad Reinhardt to Yves Klein, Frank Stella to Robert Rauschenberg. The work of artist Donald Judd (1928–1994) is a good example of minimalism. Judd explored the difference between painting and sculpture with his series of wall structures. Judd's wall structures are composed of a series of machine-made rectangular forms that protrude from the wall, forms that he called "specific objects." The work of artist Anne Truitt (1921–2004) occasionally blurred the line between minimalism and color-field painting; however, her minimalist sculpture *Grant* (1963)—a long wooden beam, painted in acrylic—was a pure, impersonal, geometric form.

CONCEPTUAL ART

What is **conceptual art**?

Conceptual art had existed in various forms for decades, but solidified into a major movement in the 1960s and 1970s. Inspired greatly by Dada and the art of Marcel

Duchamp, conceptual art is concerned with the intellectual process of art. The artist Sol LeWitt's 1967 article, "Paragraphs on Conceptual Art," did much to explain the foundations of the movement: an idea alone can be a work of art.

Conceptual art is extremely diverse and a large number of international artists are associated with it. Conceptual art can be anything from written documents to photographs, videos to performances. The work of Belgian artist Marcel Broodthaers (1924–1976) is a good example of conceptual art. Broodthaers was a writer, filmmaker, and visual artist. Perhaps his most celebrated piece, *Musée d'Art Moderne, Département des Aigles (Museum of Modern Art, Department of Eagles)* (1968), was an installation at his home in Brussels that described a completely fictitious museum. Besides the fact that Broodthaer's created posters, descriptions, and signs—the museum did not exist. The central idea of this piece was to question the authority of the museum as an institution. Conceptual art continues to be a major part of contemporary art today.

What is **performance art**?

Performance art is slightly more complicated than its name might suggest. Performance art is indeed art that blends music, theatrical performance, and visual art, rather than a single painting or sculpture. But, the form itself, which became more popular in the 1960s, also blurs the line between art and artist, and frequently produces an uncomfortable reaction amongst viewers. For example, the artists Gilbert and George sing for over eight hours in their performance, *The Singing Sculpture* (1969). In a performance piece titled *How to Explain Pictures to a Dead Hare* (1968), the often provocative artist Joseph Beuys holds a dead hare in his arms while appearing to whisper to it. A good example of the way in which both art and artist merge is Yoko Ono's 1964 performance, *Cut Piece,* in which audience participants are invited to cut off pieces of Ono's clothing until none remain. This performance is also categorized as an example of Fluxus art.

What is **Fluxus**?

Fluxus is a difficult-to-describe, anti-art movement (sometimes called neo-dada) promoted informally by an international group of artists who were interested in the relationship between art and life. The term "Fluxus" was invented in 1961 by the Lithuanian American artist George Maciunas. The word itself comes from Latin and means "to flow." Artists associated with Fluxus include (among others) Joseph Beuys (1921–1986), George Brecht (1926–2008), Nam June Paik (1932–2006), Yoko Ono (1933–), and LaMonte Young (1935–), an experimental composer and performance artist. The artist Dick Higgins (1938–1998) created a rubberstamp upon which he explained Fluxus as "a way of doing things, a tradition, and, a way of life and death" (as quoted in Dempsey 229). Fluxus art was inherently collaborative. Artists worked together to create pieces by sending art through the mail, for example. Collaborative Fluxus festivals or "Fluxconcerts" featured experimental music and other types of short, fast-paced performances. Fluxus defies narrow description. It was intended to be open, simple, and have a sense of humor.

What is *Arte Povera*?

Arte Povera, meaning "poor art" or "impoverished art" is a movement that emphasized the use of everyday objects and aims to broaden just what can be considered art. The term was invented by Italian artist German Celant in 1967 and is related to similar movements such as *Art Informel.* Artists associated with *Arte Povera* include Greek artist Jannis Kounellis (1933–), as well as Italians Giulio Paolini (1940–) and Michelangelo Pistoletto (1933–). Pistoletto is famous for his *arte povera* work, *Venus of the Rags* (1967), in which a glimmering sculpture of Venus, the goddess of love (with her back turned to the viewer), is juxtaposed with a large, colorful pile of rags. Kounellis also contrasts refined classicism with the everyday in his *Untitled* from 1978, in which fragments of a classical sculpture are held together with cord.

Rachel Whiteread's installation, *Embankment* (2005) was designed for the Turbine Hall at the Tate Modern Museum in London. (*Art courtesy The Art Archive / John Meek / Gagosian Gallery, New York, NY, © Rachel Whiteread.*)

What is **body art**?

In body art, the artist's body becomes the medium. Body art overlaps with many other forms and styles, such as performance art. It became popular during the 1960s, likely as a reaction against the cold austerity of minimalism. Examples of body art include Bruce Nauman's photograph, *Self-Portrait as a Fountain* (1966–1967), in which the artist's body takes on the characteristics of a fountain as water squirts from his mouth. An example of conceptual body art is Piero Manzoni's *Living Sculpture* (1961), in which the artist signed the bodies of living women.

INSTALLATION ART

What is **installation art**?

Installation art is art that is more than three-dimensional—it creates a complete environment. Entire gallery spaces can be devoted to a single installation, usually—but not always—temporarily. Installation art became popular in the 1970s and continues to be an important art form today. Installations rely upon the interactions of the viewer/participant and can even be collected, which means they are not necessarily site-specific. Yves Klein created one of the first installations with his work *The Void* in 1958. For this work, Klein presented a completely empty, white-walled gallery. Other famous examples of installation art include British sculptor Rachel Whiteread's *Em-*

245

bankment (2005), which she created for the Turbine Hall at the Tate Modern museum in London. The piece consisted of tower-like mountains made of thousands of white, plaster casts of boxes. Visitors to the gallery were able to move through the installation—allowing them to engage with a monumental art form on an intimate level.

Who is **Jenny Holzer**?

Jenny Holzer (1950–) is a conceptual artist known for text-based installations and public displays. Her earliest work was *Truisms* (1977–1979), which consisted of anonymous posters hung up around New York City with one-line phrases such as "Protect Me From What I Want," "Abuse of Power Comes As No Surprise," and "Expiring For Love Is Beautiful But Stupid." Along with displaying these truisms on posters, Holzer carved words into public benches, created t-shirts, hats, and more. Later in her career, she began to work with LED (light emitting diode) displays, which has garnered her much critical and popular success. For example, she created a sixty-five-foot-wide, permanent LED display in the lobby of 7 World Trade Center, in which text slowly scrolls. Holzer writes many of her own texts, and during her later career she began to appropriate language from international poets as well as text from unclassified U.S. documents, including interrogation transcripts from Abu Ghraib in Iraq. In this case, Holzer projects private words in a public space, emphasizing the difference between private and public communication.

What are **earthworks**?

Earthworks, also known as land art, are works of art made of natural materials such as earth, rocks, water—usually on an extremely large scale. Land art became popular in the 1960s. Earthworks have been linked to minimalism due to their inherent simplicity and some scholars have called this form a reaction against consumerism because it is nearly impossible for anyone to buy or sell (or exhibit) land art. The most famous example of an earthwork is *Spiral Jetty,* built on Rozel Point in the Great Salt Lake in Utah in 1970 by artist Robert Smithson. *Spiral Jetty* is monumental indeed—a 1,500 foot long embankment made of earth, mud, and basalt rocks that juts into the lake. Periodically submerged due to the changing levels of the lake, earthworks such as *Spiral Jetty* are built on such a large scale that they evoke the mystery and largess of ancient monuments and sites such as Cahokia or Serpent Mound. Other examples of earthworks are Michael Heizer's *Double Negative* (1969–70), which was created by cutting the sides of a canyon wall in the Arizona desert, as well as Walter de Maria's *Lightning Field* (1977).

What is *The Lightning Field*?

The Lightning Field (1977) is an example of an earthwork, or land art, created by American sculpture Walter de Maria in Western New Mexico. Built in the vast desert, de Maria installed four hundred stainless steel poles with pointed tips in a grid-like pattern that reaches one mile by one kilometer in area. Each pole, at around twenty feet tall, is designed to attract lightning, as well as attract visitors. *The Lightning Field* can also be considered a sculpture or an installation, and it was designed to en-

courage visitors to walk amongst the poles and engage with the natural environment. This massively scaled example of land art can be visited by contacting the Dia Foundation, which manages the site.

What is **process art**?

Process art is art that explores the act of producing art, and is often less concerned with the object or work that is eventually produced. The process art movement began in the 1960s and can be seen in the paintings of abstract expressionist Jackson Pollock, which were at least in part defined by the process through which he made them—the drip and splatter process. Other art movements also have overlaps with process art, including earthworks (land art), because of the way in which the environment acts upon them after they are created. The often monumental yet minimalist work of American sculptor Richard Serra (1939–) is a good example of process art. His steel sculptures encourage viewers to think about the nature of the materials and the way in which they were put together. What at first seems simple—a tall, tower-like slab of steel, for example, becomes a curiosity as one contemplates "how."

ART, CULTURE, AND POLITICS

What is **feminist art**?

Feminist art began in the 1960s, developing out of the politically and socially motivated women's liberation movement. The goal of feminist art was to reinterpret art history, which was deemed to be systematically sexist, and to promote women's contributions to art and culture. Women have been making art throughout history, and yet art made by women—for example, ceramics, jewelry, and textiles—has traditionally been categorized as a craft, which is held is less regard than so-called works of "fine" art, such as painting or sculpture. Feminist artists aimed to raise the status of craft, much in the way that Renaissance artists aimed to raise the status of the artist during the sixteenth and seventeenth centuries. During the 1960s and 1970s, men were disproportionately represented by art galleries, and women artists formed their own groups and collective galleries to promote their work. Feminist art groups included WAR (Women Artists in Revolution) and the Feminist Art Program, established by pioneering feminist artists Judy Chicago (1939–) and Miriam Shapiro (1923–) in Southern California. Artists who worked with the early feminist art movement were also associated with other movements and styles, including minimalism, conceptual art, and installation art.

What is *The Dinner Party*?

The Dinner Party, which first exhibited in 1979 and toured internationally, is a masterpiece of feminist art by artist Judy Chicago. *The Dinner Party* is a large work in the shape of an equilateral triangle, a symbol of femininity. Each length of the triangle is forty-eight feet long and each is set with thirteen dinner settings, mirroring the number of place settings at the Last Supper. The thirty-nine total place settings, which

were individually designed, honor thirty-nine important women from history—from Egyptian Queen Hatshepsut to Virginia Woolf to Georgia O'Keeffe. A long, embroidered runner was made collaboratively by one hundred women, under the direction of Chicago, and the triangle-shaped "heritage floor," made of ceramic, includes the names of 999 women. *The Dinner Party* highlights the often-forgotten role of women in history and celebrates women's creativity and artistic traditions. The piece is not without controversy, however. Some have criticized the work for its narrow scope, saying it communicates a predominately white, heterosexual experience, among other things. Regardless, *The Dinner Party* makes a powerful feminist statement and is perhaps Judy Chicago's best-known work.

What was *Womanhouse*?

Womanhouse was a 1971 art installation, performance piece, feminist collaboration, and actual house—located at 553 Mariposa Avenue in Hollywood, California. The project was run by the Feminist Art Program at the California Institute of Arts. A group of twenty-six women repaired the home before a planned demolition, using their carpentry skills to transform it into a space for women-made art, and a work of art in and of itself. *Womanhouse* contained eighteen installations within its rooms, including *Nurturant Kitchen*. Performances such as *Waiting* questioned the role of women as keepers of the house. The house opened to the public in 1972 and attracted nearly ten thousand visitors. When the exhibitions were complete, most of the art created there was destroyed, including the home.

Who is **Faith Ringgold**?

Faith Ringgold (1930–) is an African American artist from Harlem known for her paintings, story quilts, and soft sculpture. She was inspired by traditions and styles of African art and her work explores racial and gender identities as well as civil rights issues. She has been called a fiber artist, but her choice of media is diverse. In 1967 she painted *Advent of Black Power,* an image from her *American People Series,* which was featured on a U.S. postage stamp, and later she was a member of the black women's artist collective, "Where We At." Ringgold, who was inspired by Tibetan *thangkas,* began making "story quilts" in the 1980s. Her best-known story quilt is *Tar Beach* (1988), which was also made into a picture book in 1991. *Tar Beach* visually narrates the story of eight-year-old Cassie Louise Lightfoot, whose father is a union worker, and the way in which her imagination allows her to fly while on her Harlem rooftop. The text of the story (a version of which became the book), is written around the border of the quilt.

What is **AFRICOBRA**?

"AFRICOBRA," an artist's collective founded in Chicago in 1968, stands for "African Commune of Bad Relevant Artists" and developed out of the earlier group, OBAC or "Organization of Black American Culture," a multidisciplinary group of writers, historians, and artists. The group of artists—who were painters, photographers, printmakers, fiber artists, and sculptors—included Jeff Donaldson (1932–2004), Wadsworth

Barbara Kruger's powerful photographic works rely on the strategies of advertising to make their bold statements. Pieces such as *You Can't Drag Your Money into the Grave with You* (1991) merges image and text, which is broken up into red blocks, pulling the viewer's eye across the picture plane. (*Art courtesy Mary Boone Gallery, New York / The Bridgeman Art Library, © Barbara Kruger.*)

Jarrell (1929–), Barbara Jones-Hogu (1938–), and others. It emphasized collaboration and explored African American identity and artistic heritage in work that was often brightly colored, figurative, and focused on social themes. Donaldson, Jarrell, and other members of OBAC worked together to create the *Wall of Respect*, a mural painted on the south side of Chicago in 1967 to promote civil rights and community involvement. In 1973, the city of Chicago razed the building upon which the mural was painted, but the work spurred on similar politically-minded mural projects both in the city and internationally.

Who is **Barbara Kruger**?

Barbara Kruger (1945–) is an American conceptual artist and graphic designer known for her photographic collages. As a student in New York City, she was taught by famed photographers Diane Arbus and Marvin Israel and she later became a graphic designer at *Harper's Bazaar* and then chief designer at *Mademoiselle*. Kruger's work uses the power of mass media and advertisement to make her text-and-image pieces, which usually feature black-and-white images with bold, white-on-red text. Manipulating the power of slogans, Kruger's work broadcasts such messages as "I shop therefore I am" and "We don't need another hero." Her work also questions the traditionally passive role of women in art with her famous piece, *Your Gaze Hits the Side of My Face* (1981), which depicts the profile view of a female sculpture along with the text. Kruger

Is there a way to tell what movement inspired a work of art?

Many works of art in museum and galleries blur the lines between multiple art movements and styles. Nevertheless, here is a quick-and-dirty guide to recognizing some common forms of modern and contemporary Art.

Movement or Style	Description of Artwork
The painting is enormous, with thick brushstrokes, paint splatters, and bold colors.	This is most likely an example of *Abstract Expressionism*, which is often large, abstract, and brightly colored.
It's not clear if the artwork is a painting or a sculpture, but it is a painted square that sticks out of the wall.	*Minimalist art* is geometric, simple, and often blurs the line between painting and sculpture.
This piece of art is a telephone with a lobster for a handle.	This example could be a number of things, but it is likely either *Dada* or *Surrealist*. Both movements make art out of normal, everyday objects—transforming them from functional objects to works of visual art.
This is a photograph of a Depression-era farmer with his family.	During the Great Depression, *social realism* was a movement that highlighted the realities of American life in paintings and photographs. Similarly, *American Regionalism* depicted rural American life.
A sculpture hangs from the center of a gallery display, slowly rotating.	*Kinetic art,* such as the mobiles made by Alexander Calder, is always moving, and meant to be seen from multiple perspectives.
This painting is glossy and large, and depicts logos and brand names of familiar products.	This sounds like *pop art,* which often depicts mass media and consumer images.
This work of art is composed of random materials such as trash, children's toys, or old clothes.	*Arte Povera* is often composed of non-art materials. This type of art could also be an *assemblage,* or one of Robert Rauschenberg's *combines.*
The entire room seems to be a work of art.	This is an example of *installation art*, art that encompasses a whole environment.
The painting depicts a violin, but the image is repeated multiple times, is partially abstract, and is made up of jagged, geometric lines.	This sounds like an example of Cubism. Cubists like Picasso and Braque were interested in depicting an object from multiple viewpoints and often accomplished this through fragmentation and collage.

often uses personal pronouns such as "I," "You," and "Me" so as to avoid gender associations and make her statements universal. Her later work often uses appropriated images and more recently, she has begun creating installations. Kruger's style has been described as "agitprop" (a blend of the words "agitation" and "propaganda") and her work focuses on themes of feminism, consumerism, and identity.

FIGURATIVE ART

What is **photorealism**?

Photorealism, also called super-realism, sharp focus realism, and hyperrealism, developed in the 1970s as an extension of minimalism and pop art. It can even be considered a great-grandchild to Precisionism. Photorealistic paintings were influenced by photographic and media images, and like pop art, often feature impersonal, even banal subject matter inspired by everyday life. American photorealist artist Chuck Close (1940–) makes paintings so realistic that they seem like photographs by using a photo as a reference and painting his image on a grid with an airbrush. The artist Audrey Flack (1931–) creates photorealistic, still life paintings that recall baroque *vanitus* paintings. Photorealism often relies on *trompe l'oeil,* which means "trick of the eye" to communicate meaning and comment on social, political, and cultural themes. Other artists associated with photorealism include Robert Bechtle (1932–), Richard Estes (1932–), and British artist Malcolm Morley (1931–).

POSTMODERNISM AND ART

What is **postmodernism**?

"Postmodernism" is a complicated term and a complicated theory, which can be applied to art, architecture, literature, philosophy, and more. Literally meaning "after modernism," postmodernism has been described as everything from a rejection of modernism, to a critique of modernism, to a new phase of it. So, postmodernism is either anti-modernism, or just more of it. Either way, postmodernism is defined in relation to its earlier counterpart. If modernism is unified and serious, then postmodernism is varied and playful. If modernism is a search for absolute truth, then postmodernism is a declaration that there is no such thing.

Postmodernism began to be recognized as an approach to art starting in the 1970s, and is perhaps most easily recognized in architecture. A good example of modernist architecture is Gerrit Rietveld's Schroeder House (1924), which was designed with a uniform style, complete with coordinating furniture and interior design. By contrast, the Piazza d'Italia in New Orleans, designed in 1975, reflects the influence of various styles of architecture—from Renaissance to baroque to modernism—and is made up of a multitude of forms and colors. Where Schroeder house was stylistically unified, the Piazza d'Italia is stylistically diverse.

What are some of the important **concepts** of **postmodernism**?

Understanding some of the key terms of postmodernism will help to get a grasp of what it is that postmodern artists do.

- *Pluralism*—Postmodern art is not just varied, it is "pluralistic," meaning it reflects the perspectives of many different ethnic, racial, religious, gender, and

sexual groups. Postmodern art is also pluralistic because it reflects many different artistic styles and often incorporates features of various art movements from the past and present.

- *Appropriation*—Postmodern art often copies or borrows elements and images from other works of art to form something new. Consider contemporary television comedies such as *The Simpsons* and *Family Guy*. These shows frequently refer to, or parody, other television shows or elements of popular culture; familiarity with these references is essential in order to get the joke.

- *Deconstruction*—Postmodern deconstruction is a method of taking apart a unified whole to expose its underlying structure. It is used as a form of analysis or interpretation. It is popular amongst postmodern artists who are suspicious of the uniformity and overarching structure of modernism. In this way, postmodernism is like the child who continues to ask "why."

- *Kitsch*—Many postmodern artists challenge the distinction between good and bad taste. The word kitsch traditionally refers to ugly objects that reflect bad taste, such as souvenirs, or overly sentimental objects. Examples of kitsch include decorative garden gnomes, or plates decorated with the images of the British royal family. Postmodern artists embrace kitsch and frequently incorporate kitsch into their work.

What does **postmodern architecture** look like?

Postmodern architecture is not necessarily a style, but an approach; therefore, postmodern buildings will not necessarily look like one another, but may share some characteristics. One of the key postmodern architects is Robert Venturi (1925–), a Philadelphia-born architect who believed that the urban environment was too complex to be uniform. In 1966, he wrote *Complexity and Contradiction,* where he responded to modernist architect Ludwig Mies van der Rohe's statement, "less is more" by declaring "less is a bore." Venturi's architectural style is infused with various architectural styles from history. A good example is the Vanna Venturi House, completed in 1964 and built for the architect's mother. The Vanna Venturi house is at once complex and simple, serious and playful. It has a solid foundation and an angled roof, and evokes a sense of the traditional farmhouse—but not quite. This ethereal lack of uniformity is characteristic of postmodernism. Frank Gehry is also a well-known postmodern architect who built the Disney Concert Hall in Los Angeles, which opened in 2003, and the Guggenheim Museum of Modern Art in Bilbao, Spain, in 1997. His work is often constructed of highly polished stainless steel made up of distorted planes that form a complex, curvilinear design—a chaotic style that can be described as deconstructivist.

What are some **examples** of **postmodern art**?

Many postmodern art movements are described as "neo" movements because they respond to earlier modern styles or approaches. Here is a sampling.

- Neo-expressionism—Neo-expressionism is primarily focused on painting (though some sculpture is considered neo-expressionist) and first began in Germany in

Designed by Frank Gehry, the Stata Center is located in Cambridge, Massachusetts. It is an example of postmodern architecture.

the late 1970s and early 1980s. Neo-expressionist paintings are usually vibrant, sometimes figurative, but often raw and self-aware. Neo-expressionist artists include Anselm Kiefer (1945–) from Germany, and the American Julian Schnabel (1951–), who's large, brash paintings have been highly financially successful.

• Neo-geo—Neo-Geometric Conceptualism, or neo-geo, developed in New York City in the mid–1980s and is characterized by postmodern appropriation and a strong sense of irony. Artists associated with neo-geo include Peter Halley (1953–) and Ross Blecker (1949–), who brought new symbolic meaning to familiar modernist forms. Artists such as Ashley Bickerton (1959–) and Jeff Koons (1955–) are neo-geo artists more interested in consumer culture, and their art is sometimes also categorized as "post pop."

• Neo-pop—Neo-pop is another term for post Pop, an art movement that developed under the influence of pop art in the 1980s. Neo-pop artists include Haim Steinbach (1944–), Alan McCollum (1949–), Jeff Koons (1955–), Ashley Bickerton (1959–), and Takashi Murakami (1961–). Neo-pop artists frequently use pre-existing, everyday objects (also known as ready-mades) in their work and question the values of mainstream culture.

Who is **Cindy Sherman**?

Cindy Sherman (1954–) is a postmodern photographer known for her conceptual manipulations of media images and her use of self-portraiture. Sherman's photo-

graphs explore feminine identity and question the way women are portrayed in art and popular culture. In her series *Untitled Film Stills,* from the late 1970s and early 1980s, Sherman takes on the role of a female icon, a "blond bombshell" such as Marilyn Monroe, and other stereotypical clichés. Her characters range from self-aware to subdued to comical. Her later work takes on art history. In *Untitled #224,* Sherman becomes Bacchus, the ancient God of wine as imagined in the work of baroque artist Caravaggio, her eyes peering out from under a crown of grape leaves. Through her work, Cindy Sherman becomes the composite of the many images and film references she makes, leading the viewer to question the reality—or artificiality—of not only the artist's identity, but of the way in which subjects are portrayed in art and popular culture.

Who is **Jeff Koons**?

Jeff Koons (1955–) is a controversial, highly successful contemporary artist known for monumental, brightly colored sculpture and art produced by large teams of assistants. A former commodities broker who trained at the School of the Art Institute of Chicago and the Maryland Institute College of Art, Koons creates art that critiques commercialism. For example, he displayed vacuum cleaners in clear, Perspex boxes, in a series called *The New* (1979) and later began making enormous, highly polished balloon animal sculptures that were praised for their technical virtuosity, and criticized for their over-the-top decadence. Koons is also famous for his large topiary sculpture, *Puppy* (1992) and his rococo-esque sculpture, *Michael Jackson and Bubbles* (1988), a golden, ceramic sculpture of the King of Pop with his pet monkey. Koons' art is polarizing because it blurs the line between high art and spectacle, which some say is exactly the point.

Why did **Damien Hirst** preserve a **tiger shark** in formaldehyde solution?

Damien Hirst's preserved shark piece might not mean much without its title—*The Physical Impossibility of Death in the Mind of Someone Living* (1991). Hirst (1965–) garnered early critical success as a member of the Young British Artists, and works in a variety of media, making paintings, prints, sculptures, and installations. Hirst's "pickled shark," like much of his work, features dead animals, and is thematically focused on death, and the frailty or fragility of human existence. The once fierce and dynamic shark is now frozen, his dangerous teeth preserved in formaldehyde and kept under glass. A living, breathing beast is now as immobile and impersonal as any other example of ready-made pop art. Hirst's preserved shark has been criticized by many as a stunt, and by others who claim Hirst's work shouldn't even be considered art at all. But, Hirst has been very successful overall, both critically and financially, earning millions of dollars for his pieces, as well as the prestigious British Turner Prize for art in 1995.

Who are the **Young British Artists**?

The Young British Artists (YBA's) are a loosely affiliated group of contemporary artists working in London, many of whom trained at London's Goldsmith's college in the

late 1980s. Many of the Young British Artists gained the support of wealthy patrons, such as advertising magnate and art collector Charles Saatchi. The Young British Artists included Damien Hirst (1965–), who curated a show of YBA work at a warehouse in 1988, putting the group on the map. Other members, such as Gary Hume and Fiona Rae, exhibited in this early show, while others—Rachel Whiteread (1963–) and Tracey Emin (c. 1963)—did not, but are also considered YBA's. The work of these artists is very diverse. Gary Hume and Fiona Rae are primarily painters, while Whiteread and Emin are known for their conceptual sculpture and installations.

CONTEMPORARY ART
AND TECHNOLOGY

What is **video art**?

While artists such as Andy Warhol had experimented with film and video recordings, video art was born in 1965 when Fluxus artist Nam June Paik filmed the streets of New York City with his brand new Sony portable video camera and showed the videos mere hours later at a café. Video art (which is a medium, not a style, in the way that oil painting is a medium), represents a transition from mass media influence to television influence. Video art can take many forms, from use in sculpture and installations, to performances—and videos can be broadcast live or recorded and displayed in various settings. In 1996, Douglas Gordon won the British Turner Prize for his video work *24 Hour Psycho* (1996). Contemporary video artists include Bill Viola (1951–), Matthew Barney (1967–) (creator of the *Cremaster* film series), and Canadian Stan Douglas (1960–), among many others.

Who was **Nam June Paik**?

Nam June Paik (1932–2006) was a Korean American artist who worked in many different media, creating videotapes, paintings, sculptures, robots, laser installations, and writing. He is best known as an innovator in video art. Paik joined Fluxus while studying in Germany and was later inspired by the experimental composer and artist John Cage, who he met and befriended in 1958. Paik used the video as a structural component in his sculptures and installations. For example, he made a "cello" by stacking television sets and stringing them together with cello strings. He also made a bra out of two television screens in a work titled, *TV Bra for Living Sculpture* (1969), which he designed to be worn by cello player and collaborator, Charlotte Moorman, while she performed. Paik's *Video Flag X* (1985) is another example of video used in sculpture—a series of television screens are arranged in a grid pattern to display an image of the American flag.

Who is **Bill Viola**?

Bill Viola (1951–) is a contemporary video and sound artist known for exploring the role of technology in his work and his video and audio. One of his most well-known

and emotionally powerful pieces is *Heaven and Earth* (1992), a sculptural installation in which two video monitors face one another. One monitor displays a scene of the artist's mother on her death bed while the other screen plays a scene of his nearly newborn son, juxtaposing the beginning of life with the end. Because of the highly reflective surface of the screens, the death and birth scenes merge into one. Viola's larger installations can create a completely immersive environment through video and audio projection—making the viewer a part of the art. Viola's 1976 work, *He Weeps for You,* used video to allow gallery visitors to see (and hear) themselves reflected in a water droplet that slowly falls from a brass valve, an image that was magnified on a large screen.

What is **sound art**?

Also known as audio art, sound art developed in the late 1970s, though artists and musicians had been experimenting with sound and electronic music for decades prior. Sound art, like video art, is a medium rather than a style, and features many different types of sounds—from natural to man-made. The Italian artist Luigi Russolo (1883–1947) wrote a manifesto titled *The Art of Noises* in 1913, using new musical instruments as well as music comprised of "noise-sounds." Also in 1913, Dada artist Marcel Duchamp created the *Erratum Musical* and later, Yves Klein wrote *The Monotone Symphony* (1947), which was composed of only one note. There are a number of sound artists (and visual artists who incorporate sound) working today, including the British artist Brian Eno (1948–), who collaborated with the artist Peter Schmidt to create an artwork called *Oblique Strategies: Over One Hundred Worthwhile Dilemmas* (1975). *Oblique Strategies* is a set of cards designed to assist in solving difficult dilemmas that arise during life and creative work, such as writing a musical composition. Sound art is still in its infancy, and new audio and digital technology continues to develop and impact the medium.

What is **digital art**?

Digital art is art made by using digital technologies, such as a computer. Digital art is now more commonly referred to as "new media art" and can include two-dimensional images, whether printed or not (made with software programs such as Adobe Photoshop, for example), three-dimensional works, or even multimedia works such as animations or videos made using computer software.

What is **Internet art**?

Artists continually mine new technologies for possible artistic media, from acrylic paints to plastics, electronics to the World Wide Web. Internet art (or, net art) is a newly emerging form of digital art and can be interactive, collaborative, and accessible. Internet art is unique amongst art forms for its ability to reach a global audience in the click of a button. In 1995, the website Adaweb was created as an online gallery hosting virtual art installations by established artists such as Felix Gonzalez-Torres (1957–1996) and Jenny Holzer (1950–), who exhibited her *Truisms* on Adaweb. Another example of net art includes Russian artist Olia Lialina's interactive piece,

My Boyfriend Came Back from the War (1996), which tells a story by allowing site visitors to click on different hypertext links and GIFs (digital images in "graphics interchange format"). Internet art continues to expand, with many museums and galleries launching art websites, and new digital artists who explore the medium.

EMERGING FORMS OF ART

Is **graffiti** considered art?

From a postmodern perspective, graffiti is as legitimate a form of visual expression as any form of fine art; therefore an oil painting is no more valid than graffiti and both are considered art. Graffiti, which is often associated with vandalism and the illicit painting or marking of public spaces, has been part of painting for decades, if not longer. Artists such as Jackson Pollock and Jean Dubuffet, for example, incorporated graffiti-like markings into their work. In 1983, the first exhibition of graffiti art was held at Boymans van Beuningen Museum in Denmark—a sign that graffiti was being accepted as a fine art. The artist Jean-Michel Basquiat (1960–1988) began his career in the late 1970s as a graffiti artist, tagging buildings with short, poetic phrases, along with this friend, Al Diaz. The duo signed their work as SAMO ("same old shit"). In the 1980s, Basquiat developed a neo-expressionist style that incorporated graffiti elements, explored experimental music, and exhibited his work in galleries in New York City and Los Angeles. Another artist, Keith Haring (1958–1990) also began his career by using chalk and Magic Markers to draw his dynamic cartoon images in public spaces, such as New York Metro stations. Both Basquiat and Haring have achieved even greater success since their premature deaths (Basquiat of a heroin overdose and Haring of AIDS), as graffiti art and street art have received increasing mainstream attention.

Can a **video game** be a work of art?

All works of art, but perhaps most obviously installation art, rely upon the participation of viewer to generate meaning. When you go to a gallery and look the art, your thoughts and experiences affect the meaning of the art you see and interpret. This exchange is naturally extended to the concept of game play and video games. Game theory and game art have been a fruitful source of artistic exploration for years. In 2001, The Massachusetts Museum of Contemporary Art exhibited "Game Show," and in 2012 the Smithsonian American Art Museum held

Jean-Michel Basquiat's neo-expressionist style was inspired by graffiti, pop culture, and non-Western art. His brightly colored painting, *Pyro* (1984), is dominated by the central image of a Mayan figure. (*Art courtesy the Bridgeman Art Library, © The Estate of Jean-Michel Basquiat / ADAGP, Paris / Artists' Rights Society [ARS], New York 2013.*)

a show called, "The Art of Video Games." The show's curator, Chris Melissinos, explained that through the video game medium, we are "invited by the artist to inject our own morality, our own world view, our own experiences into the game as we play it, and what comes out is wholly different from everybody that experiences it" ("The Art of Video Games"). Like other forms of digital art, video game art is very young, and generations of innovative artists will likely mine the medium for its theoretical and aesthetic potential in the years to come.

CONTEMPORARY ART AND GLOBALIZATION

Who are some of the **important international artists** working today?

The contemporary art world is increasingly international in scope and a number of artists from around the world have achieved critical acclaim and success. The following is a short list of some of these artists.

Who is **Mona Hatoum**?

Mona Hatoum (1952–) is a Palestinian video and installation artist who was raised in Lebanon and works primarily in Britain. Hatoum's conceptual installations and performance pieces often communicate themes of exile and authority. Examples of her work include the minimalist *Socle du Monde* (Base of the World) (1992–1993), a large black cube that contrasts a metallic interior structure with a softer, more organic exterior embellishment.

The work of Iranian American artist Shirin Neshat explores themes of femininity and Islam in her work, including *Allegiance with Wakefulness* (1994), a black-and-white photograph that contrasts the delicate curves of calligraphy and the softness of feet, with the confrontational view of the end of a gun. (*Art courtesy the Bridgeman Art Library / Gladstone Gallery, New York and Brussels, © Shirin Neshat.*)

Who is **Mariko Mori**?

Mariko Mori (1967–) is a contemporary Japanese artist whose work includes videos, photographs, and installations, such as *Tom Na Hiu* (2006), a high-tech, monolithic structure whose light changes and blinks as it reacts to information recorded by the Super-Kamiokande Neutrino Observatory in Tokyo. Mori's work is often influenced by technology and Buddhism.

Who is **Shirin Neshat**?

Shirin Neshat (1957–) is an Iranian American photographer and video artist whose photographs frequently explore

stereotypes of Muslim women. Her later video work, including *Tooba* (2002) and *Logic of the Birds* (2002), explores spiritual themes through Qur'anic symbolism and music.

Who is **Gabriel Orozco**?

Gabriel Orozco (1962–) is a Mexican artist from Jalapa, Veracruz, whose work, including sculpture, photographs, and installations, often subtly alters found objects and is intellectually complex. For example, in the early 1990s, Orozco chopped up a Citroën DS automobile and reduced its width by two-thirds, making us think differently about commonly perceived objects.

Who is **Yinka Shonibare**, MBE?

Yinka Shonibare (1962–) is a British Nigerian artist whose work takes many forms, including video, photography, installation, and performance. Some of his most well-known work questions racial identity and relationships between cultures in a post-colonial world. His sculptural work, *Scramble for Africa* (2003), depicts headless European leaders dressed in European-style clothes made with African printed fabrics as they divide up the resources of the continent amongst them-

<div style="text-align: right"></div>

Contemporary artist Yinka Shonibare questions assumptions of race and class in his post-colonial work, *Diary of a Victorian Dandy* (1998), which includes self-portraits of the artist in the Victorian dress of the British upper class. (*Art courtesy The Israel Museum, Jerusalem / Gift of the Stanley H. Picker Trust, London / to the British Friends of the Art Museums of Israel / The Bridgeman Art Library*).

selves. He was made a Member of the British Empire (MBE) by Britain's Queen Elizabeth II in 2005.

Who is **Ai Weiwei**?

Ai Weiwei (1957–) is a Chinese contemporary artist and political activist known for working in a variety of media, including painting, sculpture, and installations. Weiwei, who has shown his work internationally, was arrested by Chinese police in 2011 and detained for tax evasion, and has since not been allowed to leave the country or speak publicly about his arrest. Ai Weiwei's work is often political, contemplative, and humorous. Many of his works, such as his *Coloured Vases* (2006) series, evoke a sense of emptiness.

Where does **art go from here**?

Now that modernists and postmodernists have pushed all the boundaries there are to push, broken all the rules there are to break, and generally decided that almost anything from everyday life—cigarette butts to candy wrappers to urinals—can be a work of art, the question becomes, "Now what?" Does a mere painting have any power left in it? Has art itself come to an end?

Books such as *The End of Art* by Donald Kuspit and *After the End of Art* by Arthur C. Danto raise these seemingly drastic questions not because anyone is afraid that artists will stop producing art altogether, but because of the philosophical and aesthetic implications of creating art in a technological, post-postmodern world. While some critics fear for a future that seems to care nothing for beauty, the truth is that nobody knows what art will look like in one hundred years, nor what future artists and critics will think when they look back on the art produced in the late-twentieth and twenty-first centuries.

We live in an exciting time in art history. Artists are profoundly challenged with how to approach their work in the face of thousands of years of art history. Only time will give us perspective on our current art trends and philosophies; some scholar or critic of the future will perhaps re-categorize elements of postmodernism into some other "ism" and discuss it in a completely new way. Art does not evolve in a single direction, or conclude like the narrative of a story.

Art is a messy, ever-changing human endeavor, and its future is unknown.

EXPLORING ART ON YOUR OWN

Where can I see **art in my area**?

Art is all around us, especially if you are looking for it. Be sure to check out local galleries and museums, which usually have both permanent collections and temporary exhibitions that change regularly. Cafés, bookstores, and frame shops also often hang original art by local artists on the walls and sometimes have talks about art. These are great places to meet other people who are interested in art. Especially during the summer months, arts and crafts fairs and festivals are frequently held in downtowns,

parks, and fairgrounds. Search online or stop in at your local arts and crafts store, gallery, or café, which might have some information on upcoming art events.

I want to learn more. Where I can I find **art resources online**?

There are so many websites about art that looking up art online can turn into information overload. Here are a select few websites with a wealth of information on art, presented in a straightforward and often entertaining way.

- Heilbrunn Timeline of Art History at the Metropolitan Museum of New York, http://www.metmuseum.org/toah/. This incredibly detailed site combines detailed explanations of art movements and styles with explanations of specific works of art held in the museum's collection. It is a great resource for Western and non-Western art alike. If you can't make it to New York, looking at the Met Museum's Timeline of Art History is the next best thing.

- Google Art Project, http://www.googleartproject.com/. A visit to Google Art Project is like stepping into a virtual museum. Roam the halls of the J. Paul Getty Museum in Los Angeles, the Uffizi Gallery in Florence, or the Tate Britain in London. Dozens of museums opened their doors to Google in 2011, allowing cameras to film their interiors in a manner similar to Google StreetView. After broadening the project's scope in 2012, tens of thousands of works of art from around the world can be seen online through the Google Art Project.

- Smarthistory presented by the Khan Academy, http://smarthistory.khanacademy .org/. Smarthistory is a great place to learn more about art movements and specific works of art. The site provides written essays, and video and audio guides to some of the most famous paintings, sculptures, and works of architecture around the world. Recently, Smarthistory has made an effort to include non-Western art. Smarthistory multimedia presentations are engaging and highly informative.

Are there any **good documentaries** about art?

There are literally hundreds, if not thousands, of documentaries about art and artists. One of the best recent documentaries is Simon Schama's *Power of Art* (2006) series, which does an excellent (and very entertaining) job of explaining the work of famous artists throughout history—from the Renaissance to the twentieth century. The PBS series *art: 21* is unparalleled in its presentation of art in the twenty-first century. Each episode of *art: 21,* which is organized by theme, provides a look into the minds (and usually the studios) of artists working today. For a mix of Western and non-Western art, the series *Art through Time: A Global View* is also presented thematically, and includes information from art historians from around the world. It is often shown on local PBS stations. Check your local listings.

What **movies** have been made about **famous artists**?

Artists have been inspiring films for decades. The following is a short list of movies either about or inspired by artists.

- *Exit through the Gift Shop* (2010). An intriguing documentary about the enigmatic street artist Banksy.
- *Little Ashes* (2008). Robert Pattinson plays Salvador Dali in a film about the artist's relationships with filmmaker Luis Buñuel and writer Federico García Lorca.
- *Factory Girl* (2006). A dramatic look at Edie Sedgwickæs relationship with Andy Warhol.
- *Klimt* (2006). John Malkovich plays the Austrian artist Gustav Klimt.
- *Modigliani* (2004). A dramatic romance that focuses on the rivalry between artists Modigliani and Picasso in Paris.
- *The Girl with the Pearl Earring* (2003). A film inspired by a novel by Tracy Chevalier that was in turn inspired by the famous painting by Jan Vermeer.
- *Frida* (2002). Salma Hayek and Alfred Molina star as Frida Kahlo and Diego Rivera, respectively.
- *Pollock* (2000). Starring Ed Harris as abstract expressionist painter Jackson Pollock. Marcia Gay Harden won the Academy Award for her portrayal of Lee Krasner.
- *Goya in Bordeaux* (1999). A dramatic Spanish language film about the artist Francisco de Goya.
- *Surviving Picasso* (1996). Anthony Hopkins stars as Pablo Picasso in this film about the women in his life.
- *Basquait* (1996). A biopic of the postmodernist artist Jean-Michel Basquait.
- *I Shot Andy Warhol* (1996). Lili Taylor stars as Valerie Solanis, who shot Andy Warhol in 1968.
- *Vincent and Theo* (1990). Robert Altman directs this film about the relationship between brothers Vincent and Theo van Gogh.
- *Camille Claudel* (1988). A French film about sculptor Camille Claudel and her relationship with Auguste Rodin.
- *Oviri* (1986). Donald Sutherland plays French artist Paul Gauguin.

Glossary

Abstract Expressionism—a mid-twentieth-century-painting movement that initially developed in New York City. Influenced by **Surrealism**, Abstract Expressionism is characterized by free artistic expression, abstraction, and the use of large canvases; important artists include Jackson Pollock, Franz Kline, and Willem de Kooning.

aesthetics—a branch of philosophy concerned with the meaning and significance of beauty and taste, especially in the fine arts

altarpiece—a piece of artwork usually painted or carved with religious scenes and placed on an altar in a church; an altarpiece made up of three panels is called a **triptych**

applied art—any art that is aesthetically designed but serves a functional or everyday purpose

arch—a curved architectural structure that supports the weight above an open space

architecture—the practice (or art) of designing and constructing buildings

art—the product of an artist

Art Brut—a term created by artist Jean Dubuffet to describe art created outside of the mainstream by amateur artists, including nonprofessionals, children, and the mentally ill. Also known as Raw Art or Outsider Art.

art criticism—the discussion and evaluation of works of art

Art Deco—Early twentieth-century, international design movement especially popular during the 1920s and 1930s; characterized by the use of geometric forms and ornamentation derived from both industrial and craft **motifs**

Art Nouveau—a late-nineteenth-century design movement characterized by a graceful, linear style, organic decorative **motifs**, and a feeling of energy

artist—a person who creates art

assemblage—a collection of diverse elements, such as cloth, wood, or trash, composed to become a work of art

asymmetrical—unbalanced

avant-garde—a French term meaning "vanguard," used to describe artists working with new or experimental ideas

balance—balance is achieved in a work of art when elements such as line, form, or color are evenly or harmoniously arranged

Baroque—a European art movement that lasted from the late sixteenth century to the early eighteenth century and was characterized by heightened visual realism, intensity of feeling

263

fresco—painting done on fresh, wet plaster with water-soluble pigments, allowing the pigments to mix directly with the plaster for durable results

frottage—a technique in which a piece of paper is laid over a textured surface and then rubbed with a medium such as charcoal, chalk, or crayon for aesthetic effect

Futurism—early twentieth-century art movement that developed in Italy and that energetically emphasized youth culture, modern industrial innovations, and social violence; important Futurists include Filippo Marinetti and Umberto Boccioni.

gallery—an institution whose purpose is the display or sale of art; the term also refers to a single room whose purpose is the display of art. For example, the rooms of a museum are often referred to as "galleries."

genre painting—a style of painting that depicts scenes from everyday life

geometric—designs based on geometric forms, such as circles, squares, rectangles, etc.

gilding—the process of applying a thin layer of gold paint or **gold leaf** to a surface

glaze—a transparent or semitransparent liquid used to varnish a painting; a liquid used to seal and/or color ceramics

gold leaf—a sheet of gold beaten until paper thin and used in **gilding**

golden ratio—also known as the "golden mean" or "divine proportion" among other terms, the golden ratio is 1:1.618; accordingly, the ratio of bc to ab is the same as ab to ac. The golden ratio is commonly found in art, architecture, and nature.

Gothic—a style of art that emerged in Europe during the mid-twelfth century and is characterized by a new naturalism and highly ornate design. In architecture, it is characterized by pointed arches, flying buttresses and immense height, as exhibited in buildings such as Chartres Cathedral.

gouache—an opaque watercolor paint mixed with gum or glue

graffiti—markings, including drawings, writing, or other images, sprayed or painted in public places, usually illegally or without permission

graphic design—an artistic discipline in which ideas are communicated through the combination of image and text, as in advertising

Great Master—or "Old Master," a master artist who is held in high esteem, usually from the Renaissance; for example, Leonardo da Vinci, Donatello, Michelangelo, etc.

grisaille—painting or drawing in monochromatic shades of gray

guild—a medieval organization of craftsmen or merchants that often wielded considerable power

hieratic scale—the use of size to indicate the significance of a figure; for example, in ancient Egyptian art, a god or pharaoh would be depicted as larger than a layperson

horizon line—in perspective drawing, the horizon line is an imaginary line drawn at eye level, often separating the ground from the sky

hue—pure spectrum colors, including red, orange, yellow, green blue, and violet

icon—a panel painting of a religious figure, such as Jesus Christ, that is venerated in Orthodox Christian traditions

iconoclastic—relating to the destruction of images, usually for religious purposes

iconography—the study of visual images, specifically of signs and symbols

illuminated manuscript—a handwritten book or document with **illustrations**

illustration—a picture created or used to decorate or explain a text

impasto—a technique of applying paint thickly in order to achieve **texture** and bold color

Impressionism—a late-nineteenth-century art movement that began in France and emphasizes the transitory qualities of color and light; paintings often depict movement, nature, and

upper-class social scenes. Important Impressionists include Claude Monet, Camille Pissarro, and Auguste Renoir.

installation—a work of art, usually temporary, created for a specific space, such as an art gallery

juxtaposition—the act of bringing two things together, often for the purpose of comparison or contrast

kiln—a heated enclosed space, such as an oven or furnace, used to fire clay to form ceramics

kufic—an old, angular style of Arabic writing used in medieval Qur'ans and illuminated manuscripts

landscape—a style of painting in which a nature or urban scene is represented

life drawing—drawing the human figure while observing a live model in various poses

line—the mark made by a single moving point

lithography—a **printmaking** technique using a flat, specially prepared stone which is inked and then pressed

lost-wax casting—an ancient (and still common) process for making sculpture in which a mould is formed around shaped wax; the wax is melted, drained, and then replaced by a molten metal such as bronze

mandala—an image or diagram of the cosmos used by Buddhists for meditation

mandorla—an area, usually circular, of light emanating from a sacred person in Christian imagery; often referred to as a "halo"

Mannerism—a style of art that developed in Europe after the High Renaissance and is characterized by paintings featuring elongated, contorted forms, enigmatic scenes, and a sense of eroticism. Significant Mannerists include Jacopo da Pontormo and Agnolo Bronzino.

manuscript—a book or document written by hand

masonry—brick, stone, or concrete construction

masterpiece—an outstanding example of artistic skill, perhaps the greatest work made by a particular artist

medium (pl. media)—the material an artist uses to create a work of art, such as paint, ink, marble, etc.

miniature—a small **portrait**, or an illumination in a **manuscript**

Minimalism—a Modernist art movement that peaked in the 1960s and 1970s in America and focused on the extreme reduction of form; important minimalist artists are Donald Judd, Anne Truitt, and Frank Stella.

mixed media—the use of multiple media in the creation of a single work of art; for example, a collage made with paint, ink, and photographs

modeling—the creation a three-dimensional form, such as with clay, or the illusion of a three-dimensional form through manipulation of color and light in a painting

Modernism—From the late-nineteenth to the mid-to-late-twentieth century, avant-garde art movement that consistently shocked viewers due to its departures from art tradition. Edouard Manet's painting *Le Déjeuner sur l'Herbe* (1863) is considered by some to mark the beginning of Modernism. This broad movement encompasses a number of other movements, including Cubism, Fauvism, and Abstract Expressionism.

monumental—great, imposing, historically significant, or larger-than-life; the Byzantine mosaics of Emperors Justinian at the Church of San Vitale in Italy are an example of art on a monumental scale

267

mosaic—an arrangement of small stones or pieces of colored glass forming a picture and affixed to a surface; mosaics were a popular art form in ancient Rome and in the Byzantine Empire

motif—a repeated visual element or symbol

mural—a painted wall or ceiling

museum—an institution that collects, protects, and exhibits important historic and cultural artifacts, including works of art, on behalf of society; the museum as we know it today developed within the last two hundred years

Naïve art—art created by amateurs or individuals who have not been professionally trained; famous naïve artists include Henri Rousseau and Grandma Moses.

naturalism—artistic depiction of objects in the natural world so as to be an accurate reflection of reality

negative space—the space around and between the objects in an image

Neoclassicism—a style of art and architecture popular from the mid-seventeenth to the mid-eighteenth centuries, especially in Europe, that draws on the Classical traditions of ancient Greece and Rome. Jacque Louis David is a neoclassical painter, while Thomas Jefferson's Monticello is an example of neoclassical architecture.

non-representational—not representing any specific thing or object from the natural world

Op art—also called optical art, a style of abstract art concerned with optical illusion achieved through geometric forms and bright colors; Op artists include Bridget Riley and Victor Vasarely.

order (of architecture)—a set of principles for achieving symmetry and proportion in building design; at the most basic level, the Classical orders are made of a base, column, capital, and entablature; styles includes the Doric, Ionic, and Corinthian orders.

organic—a description of forms that take on qualities found in the natural world, including curves, vegetal patterns, or irregular shapes

orthogonal lines—in a **perspective** drawing, parallel lines that lead diagonally from the edge of a picture to the central **vanishing point**, appearing to recede into the distance

Outsider art—an English synonym for **Art Brut**

paint—an artist's **medium** composed of pigment mixed with a liquid, such as water or oil

painterly—an adjective that describes the quality of a free **brushstroke**, rather than a line; for example, large, mixed, or textured areas of light, dark, and color as opposed to more rigid outlines

palette—a surface used for mixing paints

parchment—prepared animal skin used for writing or painting

patron—an individual or institution that provides financial support to an artist, usually by commissioning or purchasing the artist's work

perspective—a technique in which the illusion of three-dimensional space is rendered in two dimensions

photography—the art of creating permanent images using light-sensitive materials

picture plane—the surface of a picture or painting both real and imaginary; in the context of perspective, the picture plane is imagined as like the glass of a window in the extreme foreground

pigment—a dry, usually ground color mixed with a liquid medium to form paint

plane—a flat surface

plein air—or, *en plein air*, is a French term used to describe the act of painting outdoors in natural light, a method preferred by many Impressionists in the nineteenth century

Pointillism—also known as divisionism, an artistic style associated with the work of Georges Seurat and considered by some a subcategory of **Post-Impressionism**; Pointillism relies on brightly colored painted dots to form an image.

Pop Art—a primarily British and American art movement heavily influenced by popular culture and advertising imagery; Andy Warhol is perhaps the most famous pop artist.

portrait—a visual representation of a person showing that person's likeness, and usually his or her face and upper body

Post-Impressionism—an extension of (or a reaction against) **Impressionism** exemplified by the work of artists such as Paul Cezanne and Vincent van Gogh

Postmodernism—a broad, difficult term that describes and art and culture movement that began in approximately the 1970s and is considered both an extension and a rejection of **Modernism**; postmodern artists are often influenced by popular culture and "low" art, and their work can exhibit playful or disturbing qualities

printmaking—a process of producing multiple copies of the same image by transferring ink from one surface such as a metal plate, stone, or silk screen onto paper or other textiles; various printmaking techniques include engraving, etching, screen printing, and woodcut printing

proportion—the size or scale of one visual element as it relates to the whole; for example, the size of the human head as it relates to the size of the rest of the body. If an artist depicted the head too large compared to the rest of the body, the image would look unbalanced or unrealistic and would be said to be "out of proportion."

Realism—a nineteenth-century movement, especially in France, that emphasized the realities of every day life; significant realists of this period include Gustave Courbet and Jean-François Millet

relief—a sculpture or carving that projects into space from a flat background; a sculpture in low relief projects less into space than a sculpture in high relief

Renaissance—a cultural movement in Europe that lasted from approximately the late-fourteenth century to the late-sixteenth century and is characterized by the use of perspective in art; Renaissance artists, such as Leonardo da Vinci and Michelangelo, were concerned with Classical ideals of naturalism, balance, and harmony in their work; the term itself means "rebirth."

representational art—also referred to as objective art or **figurative art**, art that depicts, or attempts to depict, familiar objects that are part of physical reality

reproduction—an imitation or copy

rhythm—regular visual repetition

Rococo—an eighteenth-century European art, design, and architecture movement characterized by elaborate ornamentation and a playful, witty tone; important Rococo artists include François Boucher and Jean-François Fragonard

Romanesque—an important medieval artistic style that flourished from approximately the ninth through twelfth centuries and is characterized by the use of the rounded arch, the barrel vault, and heavy **masonry** walls in architecture

rotunda—a round building, usually topped with a dome

scale—the size of an object as it relates to the size of another object; for example, the size of a human figure as it relates to the size of a building

screen printing—a **printmaking** technique in which ink is pressed through the open areas of a mesh screen with a squeegee in order to make multiple copies of a design

sculptor—an artist who works in three-dimensions by carving, modeling, welding, or otherwise assembling a work of art

sculpture—three-dimensional art produced by carving, modeling, welding, or assemblage

sfumato—a painting technique famously used by Leonardo da Vinci in which areas of light and dark are blended to create "smoky" rather than harsh outlines

shade—color mixed with black

shape—two-dimensional enclosed space formed when a line curves, or when multiple lines meetsketch—a quick, often exploratory drawing

stained glass—colored glass that has been decoratively arranged and fused, commonly used in church or cathedral windows

still life—a type of painting in which an arrangement of inanimate, every-day objects is depicted

style—a distinctive manner or characteristic of a work of art that can be identified as belonging to a specific artist, period, or movement

subject matter—the main focus or theme of a work of art

Suprematism—an influential, non-representational art movement that originated in Russia in the twentieth century and emphasized formal and emotional purity in art; founded by the artist Kazimir Malevich

Surrealism—an early twentieth-century movement emphasizing chance, irrationality, and the unconscious; work by Surrealist artists such as Salvador Dali and René Magritte were often inspired by dreams

symbol—in art, an image that stands for or represents an idea; for example, the image of a dog is a common symbol for loyalty

tapestry—woven fabric that can take on many forms, including wall hangings, carpets, garments, and more

technique—a specific process or procedure for creating a work of art

textiles—materials made of fibers, yarns or fabrics, or produced by weaving, knitting, felting, etc.

texture—the feel or consistency of a surface

tint—the shade of a color

tone—the quality of a color as defined by its value; for example, whether the color is warm or cool

triptych—a work of art made up of three panels or sections

trompe l'oeil—a French word that meaning "trick of the eye," refers to painted images so realistic they create an optical illusion of three dimensional space

value—the property of a color as it relates to how light or dark the color is; light colors are "high" in value while dark colors are "low" in value

vanishing point—in a perspective drawing, the point on the horizon line at which all orthogonal lines converge, usually at the viewer's eye level

varnish—a transparent finish used to seal, protect, or give a glossy appearance to a painting or other work of art

vault—a semi-cylindrical roof or ceiling based on the principle of the arch

vellum—a type of parchment made with prepared calfskin and used for writing, drawing, or painting upon

volume—mass, or representation of mass

watercolor—a painting medium formed by combining water with a water-soluble pigment; the term also refers to paintings made using this medium

weaving—interlaced strands of fiber forming cloth

woodblock printing—a printmaking technique originating in China in which a piece of wood is carved, inked, and then usually pressed onto paper

Bibliography

Adams, Laurie Schneider. *A History of Western Art*, 4th ed. New York: McGraw Hill, 2008.

Adams, Laurie Schneider. *World Views: Topics in Non-Western Art*. New York: McGraw Hill, 2004.

"Ancient Chinese Jades." Freer and Sackler Galleries at the Smithsonian Museum of Asian Art. Web. http://www.asia.si.edu/explore/china/jades/gallery.asp#bidisks.

Boardman, John. *Greek Art*, 4th ed.. London: Thames & Hudson, 1996.

"Boscoreale: Frescoes from the Villa of P. Fannius Synistor." In Heilbrunn Timeline of Art History. New York: The Metropolitan Museum of Art, 2000–. http://www.met museum.org/toah/hd/cubi/hd_cubi.htm (October 2004).

Clunas, Craig. *Art in China*, 2nd ed. Oxford: Oxford University Press, 2009.

Curtis, Gregory. "Base Deception." *Smithsonian* 34.7 (2003): 101–107. OmniFile Full Text Select (H.W. Wilson). Web. (30 December, 2011).

Delbanco, Dawn. "Chinese Calligraphy." In Heilbrunn Timeline of Art History. New York: The Metropolitan Museum of Art, 2000 . http://www.metmuseum.org/toah/hd/chcl/hd_chcl.htm (originally published April 2008, last revised November 2008).

"Euphronios." The J. Paul Getty Museum. http://www.getty.edu/art/gettyguide/art MakerDetails?maker=86 (accessed 23 January, 2013).

Garlake, Peter. *Early Art and Architecture of Africa*. Oxford: Oxford University Press, 2002.

"Greek Art in the Archaic Period." In Heilbrunn Timeline of Art History. New York: The Metropolitan Museum of Art, 2000–. http://www.metmuseum.org/toah/hd/argk/hd_argk.htm (October 2003)

Hemingway, Colette, and Seán Hemingway. "The Art of Classical Greece (ca. 480–323 B.C.)." In Heilbrunn Timeline of Art History. New York: The Metropolitan Museum of Art, 2000–. http://www.metmuseum.org/toah/hd/tacg/hd_tacg.htm (January 2008).

Hemingway, Colette, and Seán Hemingway. "Art of the Hellenistic Age and the Hellenistic Tradition." In Heilbrunn Timeline of Art History. New York: The Metropoli-

tan Museum of Art, 2000–. http://www.metmuseum.org/toah/hd/haht/hd_haht.htm (April 2007).

Honour, Hugh, and Fleming, John. *The Visual Arts: A History*, 7th ed. Upper Saddle River, NJ: Prentice Hall, 2005.

Kerlogue, Fiona. *Arts of Southeast Asia*. London: Thames & Hudson, 2004.

Kleiner, Fred S. *Gardner's Art through the Ages: Non-Western Perspectives*, 13th ed. Boston: Wadsworth, 2010.

MacKenzie, Lynn. *Non-Western Art: A Brief Guide*. Upper Saddle River, NJ: Prentice Hall, 2001.

Mitter, Partha. *Indian Art*. Oxford: Oxford University Press, 2001.

Pérez de Lara, Jorge. "Temple of the Sun." *Archaeology* 58:6 (November/December 2005): 36–41.

Preziosi, Donald, and Louise Hitchcock. *Aegean Art and Architecture*. Oxford: Oxford University Press, 1999.

O'Riley, Michael Kampen. *Art Beyond the West*, 2nd ed. Upper Saddle River, NJ: Prentice Hall, 2006.

"Roman Copies of Greek Statues." In Heilbrunn Timeline of Art History. New York: The Metropolitan Museum of Art, 2000–. http://www.metmuseum.org/toah/hd/rogr/hd_rogr.htm (October 2002).

"Shang and Zhou Dynasties: The Bronze Age of China." In Heilbrunn Timeline of Art History. New York: The Metropolitan Museum of Art, 2000–. http://www.metmuseum.org/toah/hd/shzh/hd_shzh.htm (October 2004).

Stanley-Baker, Joan. *Japanese Art*. London: Thames & Hudson, 2006.

Stokstad, Marilyn. *Art History*, 3rd ed. Upper Saddle River, NJ: Prentice Hall, 2008.

Strickland, Carol. *The Annotated Arch: A Crash Course in the History of Architecture*. Kansas City: Andrews McMeel Publishing, 2001.

"Valdivia Figurines." In Heilbrunn Timeline of Art History. New York: The Metropolitan Museum of Art, 2000–. http://www.metmuseum.org/toah/hd/vald/hd_vald.htm (October 2004).

Wilkins, David G., et. al. *Art Past Art Present*, 6th ed. Upper Saddle River, NJ: Prentice Hall, 2009.

Woods, Kim W. *Making Renaissance Art*. New Haven, CT: Yale University Press, 2007.

Index

Note: (ill.) indicates photos.

273

baroque art
baroque classicism, 141
Bernini, Gianlorenzo,
137–39, 138 (ill.)
*The Calling of Saint
Matthew* (Caravaggio),
139–40, 140 (ill.)
Caravaggio, 139–40
Carracci, Annibale, 142
Church of Il Gesù, 137
definition, 135
The Ecstasy of St. Teresa
(Bernini), 138–39
Gentileschi, Artemisia,
140–41
Louis XIV, 142–43, 143
(ill.)
Poussin, Nicolas, 141 (ill.),
141–42
Renaissance art vs., 136–37
rococo vs., 151
Saint Peter's Square (Vati-
can), 138
Versailles, 142–43, 143 (ill.)
world changes during
baroque period, 135
Basilica of Guadalupe (Mexico
City, Mexico), 167
basilica plan
church/synagogue, 61
Basket of Fruits (Caravaggio),
139
Basquiat, Jean-Michel, 257,
257 (ill.)
The Bath (Cassatt), 17
Bathsheba at Her Bath
(Rembrandt), 144
Baudelaire, Charles, 179, 190
Bauhaus, 205, 209–11
Baule, 196
Bayeux Tapestry, 10, 10 (ill.),
95
Beardsley, Aubrey, 193
"Beautiful Padmapani," 77
beauty, 3
Bechtle, Robert, 251
Bedroom in Arles (van Gogh),
192, 240
Beethoven, Ludwig van, 162
Being and Nothingness
(Sartre), 228
Bellini brothers (Gentile and
Giovanni), 117–18
Bellows, George, 218
Benin, 129
Bentheim Castle (van
Ruisdael), 145

Benton, Thomas Hart, 218,
219
Berlin Kore, 48
Bernhardt, Sarah, 179
Bernini, Gianlorenzo, 135,
137–39, 138 (ill.)
Bernward, Bishop, 75
Beuys, Joseph, 9, 244
bi disk, 40
Bichitr, 156
Bickerton, Ashley, 253
bieri, 196
Bierstadt, Albert, 168, 168
(ill.)
The Big Splash (Hockney),
239
A Bigger Grand Canyon
(Hockney), 240
Bihzad, 128–29, 129 (ill.)
Bingham, George Caleb, 169
Bingham, Hiram, 132
Bird in Space (Brancusi), 231,
231 (ill.)
Birth of Liquid Desires (Dali),
214
The Birth of Venus
(Botticelli), 106–7, 107 (ill.)
bisj poles, 234
Black Square (Malevich), 205
Blake, Peter, 237
Blake, William, 162, 163, 163
(ill.)
Blast (magazine), 204
Blecker, Ross, 253
Bleyl, Fritz, 198
Blue Period, 200
Blume, Peter, 229
The Boating Party (Cassatt),
184
Boccioni, Umberto, 204
bodhisattvas, 77
body art, 245
Bologna, Giovanni da, 121
Book of Durrow, 71
book of hours, 98
Book of Kells, 71–72, 72 (ill.)
Borchardt, Ludwig, 36
Borobudur, 78
Bosch, Hieronymus, 123–24,
124 (ill.)
Botticelli, Sandro, 3, 106–7,
107 (ill.), 115
Boucher, François, 154
Boulogne, Jean de, 121
Boyle, Robert, 158
Bracquemond, Félix and
Marie, 185
Brady, Mathew, 179

Bramante, Donato, 116, 117
Brancusi, Constantin, 230–31,
231 (ill.)
Braque, Georges, 199, 201
(ill.), 201–2, 203, 220, 250
Brecht, George, 244
Breton, André, 212, 213, 214,
230
*The Bride Stripped Bare by
Her Bachelors, Even*
(Duchamp), 213
Bronzino, 4, 120, 120 (ill.)
Broodthaers, Marcel, 244
Brueghel, Pieter the Elder,
124
Bruggen, Coosje van, 17
Brunelleschi, Filippo, 15, 103
(ill.), 104–5
Brutalism, 212
Buddha, 31–32, 77–78
Buddhism, 31–32, 83–84, 84
(ill.), 130
Bunbury, Lady, 158
buon fresco, 100
A Burial at Ornans (Courbet),
173
The Burial of Count Orgaz (El
Greco), 126
Burke, Edward, 162
Burnham, Daniel, 194
Byodo-in (Kyoto, Japan), 84
Byzantine art
Byzantine icon, 63
definition, 61–62
Hagia Sophia, 63, 64 (ill.)
Iconoclastic Controversy,
63
Justinian, Emperor, 62
(ill.), 62–63
Saint Mark's Basilica, 64
Byzantine icon, 63

C

Cage, John, 255
Cahill, James, 80
Cahokia, 92, 92 (ill.)
Caillebotte, Gustave, 183
Calder, Alexander, 221, 222
(ill.), 241, 250
Caliari, Paolo, 119
Caligula, 138
calligraphy, 65–66, 66 (ill.)
Cameron, Julia Margaret, 179,
179 (ill.), 180
Cameroon, 196
Campbell's soup cans, 237
Campi, Bernardino, 121

INDEX

Jewish art. *See* early Jewish and Christian art
The Jewish Cemetery (van Ruisdael), 145
jinas, 76–77
Jocho, 84
John, Saint, 59 (ill.), 60, 113
John the Baptist, St., 116
Johns, Jasper, 213, 237, 238, 239 (ill.)
Johnson, Philip, 209
joined-wood construction, 84
Jomon pottery, 41
Jonah and the Whale, 61
Jones, Allen, 237
Jones-Hogu, Barbara, 249
Jorn, Asger, 229
Joseph, St., 109
Judas, 113
Judd, Donald, 243
Judith, 115, 140
Jukurrpa, 236
Julius II, Pope, 115, 115 (ill.), 116
Jung, Carl, 190
Juno, 58
Jupiter, 58
Justinian, Emperor, 62 (ill.), 62–63, 127

K

kabuki theater, 181
Kahlo, Frida, 227–28, 228 (ill.)
Kaisersaal, 151–52
Kalabari, 196
Kamakura Period, 83
Kamechameha, King, 235
Kandarya Mahadeva temple (Khajuraho, India), 75
Kandinsky, Wassily, 192, 199, 210, 210 (ill.), 212
Kano Eitoku, 149
Kant, Immanuel, 153, 162
katsinas, 232–33
Kauffmann, Angelica, 159
Kearny Cloak, 235
Keler, Peter, 210
Kelly, Ellsworth, 243
Kepler, Johannes, 110
Khafre, 35
Khufu, 35
Kiefer, Anselm, 253
Kim Hong-do, 150
kinetic art, 250
Kirchner, Ernst Ludwig, 192, 198
The Kiss (Brancusi), 230

The Kiss (Klimt), 193
The Kitchen Maid (Vermeer), 145
kitsch, 252
Klee, Paul, 209–10, 226
Klein, Yves, 231, 243, 245, 256
Kleiner, Fred S., 81
Klimt, Gustav, 193
Kline, Franz, 223, 224, 224 (ill.)
Knossos Palace, 44
Kooning, Willem de, 223–24, 238
Koons, Jeff, 253, 254
Korean art
 celadon ware, 83
 Choson period, 149–50
 pre-modern, 82
 Silhak Movement, 150
 Silla Crown, 41–42, 41 (ill.)
Koryo Kingdom, 82
Kota tribe, 196 (ill.), 197
Kounellis, Jannis, 245
kouros, 48
Kramskoi, Ivan, 174
Krasner, Lee, 224
Krishna, 156
Krishna and Radha in a Pavilion, 156
Kritios Boy, 49, 50 (ill.)
Kronos, 58
Kufic, 66, 66 (ill.)
Kuspit, Donald, 260
Kyanzitta, 78

L

La Caricature (Daumier), 174
La Grand Odalisque (Ingres), 166
La Tintoretta, 122
L'Absinthe (Degas), 183, 186
lacquer, 131
Lady Sarah Bunbury Sacrificing to the Graces (Reynolds), 158
Lakeshore Drive Apartments (Chicago, Illinois), 209
lakshanas, 32
Lalibela (city), 87–88
Lalibela (king), 88
lamassu, 29, 29 (ill.)
lamb, 60
Lange, Dorothea, 217, 217 (ill.)
Laozi, 38
The Large Blue Horses (Marc), 199

The Large Glass (Duchamp), 213
Las Hillanderas (Velázquez), 147
Las Meninas (Velázquez), 187
Lascaux Caves (France), 19, 20 (ill.), 20–21
The Last Judgment (Giotto), 102
The Last Supper (Leonardo da Vinci), 112, 113–14, 136 (ill.), 137
The Last Supper (Tintoretto), 136 (ill.), 137
The Last Supper (Veronese), 119–20
Latin American art
 Kahlo, Frida, 227–28, 228 (ill.)
 Muralismo, 226
 Peláez, Amelia, 226
 Rivera, Diego, 226–27, 227 (ill.)
 Xul Solar, 225–26
Lawson, Ernest, 218
Le Brun, Charles, 141, 142, 143
Le Corbusier, 207, 209, 211 (ill.), 211–12
Le Dejeuner sur l'Herbe (The Luncheon on the Grass) (Manet), 176, 176 (ill.), 177
Le Divan (Matisse), 198 (ill.)
Le Nôtre, André, 143
Le Vau, Louis, 141, 142–43
Le viol (Magritte), 213
Le Violon d'Ingres (Ray), 216, 216 (ill.)
Leaning Tower of Pisa, 93–94
Leck, Bart van der, 205
LED (light emitting diode), 246
Lee, Robert E., 179
Léger, Fernand, 201
Lenin, Vladimir, 226
Leonardo da Vinci, 111–12
 artist concept, 2
 Giotti, 102
 High Renaissance, 110
 The Last Supper, 113–14, 136 (ill.), 137
 Mona Lisa, 112–13, 113 (ill.)
 sfumato technique, 118
 sketchbooks, 111 (ill.)
 Vasari, Giorgio, 101
 Vitruvian Man, 112, 112 (ill.)